D1066263

PICASSO AND DORA

A PERSONAL MEMOIR

Picasso

AND

Dora

A PERSONAL

MEMOIR

James Lord

FARRAR STRAUS GIROUX

NEW YORK

Copyright © 1993 by James Lord
All rights reserved
Printed in the United States of America
Designed by Cynthia Krupat
Published simultaneously in Canada by HarperCollinsCanadaLtd
First edition, 1993

Library of Congress Cataloging-in-Publication Data
Lord, James.
Picasso and Dora : a personal memoir / James Lord.
p. cm.
Includes index.
1. Picasso, Pablo, 1881–1973—Friends and associates. 2. Maar,
Dora—Relations with men. 3. Lord, James—Relations with artists.
4. Artists—France—Biography. I. Title.
N6853.P5L67 1993 709'.2—dc20 [B] 93-671 CIP

TO MNEMOSYNE

PAX

PREFACE

MY FRIENDS say I am secretive and devious. They are right. That such an individual should undertake a work of autobiography, albeit one purposefully superficial and optimistically impersonal, must seem at least perverse and at best brazen. It is. But therein may dwell a certain stimulus to titillation, if not to honorable intellectual exertion. The devious, secretive person, you see, supposes himself on terms of such private and artful intimacy with the truth that he can thread his way without deceit but also without inexpedient disclosure through the narration of a story which is his own only to the extent that it reveals him utterly and honestly. This, of course, is the beauty of his predicament, and it may make for a certain aesthetic effect, setting the matter of contemplation apart from the means of its comprehension, rather in the relation of the apple on the head of William Tell's son to the arrow of his father's bow. We know, to be sure, that neither Tell nor his son ever existed in real life. I have not the least intention of going into any of my secrets or of straightening out the kinky circumlocutions of my itinerary. It is rightly said all the same that those prepared to describe their private lives inevitably reveal their private parts. An autobiographer is in the business of doing for himself what he wishes not to be done to him by anyone else. This is sometimes called self-abuse. Neither modest nor shy, I nevertheless recognize that words say more than a writer surmises. My residence, not to mention my existence, is already adorned

with numerous portraits of myself. The case is interesting. I think it illustrates a truth more significant than I am prepared to acknowledge, but I definitely believe, as Giacometti so often used to say, that notwithstanding the interest of art, nothing is more interesting than the truth. It is famously stranger than fiction but no stranger *to* fiction, which by way of preface will have to suffice.

PICASSO AND DORA

TWO of my forebears had the temerity to wager their lives on the probity of their words, and one of them proved his point by dying at the stake. This was an obscure but courageous cleric called John Rogers, burned at Smithfield in 1555 for refusing to truckle to the triple tiara. The other, likewise no truckler, known to every American in bygone days when national tradition inspired civic pride, was an orator, lawyer, and real estate speculator, famed for saying, "Give me liberty or give me death!" Luckily, this option was never put to the test. He got liberty, negotiated the Bill of Rights, made a pile of money, and died in bed. These two ancestors are the only ones I know of who demonstrated any concern for the responsibility of recorded utterance. I mention them mainly because heredity, like integrity, is a matter that merits much musing.

Patrick Henry's money lasted barely long enough to buy frock coats for his grandsons. Half a century after the great patriot's demise, one of his descendants, offspring of a patrician but impecunious family, set out on horseback to seek a fortune beyond the inauspicious orchards of his peaceful, slave-owning birthplace. This solitary horseman was called William Jaquelin Holliday. The second name had a Gallic ring, harking back to French forebears who fled abroad for the sake of religious freedom after the revocation of the Edict of Nantes, and it survived in all generations of the family right down to my own, for my brother Teddy, killed by the Japanese on the island of Luzon, aged nineteen, also had it as

his second name. Why the French strain persisted I've no idea, as it was never talked about at home, nor was there much discussion of passions pertaining to spiritual conviction, and France certainly cannot have loomed in my parents' view as a desirable, even suitable, land in which to dwell.

At about the same time that W. J. Holliday was riding westward from Virginia, a young fellow from Essex, Connecticut, born in 1839, my paternal grandfather James Burnham Lord, was shipping out as a common seaman aboard some of the last great vessels to venture upon the ocean powered by sail alone. His ancestry could claim no figure of memorable accomplishment, but Lords had been established in that part of the country before the Revolution and had given their name to a few inconspicuous landmarks, a hill in Lyme, a promontory in Stonington. Holliday's pioneering élan faltered before he reached the plains or the Apaches and he settled in Indianapolis, Indiana, there going into the business of manufacturing horseshoes, which prospered. So he presently returned to Virginia, married a childhood sweetheart, and took her back to Indianapolis, bringing along as well his share of family property, including some Henry furniture and three slaves. Children were born, the youngest, in 1863, named Ariana, my grandmother. Though horseshoes were much in demand in the years of expansion after the Civil War and had certainly brought good fortune to W. J. Holliday and Co., my great-grandfather got the idea that structural steel would in no time become a more profitable commodity. It did. He grew rich. His daughter in 1890 married a young manufacturer of stoves named Henry Bennett, and together they produced two children, a son who turned out neither interesting nor distinguished and a daughter, born January 3, 1895, named Louise, my mother.

James Lord meanwhile had also married, also had a daughter and a son, the latter born on May 1, 1882, named Albert, my father. The Lord family, however, was not prosperous. My grandfather had become captain of a coasting vessel that served the ports between Boston and New York. During a storm at sea he fell down a companionway, was injured, and after being brought ashore died a week later. His son was just seventeen. He had to go to work to help support his mother and sister, held various jobs in Connecticut and upstate New York, and by the time he was thirty had obtained a responsible position with the gas

company in New York City. He never spoke of his life during those years save to remark on one occasion that his enduring aversion to peanut butter dated from this period, when because it was so cheap he sometimes had had to rely on it as a principal item of sustenance. What is clear, anyway, is that he was industrious, conscientious, and virtuous, prizing self-reliance, not averse to a modicum of self-denial. Of medium height, he had a fine physique and a handsome face, with light blue eyes and wavy hair. Sociable, liking a good party and a good drink, he loved skating and played excellent tennis, winning the men's handicap singles at the New York Lawn Tennis Club in 1912. When the United States entered the First World War, he promptly joined the Air Corps, became a pilot, and reached the rank of captain. This may have been the expression of a romantic strain in his nature, a readiness for adventure, some discontent with the mundane. To his disappointment, however, he was not sent to France, never had a taste of war's metaphysical thrill or existential degradation. Instead, he was given command of a supply-and-repair depot in Indianapolis, a dull administrative job that left little opportunity for the carefree exultation—if that is what it was—of flying.

Louise Bennett had a happy childhood, doted on by affluent parents who never quarreled and waited on by affable servants who never questioned, openly at least, their subservience. She was sent to a fashionable boarding school in Connecticut called Rosemary Hall, which she hated. Adolescence awakened unpredictable sensitivity and frustrating diffidence. She felt herself unattractive, when in fact, if not quite beautiful, she was prettier than most. But in books she discovered unparalleled attachments, learned long passages of "Lycidas" by heart, and the laments of *Lear*, lines she recited still with young emotion at ninety, and knew Mr. Rochester's secret as well as the destiny of Ben-Hur, whose creator was her neighbor, his children her playmates. She determined to go to college, a resolve that never would have been taken by her mother, attended Sweet Briar in Virginia, and there apparently enjoyed some pleasurable friendships and studies, especially in literature and history. Then came the war. On Easter Sunday, 1918, Mr. and Mrs. Garvin Brown, who lived across the street from my mother's parents, gave an afternoon party to which they invited a lot of their friends plus a handful of the army officers stationed locally, and it was this perfectly prosaic occasion that brought about the meeting of my father and mother.

Their union was certainly like many and many another, but I have never known one to compare with it in harmonious serenity. To be sure, my opportunities to observe husbands and wives at close quarters have been few. In all my life I have attended but a single wedding, a ceremony at which, though best man—an incongruity—I knew that I was unlikely ever to play the leading role.

Albert Lord and Louise Bennett were married in Indianapolis on May 2, 1920. My father while in the army had made some friends who were influential on Wall Street and urged him after his discharge to join them downtown, foreseeing bullish years ahead. He fell in with this proposition, which nicely implied the likelihood of being able to provide traditional, even luxurious, well-being for a wife and family. My grandmother was dubious. Having grown up hearing stories of ruined relatives in Virginia, she believed in real property and cash, not great expectations. My grandfather, adoring his daughter, approved her choice despite the twelve-year difference in age and the uncertainty of prospects, and he deemed himself rich enough to forestall disaster should it ever threaten. It did, of course, and his wealth was enough, though he used to say that he'd made four fortunes, lost three, and saved only the least. My grandmother had time to reconsider her doubt, for she spent the final twenty-five years of her life under the roof of her son-in-law, who never once failed in the most meticulous courtesy toward her. To be sure, she brought her money with her and sometimes remarked that the roof, in fact, belonged to her. A lady given to speaking her mind, she was unfazed by its limitations.

My parents preferred to live in a neighborhood a bit closer to meadows and woodlands—and country clubs—than any in New York City, where my father nevertheless had to work, so they settled for Englewood, New Jersey, a community in the twenties as yet unspoiled by the proliferations brought about by the convenience of the George Washington Bridge. After less than ten years of marriage, four sons had been born: Bennett, myself, Edward, and Peter. At least one daughter would have been welcome, but my parents felt that four children was enough. My birth took place at 3:40 a.m. on the twenty-seventh of November 1922. This date coincides every now and then with the national holiday of Thanksgiving, a coincidence rich in potential for ludicrous surmise, inflated by the fact that I am a descendant of one of

those dour Puritans who sat down to dinner with the Indians in the wilds of Massachusetts in 1621, a fellow named Francis Cooke.

There was a gardener, a man to take care of the furnaces, a laundress, a cook, a maid, and a nurse. Many of our neighbors lived in much more luxurious circumstances in far larger houses. But I suppose we were situated in the lower echelons of the upper classes rather than in the higher ones of the middle. Stratification was clearer then. My grandmother, Colonial Dame and Daughter of the American Revolution, deemed herself an aristocrat. We attended private schools, belonged to country clubs, and went north in the summer. My parents had bought and renovated an old farmhouse in the south-central part of Maine, on the outskirts of a town named Paris.

Paris possessed almost an excess of resources that a boy in love with fantasy could long for. Standing right on the top of a high hill, it was wonderfully beautiful, with a fluttering nave of elms to shimmer over its ancient houses, a lending library built of cyclopean blocks, formerly a jail, a hotel opened in 1808, and in a jar in the general store a dead tarantula that had been found alive in a crate of bananas. I loved that place as I have loved no place save the one for which it was named and where I now live. Paris represented escape from every restraint, and the imaginable fulfillment of every aspiration, need, and desire. One day in the woods, the son of some friends of my parents, a boy a few years older than I called Freddy Rhodes, undid his pants and showed me what I should do about what was inside, introducing me incidentally to a lifelong predilection. This was entirely pleasurable and seemed entirely natural by virtue of entire enjoyment; and we did it thereafter occasionally. My father didn't come very often to Maine, having to stay at work in New York, and so I was happy to do errands with my permissive mother and play croquet with my brothers. I read *A Tale of Two Cities* and *The Count of Monte Cristo*. The faraway, real-life, glorious, triumphant, immortal Paris began to awaken in the dreams of the innocent little town.

The Depression was much talked about. My father lost everything he had and found himself nearing fifty, father of four children, employment uncertain and subject to change without notice. Yet I never had the slightest sense of the familial situation's being dire or of its conceivably becoming so, and I presume my brothers felt likewise. My

parents must have been unnerved, but they allowed themselves no expressions of worry in front of their sons. Our life continued just as it had been before, with servants, private boarding schools for all four boys, and the same vacation enchantment. This was the doing, of course, of the manufacturer of stoves in Indianapolis. He saw to it that bourgeois prerogatives, proprieties, and appearances were maintained. It must have been mortifying for my father, who had been schooled in the Puritan tradition of virile self-reliance, to accept the benefactions of a man whose daughter and grandsons he could no longer sufficiently provide for. But he never allowed a sign of tribulation to show, being a person so effectively in command of his emotions that I sometimes wondered if he had any. He was forty years older than I, a fact, perhaps, not liable to make for easygoing relations between parent and child.

I was a poor student, a cheater and malingerer, and the aversion I felt for the several schools and the university I attended was certainly exacerbated by the infatuations and hero worship felt for good-looking fellow students. Then one day I realized that what I longed for was not resplendent friendship but sexual dalliance. And yet years before being stricken by the affliction of this knowledge I had already reveled in fantasies of punishment and pain. Being in love with boys, I thought, would be not only my sin, guilt, and shame but, above all, my difference. Homosexuality, if news at all in the thirties, was very bad news indeed, when the adjective "gay" meant only merry freedom from care. So there was something to fear, not only in oneself but also in the wide world, therefore also something to overcome, and if the difference could be made different enough, it seemed, it might offer some chance of redemption. Only a lifetime could put that chance to a test sufficiently conclusive for the good of a Puritan conscience, but in the prospect of redemption slyly lurks the presentiment of superiority, hence the zest and intemperance of pride. As for my secret, it certainly came out long before I did. Schoolboys are merciless appraisers of each other's morals.

How entertaining it would have been, and would be today, to have had as schoolmates boys like Harold Acton, Cyril Connolly, and Evelyn Waugh, or anyone who attained any distinction at all, even as a figure of infamy, a traitor, rapist, or master embezzler. But there was nobody. The reminiscence-bearing magazines of prep school—a third-rate place called Williston Academy—and college—Wesleyan University in Mid-

dletown, Connecticut—accompanied by callous appeals for donations, follow alumni implacably across the world; and giving in to the itch of competitive curiosity, one scans them, but I have never discovered that a single one of my schoolmates achieved anything memorable. And yet schoolboys dream of amazing mankind, don't they? I know I did. Maybe it's as well that I had, or recognized, no eminent schoolmates. Competition would have to come from within. It came with a will but with violent feelings of unworthiness, which are often a spur to unorthodox ambition and incongruous behavior. Sometimes I fancied myself taking wing and soaring to glory above the earth while friends and enemies below gaped at the mastery they had failed to discern. Words, I felt, would supply the feathers. From an early age, eight or nine, I had written stories and poems. Writing seemed innocent and safe. But of course the danger of the creative compulsion becomes clear only when it's too late for caution.

Even then, my mind was crowded with thoughts of men who had gained true greatness, those to whom the self-sacrifice of doing meant more than the benefit of being. Mozart, his unfinished Requiem. Van Gogh, his ear, his suicide. Rimbaud's rotting leg and sojourn in hell. Galileo's abjuration. I had never heard of Ludwig Wittgenstein, but I shared with all my heart his nineteenth-century conviction that creative genius is the ultimate justification of life on earth. Seniors at Williston, in order to complete the course in English, were required to submit a lengthy prose piece on some subject of their choice. I elected to write a biography of Beethoven. In my silliness I may have fancied that telling the story of a great creator's life could grant some affiliation with his achievement. An industrious reader of biographies, I noted that the great had often been acquainted with one another, and perhaps it occurred to me that the proximity of greatness might have something to do with possession of it. Anyway, I was very much on the lookout for someone to admire, someone whose ideal qualifications for admiration would test the merit of the admirer. The only ones I could be sure of were in books, most of them, an added disadvantage, dead. In my immediate ken were merely the lords of the locker room: curly-haired players of hockey and tennis. About the eminence of Beethoven there was certainly no question. So my first considerable piece of writing was this biography, paying undue attention to the Heiligenstadt letter, the secreted bonds, and the

good-looking but no-good nephew. It was a pitiful production, riddled
with plagiarism and pretension, and received an A. But by thinking so
much about the deaf, intransigent Beethoven, I had surmised enough,
at least, to feel ashamed of what I had written, and burned my manu-
script.

Something ought to be said at the outset about seeing, seeing as a
deliberate act of looking and looking as the conscious aim of seeing.
Nobody in my family had any visual or aesthetic sense. My parents'
homes were arranged in keeping with conventional bourgeois taste, nei-
ther elegant nor ugly, like the homes of their friends. Pictures were
present purely as decoration, the occasional reproduction of a Gains-
borough or Greuze, Japanese prints, inevitable things by Currier and
Ives, even a couple from Epinal and a sensitive watercolor or two by a
spinster friend of the family. My experiments in seeing and adventures
in looking began because there was no dentist in Englewood deemed
good enough for the family teeth. We went to Dr. Hollingshead on East
Sixty-first Street and I had cause to go more often than any of the others,
traveling by bus and subway, trips perfectly safe for a boy of twelve in
those days and costing less than a dollar for the round trip. It became
easy while in New York to start haunting the available museums, the
Metropolitan and the Frick, to which admittance was free. Haunting
them was to dwell in a sort of heaven on earth of art, for other visitors
were thoughtful and infrequent, the guards itinerant and drowsy, so that
very often one could be quite alone for prolonged periods in galleries
filled with masterpieces, alone indeed quite long enough to feel a physical
as well as mental affinity with the objects of one's admiration. This
affinity was sufficiently profound, in fact, to generate a sense of pos-
session, a feeling that certain works of art entered into one's being to
such an extent that the union with them seemed virtually connubial, and
that the premises where such a match was made possible had become
one's true home. Whether the passion for seeing, the love of looking
began because I started haunting museums or whether it had other, more
provocative origins I don't know—there are far more interesting matters
to ponder—but the interpenetration of art and desire was certainly fixed
for life by the time I reached puberty.

To have one's actual, material abode adorned with works of art
appeared to me an ideal objective. The walls of my dormitory room at

Williston were crowded with etchings, watercolors, paintings pilfered from the family attic or picked up in thrift shops. My schoolmates thought me odd but brash, sometimes even funny. I once returned to my room and found in it sixteen garbage cans. At the head of my bed hung a large sepia photograph of the Hermes by Praxiteles, in whose works the Platonic ideal of love was fused—for the first time—with an autobiographical element as the motive for artistic creation.

Museums led to museums. And my first few led naturally to the Museum of Modern Art, where when I had just turned seventeen, World War II then under way, I became acquainted with the works of Picasso. I fell for them, the sad-faced but beautiful young men, melancholy acrobats, wistful dogs and monkeys of the Blue and Rose periods, admired terrible *Guernica*, too. In the exhibition catalogue I took quizzical note of some statements made by the great artist: "We all know that art is not truth. Art is a lie that makes us realize truth." Perhaps. If art is a truth-revealing lie, can it picture even the changes imposed upon itself by our transient, fickle perceptions? Gertrude Stein had reputedly protested, when Picasso finished her portrait, that it was not a good likeness, to which he supposedly replied that in time it would be. Truth dwelling in the portrait or in the model? Neither Picasso nor Miss Stein in 1939 yet enjoyed the status of a living legend. For a very large part of the public, in fact, both were as considerable figures of derision as they were of adulation for the perspicacious few. This added much to the sense of distinction available by way of acknowledging their greatness.

No good at anything but English, French, and history, I nonetheless managed to graduate from my third-rate prep school after an extra year of sullen drudgery. My parents were gratified, for which I blamed them. Astonishing was my acceptance at a decent college, Wesleyan University, where I arrived in the autumn of '41, aged eighteen, resolved to make my difference my distinction. Those who noticed looked askance. I was miserable but stubborn, did much writing, read *Of Human Bondage* and *Tonio Kröger*, and got arrested for jaywalking in Hartford. En route, it might logically have seemed, to nonentity.

World War II went catastrophically on, leaving me mostly unmoved, even by the defeat of France and the Occupation of Paris. The Nazis, despite their stunning conquests and fanatic barbarities—which were from the first no secret—seemed to me too arrogant, melodramatic, and

altogether piggish to win. Moreover, I had my adolescence to worry about. For my parents, with four sons, it was otherwise. They were conscientiously patriotic, though by no means chauvinistic, and foresaw that the United States would have to be, and ought to be, drawn into the conflict. On that fateful Sunday during the weekly broadcast from Carnegie Hall, when Brahms's piano concerto was interrupted for the announcement that Japanese warplanes had bombed somewhere in the Pacific Ocean a place of which I had never heard, causing great damage and large loss of life, I had no inkling that this disaster would bring about the fulfillment of dreams I had as yet hardly dreamed.

Refugees from Europe came crowding to America. Accommodations for them were scarce, and my parents, having space to spare, offered to take in a couple. Early in 1942, Monsieur and Madame Yakovleff came to stay on Hillside Avenue. Russian, tall, stooped, and despondent, he was about seventy, a former journalist, outspoken in his hatred of Fascism and, for that matter, of Communism, not concerned with being a congenial guest. His wife, younger, her spirit unbroken by the calamities that had driven her from her home and compelled her to solicit the charity of strangers overseas, was lively, cultivated, eager to make herself agreeable. From an early age I had felt an affinity for things French, the language, the country, the history, and especially Paris, which romantically beckoned amid adolescent crises as a refuge from Anglo-Saxon constraint and as a tolerant metropolis where the creative temperament, however unconventional, and whether truly talented or not, was by tradition made to feel at home. Madame Yakovleff came from Paris, indeed had left a daughter there, named Claudine, who had once aspired to become a ballet dancer but married a dentist instead. In my family, only my mother and I spoke French. The Yakovleffs spoke next to no English, and my mother was too busy to do much conversing with the refugees she had gladly befriended. They came north with us for the summer, one of the grimmest periods of the war, and it was there, in the other Paris, that I spent hours under the grape arbor chatting with Madame Yakovleff about French poets, painters, and politicians, acquiring a certain conversational fluency in that evocative tongue which fell in very nicely with my mawkish, *Moon and Sixpence* hankering after an exotic destiny, and which, in fact, virtually decided it.

Detesting college, ignorant to a fault of the ways of the world, but

confident of a knack for avoiding adversity—a simpleton, in short—I thought that enlisting in the army might be a convenient deliverance. I wrote a letter to my father alluding vaguely to such an eventuality, he responded immediately with enthusiasm, and I think that no other act of my life so roused his paternal pride as my enlistment in the army. Perhaps I was merely hurrying toward the inevitable, although I knew that there were ways of evading military service. However, I had no idea what I was getting into; therefore, felt only the sort of malaise familiar to boys at boarding school. And less than a year after the irritating interruption of the Philharmonic concert, I became a private in the United States Army, number 12183139.

Soldiering was in no sense whatever an occupation for which I possessed an aptitude. But the army, especially in wartime, offers not only opportunity but a chance at apotheosis for those with no aptitude for military tactics of any kind. Having enlisted in the Air Corps and undergone basic training in Atlantic City, I was transferred after a transcontinental train ride into the Chemical Warfare Service, stationed in the wilds of Nevada. There I fell in love with a corporal named Keith MacNab, an embittered but heterosexual socialist, who helped me, before discovering my secret, to secure transfer to a special training program in Boston. It was there I learned how many of my comrades-in-arms were as eager as I to sleep in the arms of their comrades, a discovery that transfigured my view of the world. This lecherous interlude came to its conclusion in February of '44, when I was sent to the Military Intelligence Training Center, Camp Ritchie, in the mountains of Maryland.

Language, not intelligence, was what got me into the military intelligence service, specifically my fondness for the French language and for France itself. The Allied invasion of Nazi-occupied Europe having long since been decided upon, a tardy search—"frantic," according to *The New York Times*—was made among American troops to find speakers of the languages native to the lands soon to be invaded. And indeed the search must have been nearly frantic to hit on me as a recruit likely to be of any tactical use by virtue of the French language. I do not mean to disclaim the responsibility for evil to which every man in uniform during wartime inevitably subscribes. I might have done less but could very well have done much, much more.

Perhaps it should, at all events, be made clear that the MIS was quite separate from the Office of Strategic Services, the myth-making OSS, later to mutate into the CIA. None of us were expected to parachute into occupied territories, slit sentries' throats with Bowie knives, or pass pouches of gold sovereigns to bearded men in the toilets of provincial hotels. Our doings and duties were all supposed to conform politely to the rules of warfare set forth in the Geneva Convention. They did nothing of the sort. Instead of being spies ourselves, we were meant to recruit and/or catch them, to gather tactically useful information by whatever means we could, to establish expedient relations with the rightful local authorities, if any, and to keep a sharp eye on the civilian populace to make sure no errors of allegiance interfered with the extermination of the enemy. All this eventually involved us in the absurdity and iniquity that goes by the name of war. The sense of guilt, to be sure, had been ingrained for a long time before I invited myself into the army, but military priorities seemed made to order to provide rare, felicitous opportunities for weighing its relevance. As a consequence, I may have judged myself more doomed and privileged than most to seek the dispensation of imaginations greater than my own.

In the late afternoon of September 13, 1944, the Liberty ship *James R. Randall* dropped anchor off Omaha Beach on the coast of Normandy. A great swath of crimson lay in the west, and the surface of the sea looked awfully red. The men of the 95th Infantry Division huddled on deck, waiting to go ashore. The fighting there had finished three months before, and while the outcome of the war now looked like a sure thing, it seemed equally sure that some of the soldiers aboard that ship would be dead before hostilities ended. However, "no man is killed or wounded in his thoughts," I wrote in my diary. I was one of six French-speaking personnel attached to division headquarters, my rank Technical Sergeant Third Grade, the lowest that a member of MIS could have. My first view of France had been disappointing, for the Norman coast looks like many another seashore, and I had been anticipating something that could surpass the capacity for surprise. That, of course, is why I failed to see my whole future spread out beautifully before me, because either genius or a lifetime of lucid hindsight is necessary to perceive the amazement concealed in the commonplace.

We went ashore on barges in the midmorning of the fourteenth, a

Thursday, and by midafternoon were comfortably settled in an apple orchard one mile from the village of Trévières, which lay in ruins. The Germans were in full retreat, having fled Paris three weeks before, and nothing was required for their pursuit but gasoline to power the tanks of General Patton, who furiously awaited the truckloads of fuel driven at suicidal speed toward the front by hilarious Negroes. The enemy formed a battle line in early October, running roughly from Arnhem in the north to the Swiss frontier at Basel. We left Trévières on the twelfth, passing through the outskirts of Paris two days later but not pausing there, a painful disappointment. To be so close to the site of so much glory—I could see the Panthéon, the Sacré-Coeur, the Eiffel Tower, as we passed along the outer boulevards—and yet to be deprived of any benefit from this proximity seemed unbearably thwarting.

On October 19 we moved into the front line as part of the XX Corps of the U.S. Third Army, under the command of the pugnacious, outrageous General Patton, who came to our HQ to talk to the officers. He said, "If you listen to what I say, you will come back alive. If not, you'll be dead. Go in standing up. No digging. The division against you is the 17th SS Panzer Grenadier, all replacements, so young their balls haven't come down yet. Remember that a dead prisoner can't throw a hidden hand grenade." Etc. He certainly personified with swagger the notion that a soldier is not only a doer of duty but a goer after glory.

My team caught a few spies. Our master sergeant, a man named John F. Majeski, seethed with such hatred for the Germans, he said, "it makes my urine boil." He and a French civilian called Georges did the interrogations. The rest of us went out of the room. We always went out of the room, but one would have had to be very hard of hearing and very hardened in common scruples to pretend to be unaware of what went on behind the closed door.

•

The corpses of dead soldiers flung askew, guts spilled around them, along the roadsides or flopped in the streets of perfectly ordinary villages didn't look a bit like the ones which in scores of movies I had learned to look upon as merely dead. These were horribly unusual but terribly specific and they looked very much like oneself, an identification requiring next to no help from the imagination. The utter absence of life

in forms once so full of it can be so repellent that it arouses as a kind of morbid excitement the abhorrence inherent in a craven longing to stay alive. An overt propensity for make-believe as a matter of life and death is certainly implicit in the quaint notion of military morale. One day, while on a tour of the front lines, I asked an infantryman where the enemy was. A mile or two away on the other side of a shallow valley, he said, pointing. I aimed my carbine in that direction and fired a few rounds. The gesture seemed to exist in a context where the will to survive is satisfied by a passion to be what one is not. At about that time I wrote in my diary: "I am always conscious of the roles I play, of their truth and falsehood and influence." And yet the supposition regarding art as a conceivable means of redeeming sham—if not shame—from itself was a genuine article of my imaginative faith, for I also noted without comment this quotation from *Ulysses*: "A man of genius makes no mistakes. His errors are volitional and are the portals of discovery."

Death, warfare, cruelty, all sorts of violence are plentifully represented in the works of Picasso, more emphatic and emotive, perhaps, when not immediately apparent. It seemed quite appropriate that an exhibition of his wartime paintings, as I learned from the newspaper, had recently caused a riot in Paris. And from that city, focus of longings, I had now received a letter, sent by the daughter of Madame Yakovleff, who wrote that she would happily do anything she could to make as agreeable as possible a visit by the son of those who had befriended her refugee father and mother. The fighting had now begun to advance on German soil. As I belonged to the French section of MIS, spoke no German, and was therefore supposed to be of military use only in France, reassignment became probable. That would mean a return to MIS HQ, located in the Parisian suburb of Le Vésinet, so a visit to the city itself had in fact become a possibility. I immediately realized what Claudine Goutner could do to make such a visit agreeable. My reply to her letter requested that she promptly find out where Picasso lived, go there, and tell the artist that before long he might expect to receive the visit of an American soldier named James Lord.

My request was unpremeditated, the response to an impulse seeming entirely natural and without ulterior motive, a mere matter of appropriate planning. I don't even think it fair to say that an overfamiliarity with death or a well-satisfied interest in suffering could explain my want

of prudence. Assuming all negotiations with the future to be tentative and revocable, I never suspected that arrangements might already have been made. Celebrating my twenty-second birthday in the cellar of a bombed-out store at a place called Boulay, I wrote: "When am I going to be able to think of things other than the dead and those who are guilty or not guilty?"

To consecrate the utter fatuity and futility of my part in the war, I received a decoration: the Bronze Star. My teammates, it appears, had accomplished something strategically advantageous, though I never knew, or wanted to know, what it was, and as a consequence the entire team came by this award. I did not disdain to wear the red ribbon meant to single one out as a soldier of distinction. The disguise of the uniform had improved upon itself, and is it any wonder that within it, reveling in false appearances, blind to their goal, I regarded myself as eligible to meet the most famous artist alive?

HAVING "just returned from combat," I was entitled to a three-day pass, and emerged from the Gare Saint-Lazare in the midafternoon of Sunday, December 3. Though grimy and gray, Paris was glorious, everything I had ever wanted it to be, and I had wanted it to be everything I had ever wanted. In the daze of surpassed fantasy, I wandered for hours.

At nightfall I made my way to 118 Avenue de Versailles, a drab address, where I found Claudine Goutner, her husband, his parents, and her brother, Pierre, who had just deserted from the French Army. They greeted me with warmth in the dingy apartment, offering a glass of wine. It turned out that my request had entailed a good deal of bother, as Picasso's address was not easily obtainable and he did not welcome strangers, whose business might turn out to be a nuisance. Moreover, there had been a mystery. Claudine had assumed that this must be a matter both personal and important. But when persistent efforts had finally brought her face to face with the artist on November 13, after hearing why she had come he said, "Who is this James Lord?"

Picasso possessed a fantastic acuity for instantly perceiving distinctive features, and his question was supremely to the point, the point, indeed, as to which he would soon be asked to give *prima facie* evidence, having himself been in search of it for half a century. Claudine was puzzled, but polite; she had been merely instrumental—I could never

on my own, so to speak, have located Picasso in three days' time—but, as an individual, irrelevant. I was embarrassed. She asked me to have dinner with her and her family. I accepted gladly. We conversed in French, of course. It was my ability to do so, after all, that had brought me to France, and all my conversations with friends in this country have always been in French. When recording them, I have usually done so in English, but my translations are reasonably accurate. The evening with the Goutner–Yakovleff family was pleasant, but I never saw them again.

The rue des Grands-Augustins is a short, antique street on the Left Bank close by the river and the Pont Neuf. Number 7 is a majestic, L-shaped building of cut stone, with arched gateway and cobbled court-yard. The site is historic, for the property at one time or another was owned or occupied by several kings of France, not to mention eminent statesmen and assorted grandees, one of whom was fond of boasting that no man in Europe had made more numerous or important enemies. A phlegmatic concierge snorted in answer to my query, "Picasso? He won't see you. Stairs to your left at the top." They were narrow and semicir-cular, leading upward rather steeply for two and a half stories to a stout oak door with an iron ring set into its center. There was a bell. I pressed it. A tiny tinkling remotely announced that I was capable of something, then ensuing silence suggested that this was not much. I rang again. A muffled shuffle became audible, locks croaked, and in the middle of a slit of light appeared a pointed nose, eyeglasses, and a thin mouth, which said, "What is it?"

I explained that I wished to see Picasso but had to admit that I had no appointment. I was able to assert with conviction, however, that the artist had been advised in advance of my visit. The doorkeeper opened a little farther. He was old, dressed entirely in black, wearing black-rimmed glasses and a black beret. He squinted skeptically down at me, as I had to stand two or three steps below the door because there was no landing in front of it. My uniform was the object of his scrutiny; it bore no insignia of any kind, because intelligence personnel sometimes had to pass themselves off as autonomous "agents," thus exempt from the symbolism and constraint of regular service. I told him that I had taken considerable trouble to send a messenger just three weeks pre-viously, a woman, to see Picasso in person and tell him that James Lord

might soon turn up. Her name: Claudine Goutner. The doorkeeper shrugged, but the indications of painstaking prearrangement appeared to have made an impression. "You are an American officer," he said.

"American, yes," I replied, taking advantage of the ambiguous uniform.

Then the doorkeeper said I'd better come inside and led me to a long, narrow room, its high windows split into narrow panes that let down the gray daylight dustily onto an incredible collection of junk and treasure. Introducing himself as Picasso's secretary, he gave his name: Jaime Sabartés. When I told him mine while we shook hands, he remarked that we had the same forename, a felicitous coincidence. He asked me to tell him about myself, a request immediately making for such awkwardness under the circumstances, an awkwardness actually physical, that I turned in my fear of making some misstep and on the uneven flooring made a real misstep, almost stumbling, putting out a hand to catch at an adjacent table. Whereupon Sabartés asked what was the matter. "Are you ill?" he asked. "You have been wounded in the war?"

"Yes," I said, and when Sabartés came as if to help me to a chair, I limped to it, my gait made more genuinely ungainly by the assumption that a wounded man may find easier grace than an uninjured one in the judgment of a stranger. Thus I introduced myself into the dwelling of a great artist with a deliberate lie, which all unbeknownst to me revealed a truth that today has the look of childlike innocence. The wound I feigned was false, but what it revealed was straightforward and sound. In short, I was true to myself. Of course my aspiration was to become an artist.

So when Sabartés asked whether I was in pain I said no. He inquired about my role in the war. Explaining why my uniform bore no insignia, I told him that I was a member of the military intelligence service. This clearly entitled me to more serious scrutiny. He remarked that I must have had fascinating, dangerous experiences. Not in the least, I rejoined, trying to suggest that for me the war's horror had been all the more obsessive for having put me in the position of a mere onlooker.

"I understand," he said, "that it wouldn't be right for you to talk about military secrets," appearing pleased by the surmise of an importance I had just attempted to deny. "And you want to see Picasso?"

"Yes."

This, too, seemed satisfying to the secretary, and there was a pensive silence, allowing me to take a closer look around the room. It was a fantastic sight, where no order appeared to exist. On the walls hung a single painting, a tiny still life of a lemon and glass against a crimson background,* but on the floor and on tables and chairs were posed quite a few others, mostly small, among heaps of books, photographs, newspapers, unopened parcels, musical instruments, and extraordinary objects. I noticed a remarkably complicated antique lock with an ornate, enormous key, and also a large photograph of a handsome young man in a white shirt. Upon everything shimmered a patina of dust.

Sabartés inquired whether I knew an American called Jerome Seckler, adding when I said I didn't that there were lots of Americans who had wanted to see Picasso in the three months since the Liberation of Paris. I knew no way to redeem myself from the insignificance implied by all those other Americans, so I just sat there, whereupon the secretary added, "You would prefer to see him alone, no doubt," and I nodded, wondering at the preference he attributed to me. "Then come back the day after tomorrow. At eleven o'clock exactly, because later it would be too late—for your visit to be worthwhile."

"Yes," I said, rising at once, not even curious, now that an introduction had been promised, to know why it might prove worthwhile. But I was careful to limp toward the exit, sustaining the sham meant to procure grace. Sabartés followed. At the top of the stairs I thanked him for his consideration, etc., and promised to return two days later at eleven sharp. Then I went down, still limping, and the door closed solidly behind me.

An aptitude for pretense and a readiness to resort to the virtue of false appearances might have seemed to present problems beyond the competence of a young man utterly unversed in the manipulations of point of view that art takes for granted. But I didn't question the law of gravity or care two straws how many other Americans Picasso had met. (Jerome Seckler, I subsequently learned, had interviewed the painter regarding his recent membership in the Communist Party, an allegiance

* Zervos, Vol. 11, No. 159.

which—as yet—seemed irrelevant.) The only meeting that meant any-
thing to me was mine, and in that scheme of significance there was
plentiful potential for trouble.

Two days later, having taken care to limp while approaching, I was
at the appointed place precisely on time. Sabartés opened and led me
through to the farther room, remarking that I had done well to be punctual
and that Picasso was extraordinarily attentive to the fact that each day
brought an altered perspective to the prospects of a lifetime, "because,"
he said, "genius makes every minute momentous."

I was embarrassed. That was the first time I heard Picasso called
a genius by someone whose familiarity with him would have seemed—
to me—to allow for the assumption that he was a man like any other.
But it was just on the grounds of my readiness to share this opinion and
profit by it that I stood where I did that morning, while the secretary
went on talking and I tried to feel equal to the occasion. In the periphery
of awareness, the fact was now casually registered that someone else
was in the room, standing slightly to the side by a window, its light
behind him—a short man almost bald but with wisps of white hair,
wearing a tan cashmere sweater. I took little notice of his presence, as
he said nothing and was of slight stature, whereupon Sabartés jerked
about like a puppet on a wire, declaiming histrionically, "Here is
Picasso!"

My inadequacy was breathtaking. To look like a fool, however, may
have been the very best thing that I could have done. Mumbling some
salutation, I shook the artist's outstretched hand, aware of being scru-
tinized, though not at the time especially awed by the famous eyes.

"You wished to see me?" he asked.

"Yes," I said.

Stepping back a pace, the artist made a gesture toward himself with
both hands, as if to demonstrate the obvious, which he then did by
saying, "Well, here I am."

The fact was overwhelming, and that I had no answer to it pro-
portionately plain, which Picasso proved by adding, "And what is it that
you wanted to see me about?"

"I just wanted to see you," I stammered, blushing hard. And per-
haps it was immediate evidence of Picasso's uncanny power that that
reason may have been the very best that anyone could give for presuming

to intrude upon a great artist. What surer virtue in his sight could there be?

He said, "Have you had your breakfast?"

I admitted that I had.

"Well," he said, "if you want to, you can come upstairs and sit with me while I have mine."

I said yes, blushing again, and maybe it was the fire in my face that did the trick, because a blush cannot be feigned and usually signals something the blusher would prefer to conceal.

Picasso proceeded to an open door at the far end of the room, while his secretary nodded like an entrepreneur pleased by the profitable outcome of his arrangements. The young soldier followed, limping, the very picture of one who has come to harm through disasters of war, thus *par extraordinaire* entitled to the attentions of the great. Like many injuries, however, such a one as I pretended to have sustained could very well have been but the bodily manifestation of a hurt long before made wounding to the spirit. There is no need to evoke the implications of a limp.

We came into another room, filled with such a clutter that I barely had time to recognize it as sculpture, while Picasso went quickly up a circular stairway in the far corner. The room above was packed with paintings of all sizes, colors, configurations, placed on several easels and stacked one against another on the bare tiled floor in such profusion that not much space was left to move about in. "This is where I do my painting," said the artist, waving his hand at a pile of canvases set out beside a window.

Confronted so abruptly by the creator in the presence of his creations, I was utterly at a loss for the least ability to live up to the occasion. He may have sensed how this was, as geniuses understand what effect they have on other people, being compelled to come to terms with the effect which genius has upon them, a difficulty infinitely greater than mine. He said, "Sabartés tells me you have been injured in the war."

"It's nothing," I said.

"You limp."

I admitted it.

"Sit down, then," said Picasso, indicating a green wooden bench

of the sort found in public gardens and parks, "and tell me what happened to you in the war."

The war was a topic I definitely felt authorized to talk about, having viewed it from the sidelines, never on the battlefield, so I dwelt with disingenuous conviction on the sordid hypocrisy and moral squalor that flourish when patriotic duty summons men to murder one another.

Picasso's breakfast, consisting of a large bowl of black coffee and a couple of pieces of bread, was brought by a beautiful young woman, dark, full-breasted, with lustrous long hair, who appeared not at all intimidated by the great painter.

As for the opinions I had the temerity to advance concerning the ethics of people caught up in the lunatic circumstances of warfare, Picasso readily confirmed my impression that plenty of people in France had come to comfortable accommodation with enemy rule, and *sauve qui peut*. Gertrude Stein, he said, Jean Cocteau, and Aristide Maillol, the sculptor, had been among those not too mortified by a bit of Teutonic hegemony over the easygoing Gauls. These were only names to me, and I didn't question the artist's right to name them. He himself could hardly have foreseen that he might one day extend the credit of his genius to experiment with my discernment by making me acquainted with the first two people whose good names he had just disparaged, the third, very recently deceased, being unavailable.

It was especially against the repute and integrity of the dead sculptor that Picasso inveighed that morning. He said that Maillol had been the champion of a German sculptor called Arno Breker, Hitler's favorite artist, and had used this connection to beg favors from the Nazis. Talking about Maillol's turpitude, Picasso worked himself up into a dither, but I never wondered by what chance an insignificant American soldier, a total stranger, might have appeared to the artist a person qualified to consider the merits of his tirade. Even had I wondered I could not have understood, nor could Picasso have explained.

The war was far from over. Twelve days later, in fact, the prelude to the last act of *Götterdämmerung* started in the Ardennes, costing 75,000 casualties in four weeks. I impolitely asked Picasso what he would do if the Germans somehow managed to recapture Paris. Keep on painting, he said. All he wanted in life was to be free to keep on working. By an irony, he added, the war years had been the most peaceful

of his career. Denounced as degenerate and subversive, forbidden to exhibit, he had been left in peace to work as he pleased. Since the Liberation of Paris, he had been subjected to increased annoyance, an exhibition of his paintings had caused a public disturbance, and he constantly received insulting letters.

We spoke in French, of course, Picasso's Spanish accent throaty and lilting, my own accent pronounced but less lyrical, and when he laughed, as he occasionally did, it was akin to a lingering whinny, the humorous neigh of a wild pony on a windswept mesa. I tried to tell him how much I admired his art, which he took in with tolerant indifference, gesturing toward the pictures stacked near the window. He said he would show me the room where he worked on etchings. It was small, opening from the rear of the main studio, and contained principally a large, old-fashioned press with a four-hafted cylinder. But no etchings were to be seen. In one corner was a sink. Picasso turned on the water, letting it trickle for a minute over his fingers, splashing, then shut it off abruptly, spun around, and said, "So? Have you nothing further it's necessary to speak to me about?"

"No, no, nothing," I apologetically admitted.

"Well, then . . ." He shrugged, went back to the studio, where I followed, and took the stairs to the room below, which indeed was filled with large sculptures, though I hardly had the competence to study them. "You understand," he said, "that other people are waiting. I must say goodbye."

"Oh yes," I exclaimed, anxious not to seem presumptuous when I had been nothing else. But I did not forget to limp as we went through into the room where Sabartés and two or three other men waited.

However, the artist added that my visit had been welcome; I had done well to come and see him. Now that I knew the way, and hour, I should not hesitate to return when circumstances allowed. I said thank you and that I would.

Sabartés went with me to the stairway and, saying goodbye, added, "Do take care in case of danger."

"Oh, I've never been in the slightest danger," I said, though this was untrue, and certainly it was time for me to leave, as I had sustained false appearances almost beyond endurance.

My friends, when I got back to MIS HQ, were unimpressed when I let slip the news that their buddy had made the acquaintance of Picasso. Soldiers, to be sure, are famous for being braggarts, tricksters, and liars, a fact gladly agreed upon by them all, making it easier, perhaps, to pretend that they are not in the business of dying young. Mortality was much on my mind despite the actual slightness of danger, and certainly death obsessed Picasso, and maybe my desire to make his acquaintance was dictated not only by admiration but also by fear.

When I reported for reassignment, a supercilious captain told me I was to proceed to Brittany—there to engage in some counterintelligence duty—traveling with several others by rail in a French train due to depart on December 7 at 0700. We missed it, a lovely stroke of luck, laughed, and said we'd take the train on the eighth instead, giving ourselves an extra day to enjoy Paris. I knew immediately what enjoyment I wanted, and the craving must have lain in wait deep within. If Picasso was the obvious person, I could not have known he was the inevitable one. Comprehension, however, is not the key to satisfaction. That chilly December morning the transcendent potential of portraiture took possession of me for the first time, seized me as fiercely as lust, and doubtless it had much to do with cravings of the flesh. By way of what Picasso did, as well as by virtue of what he was, my satisfaction would be made. The temerity of the thing was fraught at the same time with a sense of peril, but I could no more have discarded my idea than I could have thrown myself into the Seine.

Along the Quai Voltaire was a shop that sold supplies for artists, and instinct suggested that even a perfect portraitist might be helped by having the instruments of perfection thrust upon him. I bought a pad of drawing paper and one pencil. They were cheap but were all I could provide in addition to my mere appearance in quest of something to compete with the rot of eternity.

Approaching Picasso's house, I fell into the wounded way of walking on which my access to the place seemed to have been dependent from the outset. Apprehensive, I hung back on the lower steps of the staircase. Then a door flew open on the landing above. Out came the pretty girl who had served the artist's breakfast. She gave me a smile and said I'd no doubt come to see her boss. But it was still a little early; better to wait a few minutes in her place, she advised. I followed her into a small,

dim, low-ceilinged room, crowded with ugly furniture. But the walls were resplendent with Picassos, several of them superb portraits of her.* I made an admiring exclamation, for here was sudden proof that my purpose might be to the point. The girl's name was Inès. She apologized for having no coffee to offer. The boss himself, she said, had trouble getting supplies, and he had connections. I realized I should have brought something. If ever opportunity came again, I resolved to arrive bearing supplies for all the household.

The few minutes went by, mercifully. Then Inès said she would go up with me. She had a key and unlocked the imposing oak door as if it were nothing. Sabartés was taken aback and said I'd reappeared quickly. Maybe my injury prevented me from resuming duty, thus keeping me out of danger, he remarked. Not really, I said. The sense of danger, however, was piercing. The secretary told me that Picasso expected numerous callers that morning. Was there any matter of particular urgency that warranted the artist's attention? I admitted there was not. He nodded pensively, said he'd see what Picasso had to say, and left me alone, Inès having disappeared. I put down the drawing pad, took off my cap and coat, looked around, and pretended to feel at ease, while intimidation took my breath away. Then Sabartés returned, saying Picasso would be happy to see me again—smiling, I thought, craftily; I was to wait.

The artist soon burst into the room. "So you have been making up to Inès," he said.

"She let me in," I said. "That's all."

"What a story!" he cried. "No wonder you are in the secret service." Sabartés, who had left us alone, came back with several men, to whom I was ceremoniously introduced, though I noted none of their names, and Picasso asked us all to come upstairs with him to the painting studio. There he showed recent canvases, stacking them one above the other to make a pyramid in the light from the window to his left. Though these were the same ones I had seen three days before, the passion of his interest in them seemed as keen as if he were viewing them for the very first time—as if someone else had painted them. And then, curiously, it occurred to me that the real Picasso might not be the man standing

* Zervos, Vol. 12, Nos. 33 and 34.

and talking before my eyes. Yet I had to believe in his reality if my own presence and purpose were to be believable.

The artist and his friends presently left off looking at pictures to talk about politics, leading to exclamatory exchanges, leaving me out entirely, so I concentrated on the paintings, picking one up from the top of the pyramid to examine it more closely: a small canvas of boats moored beneath a bridge. By making free with it, I felt more in awe of it. I picked up another, this one larger, heavier, a distorted female figure outstretched. What bold élan! Holding Picassos in both hands in his presence, I seemed at liberty to see them not only as a challenge to my discernment but as a feature of my distinction. This was dangerous. When I placed the pictures back on their pyramid, the whole structure went suddenly askew, collapsing with a catastrophic clatter of eight or nine canvases on the tile floor.

Picasso laughed. I was paralyzed by embarrassment, clumsily trying to set the paintings right. He came over quickly and in a minute had put all the pictures one on top of another again. Then, without bothering to lower his voice, he said, "When the others leave, you stay."

It was neither a suggestion nor an invitation, as if the future quite naturally existed at his discretion. After a while he made a move to go back downstairs, the rest of us following like fragments dragged by a magnet. Sabartés took his employer to one side by a window and whispered to him. The others went toward the exit, Picasso accompanying them. When he came back, he said, "You have no plans for lunch." Again it was a declaration of fact, with which I meekly concurred. "Then you will be able to eat with me and a friend," he concluded.

I immediately said yes, never pausing for an instant to wonder why he should invite me. But I knew next to nothing at the time about his art or even about how artists lived.

Picasso picked up his telephone, dialed a number, spoke for a minute or two, put it down again, and shrugged into a woolly tan overcoat. I took my cap, coat, and pad of drawing paper from the chair where I'd put them long before. Sabartés, silent, stayed behind, while Picasso went ahead to the stairs and I limped after him.

In the street, in the open, he seemed smaller. In his studio, where everything pertained only to him, his size seemed immeasurable. Here it was different, yet he was the same man, no less Picasso than before,

and by the very semblance of being small in the perspective of the city he seemed at the same time to be immense, limitless, and, in a word, terrifying.

My chance had come to a crisis. I said, "I have something to ask you."

The artist spun around. His eyes shot at me. "What is it, then?" he demanded, as if he had been waiting just for this.

I was in the void. "I'd like it very much," I said, "if you would make a portrait of me," adding quickly before the end could come, "just a drawing, you know."

He said yes and of course, whenever I wished, but not just then, holding out his hands, palms upward, since he had with him none of the necessities. A pity.

But I had the pad of drawing paper, a pencil.

Picasso had turned away. He was waving to someone who stood waiting at the nearby street corner. It was a woman. True, he had said *une amie*. Still, I was displeased, as it seemed her presence could hardly be compatible with my purpose. However, Picasso then turned back to me and said I'd done very well to bring paper and pencil, and he would be happy to make my portrait. In the restaurant, he said. He led me to be introduced to the woman, asking me to repeat my name for her. She held out her hand without removing her glove and I shook it, while Picasso told me her name, which I didn't catch or care about. I paid attention to her that first time principally because it seemed that she was far more displeased to see me than I could ever have been to see her. Picasso appeared as pleased as Punch, going on ahead, motioning to us both to follow with sweeping, exaggerated gestures that would, in fact, have been well suited to the commedia dell'arte. Her name, of course, was Dora Maar.

The restaurant was farther along to the left. Picasso's entrance caused a hush, an atmospheric alteration that wafted me into the empyrean of vicarious importance. The proprietor greeted his illustrious client with servile familiarity. A drawing of him by the artist hung close to the door. Our table was to the right, against the wall. Picasso and Dora sat side by side, and I facing him. I placed my pad on the table. At once the artist produced a blue packet of cigarettes, offering them first to Dora Maar, who took one, then to me—but I refused—before

placing one precisely between his lips. She opened her purse, rummaged in it, and brought out a gold cigarette holder, a slender tube several inches long like a tiny trumpet, with a black Bakelite mouthpiece and a flaring bell, into which she studiedly inserted the tip of her cigarette. She had remarkably beautiful hands, the fingers exceptionally slender and graceful, with long, pointed, scarlet nails. Having set the cigarette into its holder, she placed the mouthpiece between her teeth and must have clenched them, because the holder jutted upward at an acute angle from her lips. Then she sat there, staring straight in front of her, moving not a muscle, with the unlighted cigarette projecting into space. Picasso also had his unlighted cigarette in his mouth and also sat stock-still. Then he murmured to his neighbor. He was asking her for a light. But by a barely perceptible shift of her shoulders and features, without a word, she made a negative response. Picasso insisted, mentioning a cigarette lighter. Dora shrugged, didn't glance at him, and remarked that the lighter must have gotten lost, whereupon Picasso began berating her explosively, speaking in Spanish, rapping his knuckles so loudly on the table that people turned to stare. But he appeared supremely indifferent to everyone but Dora, whose own indifference to Picasso and his tirade was evidently absolute, as she simply sat there, the unlit cigarette immobile in front of her face.

The storm stopped suddenly. A puff of air from Picasso's mouth, then stillness. Turning to me, he said, "You have matches. Sure. All soldiers smoke, get drunk, and run after girls."

People all over the world at that moment were selling themselves for cigarettes, and I was compelled to say I didn't smoke and therefore carried no matches. Picasso laughed and took from his jacket pocket a box of matches, lit one, and held it up to Dora's cigarette. She gracefully inclined her head toward the flame and puffed her cigarette alight without glancing at either of us. Picasso lit his own cigarette and dropped the match on the floor.

Edging my pad toward him, I said, "If you could do the portrait now," and put the pencil likewise in front of him. Exhaling an abrupt burst of smoke, Dora then turned to look at us. An extraordinary intensity emanated from her gaze. But she did not speak.

"I'll do it immediately," said Picasso. Taking my chin in his hand, he lifted my head slightly and turned it to the left until the position must have suited him, then said, "Good. Now don't move."

I didn't, sat staring straight ahead, yet I could see what he was doing. He opened the pad, took up the pencil, and studied me fixedly for a moment or two, no more, then drew very fast on the page, glancing again but once or twice. It was done in two or three minutes. "There it is," he said, holding across the pad so that I could see.

I had no first impression, I think. The magic of the effect was too overwhelming. Where there had been nothing, suddenly there was being, of which I was possessed.

Picasso said he would dedicate the drawing and asked me how to spell my name. Then he signed, adding the name of the city and the date, closed the pad, and handed it back to me along with the pencil. Oh, he made in his lifetime tens of thousands of drawings, to be sure, and many, many of these were portraits of people he knew far better than he ever knew me. But genius is wont to fight shy of conquests that are too easy. To capture a likeness is one thing; to accept its surrender is very definitely another. I placed the pad on the chair beside me, feeling that to concentrate immediately on what it contained would be unseemly and compromising.

Then I saw that Dora Maar was looking at me. Her gaze possessed remarkable radiance but could also be very hard. I observed that she was beautiful, with a strong, straight nose, perfect scarlet lips, the chin firm, the jaw a trifle heavy and the more forceful for being so, rich chestnut hair drawn smoothly back, and eyelashes like the furred antennae of moths.

Of the lunch itself—what we ate, etc.—I remember nothing, except that the plentiful quantity and good quality of the food made it clear that we were being fed by the black market. The artist and his mistress spoke occasionally, sometimes in Spanish, and even I now and then managed to find something to say. Picasso took a fountain pen out of his pocket and on the paper table covering drew a face, beginning with the eyes, a woman's face, very lifelike and exquisite, closely resembling Dora. When he put away his pen, she took up a knife, cut away the drawing as expertly as a surgeon, rolled it up carefully, and put it into her purse. Picasso smiled.

An elderly man from one of the neighboring tables came over to ours to speak to Dora and Picasso, in Spanish, calling him Pablo. That was the first and absolutely the only time I ever heard anyone make free to call the artist by his first name. Dora did not appear to mind. She

meticulously inserted another cigarette into the trumpet tip of her elegant holder, then brought out from her purse a silver lighter and lit it. Turning with reptilian rapidity, Picasso darted his head very close to hers and whispered something into her ear, whereupon both of them burst out laughing, as though struck simultaneously by the thunderbolt of hilarity. It excluded everyone and everything else. The elderly man went away. I sat there. When the laughter of my companions had ended, the meal had ended.

Picasso stood up, so Dora and I did likewise. No money changed hands, no bill was even presented. I later learned that Picasso could, and often did, pay for almost anything with a work of art. We went outside into the gray afternoon, I clutching the pad that now held my likeness. At the street corner where we had met Dora an hour or so before, Picasso turned to me to shake hands and say goodbye, adding that I must come to see him whenever I wanted to. I held out my hand to Dora, who allowed her gloved fingers to be pressed only briefly before withdrawing them but gave a little nod of her head as a sign of politesse. It was then that I realized I had hardly heard her voice during the time we had been together. Picasso walked away beside her along the narrow sidewalk, and hardly had they gone eight or ten paces before she started to speak. I couldn't hear her words but the sound of her speech was quite audible, rising in volume and velocity as they moved away, and they seemed almost to be conveyed physically down the street by the momentum of her utterances.

Alone, I limped along the rue des Grands-Augustins toward the Seine. I didn't look at the drawing. Not yet. It, I felt, would know when the moment was propitious. Already, however, and with such apparent simplicity, my aspiration seemed to have been gratified. I had made the acquaintance of a great artist, the most famed and most emblematic of his era, and had in my possession my portrait from his hand, tangible proof—was it not?—that my person had commanded the scrutiny of a genius. Such consummation, I was aware, came to very few, and so I might naturally have assumed that in this domain of craving I had nothing further to want, that my quest was at an end. But no. It was only beginning.

C H A P T E R

T H R E E

I WAS sorely disappointed.

All that Thursday afternoon, wandering the wintry streets and bou-
levards, again and again I reopened the pad for still another look at the
drawing inside,* as if one more glance might generate the satisfaction
I'd wanted. It didn't. But why? The first portrait ever made of me,
executed by the most remarkable artist to live during my lifetime, seemed
the very image of inadequacy. The secret self must have been up to
something. I described in my diary the meal with Picasso and Dora,
also the portrait: "A quick little sketch dashed off during lunch." That
was all I had to say about the drawing. Why so depreciate a work of art
representing such idealistic presumption?

Picasso's attention and creative faculties clearly had not been en-
gaged very deeply either by his model or by his drawing while I sat
before him in the restaurant. The ink sketch on the paper table covering
had been appreciably more vivid and exciting. I saw in my portrait
principally evidences of haste and indifference, its inadequacy, not my
own. The rendering of the GI-cut hair, the ear, the body, eye and
eyebrow, to be sure, is perfunctory. Not so the profile, though, which
is aquiver, especially the mouth, feeling and alive. But I didn't have

* Zervos, Vol. 14, No. 122.

the insight to see what I had been searching for. On the evidence of his drawing, Picasso appears to have seen in me something similar to my own sentimental view of his Blue Period pictures of wistful harlequins and romantic acrobats, several of whom I'd fallen in love with five years before. The pensive, slightly melancholy, ambiguous expression of my features, and in particular the physically impossible but aesthetically effective depiction of the left shoulder hunched upward before the profile, seemed designed to compose an image imbued by the same narcissistic pathos I had thought to discern in Picasso's youthful art as a reflection of my adolescent vanity and sensual desperation. Perhaps it is just as well that I didn't understand what desire had guided my steps to the rue des Grands-Augustins or suspect what wizardry enabled Picasso to see what I wanted and give it to me by making a portrait so peculiarly like a representation of *his* youth, not mine. In the catalogue of the 1939 exhibition whereby Picasso had first gotten me excited I had also under-lined the following statement by the artist: "A picture lives in life like a living creature, undergoing the changes imposed upon us by our life from day to day. This is natural enough, as the picture lives only through the man who is looking at it."

It may have been inevitable, therefore, that I should succumb to some confusion when it came to taking liberties with my likeness. I felt no compunction about making free with the work of art created at my request by Picasso. In addition to its inadequacy as a mirror, the drawing qua drawing appeared to my insatiable eye a bit incomplete, lacking a full adequacy of lines. One small spot in particular left empty by the artist wanted, I felt, a finishing touch, and the selfsame pencil used by Picasso, having been handed back along with the pad, could serve the disappointed model to improve upon his portrait. The particular spot was at the nape of the neck. So I took the pencil and drew there a three-looped line, suggesting a scarf or the rumpled sweater I had in fact been wearing, and maybe I was never so happy with any of the many likenesses of myself as then, when a single line could introduce *me* into the very matrix of the creative act. It was the only time I ever presumed to possess such a prerogative.

Meanwhile, I had been sent to the remote, picturesque Breton town of Quimper, one of only four Americans in that area. My duties were next to none, and I became friendly with a doctor at the local insane

asylum, himself an artist of sorts. He went by the odd nickname of Pluto, which I think was more appropriate than he knew.

In Quimper, I often lay awake at night, wondering and wondering how I could persuade Picasso to make another portrait of me, one more impressive, larger, and better as a likeness. The uncertainty fused with the desire to such a degree that it became strangely united with obsessive brooding about the war, guilt, suffering, and death. As a sort of ritual prelude to sleep, which never came easily, I used to think most intently about the possibility, representing to myself in preparation for dreams the moment of exaltation and deliverance when I would come into possession of another portrait of James Lord by Picasso. Never for an instant did it occur to me that I might not chance to find myself once more in the presence of the great artist. Nobody, I think, having known him at all, could ever afterward foresee a time when Picasso would cease to be present in the perspective of things to come.

My teammates in Quimper took no liking to their moody, self-regarding associate, wherefore after seven weeks I was sent back to Brittany Base HQ for reassignment. It was into the Vosges Mountains, freezing cold in the month of February, that I was sent this time as an interrogator at a camp where German prisoners, both Wehrmacht and SS, were being held with thousands of displaced persons of myriad nationalities, Italian, French, Belgian, Norwegian, Polish, Russian, Greek, Indian, and more in conditions of miserable disorder and degradation. With the assistance of various interpreters, for several sickening weeks I spent ten to twelve hours a day interrogating random prisoners in an effort to learn what they had been doing during the war and especially to determine if any had been guilty of crimes or atrocities. For someone to have to do this work was no doubt necessary, however unpleasant, even odious, but to have to do it myself seemed to symbolize some guilt of my own in a manner both inexplicable and inexpiable. Most of the men I questioned pleaded with me to help them return home, but some, especially Russians, Poles, and Greeks, were terrified of being sent back to their homelands, where they said that certain death, or worse, awaited them. Many wept. My superiors criticized me constantly for being too soft, too gullible, and too slow. I wrote morbid paragraphs in my diary. The commandant requested my recall, so I returned to Paris by train on March 23.

The following Monday I received orders to proceed with ten others to Germany, where I would have to undertake further interrogations in the prisoner-of-war camps in the area of Mannheim. But first I was allowed a two-day pass in Paris.

Picasso had by no means been forgotten during those harrowing weeks. My longing to possess another portrait of myself by him had, if possible, only been intensified by the traumatic illusion of responsibility for the fate of men in whose terrified eyes I saw myself. Maybe this made me so reckless and rude that I decided to disregard Sabartés's admonitions about timing and get to the rue des Grands-Augustins good and early. Over my shoulder I slung a musette bag filled with cartons of cigarettes, cakes of soap, some coffee, cans of Spam, and a bottle of whisky. But I prudently left behind at my billet the pad containing the sketch hurriedly dashed off long before by Picasso. Dawdling did not commend itself to the emotion with which I approached for the fourth time the artist's home, and I was there well before nine.

Nobody inquired as to my business when I entered the courtyard, and there was no Inès this time in the stairway to make me welcome. I went up in the intimidating silence and rang the bell. At this egregious hour, I surmised, nobody but the artist could be inside, and even as I rang again and yet again I felt appalled by this wanton lack of awe and overstepping of myself. Still, it never occurred to me that Picasso might be absent or that my audacity could come to nothing.

Eventually a next-to-noiseless rustle, a breath of stealth, stole through the door. I knelt there in the semidarkness, apprehensive but expectant. I heard nothing but sensed something. Raising tensed knuckles, I tapped several times on the faceted panel.

"What are you doing here?" came a strident whisper from behind the door. It was Picasso's voice. "Can't you leave me in peace? I passed all this night without sleep, without rest, in despair, through your fault."

There was evidently some mistake. I said, "It's James Lord."

Silence. The mistake had definitely been mine. I said that I had simply wanted to see him.

Picasso uttered a loud grunt, as of a wild animal aroused, and when he spoke it was in another voice. "But I was asleep!" he exclaimed. "Your bell ringing roused me out of a profound sleep. What's so important that it can't wait till later?"

"Can you open the door?" I said.

"I don't have the key."

That settled me. I knelt stymied on the stairs. Picasso said, "Is this very important?"

I admitted it was not, whereupon he repeated that he had no key and that if necessary I might return later at the habitual hour. Then silence, within which I was left kneeling on Picasso's doorstep. For a few minutes I stayed there, as if by my posture symbolically to atone for the guilt of having come. Then I stole away, happily encountering no one en route to witness my transgression. Now, at least, I was able to walk without the falsehood in my steps.

In the unkempt little garden in the courtyard of the Louvre stood a statue of Lafayette donated to France by American schoolchildren. I sat beside this monument to innocent gratitude, musing upon the strangeness of my ungrateful blunder, wondering how deeply it put me in the wrong, but surprised at the same time by the peculiarity of the artist's initial response. And how could I now expect myself to be portrayed? I had not forgotten the imperative raison d'être of the day. It was ticklish. I didn't want to tell a lie. Some answer nonetheless would have to be ready in order to make the execution of the hasty little sketch irrelevant. Lying in bed night after night in Brittany and in the neighborhood of the prison camp, I had thought that evocation of a misfortune best left unexplained must meet the need. Even Picasso, famed for the creation of monsters and massacres, could hardly argue with a mishap attributed to the adversity of fate. And if a single line from my hand added to his creation was fate, then adversity, indeed, would be no lie.

A visit to the nearby art-supply shop was necessary. This time there must be no mistake about the size of the paper. On my previous visit I had not yet seen the imposing portraits executed by the boss of his maid, none of which was little or lacking in abundance of lines. I purchased a single large sheet of drawing paper and selected the darkest graphite pencil available.

The wretched impetuosity that had made me kneel too early at Picasso's door made me cringe before it when the "habitual" hour came. A man unable to unlock his own front door, I thought, must be capable of almost any stratagem. Besides, the offerings in my musette bag might appear too slyly contrived to extort a favor. So be it. Picasso had also frequently depicted the artist as a mythic deity. I rang.

"We wondered whether you would come back," said Sabartés, attired all in black as always, his spectacles glinting.

I looked with care at the door as he shut it, and there was, in fact, a lock on the inner side so intricate that a key might well have been needed to open it from within.

The plural pronoun made things sound all right, and I didn't ask questions as we passed through into the first room, where everything dusty and numinous was the same. Sabartés made no mention of the roll of paper in my hand. I put it down on the table, at the same time lifting my musette bag bashfully, as if to apologize for presuming that a few privileged items might make my presence seem likewise. We were still busy with soap, cigarettes, and coffee a few minutes later when Picasso strolled into the room.

"Here you are, here you are!" he exclaimed, grinning as he caught hold of my left cheek and tugged it playfully back and forth. "Let's go have breakfast. You can flirt with Inès." He took appreciative note of the offerings from the musette bag but did not touch them.

We went upstairs to the painting studio. Inès was there, so we said hello, but no flirtation ensued. Perhaps she was more perspicacious than her boss. He sat down on the park bench. By the window was propped up an enormous canvas I hadn't seen there in December, and the image it bore seemed immediately to leap forward to seize upon my attention. This image, outlined in black on the white canvas, was a jumble of bodies—obviously dead—limbs disjointed, asunder, buttocks, bellies, breasts twisted and contorted, gruesome faces, splayed feet, and above this terrible heap a pair of huge hands lashed together at the wrists: a representation of atrocity.* The picture instantly evoked sights seen all too recently, stockades packed with prisoners huddled in fetid mud and their own festering filth, many next door to death. The camp had been intolerable. The picture was not. It dumbfounded me. I could say nothing. Then Inès came in with coffee.

Picasso said not a word about the appalling picture. We talked of other things. The war must soon be over now. No danger of Allied reverses remained. But nothing could compete with the overpowering impression of that picture, and I was stunned by the artist's ability to know what

* Zervos, Vol. 14, No. 72.

he had no means of knowing. The abominations of the Nazi camps were not public knowledge, no photographs having yet appeared. How could I expect to present myself to the scrutiny of a man whose vision encompassed the grimmest as well as the sunniest of human extremes? I who had only my nonentity and temerity to offer by way of distinguishing features? Still, there I was, while Picasso went on talking about war and the weather, which was unseasonably summery, and I waited for my moment.

Then Sabartés tapped on the door behind the big picture, edged into the studio, and said that some men were waiting downstairs. There were three standing in the dusty sunshine, and Picasso introduced me. He had got my name, my surname, firmly in mind now, and it seemed to amuse him to pronounce it with a guttural roll of the *r*, "Lorrrd." I had noticed that when he spoke of other men he invariably used surnames. The others paid no attention to me whatever. My roll of drawing paper still lay where I had put it ages before beside the musette bag, now empty, its contents having disappeared. But my status as a denizen of Picasso's studio appeared to have changed. This had something to do with the picture I had recently seen upstairs—I couldn't have said what—but there was a sense of some prerogative. Though still afraid of the man, I felt less frightened of the artist's power. Otherwise, how could I casually have interrupted his conversation to say, "Would you make a portrait of me?"

Picasso, not a bit taken aback, replied, as I'd expected, "It's already done."

"A misfortune befell it," I said. Hadn't Picasso himself said that art is a lie that makes us realize truth? He didn't inquire about the misfortune but fixed his eyes on me.

Stepping across in front of him, I unrolled the sheet of drawing paper and from my pocket brought out the pencil, aware all the while that the others were observing this as if in a trance. Picasso took the paper and pencil, holding the sheet up to the light. "Bad quality," he said, shaking it, "and too large." He folded it quickly in half, the creasing hissing under his fingernails. "Then sit down over there," he brusquely bid me, "and turn yourself toward the right."

He was seated on the other side of the room, paper propped before him on a portfolio he'd picked up, farther from me than in the restaurant,

and I was hardly conscious that he studied my appearance at all. The pencil was rasping on the page, slowly, slowly at first, then faster, and I was only aware that I wanted it to go on indefinitely, assuming foolishly that the longer it continued its action, the surer I could feel that the outcome would live up to the mystery of my hope. But before I could even apprehend that the experience was an event, much less that it had a meaning, it was finished. Picasso stood up, tossing the paper carelessly onto the cluttered table between the windows. "It's finished," he said.

The others crowded in front of me to look, and before I had even gotten a glimpse of my portrait Sabartés cried out, "The latest masterpiece!"

Then I saw the drawing.* It baffled me. Maybe Sabartés was right, but I was embarrassed by what he said. I realized that I didn't know what I had wanted. I'd wanted a Picasso, yes, and I had one. He had already written *Pour Lord*, signed *Picasso, Paris, 27/3/45.* A portrait, a likeness, had also been my desire. Certainly this drawing looked like me, was adequately large, in no way a disappointment. Never once did I dream that adding or altering a single line could improve it. If it was perfect, then Sabartés perhaps had spoken well and my embarrassment was the evidence of my ignorance. Picasso had said that a picture lives only through the man who is looking at it. Clearly, he had seen in me that morning a being very different from the one who had come unbidden to ring at his door several months before. I tried to express some awkward manner of thanks, but he dismissed this gently. One of the other men standing by asked me to let him borrow the drawing to be photographed for inclusion in a catalogue of Picasso's works. No, I said, that would be impossible, as I must leave two days later for Germany and God only knew when I might ever come back. Picasso seemed utterly uninterested.

Having carefully rolled up my drawing, I made farewells. Picasso again pinched my cheek and laughed. "Don't forget the right time," he said.

Sabartés went with me to the stairway, explaining that it would be important to have the drawing photographed, and to send him a print for the catalogue. I promised to do that. He thanked me for the things from the musette bag, and then as I was about to go down added, "Don't forget us."

* Zervos, Vol. 14, No. 123.

That seemed the second strangest thing of the morning, I thought as I walked into the street, and that afternoon, while writing about what had happened, I wondered whether Sabartés might have meant that my remembrance, if it were to possess any relevance to experience of enduring value, should be looked upon as an aspect of the portrait itself. I bought a portfolio to carry both portraits with me, wrapped up in brown paper and bound with twine. There was no doubt that I had achieved some kind of triumph, had been successful in a feat of the imagination rarely, if ever, vouchsafed to common mortals. It was thrilling but lonely, and marked by ineluctable hubris.

The very next day, my last in Paris, I returned again to the rue des Grands-Augustins, this time with no obsession, no bold purpose in mind at all. But Picasso already had several visitors on hand. Sabartés said that a very brief hello was all the artist would have time for. Instead of dismissing me peremptorily, however, a tactic at which he was expert, Picasso asked whether I had met Gertrude Stein. No, I said, to which he replied that he would promptly arrange it, and he took his telephone. That is how I happened first to go to the rue Christine.

CHAPTER

FOUR

IN GERMANY, the three POW camps—at Ludwigshafen, Edingen, and Heilbronn—where I was sent to conduct interrogations were no worse but no better than the one near Epinal. No displaced persons in these camps, only regular army officers and men, the stray SS upon occasion found strangled in the latrines. Nothing, of course, went on that was in any way comparable to the routine of the Nazi camps. Ours by comparison were Disneylands. But the dehumanizing factor inevitably prevails when captors not only administer with impunity but superintend with complacency the misery of their captives. For me this was profoundly oppressive and has remained so to this day.

Picasso, in any case, had nothing to do with my experiences in Germany. Is it not true, however, that a man of genius is in some way concerned with everything concerning mankind? I had not forgotten the terrible picture at the rue des Grands-Augustins, and what was in the artist's work was certainly in him. He remained much on my mind, though I felt no desire now to have him portray me again. I seem to have wanted to be possessed somehow by his power. I was mindful of his much publicized commitment to the political ideology that claimed to be the only one dedicated to creating a free, equal society. Of course, the legitimacy of this claim, like the sincerity of the dedication, had been very subject to doubt and is today acknowledged to have been an abject travesty. But I had never paid close attention to politics.

Meanwhile, it was springtime, and one day the war in Europe was over. The POW camps gradually began to empty, as there was no more war to hold prisoners from, and MIS men started worrying about the risk of reassignment to the Pacific. All I wanted on earth was to be set free in Paris to admire its sights, make love to other military men, and go to see Picasso. And by one of those ridiculous miracles which are the logic of the military life, that is precisely what I presently found myself able to do. My billet was a hotel called the Ambassador near the Opéra. Duties were nominal and negligible: spying on other members of the Armed Forces to see whether they were up to anything shady, such as selling cigarettes, gasoline, or themselves for outrageous prices in the side streets of the capital. To observe this kind of commerce, one had only to look out the window, so I had all the time I wanted for Paris, pleasure, and Picasso.

My facile visits to the rue des Grands-Augustins encouraged me to take liberties. While waiting one morning for Picasso to make his entrance, I wandered into the large room cluttered with sculpture, where junk and masterpieces mingled in the dust. To the left of the door stood a capacious old sofa covered in red rep. The day was warm. I stretched out on the musty cushions, shut my eyes, and slid sweetly into repose. The warmth took on an interminable immobility, holding time still. I began to feel superfluous. So, though wide awake, I kept my eyes shut and slumped into the posture of slumber, which was intended to show how superbly unmoved by my insignificance I could appear. The wait was long, but eventually the inevitable footsteps approached, followed by dense silence, then very quietly by Picasso's laugh. He departed, leaving me in the semblance of deep sleep, which expedience ordained should be convincing because I sensed that the artist would come back and upon his impression depended my importance. Whispering and laughing, he did return, showing off the sleeping soldier as if I were another oddment conjured up to astonish his admirers. And did I not, after all, aspire to appear as a figment of his creative imagination? I was not then aware that the image of a person asleep watched over by a brooding observer recurs constantly throughout Picasso's oeuvre, the sleeper being usually the beloved of the observer, who is often an artist, if not *the* artist, and that this image seems to symbolize the entire surrender of the sleeper to the observer. Can it have been by pure chance

that I schemed to capture Picasso's attention by enacting a situation so frequently represented by him? Inspiration is self-invention. In my obsessive dreams, of course, I had never yet fancied that I might appeal to Picasso physically—besides, the sleeper in his pictures is usually a woman—but I often thought of those wistful, pretty boys of the Blue and Rose periods who had so aroused my adolescent yearnings and wondered whether or not their creator had felt for them emotions similar to mine.

Twenty years later, when Françoise Gilot, his ex-mistress and the mother of two of his children, came to tell the story of her life with Picasso, she said that after the Liberation, multitudes of worshipful GIs had come to call on him and that many of them had dropped off to sleep upon arrival. Twenty, she said, she once counted in a single day sprawled in slumber around the studio. Maybe. As for myself, I never ran into a single other American soldier at the rue des Grands-Augustins, though Sabartés sometimes spoke of visits. It seems to me highly unlikely that many of the military personnel who won admission to that studio should have celebrated their achievement by falling really and truly asleep on those prodigious premises. I suspect that Françoise's memory was multiplied by the aftereffects of Picasso's glee that one morning when I pretended to drowse. It is perfectly possible that the artist was aware that my slumber was a sham, and that this might have appealed to him far more than the real thing, especially should the make-believe sleeper be someone already familiar to him as an object of creative contemplation. The day would come when my presumptuous pose on Picasso's sofa could claim to be regarded in its own right as a work of art, complete and autonomous, a masterpiece—why not?—of the conceptual category, by virtue of uniting a great artist and his model in a true-to-life tableau representing the selfsame image so often summoned into being by his genius. Thus by deliberate pretense perhaps I succeeded for the first time in realizing ever so slightly the dream of art, and by attempting to delude Picasso I may simply have revealed to him the logic of my desire to make his acquaintance and to prevail upon him to make my portrait.

When "awakened" from my dream, I returned to the other room. Nobody paid the least attention to me, so I said I'd have to be going. Picasso kissed me. Holding me by the arms, he pressed his lips first to one cheek, then the other. Too astounded to respond, I let myself be

embraced without response, but at the same time it seemed that this must be what I had wanted, and therefore should be accepted as a matter of course. Later I learned that in France such embraces can be as casual as a handclasp, though in Picasso's case nothing could ever be counted upon as self-evident.

One evening early in July, in a bar in the rue de Ponthieu, I met a French soldier called Roger Laflotte, and we became lovers. By that time I had come to consider Picasso and Sabartés my closest friends in Paris; Inès, too, and her husband, Gustave Sassier, a truck driver. I mentioned to them that I had found a good friend in the French Army, news they heard with calm. As I became more familiar with the artist, I also grew in familiarity with his work, not only that of the wartime years but also that of previous periods, principally by studying the many books about him to be found in his studio. I noticed that at one time he had made a number of drawings of good-looking young men, ballet dancers, posed together. This had been about twenty years previously, not long after his marriage to a Russian ballerina. It occurred to me that a double portrait of Roger and myself would be a fitting souvenir of our devotion to each other. Not wanting to seem to expect special consideration from my lover because of the éclat of my acquaintances, I had till then kept from him my friendship with the famous painter. But I mentioned to Picasso my idea of the nice souvenir; he said it was excellent and promised to make a drawing if I brought my friend to the rue des Grands-Augustins the very next day.

Roger refused to go. Picasso, he said, was a cynical charlatan and any child of ten could turn out better stuff. This, to be sure, was 1945. An exhibition of the artist's recent work was on view in the Avenue de Messine. I took Roger to see it. He said it only proved his point. I said he was a fool. We parted despondently that night.

Sabartés held the oak door but very slightly ajar in the morning, peering out, and said, "Picasso is not here today."

This had happened on other days, so I was not offended. However, I had taken for granted that the artist must be expecting me and my friend. Spirits still low, I told Sabartés that it didn't matter, I could come again some other time, and turned to go back down the staircase.

Behind me then the door opened a bit wider and the secretary asked, "Are you alone?"

I was, of course, a fact perhaps not at first discernible in the dimness of the staircase, which had no window at that level. Sabartés said that I might as well come inside, and I followed him through to the room which by then I had come to think of as the waiting room. He left me alone there. But he soon returned and said, "Picasso is upstairs. You may go up."

To quibble about the artist's ubiquity never occurred to me, Picasso's presence or absence seeming to be a demonstration of manifest destiny, and anyway I was mainly concerned with feeling sorry for myself. When I came into the painting studio, it was empty. The large picture of atrocity and death had undergone some change since my first view of it in March. No color had been added, but half the canvas was now filled in with gray or black, making the effect even grimmer than before.* I sat down on the floor.

Attired only in his underwear shorts, Picasso came in after a minute or two from the direction of his bedroom, strode to where I sat, and, grasping a good handful of it, yanked hard on my hair.

I yelped.

He laughed and said, "Where is your friend?"

"He had to go back to his regiment."

"Pity. I was all prepared for your portrait. Paper of the very best quality. No matter. I've already had a difficult morning. You're a nice boy. Wait a minute while I get dressed." Whereupon he went back to his bedroom, leaving the door open. I heard a murmur of voices; then the artist's dog, a sickly, silken wolfhound, sauntered into the studio. This was a rather repellent creature called Kazbek, skeletal and frail, his pelt matted with running sores, to whom the painter was demonstratively devoted. I couldn't understand why he had pulled my hair but felt that the man who'd done it was definitely the real Picasso, which added to my emotion.

When he returned, fully dressed in a dark suit, white shirt, and necktie, he was accompanied by someone else, a woman, the same one with whom we had had lunch on that dreary day in December long ago. Dora Maar. I stood up to say hello, expecting her to be aloof. But she smiled and clasped my hand with palpable warmth. She said that I

* Zervos, Vol. 14, No. 76.

seemed to have made quite an impression on Picasso. He was singing my praises, she said.

Then the artist said not really, not singing, he had only commented on my love for painting.

That was certainly commendable, Dora said, adding that, as it happened, she herself was a painter, lived close by, and perhaps I'd like to come and see her paintings sometime.

Picasso added that she had a very nice cat.

Without another word, Dora went to the stairs in the corner and started down. The artist followed, so I did likewise. She went on through the sculpture studio below, then the waiting room beyond, where Sabartés and a couple of others were seated, and onward toward the exit. Picasso said something hurried to his secretary and to one of the others, a burly fellow called Marcel, his chauffeur, who leaped to his feet to join the parade in pursuit of Dora, who by that time had disappeared down the staircase.

At the street corner facing Picasso's house stood a shiny black sedan. Dora waited in front of it. Passing his palm fondly along the hood, Picasso said something proud about this vehicle, a recent acquisition, which he wanted us to admire. Dora and I both acknowledged that the car was a beauty, civilian conveyances of any sort being hard to come by. "Not to mention the gasoline to run them," remarked Marcel, getting behind the wheel. So I said to Picasso that I'd take his picture beside the car, as I had with me a little camera I'd picked up somewhere. The artist said no, if there was any picture to be taken, better let a professional do the job. And he snatched the camera from my hand, holding it out to Dora. "The lady is an expert photographer, you see. Never touched a paintbrush till she met me. A photographer of genius, she has taken hundreds of pictures of me, might not be too happy to have somebody else usurping her place." He laughed his neighing-pony laugh, as if a memorable *bon mot* had been made, adding that the camera didn't look like much but that a true artist could get a rich result from the poorest equipment, wasn't that so?

"You're always right," Dora said, taking the camera.

Picasso seized me by the arm, drawing me to his side, and said, "Take the two of us together. It's not every day one gets the chance to have a good-looking soldier for one's model."

Having no time or sangfroid to prepare a posture or a countenance, I kept my hands behind me, with a gawky sense of awkwardness because I was so much taller than the great man at my side, bending my head a little as if to compensate, while Dora hastily snapped the shutter. She handed the camera back to me as if it had done her an injury.

That was a good thing done, exclaimed Picasso, and all for the best, as I'd wanted a portrait with my friend. He happily stood in for the missing man. And Dora made the portrait. Who could ask for anything more? Whereupon he stepped onto the sidewalk, flung open the front door of the car, and leapt inside, remarkably agile for a man of sixty-three. The motor detonated, then the vehicle drew away quickly, turning toward the Seine, and Picasso had looked neither to the right nor to the left nor uttered a word of farewell.

Dora strolled nonchalantly away, and from a sense of inadequacy I went along beside her. She said, "My professional pride is not such that I worry about anyone usurping my place. Because we happened to meet in Picasso's studio and now find ourselves alone together we are not compelled to become friends."

With burning embarrassment, I asserted that that went without saying, nor would I want to intrude or cause the least inconvenience. I felt innocent of any wrongdoing, however.

She fumbled in her purse for a package of cigarettes, then came the gold trumpet holder, the fitting of the cigarette into it, and the silver lighter to complete the ritual. When she had taken a puff or two, she said, "I never had the least intention of showing you my paintings. People casually acquainted with Picasso are not free to come and go in my home."

"Oh, I understand," I protested. "I understand very well."

"Not at all," Dora said. "You understand nothing. It's not your fault. I haven't been well recently. What I need is a sojourn in the country. And that's exactly where I'm going. With Picasso. It's what we were deciding upon when you made your unexpected appearance."

"But Picasso knew I was coming," I protested.

Dora said that she had not seen the Mediterranean since the summer of 1939. I said I'd never seen it. She held out her hand, gave me a formal smile, and said that I would have plenty of opportunities to see the Mediterranean. How astounded both of us would have been to think that we might ever embark together upon that sea. So we said goodbye

with a minimum of politeness and parted at the corner where we had first met more than seven months before.

•

My real love affair, of course, was not with the soldier but with the city. During that lustrous summer and topaz autumn I had nothing to do but indulge my passion. I did that by looking. Yes, I was young, naïve, excitable, self-indulgent. I was in love, and still am. Not an instant's regret or disappointment has ever been mine because of this liaison.

Picasso, as Dora Maar had predicted, did leave Paris that summer, going away at the end of August and not returning till several weeks later. His absence did not keep me from calling occasionally at the rue des Grands-Augustins. Sabartés in his employer's absence was a rather different person, less formal, wary, self-effacing. Seldom taciturn, he now grew sometimes nearly loquacious, and the topic he never tired of talking about was Picasso. He had been with the artist as a very young man during the early years in Barcelona and Paris and now had served as secretary and confidant for more than a decade. Sometimes he talked about himself, his youthful aspirations as poet and novelist, employment in the furniture business, travels in North and South America. He lived in a very small apartment on the roof of an ugly building at 88 rue de la Convention, a drab street several miles away from the rue des Grands-Augustins. A more flagrant contrast with the spacious, picturesque lodgings of his employer would have been hard to find, but it was a little chapel to their friendship, though I was shocked by the sparseness of evidence attesting to it. This consisted of a small oil portrait of Sabartés dressed as a Spanish grandee, and a small abstraction of the twenties, plus a handful of etchings and a couple of reproductions of portraits of him dating from the Blue Period. The comparative loquacity of Sabartés in his employer's absence became more understandable when one was confronted by Madame Sabartés, who talked with such precipitation that nobody could hope to converse with her. I later learned that Picasso had made it a categorical condition of the secretary's employment that his wife should never set foot in the studio. I went for quite a few long walks with Sabartés and felt sorry for him, which did me no credit and him no good.

Paris's many art galleries had stayed open, and done good business,

so it was said, during the Occupation. Museums, on the other hand, were mostly still shut, though a token exhibition of masterpieces hurriedly brought back from wartime hiding places had been put together in the Louvre. For those in love with art, it was consequently a good thing to seek out the premises, often shabby and unprepossessing, of the dealers. What treasures could still be lured forth from dusty back rooms! Delacroix drawings by the dozen, batches of watercolors by Cézanne, sketches by Seurat, Degas, or Ingres, paintings by Corot, Courbet, Monet, not to mention a hundred lesser figures, and etchings by everybody. What's more, none of it was excessively expensive, even for the very modest likes of me. So I got together a little batch of prints and drawings, several by Picasso, which could pretend to be the beginnings of a collection, and it was certainly then that I became infected by the acquisitive craving and the fever of vicarious experience that goes with it.

The galleries I liked best were on the Left Bank, where browsing and chitchat were more acceptable than on the Right. One afternoon, in the vicinity of the rue de Seine, I strolled into a place called Galerie Marcel Lenoir, given over entirely to the display of works by a painter of that name. They evidently dated from the twenties and I thought them in every respect devoid of merit. A stocky, gray-haired lady presided. I thought it all right to let her know how poor an opinion I had formed of Monsieur Lenoir's creations and said something condescending. She replied with asperity that Marcel Lenoir, deceased before his time fifteen years before, aged but fifty-nine, was an artist of undeniable greatness, extolled by the foremost critics and connoisseurs. Besides, how could I, an ordinary American soldier, have an opinion worth anything?

I loftily retorted that the great artists of the time were well known to all.

She said, "Name them."

"Matisse, Braque, Léger, Rouault," I saucily answered, "and the greatest of all, Picasso."

That was the name she must have been waiting for, because it put her into a fury. She fulminated against Picasso far more vehemently than poor Roger had and concluded by stating that, as she happened to be none other than Madame Marcel Lenoir, she knew all about creative greatness from having witnessed at first hand how it came into being.

I said that I also had had that privilege.

She sniffed, looking me scornfully up and down.

"It may surprise you to hear this," I said, "but Picasso happens to be my father."

That statement gave her pause. A moment of crazy gratification for me. But then she said, "If that's so, I feel very sorry for you," and turned her back.

Madame Lenoir had the last word, doubly final because wounding ambiguity prevailed as to whether her pity and scorn were directed more toward the pernicious paternity of Picasso or the woeful folly of my fabrication. I got out in a hurry, but the bizarre question of my lie followed right along. To be sure, the search for paternity is never-ending, but I knew nothing about Picasso's behavior as a parent. If I had, I would never have tempted fate by pretending to be someone so deserving, in fact, of pity.

On my first visit to Picasso's studio I had noticed a photograph of a handsome young man in a white shirt, wondering who it was. I found out one evening in August when I had dinner with Inès and her husband. We were joined toward the end of the meal by the young man of the photograph. This was Picasso's son, Paul, nicknamed Paulo in childhood, which never ended, and called so all his life, which was to be troubled and short. That first evening, however, I found him easy to like, affable and unpretentious. Wide-shouldered and well built, with red hair and freckles, he was a larger man than his father but without the artist's intimidating aura. A year and a half older than I, he seemed younger, bumptious, and a bit crude. I happened to be the first American he had met and we had hardly said hello before he told me that to own an Indian had always been his dream. To this exotic desire, silence seemed the most sensible response. Indians, Paulo went on, were by the far the fastest and toughest, and he wondered whether I could tell him how much he might have to pay for one. Even a used one, he said, would be all right, as he knew how to make them good as new. Then I guessed he must be referring to an American brand of motorcycle, which he soon confirmed by saying that the Harley-Davidson wasn't nearly so good as the Indian. I confessed that I knew nothing about motorcycles, much less their prices. Paulo's disappointment was patent. He must have been one of the first devotees of the motorcycle cult, a precursor in that, at least.

Sabartés sighed when I told him I had made the acquaintance of

Picasso's son. The boy's mother, he said, was a Russian of unstable temperament, entirely responsible for his bad upbringing. Neither of them had proper understanding of or respect for Picasso's genius. It had taken all the tolerance and compassion of greatness to give love and understanding to a boy like Paulo. I allowed that this was undoubtedly so, though ignorance of the case should have shut my mouth out of prudence, if not shame.

Picasso came back from his sojourn in the South. On several occasions I had the opportunity to observe father and son together. It seemed to me that Paulo was treated with brusque impatience, sometimes with deliberate disregard. Once he brought to the studio a girlfriend he wished to introduce to his father. Picasso patiently waited out the preliminaries, but when the instant of introduction came and the girl held out her hand, he turned on his heel and strode from the room. Paulo went scarlet in the face, while his girlfriend had to withdraw her unshaken hand. Sabartés airily acted as if nothing had happened. The artist also had a daughter, named Maya, and he was wont to extol her charm and talents, saying that she, at least, gave him cause to be proud as a parent, remarks sometimes made in the son's presence.

Of the many other visitors to the rue des Grands-Augustins, the only one with whom I became friendly was a young painter called Chapoval. Picasso had a high opinion of his work. He and his wife, Jeanne, lived in an apartment facing the gardens of the Musée de Cluny, where I often visited them and Chapoval made several portraits of me. Had he not killed himself at age thirty-two over a love affair with the wife of a diplomat, I think Picasso's high opinion would have been well vindicated by his career. Its untimely conclusion notwithstanding, the paintings he left behind are esteemed and collected by connoisseurs.

Almost all the people who called on Picasso were men, few of whom made much impression on me. Those I noticed most and remembered best, and this perhaps because in later years I had further acquaintance with both of them, were the writers Louis Aragon and Paul Eluard. Sabartés told me that they had greatly influenced Picasso in his decision to join the Communist Party, both being long-standing members. Aragon, handsome, ingratiating, well dressed, I disliked, thought devious and reptilian, overanxious to please. Eluard, on the other hand, seemed bland and charming, unpretentious, courteous even to nonentities like me.

By a coincidence that may not be altogether coincidental, both were present one day when Picasso made an extraordinary prediction concerning my future. It was in the waiting room as the group of that day, including a couple of other men in addition to the two writers and Sabartés, prepared to leave. Suddenly Picasso seized me by the shoulders and turned me to face the others. "Here is my young friend Lord," he said. "Look at him closely. Someday he will surprise us. There will be great things in his future. He will do something to astonish us all someday." Then he stepped aside and there was a moment of silence while the others, in obedience to the artist's command, looked closely at me.

Confounded, embarrassed, I stood dumb and stock-still, which was the best thing I could do, because the moment didn't last very long. The others were taking their leave, and I gladly followed, neglecting in my confusion to thank the artist for his flattering prophecy. But fate is not eligible for gratitude, and thanks would have spoiled the miraculous effect.

When I thought about what Picasso had said, I didn't know what to think. It goes without saying that an acknowledged genius may be supposed to possess greater perspicacity than common mortals, and it is likewise self-evident that young men who dream of great accomplishments believe by definition that they have it in them to astonish the world, and if they can believe that, to be sure, they can believe anything, which gives them a chance. So I was satisfied to think that I might fulfill Picasso's prophecy by writing and publishing something astonishing.

"It's odd," I said one day to Picasso, "that I don't feel a great difference in our ages. I know you're a lot older than I am, and yet when we're together I don't feel that I'm so much younger."

"You're not younger," he said. "You're older. You see, the longer one lives, the younger one grows, assuming that one is truly alive at all, because a person attains his maximum potential at about the age of twelve, and then if he is to make anything of his life he must grow back to that potential in his maturity. I'm a lot closer to doing that than you are."

He was, indeed, and always will be.

Then the month of November put an end to strolling in violet afternoons and visits to the rue des Grands-Augustins. Demobilization was imminent. An MIS officer made vague representations to me concerning possible advantages and excitements available to intelligence

personnel disposed to continue in the same line of business. Though slow to take his meaning, I said no, and in any event I had had more than enough of duties, whether real or imaginary, providing raw material for obsessions and nightmares to last till I die. I went to say farewell to Picasso, Sabartés, and Inès, and the occasion was in fact fraught with considerable sentiment. I left behind in the studio my steel helmet, my trench knife, and a few other oddments of military equipment, thinking the artist might make symbolic use of a soldier's things. He kissed me goodbye and gave me a large drawing of a man balancing on a ball in the midst of a desolate landscape.* Having fierce faith in the power of aspirations to bring about their fulfillment, I promised to come back one day.

On the morrow of my twenty-third birthday I sailed from Le Havre, and two weeks later was (honorably) discharged from the Army at Fort Monmouth, New Jersey.

* Zervos, Vol. 14, No. 127.

CHAPTER

FIVE

THE TRANSITION from military to civilian life was reputed to be traumatic, and it was. I went back to haunting museums and art galleries. I wrote letters to the friends I'd made in France. Sabartés replied with warmth, telling me that I was well remembered at the studio: "The American who sits on the floor, who lies down anywhere at all, who throws himself onto the big couch." I felt that I had already accomplished something rather surprising by establishing myself as an individual, however capricious and erratic, in the memories of men who had known true glory. My mother said, "I'm sure it's very interesting for you to have met these famous people, but I can't help wondering what it is they see in you." I affected to be put out by this well-meant candor. The question, however, of what could be seen in me by an individual of world-renowned discernment was precisely the one to which a lifetime of searching might provide no answer.

I returned for two dreary semesters to the university I'd left three years before, all its potentialities seeming intolerably tame to one who had had his hair pulled by Picasso, and then I decided to return to France to devote myself entirely to writing. My parents thought this a perilous and irresponsible course which they were ill disposed to finance. So I went to New York and sold a batch of etchings and drawings, including some given to me by Picasso, to raise money for the trip. How, and where, I might live in France presented no immediate difficulty, as

Pluto, the doctor at the insane asylum in Quimper, had invited me to stay for as long as I liked with him and his family in their spacious and tranquil apartment. Applying for a French visa, I named Picasso and Pluto as the persons who could vouch for me as a responsible visitor to that country. My parents thought me headstrong and unrealistic but may have been bemused to find one of their offspring so defiant and quixotic. Besides, they were people of comfortable means and common sense, aware that if any emergency arose I would turn at once to them to cope with it, which I and they inevitably did. So I went aboard the R.M.S. *Queen Elizabeth* on March 22, 1947, with a self-satisfied sense of setting out to confront my destiny.

All adventure is concerned with going somewhere, attaining a destination, either actual or spiritual, one usually remote from the point of departure, which in any case is irretrievable in the past. Also involved is the eventuality of search or quest, even though it be only to seek out oneself. My previous ocean crossings had not been undertaken on my own initiative. This one was, and much of its importance seemed to reside in the establishment of a great distance, both geographical and cultural, between myself and my homeland. The idea of expatriation never occurred to me. I wanted simply to get far away from the constraints of my Puritanical background and prevailing social conventions, free to work hard as a writer in a land where the literary calling has long been regarded as honorable. Also it seemed that an exotic locale would leave me more at peace with the difficulty and alienation of my desire to make love to men. Homosexuality in America in 1947 was deemed a shaming and guilty perversion, and only people who knew this from experience had the audacity to call each other gay.

Sabartés's black beret and spectacles had not changed, nor his dry, bony handclasp. He had been expecting me. The postal service had been employed to make the rue des Grands-Augustins anticipate my return. The secretary thanked me for packages of cigarettes, coffee, soap, and books. The studio looked unchanged; perhaps a little more disorder had been added to Picasso's chaos, but the place seemed immutable, eternal. Sabartés said that though the artist was still in bed he wished me to go up immediately to his bedroom. It opened off the painting studio, was small, with dormer windows and an enormous brass bedstead. The door stood open.

Picasso, propped up on pillows, motioned me forward and kissed me on both cheeks. He laughed uproariously and said it was a wonder I'd been allowed into the country, having used his name as a reference.

The thrilling fear I always felt in his presence caught me in the throat, a delight at the same time, and I asked what was so funny.

Well, he said, as a subversive artist and an avowed member of the Communist Party he was in a ticklish position, maybe not an ideal sponsor, especially for a member of the intelligence service.

But I was no longer in the army, I protested; I was finished with all that.

Just what one in my position would be bound to say, he rejoined.

The war was over, I said.

Wars end, said Picasso. Hostilities go on forever.

Obsessed by findings of responsibility and the apportionment of guilt, which had more to do with interior strife than with worldwide conflict, I had paid little attention during the war to the political issues at the root of so much suffering. But after Churchill's speech at Fulton, Missouri, denouncing Soviet Russia as an evil tyranny, I began to wonder, read books, magazines, newspapers, and presently thought I could have a few opinions about the conduct of governments. Needless to say, I believed America's to be best despite crass commercialism and hearty disdain for high culture, abject worship of novelty and success, indifference to the past, crude confidence in the future, ugliness, disorder —and despite the fact that I had no inclination to reside in America.

Scattered across Picasso's bed were quantities of papers, envelopes, newspaper clippings, which he brushed aside, motioning to me to sit down. Emboldened by this invitation, I said that if being a Communist made things ticklish, then why had he joined the Party?

He grimaced, then sighed. Oh, that was just the question that was bound to be asked, wasn't it? Everybody has to belong to something, he said, to have some tie, to accept a loyalty. One party being as good as another, he had joined the party of his friends, who were Communists. "Anyway," he added, "my party is my painting."

True. And yet . . . And yet I had heard of Siberian concentration camps and ubiquitous secret police and the reign of terror, had read *Darkness at Noon*. And if I knew anything, Picasso must have known more, must have known especially of the murderous treacheries per-

petrated in the name of the Party during the Civil War in his homeland. Could the painter of *Guernica* have failed to learn of all of that?

Picasso picked up a packet of newspaper clippings and waved it in the air, complaining of the stupidities written about him in the press. Sometimes, though, the criticisms made a valid point, he said, but since all the critics without exception were a crowd of lamentable imbeciles, the sensible criticisms were just as bad as the stupid ones. The clippings were sent to him regularly by a service. I wondered why he troubled to read them if they had no merit. Flinging down the packet and pushing back his bedclothes, he got out of bed, attired only in undershorts, and said that he must get dressed, went into the adjacent bathroom, and shut the door.

I glanced through the letters littering the bed, reading one from the Museum of Modern Art in New York, an appeal to the artist to sell *Guernica* to it. Suddenly the door from the painting studio snapped open. A young woman came in. She held out her hand. "You're Lord," she said. "I am Françoise Gilot."

It had been in the papers, of course. Picasso was now well launched toward the status of legendary celebrity, a very criterion, indeed, of what fame can come to, of how notoriety can multiply itself until the individual becomes the creation of his publicity. Everybody interested had gossiped about Picasso's affair with a woman forty years younger than he and his abandonment of Dora Maar, who was said to have suffered a nervous breakdown nearly of madhouse gravity and to be living in seclusion. Mademoiselle Gilot was almost ostentatiously pregnant. We shook hands. I said, "Picasso's in the bathroom."

She went in without knocking and shut the door behind her. I went out to the painting studio, where I found Sabartés. He said that Picasso was working with the energy of a man of twenty, not sixty-five. As before, paintings were piled pellmell around the large room, many of them recent. The very large black-and-gray canvas, the scene of carnage I'd found so depressing as a soldier, was set off to one side, still unfinished, half-hidden. I was struck by a picture of an owl perched in a barren, gnarled tree. Sabartés told me that Picasso had acquired a pet owl, which he kept in a cage in the kitchen downstairs.

The artist, now dressed, and his young mistress came in behind us. She had a funny story to tell. As there were in her opinion too few

places to be comfortably seated in the studio, she had gone that morning to a nearby shop that sold inexpensive furniture and ordered several chairs to be delivered C.O.D. to Monsieur Picasso, 7 rue des Grands-Augustins. The shopkeeper had received this order with skepticism, knowing of the painter's fame, and had asked whether the young woman was in his employ. Françoise said she had replied to this inquiry with hauteur, "I am Madame Picasso." At which the shopkeeper immediately retorted, "Then I'm Napoleon."

Everyone had an uproarious laugh over this, including myself, and nobody seemed the least bit embarrassed by what was really funny. Françoise had a high, metallic laugh, a sort of shriek, as if she were straining for hilarity, but she seemed entirely self-possessed, awed neither by her lover nor by her situation. We went to lunch at the Brasserie Lipp, where she insisted on feeding Picasso much of his meal, holding the fork to his mouth as if he were a child, which he coyly accepted, and I thought both of them were well aware of the people watching at adjacent tables. It seemed to me that Sabartés did not care for the new mistress, but he was circumspect to the point of mystification.

For ten days I lingered in Paris before traveling out to Quimper, the birthplace, Picasso said, of Max Jacob, one of his greatest friends, a poet done to death by the Nazis. I visited the *marché aux puces* with Chapoval and bought an alabastron for a dollar, went to the Louvre, and wandered around the art galleries. In the back room of a dealer called Paul Pétridès I found an unfinished canvas by Cézanne that cost $500, and bought it.* I also bought a French naval officer's cap and wore it everywhere, outdoors and in, glad to be conspicuous. When I showed my Cézanne to Picasso, he said, "The soul of Cubism is in this picture." But he didn't say that the soul of Cézanne was to be found in Cubism, and when I asked him several years later to make a small gesture of homage to the memory of Cézanne he refused. It never occurred to me to suggest again that he do my portrait, nor did he volunteer to.

One afternoon I went into a small shop in the neighborhood. It was dim; crowded with boxes, crates, shelves; dusty. Another customer, a woman, was there before me, her purchase, wrapped in a sheet of

* Reproduced in *Cézanne: The Late Work* (New York: Museum of Modern Art, 1977), p. 277, Plate 74.

newspaper, being handed across the counter. When she turned, holding the package in front of her, I saw that her face was familiar. Surprised, I hesitated to speak. She, on the other hand, perfectly composed, as though nothing could have been more commonplace than this encounter, extended her hand and said, "We meet anew." It was Dora Maar.

I said what a surprise as we shook hands.

An agreeable surprise, she said pleasantly, and I thought that her eyes gleamed in the dingy shop. Then she mentioned that on a previous occasion she had invited me to look at her paintings but that I had failed to make that visit.

I said I remembered, and I did, startled by the reminder.

Then perhaps I might still be interested, she said, and she would be pleased to receive me. Her implication, it seemed, was that the failure on the previous occasion had been mine, and at once I felt I had something to atone for. As she spoke I realized that I had not before been aware of the unique beauty of her speech, the extraordinary bird-song resonance of her intonations, as if from her throat issued the quivering but indomitable voice of the skies, ever so sweet, almost melancholy, yet quick in flight and incisive at the same time. Since I planned to leave soon for Brittany, we agreed that I should come the very next day at four o'clock, and she explained how to find her apartment at number 6 rue de Savoie, to the rear of the courtyard, on the second floor. So we parted with every semblance of cordial familiarity, never once having mentioned Picasso.

In museums and art galleries I had admired distorted, tormented portraits of Dora Maar—how unlike those of myself—without wondering what the real person was like. Now there was a tantalizing sense of challenge, of opportunity, of mystery. I went to the Lachaume flower shop in the rue Royale and bought a bouquet of orchids, the brown, green, and speckled variety. The rue de Savoie ran east from the rue des Grands-Augustins, its houses all ancient and rather nondescript, none as impressive as the residence of Picasso. The courtyard of number 6 was drab, with double doors at the back opening onto a light, wide staircase smelling of wax. It was exactly four o'clock when I rang and heard the nearby electric jangle. But there was no response save silence. After a wait rather longer than dictated by politeness, I rang again. Still silence, but then the sound of clicking bolts and rasping locks. I noticed

several keyholes. The door swung open and there stood Dora, her hand outheld. She accepted the bouquet with perfect composure. I had heard no footsteps, and wondered whether she had just been standing there. The entrance hall had a tiled floor and high ceiling and was barren of any furniture or decoration. In the next room, in front of the window, stood a large, ornate birdcage containing several canaries, and to one side a tall mahogany bookcase with glass doors—books and objects inside. On the walls were six, eight, ten paintings and drawings by Picasso. The room adjoining was occupied by an enormous Empire bed, a few armchairs around a fireplace, and a mahogany screen set with glass panes. More Picassos, several unframed, recognizable as portraits of my hostess, were on the walls. Dropping the orchids onto a table, she proceeded through a door to the left of the fireplace, I following, and so we came into her studio, cluttered, quick with the scent of fresh turpentine. On a flimsy easel stood a large still life of a bottle, a loaf of bread, and eating utensils on a table, a dark picture.

"What I'm working on for the moment," Dora said. She had a large ring on one finger, I noticed, which appeared to be a star sapphire of considerable size mounted in agate.

I didn't think much of the painting, though it made no overt reference to the great ex-lover. Even at that inexperienced age I was learning to simulate an appreciative posture. Dora Maar plainly expected some pondered appreciation. Her power to project imperious expectancy was unnerving. I nodded, squinted, stepped forward, then backward, murmuring a few affected phrases, resenting my self-made ineptitude.

Dora replaced the painting on the easel with another, saying not a word, then with another and another and yet another, still lifes for the most part, but a few views of Paris, each time silently waiting for me to make a show of respectful consideration. I did. This lasted for a long time, while I was never actually asked a thing or invited to sit down, and I no longer cared whether or not I saw her Picassos or anything else so long as I could leave quickly. When every single canvas in the room had separately been placed before me, Dora matter-of-factly said, "I'll make some tea."

"Please don't take any trouble for me," I protested.

She gave me a glance and said that it was already done, leaving awkwardly ambiguous the implications as to tea or trouble.

In the other room, where the huge bed stood like an exhibit in a museum, she gestured toward an armchair, at the same time seizing my bouquet and disappearing through the door opposite. Seated, I had time to look at the walls. Eight Picassos I counted, all portraits of Dora save a small Cubist oil by the foot of the bed. The best picture was the one beside the door, a figurative, frontal image, head and shoulders, wearing a green-and-orange-striped dress and white kerchief, off-center in a Prussian-blue room, too staring and stark to be a good likeness, however, and unframed.* Above the radiator to the right of the fireplace hung a pencil drawing of Dora in profile that looked more lifelike than any photograph.† To be confronted in a single room by so many portraits of the person who lived there was intimidating, but my heart was gripped by awe, and by envy.

The tea must indeed have been ready, because Dora came quickly with the tray, placing it on a low table between us. The china was fine and fragile, the silver shiny, and she managed the ritual with authority, adding to my cup one sugar lump without a murmur of inquiry. The cookies were sweet, dry, stale. I ate several. My orchids never reappeared. Dora did not speak, offered me no more tea, and sipped hers very slowly, gazing into the gray air. Then she took a cigarette from a packet on the mantelpiece, inserted it with precision into the trumpet holder, and lit it with the silver lighter. We were seated face to face but did not look at each other. A gray, striped cat came inaudibly across the bare floorboards, passing between the legs of the chairs with supple disdain. As the light in the tall-ceilinged room started to shrink, the paintings became indistinct and the furniture little by little lost detail. Dora's cigarette had long since been put out. A few words must have been spoken, but my memory is of a silence growing minute by minute more taut, and the whole awkwardness seeming to be my fault because my presence was creating it. I stood up. Dora rose immediately and strode out toward the door. Without a word she held up her hand, so I had to try to say something, thank her, be polite.

Oh, it had been no inconvenience, she said. People were constantly coming to look at her work, the dealers were always after her. Serving

* Zervos, Vol. 12, No. 154.

† Reproduced in catalogue of Picasso exhibition, Arles, Musée Réattu, 1957, No. 64, Plate 27.

a cup of tea was the least one could do. Again I was touched by the remarkable, elusive beauty of her voice.

I said that I had much appreciated the privilege, also her paintings, and hoped someday perhaps to have another opportunity, etc., etc.

"No doubt," said Dora.

Even as we shook hands, the door was closing between us. The clicking and rasping of locks and bolts resounded metallically behind me as I went down. In the street, Paris drifted sweetly through the April twilight. Going around the corner into the rue des Grands-Augustins, toward the river, I glanced upward. The lights were on. I quickened my pace, now having no wound to feign. The breath of the earth, auspicious springtime, swept along the Seine and I hurried toward the Pont Neuf. Had I but given good thought to the trickeries of the heart or put the future into the frame of the past, I might have hastened back to that door with so many bolts and locks. But I was twenty-four.

On April 14 I arrived in Quimper. My friends installed me in a quiet room and saw to needs material and other. Living within the walls of an insane asylum worked upon one's imagination. I stuck the Cézanne canvas to the wall by my bed with thumbtacks, and thus I could feel not too idiotic supposing that a manifestation of genius presided over my dreams and kept watch while long mornings and afternoons were spent writing.

C H A P T E R

S I X

THE EMERGENCY which arose that my parents coped with was my appendix, for the removal of which I flew home in mid-November, having first ferreted out in Paris a Cézanne watercolor of the Vallée de l'Arc* and a Tahitian charcoal† by Gauguin. How thrillingly easy it was in those gentle days to come upon wonders at wonderful prices, the art world and market undefiled as yet by unscrupulous hype or shady manipulators.

While in America I wrote a very long novel, its protagonist an intelligence agent who is assigned to interrogate enemy prisoners of war suspected of crimes against humanity, but who becomes so obsessed by the all-inclusive criminality of war that he contrives to assume the identity of one of his own prisoners, confesses to terrible barbarities, is tried, and is hanged. This was an ambitious and pretentious work, for which I had great hopes.

During the war I had written a letter to Thomas Mann, the author I then most admired, seeking some kind of counsel, solace in my distress, reassurance about the survival of gravely endangered cultural values. Conscientious and kindly, the renowned novelist replied, saying, in part,

* Reproduced in John Rewald, *Les Aquarelles de Cézanne* (Paris: Arts et Metiers Graphiques, 1984), Plate 237.
　† Reproduced in the catalogue of the 1989 Gauguin exhibition, Paris, Grand Palais; Washington, D.C., National Gallery of Art; Chicago, Art Institute: No. 123.

"War has a corrupting effect upon him who handles it. It is this you write about with such passion and such understandable abhorrence." Subsequently we had several exchanges of letters, and in one of his, written on October 3, 1947, he said, "This much your letter shows me: you have the gift for admiration, and this is a valuable good without which I myself would never have become what I am." The gift for admiration, indeed, is one I have endeavored all my life to cultivate, and still do. Not wishing to take unfair advantage of Mann's courtesy, I yet thought his influence might help my novel to be accepted by a publisher. It did not. No publisher, in fact, would take it. Mann wrote, "You will find consolation in renewed creative efforts which will benefit by your growing years and inner maturity": an optimistic prediction that proved not entirely inaccurate.

I never met my eminent correspondent. An opportunity once presented itself, but I shyly chose to keep my distance. The year after his death, I chanced to have dinner with his widow in Florence, and she told me I had made a mistake.

After more than a year in America, I longed to return to France. Meanwhile, my parents had granted me a small allowance, just enough to live on but not enough to be impulsive on, a very sensible arrangement. What but impulsive, though, does one want to be at twenty-six? Being impulsive meant seeing Europe, not only France but all of Italy as well, so I set about selling the painting by Cézanne, which was a difficult job. In New York I'd made the acquaintance of a roly-poly dealer named Curt Valentin, admired and beloved by curators, collectors, and critics alike, the only dealer I've ever known—and I've known plenty—of whom such a judgment could begin to be made. He sold the Cézanne for me for $800. I believe it is now in the Fogg Museum at Harvard. I myself sold the Gauguin girl, today prized by the Art Institute of Chicago. I sailed this time aboard the *Queen Mary*, the most agreeable of all the liners that still traversed the ocean in that leisurely era.

Picasso was not much on my mind, the two portraits left behind on the walls of my bedroom in my parents' home. But I went to the rue des Grands-Augustins all the same, and Sabartés told me that the artist, with his new family, was installed in the South of France, busy making pottery. We discussed a recent book about Russia by John Steinbeck. Then I went to Brittany. Behind the walls of the insane asylum, I began

to feel that I was not only a guest but an inmate, and like the inmates I craved freedom. Pluto had begun to hector me about my moral laxity, not to mention my psychic lack of fiber, so that my friendship with the doctor and his family suffered. On September 8 I went to Paris and set myself up in a small room on the top floor of a little hotel near the Luxembourg Gardens.

I owned a motorcycle. In those modest but virile years, this said no more about a man than that he could not afford an automobile. I rode up and down the avenues. Living was inexpensive, restaurants were cheap, and nobody was expected to spend money in order to be worth knowing. Much more valuable than cash were a readiness to talk, a willingness to listen, and an eagerness to know other people and to become known by them. My days were spent writing short stories in the hotel room, the evenings seeking acquaintances in bars and cafés. Before very long, I had made quite a lot of acquaintances as well as a few friends. Almost all were French. The Second World War, unlike the First, did not beget a plentiful Parisian population of expatriate writers and artists. This later generation, far from being lost, found abundant appreciation, success, and alcohol at home—but not the consecration of genius. Anyway, the high season of Parisian supremacy as a creative capital had waned. No matter. I have always been in love with autumn and twilight.

One of my non-French acquaintances was an English literary critic called Robin King. In October I went with him to London, where I met a lot of people, some of them already well known, others to become so, but only one who has some relevance to the story of my relations with Picasso and Dora. This was Douglas Cooper, a critic and collector of contemporary art, mainly works by Picasso, Braque, Léger, and Juan Gris, who shared a handsome town house in Egerton Terrace with a friend named Basil Amulree. The place was packed with pictures, many of them masterpieces, and my eyes popped as I went through. Douglas, then about forty, was fat, anything but handsome, his face peculiarly askew, said by some to have been surgically renovated after a serious auto accident. He dressed in clothes too tight and too garish and spoke in a shrill, high-pitched voice with an occasional lisp. But he had a commanding personality and an extraordinary knowledge of art. People younger and less learned, like me, were somewhat in awe of him, which

he relished. He could be exceedingly funny, witty, also outrageously campy and viciously bitchy. There was a nasty sadomasochistic side to his nature—before such perverse urgings became fashionable—and he alienated countless people, including many who might have helped him obtain the official recognition, honors, and appointments he craved but never received. In short, he was an English intellectual eccentric rather in the Evelyn Waugh style, made more eccentric still by the flamboyant aggressiveness of his homosexuality. He was often in France, where he knew everyone I knew, and many more besides, so I saw him here and there through the years, we occasionally dined together, and as I myself made my way into the web of the art world we counted as amicable acquaintances.

There was a somewhat ridiculous and pathetic countess called Mignon Wurmbrand-Stuppach who lived in those years in the rue de Verneuil. She drank too much and gave frequent parties at which many of the men were homosexual. When the evenings grew late and the men began to drift off with one another, the disconsolate hostess could often be heard murmuring, "There's nothing left for poor Mimi." It was at her house at all events, in December 1949, that I made the acquaintance of Bernard Minoret, the most consistently entertaining person I have ever known, one of the most intelligent, and the only friend I can say I have continuously counted upon, and contended with, for forty years. Our friendship started as a love affair, which lasted with the ups and downs inevitable in homosexual relationships for only a few of those forty. The Minoret family was a well-established, well-off bourgeois one, no member of it, so far as I know, having undertaken gainful employ since the middle of the nineteenth century. Bernard's parents were an eccentric couple—he drank and joked, she scolded and wept—unfailingly gracious to me, but neither so understanding nor so generous as they had every reason to be toward their only child. Still, he had his allowance and knew that he would never have to worry about money. His ambition when we met was to become a distinguished man of letters. In collaboration with others, he has by now written three plays, all three produced and received with rightful esteem, plus two or three occasional volumes, and it is not unfair to say that a relatively restrained productivity has generated more than a modest measure of gratification. But Bernard's true talent has always been for forming friendships and for being punc-

tilious about the tests to which they owe their survival. Despite his humor and wit he is a man of profound seriousness and intellectual penetration. Like his library, his memory is comprehensive, his knowledge of history nearly encyclopedic. When he talks about historical figures, Madame de Pompadour, the Earl of Essex, or Sophie of Anhalt-Zerbst, one can almost feel that he has dined with them the previous evening.

Old people invariably look back on the days of their youth and say, "Those were the days!" And of course they were. Maybe not in 950. But in 1950, for a certainty. Then there were fewer people, fewer cars, fewer drugs, fewer ecological catastrophes, and many more elephants, more salubrious seas and skies, safer subways, and inexpensive pleasures. And in all the world the place where it was most bliss to be was Paris. A final, lingering aftertaste of the sweetness of life under the ancien régime was still to be savored there. In the cafés we frequented, our friends were always to be found, ready to argue or flirt, and good for a loan. In a few picturesque apartments and palatial *hôtels particuliers* the tradition of the salon was even then coming to its gracious conclusion—a flicker rather than a flame—and we talked about the future of the novel, played the truth game, analyzed each other's ulterior motives, rubbing elbows with the occasional André Breton, Rebecca West, Balthus, or Prince de Faucigny-Lucinge. Our hostesses were Marie-Louise, Marie-Blanche, and Marie-Laure: Bousquet, de Polignac, de Noailles. Also Lise Deharme, Suzanne Tézenas, and Edmée de la Rochefoucauld, a duchess second to none in her passion for Paul Valéry. These ladies competed for the conversation and companionship and compliments of the Paul Valérys, Picassos, and Ravels of the day after tomorrow, and it was perfectly all right if that day never came because nobody in his heart of hearts believed in another Proust, another Cézanne, or another Debussy. And yet never for an instant did we doubt that where we were was where it truly mattered to be.

In May 1950, Bernard and I went to Italy, stopping on the way back at Villefranche-sur-Mer, a picturesque little place on the French Riviera, not far from Nice, and there we decided to spend our summer. Having rented a small apartment overlooking the town square and harbor, we returned to Paris to collect the necessary gear, including my motorcycle. By June 20 we were happily settled in the rather uncomfortable and homely apartment ideally suited to our age and circumstances. The

Riviera in 1950 had hardly changed since the time of *Tender Is the Night*. Though Scott and Zelda were dead, and the Villa America had long since lost its Americans, it was still possible to live for the moment while fixing one's gaze upon the future in that same youthful spirit of exuberance and optimism. Going on vacation had not yet become work. Just enough people were around to give parties in their gardens at Cannes and Cap-Ferrat and to populate public places sufficiently for the enjoyment of haphazard gregariousness. The young are instinctively ingenious about getting to know people, seldom guessing, incidentally, that their main recommendation is their youth. We had come prepared with addresses, telephone numbers, letters of introduction. The company we kept was pleasure-loving, entertaining, and, if possible, illustrious. Evelyn Waugh's brother Alec passed through; we went to lunch with Florence Gould and saw something of the outrageous, disastrous, but hilarious Brian Howard, with whom we had drinks and laughed and sat under the awning of the Hôtel Welcome, where Cocteau had smoked opium and made love to the sailors of the fleet twenty-five years before. On the Fourth of July I went on my motorcycle to the Villa Mauresque and had a drink with Somerset Maugham. The day was very hot, I very thirsty, and the drink delicious, a confection of gin, cream, and raspberry juice exclusive to the Villa, so I started to swig it down. "Don't drink it too quickly," said the novelist, stuttering just enough to emphasize each utterance, "because you're only going to get one."

Less than a week after our arrival, the Korean War broke out, rousing instant anxiety in a country where memories of enemy occupation and wartime atrocities were raw. Bernard and I didn't worry too much about what was going wrong on the other side of the world. All we wanted was to spend everything we had on having a good time, and we felt perfectly entitled to do that. Nevertheless, I had not forgotten that I intended to be a writer and that art meant more to me than drinking gin on the Promenade des Anglais. I knew, as everyone who read a newspaper knew, that Picasso was living somewhere along the coast, but I had no idea where and felt no urge to find out. There was even a Picasso Museum in Antibes, I knew, but there was also the Matisse Chapel in Vence, presenting an attraction of at least equal felicity, and I saw no need to hurry to visit either. I was busy writing another novel about guilt and the war, which demanded a daily stint of sacrifice, if not actually

of creativity. Meanwhile, Bernard read a lot of books, studied the Al-
manach de Gotha, and repainted the shutters opening onto our terrace.
And then we rode about on the motorcycle, visiting secluded beaches
and breathing the clean air.

One fine afternoon early in July, we were spinning along the flat
stretch of highway between Cagnes and Antibes when a large convertible
whizzed by us, then pulled up abruptly just ahead, compelling me to
do likewise. A short, bald, stocky man attired in a garish sportshirt
stepped down from the car and walked back toward us, waving his arms.
It was Picasso. How phenomenal indeed must have been his visual acuity
to have discerned in an instant a vaguely familiar profile flashing by in
the afternoon dazzle. Bernard and I got off the motorcycle. Picasso,
exclaiming over the surprise of the pleasure, came up and kissed me
on both cheeks. I introduced him to Bernard, who didn't hide his delight.
But how did it happen, inquired the artist, that I came to be in this part
of the world without having let him know of it? I said something awkward
about having arrived only recently but with the intention of seeking him
out as soon as possible, etc. The other men in the car, the chauffeur,
Marcel, and Picasso's son Paulo got out and said hello.

This was perfectly timed, this chance encounter, said the artist,
because the very next morning at eleven o'clock at a movie theater in
Cannes there was to be the first private screening of a recently completed
documentary film about him and his work. It evidently went without
saying that we would deem it imperative to be present, and of course
we did, but I was reminded of previous occasions when Picasso had
taken compliance for granted. Twice he repeated the name of the theater.
We would certainly arrive in good time, I said. Then he told us that
Vallauris was the name of the place in which he presently resided, a
town set just up the hill from Golfe-Juan, where Napoleon had come
ashore on his return from Elba, and the selfsame shore he daily visited
for a noontime swim. Anybody in either place could explain where he
was to be found. All this information evidently having been imparted
with adequate emphasis, Picasso said that he would expect to see us in
the morning, waved his son and his chauffeur toward his automobile,
and made off.

Though but secondarily interested in the arts of painting and sculp-
ture, Bernard responded, as I did, with exuberance to an affinity with

fame. We got to Cannes early but were by no means the only moviegoers waiting in front of the theater, which was shut, Picasso nowhere to be seen. The only person I knew was an art dealer from New York called Klaus Perls, a colorless character whose greeting plainly expressed skepticism as to the legitimacy of my presence. After about twenty minutes a shiver of vicarious achievement agitated our little crowd when Picasso's car swept up. He greeted us one by one, making a minute ceremony for each, leading all at the same time into the theater, its doors opening as if by magic the instant he approached. He was accompanied by his mistress, son, and chauffeur. We all took seats in the center of the balcony, waiting to be wafted into the stupendously extensive presence of the man seated among us.

Entitled *A Visit to Picasso*, the film, lasting about thirty minutes, had been produced by a Belgian named Paul Haesaerts and showed the artist at work along with many recently executed paintings. Both the man and his creations were projected into a continually changing immediacy by the novel effects of the medium which pictured them. There was one shot of Picasso painting a woman on a pane of glass, so that his creation, his act, and his person seemed a single reality, fugitive and yet imperishable. Nobody spoke—except the artist. Seated just in front of me, Picasso was exceptionally, volubly, physically responsive to the vision that represented his own exploration and exploitation of himself. He commented loudly and repeatedly upon scene after scene, gesticulating, clamoring, laughing, as if he alone constituted a numerous public for a performance both astonishing and unprecedented. This was the first time, to be sure, that he had witnessed as a mere member of the audience the spectacle of himself, his creativity, and his art, and the experience clearly left him beside himself. I felt embarrassed for him, as if his reaction had been rehearsed, which of course for fifty years already it had.

The applause at the end sounded sycophantic but was no doubt sincere. Several people pressed past grudging knees to compliment the artist, then departed, but he kept his seat, crying out, "Show it again!" So the rest of us had to stay, not a hardship for anyone interested in Picasso. His response to the second showing surpassed itself in animation, as though the famous eyes had failed at first to see what wonders played upon the screen. This boisterous enthusiasm for the performance

of the self was endearing in its candor but almost pitiful, I felt, in its turbulent vainglory. When the film had again run its course, there was more applause, there were more compliments, my own included, and everybody stood up. Before we could quite start to leave, however, Picasso once more shouted, "Show it again!" But I said that we would unfortunately have to be going. He responded with composure, reminding me to come see him soon at Vallauris or on the beach. The others, six or eight, obediently resumed their seats in the shadowy theater. Bernard and I went outside into the sunshine, where I was able to ventilate my disapproval of the vanity and theatrical posturing of the great artist.

I was a fool: not only because I was wrong and patronizing but also, and far worse, because I had failed to perceive that it could have been my luck to participate knowingly in the spectacle rather than merely to watch it. What had been significant had been neither on the screen nor in the seat just in front of me but in the entire space of the theater, including all its occupants, where one man had deliberately celebrated the rite by which he fused the transient, personal self with a universal, deathless self in order to become a mythic individual. It had been right and inevitable for Picasso to become fascinated by what he saw, for at every instant he had been actor, spectator, designer, director, producer, and proprietor in the theater of himself, which was the world stage. And indeed toward the end of his career, having from the first been attracted to theatrical figures and subject matter, he graphically depicted many scenes of symbolic autobiography in the representational theater of his imagination. In the spectacle, moreover, of the corrida and in the haunting imagery of the minotaur, mingling art, artifice, audacity, and death, his identification of himself with mythic ritual had been lifelong. I missed all this that morning at the movie in Cannes. I was still afraid of him, of course, and fear can be blinding.

During that summer of '50 I saw quite a lot of Picasso one way or another, on the beach, at his house, in the factory where he made his ceramics, and in the studios for painting and sculpture. Seeing him did not represent much of a feat, for the artist's life had become a public show. When he said that to learn his whereabouts one could ask anybody, it was close to the truth. Newspapers and magazines, local, national, and international, were full of his doings. Photographs of him, his mistress, his children, his home, his automobile, even his latest creations

were ubiquitous. He plainly reveled in this riot of publicity. Reported —accurately—to be the richest as well as the most prolific artist ever to have lived, he was also becoming one of the best-known personalities on earth, rivaled, perhaps, only by a movie star like Charlie Chaplin, of whom, as it happened, Picasso was not only an admirer but also something of an emulator in his fondness for buffoonery, masks, disguises, all the resources of the circus. Between the artist and the clown the dividing line sometimes grew difficult to discern, and Picasso gladly confused the issue by asserting he was a man like any other while testily taking for granted the deference due greatness. Fame such as his, of course, was not the outcome of accident. He created it as capably as the Blue Period, Cubism, or *Guernica*, proving his genius for making a legend of his life even as he demonstrated his workaday humanity by complaining bitterly about the inconveniences of celebrity.

One day, while sitting with him on the beach, I remarked that it was much easier to approach him on the Riviera than it had been in Paris. That, he rejoined, depended on his humor, adding in all seriousness, "Sometimes even my best friends don't get past the box office."

Vallauris was a commonplace little town set back on a nondescript hillside a couple of miles from the coast. Its only commerce was the manufacture of pottery, principally cooking utensils, and this business, like the potters' craft itself, had fallen on rather hard times when Picasso first went there. He changed all that by making himself a focus of public fascination, making the town famous and its products, not only his own pottery but everybody else's, fashionable. On July 29 Vallauris was packed with people for the inauguration of a pottery exhibition, presided over by Picasso and Prince Aly Khan, while a week later the crowds were even denser for the unveiling of one of his sculptures in the town square. Everything Picasso touched underwent a vital transformation. He brought renewed prosperity to the place he lived in and new prestige to the medium in which he worked. The irony of this was that prosperity spoiled Vallauris and prestige made its homely products turn gaudy and vulgar. Picasso saw what effect he had had, but he never seemed to feel responsible for it. On the contrary. He liked to quote Degas's remark that the creation of a work of art is an act requiring as much trickery and vice as the perpetration of a crime. And he was fond of saying, "Picasso is someone else," providing himself with a consummate alibi.

La Galloise was the ridiculous name of Picasso's ugly little house, which in no way evoked Wales or the Welsh. It stood outside of town, well back from the road, up a slope of unkempt grass, and consisted of four rooms on the main floor, with one more, damp and ill lit, in the semi-basement. There was no telephone, conveniences were rudimentary, comforts meager, furnishings humble. Why the wealthy, world-renowned painter chose such an unlovely, inconvenient habitat when he might just as well have had the grander premises he had been accustomed to in Paris and later acquired in the South was to me a mystery. Françoise Gilot, with two small children to care for, not to mention chores of housekeeping and creative work of her own, must have found the mystery far deeper and murkier than I did. At all events, Picasso made his move toward finer residences only in the company of the woman who took Françoise's place. Meanwhile, his studio, though in poor repair and cluttered with the heteroclite accumulation of trash and treasure he habitually got together, was appreciably more spacious than his home. On the other side of town, also set back from the street, and protected by a high wall and iron gate, it had formerly been some sort of factory and had three large studio rooms, two for painting and drawing, the third and largest for sculpture, of which he was then producing quite a lot, the principal item being a life-size pregnant goat.

On the beach at Golfe-Juan that summer, Picasso was undisputed sovereign of the sands and the lord of its castles, albeit builder of none. He didn't go in for impermanence, only occasionally executing inspired doodles in the narrow slick left by the recession of unpolluted wavelets, eyeing with sardonic mastery the wistful disappointment of admirers when the succeeding wavelet would wash his doodle away. And there were plenty of gawkers, readers of *Le Provençal* and *Nice-Matin*, who knew exactly where their capacity for wonder, envy, infatuation, and frivolity could be gorged like a goose for pâté. They circled about, stared, and took snapshots while the artist benignly played with his naked children in the shallows, appearing never to notice that everyone noticed him, he whose eye could register in an instant infinitesimal details. I thought that this utterly unstudied semblance of indifference to the legendary status must be essential to the creation of a legend, Picasso yet again serenely presuming to ignore that he was Picasso as he lolled in mythical anonymity by the edge of the sea, a deity whose whim of genius was to look like a mere mortal.

Unlike her lover, Françoise did not enjoy being ogled by sightseers. When total strangers occasionally became intrusive on the beach, pretending to play with the children or angling for close-ups with their cameras, her annoyance and impatience could be brisk. At La Galloise, if uninvited guests came toiling up the path, hoping for some Picassian magic, she could be openly irritable. Especially exasperating to her were the frequent incursions of Communist Party hangers-on, who often arrived just at lunchtime with fanatic appetites, ready to rant all afternoon against American perfidy and bourgeois evil, then ask Picasso for a hefty contribution before departing. I didn't think Françoise much cared for me, either. She was perfectly civil but aloof, rather inscrutable. There was a very good reason for her remoteness, one which never would have occurred to me then and said much for her character, but I didn't learn what it was until fifteen years later. If I felt intimidated by Picasso, she certainly did not, and sometimes they engaged in fierce altercations that as often as not ended in her favor. She was clearly shrewd, exceptionally intelligent, a woman resolved to live life on her own terms, but at the same time good-natured and quick to laugh.

Bernard was one of the rare individuals not a bit intimidated by Picasso, though impressed by the man's personality and fame. He occasionally accompanied me on my visits to Vallauris or Golfe-Juan, a jaunt of about an hour by motorcycle. With him, Françoise was not in the least distant, both of them keen on the sort of rarefied referential discourse practiced in France as sociable chitchat. They used to swim out to a raft some hundred yards or so from the beach and lie there in the sun and breeze, talking about Melville and Reverdy. This greatly annoyed Picasso, who sarcastically remarked that it wasn't as if there could be secrets between them. I understood what he meant. More than once he sent me out to summon them back to shore, it being more dignified to have his displeasure conveyed by someone else. Besides, I'm not sure that he could swim, or, if he could, that he much liked to, for, though often in the water, he was never very far in. And yet he was born beside the sea, and marine scenes, both forbidding and playful, abound in his work.

A whiff of panic was wafted across the world that summer by the fighting in Korea. History's most horrendous conflict, and especially the apocalyptic detonations that ended it, being of such recent memory, fears were rife of similar, if not worse, hostilities. These were fiercely

fanned by friends of the aggressors, the Communists, who ferociously denounced the military assistance provided in extremis to South Korea by the United Nations, the United States in particular. Furious diatribes against American warmongering, the perils of U.S. imperialism, and evil Yankee hankerings to terminate civilization by using the Bomb came incessantly from Communist regulars, organs, and fellow travelers. There were meetings, rallies, congresses, editorials, placards, and maneuvers of every sort. One of these, by no means the least devious, was the so-called Stockholm Peace Appeal, a ploy that tried to represent itself as a guileless tide of public opinion thanks to legions of starry-eyed young-sters who solicited signatures up and down the Continent with indefa-tigable pertinacity. Nor was the sun-spangled Riviera spared its lavish share of all this hullabaloo. There was a youth congress in Nice, or-ganized by the Party, for which Picasso dutifully provided a poster: a beautiful girl and a handsome boy holding between them a dove, the symbolism a trifle cloying but not nearly so nauseating as the cause. Even the public *pissoirs*, of which in those earthy days there were many, were plastered with this superb pictorial propaganda.

That Picasso, like everyone else, was seriously worried is true. Indeed, he may have sensed that he had more reason than most to be so, having cast his lot on the side of a dictatorial regime not known for friendliness to doings that smacked of the avant-garde. Many of his finest early pictures were in Russia but in these years were still kept securely secreted from public view. During the German Occupation, Picasso had shown courage by remaining in France, though his works were anathema to the Nazis. Now he wondered where he would be safe if war came again. The concern was complex, because his personal safety involved also the safety of his family, his paintings and sculptures, his servants, and his money. He talked and talked about possibilities and probabil-ities, and I assumed that if he talked about them in front of me he must have talked about them in front of everybody. How would it prove practical in case of emergency, he wondered, to transport in a hurry everything that had to go somewhere to the safe place where it had to go? And where was that place? Switzerland? Africa? South America? Nairobi? Zurich? Rio? The pictures, the money, and the children all seemed to preoccupy him equally, as if they were interchangeable ele-ments of a single reality, which, of course, was Picasso. Françoise paid

only casual attention to all this talk, hearing certainly far more of it than I. It didn't represent, I suppose, a reasoned appraisal by the artist of his relation to an international crisis but, rather, a flight of imagination meant to help the great inventor live in peace with the war inside himself.

Picasso possessed a fantastic capacity for making every moment spent with him memorable. This sense of importance sprang from the certainty that he *was* Picasso and not somebody else. Being with him aroused a craving for his company that seemed insatiable, a craving akin to the passion of Narcissus, though saved from lethal egoism by the assumption that consorting with artists is a right reflection of one's love for art, and that one's portrait is a selfless symbol of that love. I didn't lie awake at night on the Riviera, as I had in Quimper, wondering how I could prevail upon Picasso to portray me. That was done. What I fancied that I longed for now was something far more precious than my likeness, more difficult to acquire, and hence more frightening. By being free and easy with Picasso, I aspired to be likewise with his genius and his myth, to be assured of a glorious future, saved from an ignominious past.

One morning on the beach, the painter asked me whether I knew Jean Cocteau. I said no, whereupon he told me that the renowned poet, playwright, novelist, and filmmaker was residing at Cap-Ferrat, only a stone's throw from Villefranche, the guest there, with his present boy-friend, of some rich lady, and that it would be a very good idea for me to make his acquaintance. I protested that I couldn't very well just ring Cocteau's doorbell and expect to be made welcome. "And why the devil not?" cried Picasso, whinnying with high humor. "That's what you did with me, and look how well it's turned out. You tell Cocteau I sent you, and you'll see, everything will be just fine."

I was diffident, but quite by accident I met Cocteau not long afterward, and a pleasurable semblance of friendship evolved rather quickly. That was his way. I found him much easier to like than Picasso, more difficult to revere, but at the time I was far too elated by the facile sociability of celebrated men toward an insignificant foreigner aged twenty-seven to be very discriminating or, even more important, suspicious.

Madoura was the name of the pottery where Picasso made his platters, pitchers, vases, and various other vessels. The proprietors, a

couple called Ramié, had by dint of artful and persistent attentions gotten the painter interested in the wonders of the kiln. They were quick to perceive that a mint could be made from the artist's Midas touch, and their showroom rapidly filled with replicas of Picasso's plates and jugs in "original editions," snapped up by a public avid for anything bearing the magic name. Monsieur Ramié was colorless, courteous, withdrawn, apparently comfortable with practicalities and profits, while Madame was the Machiavelli of Madoura. Sycophantic, conspiratorial, imperious, as the occasion seemed to require, she was clearly ready for anything in order to keep Picasso producing merchandise for her shop, and equally ready to have him glorify her workaday premises by producing for his own satisfaction hundreds of creations that she could not offer for sale. I was often in the pottery, a presence annoying to Madame Ramié because she perceived neither advantage nor merit in it. For my part, I was surprised that Picasso should put up with a person so vulgar and transparently grasping, but I supposed that he, too, took his advantage where he found it and from the extreme remove of his genius could appreciate people according to criteria unique to him. Madame Ramié demonstrated her tactical expertise by intriguing for Françoise Gilot's exit from the scene and by supervising the gradual installation of her own cousin, Jacqueline Roque, as Picasso's last mistress, model, and—apotheosis of ingenuity—wife. I don't know that the resourceful lady got much thanks or gain from her cunning, because Picasso moved away from Vallauris shortly thereafter, while Jacqueline proved adept at eliminating from her husband's life most of the friends and courtiers of the era previous to her ascendancy.

Critics and connoisseurs have paid less attention and lavished less praise in evaluating Picasso's pottery than when considering his painting and sculpture. Art apparently seems diminished by being inseparable from a utilitarian or "merely" decorative support. Even the ceramic masterpieces of the Egyptian, Greek, and pre-Columbian cultures suffer from this strange stigma. But Picasso was never an artist to take the slightest account of any aesthetic *parti pris*—quite the contrary—and he had a strong affinity, both creative and mythic, for the works and purposes of his artistic predecessors of all cultures. To see him working in the Ramiés' pottery was exciting and moving. He did not know how to throw a pot or platter and was therefore obliged to explain to an artisan

what he wanted and then take over the malleable clay when it had been worked up to the desired size and shape. He would fold it, bend it, gouge, incise, or cut it according to his intent, and the outcome was always surprising, even to him, I think, as if his omnipotent fingers went unbidden about their predestined business. His deference to the artisan who prepared the clay and worked a wheel for him was so attentive as to seem a function of the creative act. Picasso's pots were fashioned by the same eye, the same hand that portrayed the horrors of war and the joys of maternity, and accordingly are entitled to contemplation from the same viewpoint; many may be perceived as masterpieces of elegance and modesty.

An exile from his homeland, a transient even in the city where he had resided and been glorified for half a century, Picasso made a good show of taking to heart the homely hospitality of the town upon which his presence had bestowed publicity and prosperity. He was shrewd enough to realize that the commercial miracle created by his presence could but profit further from a concrete symbol of his supernatural ability to transmute less noble materials into gold. He decided to donate to the town of Vallauris a large work of sculpture, something which, incidentally, he had not yet done for Paris. The specific work he had in mind was a larger-than-life-size sculpture he boasted of having thrown together in a couple of afternoons six or seven years before: *The Man with a Lamb*. This was the creation which in its eerie plaster version had loomed over the sculpture studio at the rue des Grands-Augustins when I first went there. Now it was to be set up in the market square of Vallauris, where it could brood over the pageant of rural commerce. Despite the forbidding mien and hulking morphology of this man holding captive in his arms a struggling lamb, the sculpture is charged with an extraordinary sense of primordial energy and an aura of dark ritual, as if the animal were destined for sacrifice in order to gain superhuman powers for the man.

A Sunday in August, the sixth, was the day chosen for the great unveiling. The Communist Party, both local and national, had deployed its forces to make the event seem symbolic of aspirations shared by artists and laborers alike, of universal yearnings for international amity, understanding, and peace. A mighty burden of ideology for one statue to bear. But the organizers of the event felt no misgivings about Picasso's

power to provide adequate support. All he had to do was appear. Whatever Vallauris may have thought about doctrine, the town was of a single mind when it came to business, so no expense of posters, banners, and panoply was spared. An elevated platform had been built to one side of the market square facing the pedestal upon which, shrouded in a tarpaulin, stood *The Man with a Lamb*. The day came up bright and sharp. By afternoon the crowd was dense, the heat great, the traffic in town at a standstill.

I rode over after lunch from Villefranche with Bernard and Cocteau in the convertible Studebaker driven by the chauffeur of Cocteau's rich hostess. We arrived in plenty of time to look for a good place from which to view the proceedings. Though unfailingly courteous and polite, Cocteau was not the best-humored man on the Riviera that afternoon, for he had not been invited to participate in the Picasso pageant, and he, too, was accustomed to attention. Making matters worse was the well-advertised presence of another poet, a man who, like Cocteau, had much lauded the painter in print and also been portrayed by him: Paul Eluard. As he was an eminent Party member, his attendance was appropriate, whereas Cocteau had always slyly eschewed politics.

Picasso, Françoise, Eluard, and a dozen or more other people were seated on the platform. Passing to one side of it, we made gestures of salutation, to which they responded with smiles and waves but no summons to the center of attention. Behind the platform stood a building with a wrought-iron balcony on the second floor, and we managed by ingratiating persistence and the pressure of Cocteau's celebrity to squeeze in up there. Thus, though behind the platform, we were able to see and hear all that went on. The principal speaker was a thick-set Communist called Laurent Casanova, nicknamed "the French Zhdanov," said to have been one of those, along with Aragon and Eluard, most persuasive in bringing Picasso into the Party. His address, broadcast by loudspeakers to the crowd that brimmed in the square and flowed over into adjoining streets, was by no means an airy effusion attuned to the mood of Sunday-afternoon jollity. Picasso was praised for magisterial attainments as a painter, but it was his exemplary commitment to a logical program for mankind's betterment that excited the eloquence of Monsieur Casanova. There was urgent work to be done in the world, and just as art had its useful role in disseminating truth, a revolutionary

artist must participate in revolutionizing society, redressing its injustices, and reconciling its disaffected elements. *The Man with a Lamb* stood for the principles of brotherhood and political progress personified by Picasso. Etc. Etc. Etc. Casanova was no partisan of brevity.

During this lengthy harangue, the painter sat still on the platform. Photographs published later show him to have been smiling. Cocteau was not. Françoise in her memoirs asserts that he interrupted the proceedings to declaim opinions of his own. I never left his side, and throughout the entire ceremony he remained exceptionally silent, gazing down at the spectacle below, I thought, with dismay. There was hectic clapping, probably thankful, at the conclusion of Casanova's speech, whereupon an obscure poet called André Verdet stood up and recited a tedious ode. Then the tarpaulin was tugged off *The Man with a Lamb*, followed by further applause, and that was the end of the ceremony but clearly the start of a lively village festivity.

Cocteau said, "I have no business being here." So we went down into the square. Picasso was surrounded by a press of admirers, and we made no attempt to tell him goodbye. Progress back to our car was impeded by boys and girls soliciting signatures to the Stockholm appeal, especially insistent that Cocteau, a recognizable celebrity, should sign, and his very politest pirouettes were improvised to avoid it, the inveterate giver of autographs repeatedly insisting, "Je ne signe jamais rien, mon chéri."

Casanova's speech had seemed to me nothing better than cynical hogwash and bile, especially since the Communist armies in Korea had at that very moment overrun almost all of the South, but I dismissed it as irrelevant, assuming that any person with a grain of good sense would have recognized it for the crude stuff it was. Besides, I felt, the entire occasion had been disengaged from any authentic political significance by the fact that its whole point and purpose had been the unveiling of Picasso's sculpture. Picasso, not Communism, was what mattered. Cocteau was decidedly not of the same mind. He was incensed, and en route back to Villefranche in Madame Weisweiller's car he delivered himself of a considerable diatribe. Picasso's politics, he said, were a travesty and a dishonor. Nobody who cared two straws for decency and justice could conceivably have anything to do with Communism, not after Gide's return, the Great Terror and trials of '37, treacheries in

Picasso's own homeland, the Stalin–Hitler pact, the betrayal of the Warsaw uprising, the Iron Curtain, and so much more. How could Picasso, the artist who had set art free, who had employed his genius to denounce tyranny and reaction, the painter of *Guernica*, how could this man connive with agents of a dictator and let them use his works to advertise their sordid schemes? It was worse than hypocrisy. It was ignominy. And one day his art would show the stain of corruption and guilt. Cocteau was vehement, trenchant, categorical. It was quite a tirade, embarrassing to me, as I had been the unwitting instrument of a supposed rapprochement between them after a certain estrangement, and I wondered whether his denunciation would have been altogether so vigorous had he, instead of Eluard, been invited to preside alongside Picasso during the ceremony, compromise notwithstanding, the power of *amour propre* to rationalize pique being of course phenomenal. But Cocteau was right about the occasion, anyway: it was tacky.

The following Friday, I went alone to Vallauris for lunch. Besides Picasso and Françoise, only Eluard, his wife, Dominique, and the artist's son Paulo were present. I was laughingly chided for having decamped in the wake of Cocteau after the ceremony the previous Sunday, which was made to seem not only a failure of camaraderie but a failure of goodwill. To this I shamelessly protested that we had had to conform to the timetable of Madame Weisweiller's car, which had been needed by its proprietor to attend some cocktail party. The meal being not yet quite ready, we stood around the table under the grape arbor, waiting.

Paulo, attired only in sandals and shorts, sat to one side on a stool, staring into the midday sunshine. Once good-looking, slender, muscular, he had taken to drink and run to flab, and his recent marriage did not seem to have improved a disposition prone to sulky indifference and laziness. What ignited Picasso's exasperation at this particular moment was not apparent, but all at once he gestured toward Paulo and loudly exclaimed, "Isn't it terrible for a man like me to have a son like him!" To this exclamation—itself terrible—none of us made a murmur of response, and Paulo, apparently unperturbed, continued to gaze at nothing in the dense silence. It is shocking to have to witness, and thus become accomplice to, the humiliation of a son by his father, especially when the latter is an artist and a genius who tenderly and masterfully portrayed that child, his firstborn, in the years of innocence. Françoise,

always friendly toward Paulo, and the Eluards, I felt, were embarrassed by Picasso's outburst. As for me, I recalled with a certain consternation that once in vain pursuit of self-importance I had claimed Picasso for my father, only to be dismissed as pitiful if, in fact, I was his son. And Paulo, I thought, indeed deserved pity. But then what did his father deserve? It goes without saying that the offspring of eminent persons very seldom parallel parental attainments, but whether this rule is more terrible for parent or for child is quite as difficult to ascertain as is assigning responsibility for the inequality of endowments. Picasso was far more gifted, anyway, for putting himself into works of art than for reproducing himself in the form of offspring or even for adapting himself to the metamorphoses of human relationships. It is curious to observe that his experiences as a father began when the noblest accomplishments of his art were already things of the past, and when his creations began gradually to depict the nostalgia, the rage, violence, and erotic ferocity, the superficial, sardonic bravura that led to the sorry debacle of his final years.

The awkwardness of unspoken thoughts was undone by the arrival of lunch, borne down an outside stairway from the kitchen by the woman who took care—rather grudgingly, I thought, and without the slightest awe—of the Picasso household. Food and drink at the painter's table were always plentiful and of good quality but never, so far as I knew, luxurious, perhaps because no better nourishment or stimulant than his presence could be found. It's true he had a unique power to stimulate imagination and feed thought. Nor was anybody better, when he felt like it, at making people laugh—or cry, I suppose—a potentate of surprises. That day at lunch, for example, he made inquiry of Eluard concerning some prize to be awarded by the Communist Party to the artist who had done most for the cause of peace in the world. The poet replied that he didn't know what decision had been made as to the recipient, whereupon Picasso energetically declared that nobody was more deserving than he was, that he had an undeniable right to the prize, and that "if there was any justice" he would receive it. Repeatedly tapping his forefinger on the tabletop—the sound like a furious woodpecker—he demanded that Eluard do whatever needed to be done to make certain the prizewinner was the right one. Politic, though reputedly prone to uncontrollable rages, Eluard said everyone could be sure that the Party would lucidly decide,

as always, in the interests of justice; consequently, Picasso need not worry. And without the least lapse of continuity he inquired what the artist had thought of a deluxe volume of Pablo Neruda's poetry recently presented to him. Picasso expressed admiration, and there was no more talk of the prize, nor did anyone mention Neruda's dubious doings during the Spanish Civil War or his involvement in the plot to murder Trotsky.

When the coffee came, it was almost immediately accompanied by the arrival of three athletic and loquacious young men, regulars from the Party HQ in Nice, who had just happened to be passing by. Without preamble, they set about denouncing and deriding the American passion for war, resolve to rule the world, and sinister disregard for the time-honored principles of civilization, depicting the United States as a vast concentration camp where freedom was an obscene joke and men of goodwill routinely disappeared without leaving a trace. To all of this inspired demagoguery both Picasso and Eluard volubly subscribed, adding such ready indignation and passion of their own that it seemed impossible to be skeptical of their commitment, not only emotional but intellectual. Françoise and Dominique Eluard said nothing. Paulo eyed the three vivacious youths with ennui. I was astounded, and remain so to this day, unable to believe that men like Eluard and Picasso, mature men who had lived all their lives in comfortable bourgeois freedom, even to the point of extolling it by mocking it, could with the straightest of faces mouth such preposterous opinions. Needless to say, I kept silent, wondering at the same time how the poet and painter, if they thought of it at all, might square their invective with the presence of an American at the table. But it was as if I'd ceased to exist, annihilated by the opprobrium heaped upon my miscreant homeland. I felt it exceedingly strange. The situation was resolved after a time by Françoise, who reminded Picasso, with a certain asperity, that he must accompany her on some errand. He obediently rose from the table, everyone else immediately doing likewise, as befitted a monarch, and that was the end of the party; farewells perfunctory all around.

The Picasso Museum in Antibes was, and still is, housed in an ancient fortress, itself more imposing than the works of art inside, which are for the most part minor though not disagreeable divertissements. Bernard and I went there one afternoon in August, had a look around, took a few snapshots, bought a couple of posters, and then stopped in a nearby bar for something to drink. The young man behind the bar,

not bad-looking but too fat for his age, seemed vaguely familiar. When I ordered my drink, he said, "Hello, James," and I realized that he was Roger Laflotte, my sometime military lover, who had so scorned the prospect of being portrayed by Picasso, a prospect, of course, which had never been more than a wishful thought. Now here he was virtually on the doorstep of an edifice dedicated to admiration of the artist he had damned. When surprise, greetings, introductions were finished, Roger explained that he had come down to Antibes a year or so before with a friend to set up business in a bar and that they had chosen this location precisely because of its proximity to the Picasso Museum, supposing it would attract plenty of visitors, appreciable numbers of whom might incidentally become their clients, a supposition experience had proven profitably shrewd. So we all said Picasso was certainly a worker of wonders, an assertion reducing us to the status of material indiscriminately manipulated by him. Roger asked whether I still kept up with the artist, and I said, "Oh no, not now that he's such a celebrity." The drinks were on the house.

Les Trois Cloches was a homosexual cabaret in Cannes, that town being something of a free port for male affinity in the days before "gay" became, so to speak, lingua franca. With Bernard and a couple of other pals one evening at the bar of the Cloches, I found on the stool adjoining mine an American with whom I got into frivolous but sexually apathetic conversation. I thought him the silliest of fags, fascinated by the goings-on he imagined at the nearby Château de l'Horizon, the retreat of that doomed pair Aly Khan and Rita Hayworth. It was not incongruous that Picasso's name should presently crop up. Yes, everyone knew that he lived somewhere along the coast and was regularly to be seen showing off for the photographers on the beach. And it seemed, added my neighbor, agog with the privilege of imparting gossip, that one of his frequent companions during this summer was a young American who came and went by motorcycle and was suspected by knowing observers of being quite as homosexual as we were. So the question that naturally arose, he went on, was whether it could be that Picasso, in addition to his famous fondness for women, might, just might, have that very secret little lust for boys. To which I brusquely retorted that this was utter nonsense and that if anyone knew it I did, because, should the truth be told, the American so often seen with the artist was none other than I.

"You!" shrieked my compatriot. "You! You ridiculous little fruit!

Who are you trying to kid?" And he let out a yawp of scornful laughter, leaning across to Bernard and my other companions and exclaiming, "You know, your friend's crazy! He claims he's Picasso's boyfriend."

I threw up my hands and said something rude. Bernard and the others burst out laughing, which only made my situation more absurd, argument by then being out of the question, and there seemed nothing to be done but to leave my unknown mocker with the supposition of having scored an accurate point. So I told the others I was leaving and they were free to follow or not as they pleased. They kept on laughing but at least they came along with me into the street. However, there was nothing I could say to neutralize their assumption that the contemptuous outburst of my barroom neighbor had been provoked by my own boastful prattle about intimacy with the famous man.

It was a ludicrous incident, and yet a peculiar surmise of seriousness remained tantalizing afterwards. Of course, I had in no way suggested that my acquaintance with Picasso could be considered an intimacy. Why, then, had my unknown interlocutor at once assumed that that precisely had been my contention? The well-known homosexual proneness to bitchy gossip and derisive persiflage—the phenomenon called camp—could hardly account for such a provocative allegation. There was something more to it, I thought—and I thought of it a good deal— something that must unconsciously have come from me. Could it be that my desire for Picasso's company, my longing at the very outset of our acquaintance to be portrayed by him, my craving for familiarity with his myth and his genius—could it be that these compulsions, and others too obscure to be suggested, constituted without my will or knowledge an aura of passion perceptible to other people? Perhaps. I have known many painters and been portrayed, always with keen gratification, by a number of them. And it is a fact that the surrender of one's likeness suggests an inclination to be possessed or a will to possess, just as the capture of a likeness implies mastery and its satisfaction. In this there need be nothing carnal. It is infinitely more profound, concerning the life instinct itself, that universal yearning for survival by means of participation in the miracle of creativity, both physical and spiritual, the hope against hope that the tomb of time may not mark a demise of individuality. Picasso certainly was passionate in all such hopes, yearnings, desires, and he often portrayed himself, not only specifically but

also symbolically, as a figure wrought from his own mythology, and indeed his models were very often his mistresses, uniting in personal pleasure—or despair—a general spiritual and physical aspiration to defy mortality. I remember thinking at the time that if ever Picasso had told me to throw myself out a window, I might have done it. So perhaps, after all, the stranger in the bar at Cannes had intuitively touched a nerve of truth. I am prepared to acknowledge a lot—some may say too much—but there were extravagances of imagination from which even today I keep my distance, even today when I frequently dream of him still.

(In April 1986, I asked Françoise whether Picasso to her knowledge had ever had a homosexual relationship. She said she felt sure he had, because he lived with Max Jacob for a time in the early years and was also intimate then with a Spanish art dealer–writer–connoisseur who had a very powerful personality and dominated Picasso, who often referred to himself as an "honorary homosexual." I once asked Jean Cocteau, an unreliable witness, the same question, to which he gave a sensible answer: "A man of such insatiable and universal curiosity as Picasso, as handsome, sensual, and overtly genital as he, could hardly have failed to find out for himself what sort of sexuality men might experience with one another." And the Minotaur, after all, devoured boys as well as girls. Moreover, his most sublime works were all created in intimate collaboration with another man, of whom he sometimes ironically re-marked, "Braque is my wife." When that collaboration ended, he was never again so great an artist.)

For all the rest of that summer, until the breezes and sore throats of September put an end to it, I continued to see Picasso and Françoise frequently. He was welcoming, companionable, patient, and generous. I received several gifts of drawings and a couple of his pieces of pottery. They were dedicated "To Lord, [from] his friend Picasso." And in one case, "his old friend," but instead of using the correct French word for "old," *vieil*, Picasso wrote *ancien*, which most often means "former." Was he diabolically clairvoyant? I thought nothing of it at the time, but Bernard made fun of this glaring error of usage on the part of a man who had spent half a century in France. The word that should have drawn attention to itself, of course, was "friend." Its meaning for a man of genius cannot be equivalent to our comfortable, humdrum definition,

and there is danger in trying to traverse the crevasse separating convenience from necessity. I never thought of myself as Picasso's friend, nor do I believe that even so familiar a spirit as Sabartés would have presumed. The illusion was fine, it was like the lines on a piece of paper that happened to limn my likeness but was as superficial as they were, whereas the work of art and the reality of a human relationship lay infinitely deeper, at a depth all the more compelling because it had no visible limit. I had contrived to establish a certain familiarity with a great artist, but my own accomplishments were nil; I remained a nonentity. In my diary I wrote, "I would like to contract genius from him as one contracts a disease."

So I went back to Paris, and life there continued to be delightful. In Passy there were parties lasting till dawn, at which some of the guests came attired as Cleopatra, Charlotte Corday, or the Blue Angel. Picasso was awarded the Lenin Peace Prize in November, which meant that Eluard had seen to it that justice prevailed in the world. I couldn't understand why Picasso had wanted it and so insistently demanded it, but I didn't suppose that this was my business and, in fact, I really wasn't interested. Political contingencies still did not concern me. Hard at work on an unpublishable novel in my small hotel room, I was too busy being carefree to be bothered with thinking about Picasso. It may be, in fact, that I enjoyed the notion of having deposited cozily in my past the acquaintance with the renowned painter. Even as I fancied that I had ceased to be obsessed by him, however, I was preparing to catch at a thread leading deeper and deeper into the labyrinth where he dwelt.

IN OCTOBER 1950, I ran into Dora Maar in a Left Bank restaurant. She was accompanied by a lanky, handsome man who looked to be about her age, to whom she introduced me. His name: Balthus. At that time he was entirely unknown outside a small circle of avant-garde Parisians. I had seen his portrait of Marie-Laure de Noailles and much admired it but knew nothing else about him. He was aloof though polite, whereas Dora seemed positively friendly, which surprised me. Before the end of October, however, I had returned for a four-month visit to America.

During the next couple of years I traveled a good deal, often with Bernard, making long stays in Capri, where Norman Douglas could still occasionally be seen caressing young boys in the piazza and Edda Ciano glimpsed at a cocktail party; then in Florence, the guest there of Harold Acton; and visited also Germany, Austria, Switzerland, and Spain.

It was on August 29, 1951, that I first went to Aix-en-Provence and spent half the afternoon searching for Cézanne's studio on the Chemin des Lauves, then at the outskirts of the city. Going into a nearby grocery store, I asked the very old lady who ran it whether she could direct me to Cézanne's studio. "Cézanne?" she murmured. "Cézanne? All I can tell you is that he doesn't live in this neighborhood." Still, I finally found the place and was admitted by another aged lady, the housekeeper of the man, a local poet, who had bought the studio from the artist's son shortly after Cézanne's death, this poet recently deceased.

She invited me inside and allowed me to go upstairs alone to the large studio, where, it seemed, everything had been scrupulously preserved just as the painter had left it. Cézanne's easel, paintbox, brushes, dried tubes of paint, his furniture, the numerous objects, including several skulls, which appear in his still-life paintings, even a couple of his overcoats and a hat or two—all were still there in fittingly dusty disorder. Fragments of two paintings, Cézanne having been an implacable slasher of unsatisfying works, were stuck up on one wall. It was easy to imagine that the artist had just stepped out to execute a watercolor and might return at any moment, the sense of his continuing presence profoundly moving, a sort of epiphany for one to whom Cézanne represented the noblest exemplar of artistic commitment since Rembrandt. But I had no idea then that anything might ever come of this emotion.

The next day we drove on to Nîmes and Tarascon and near the Pont du Gard paused for a look at a château purchased not long before by Douglas Cooper. It was then still in a state of considerable dilapidation but obviously offered promise of grandeur if conscientiously restored. There was a half-ruined semicircular colonnade in front, a miniature replica of St. Peter's, and a great many more columns leading toward the château itself, and surrounding it, the whole place constructed in the cut stone of the region and baked a delicate umber by the Provençal sun. This folly had been built toward the end of the eighteenth century by a baron named Castille from the nearby city of Uzès, where he also maintained an imposing mansion, being a man who did not shrink from ostentation. Neither did Douglas.

In Paris, I ran into Dora two or three times by chance. She was friendly and we both said that we must meet again, but nothing came of these formalities. I did not see Picasso, or attempt to. He remained very much on my mind, however, and news of him was readily available by way of newspapers, magazines, and ceaseless gossip. At the Salon de Mai in 1951 he exhibited a large painting entitled *Massacre in Korea*, a propaganda piece meant to decry American intervention in that country. Aesthetically and dramatically a poor production despite vague reminiscences of Goya, it was also found wanting by the Communist Party, and I, too, disliked it. Then, in the autumn of 1952, the rumor began to go around that Françoise Gilot was leaving Picasso. The press was full of it and people who had never laid eyes on either of them talked

the matter over as if they were members of the family. To the delight of the public, this dragged on for more than a year. Cocteau wrote to me: "You must have learned of the Picasso drama. Françoise has left the conjugal domicile with the kids. But *silence*. Picasso likes to do the leaving, not to be left."

Meanwhile, having departed from France on April 9, 1952, I traveled all over the United States that spring.

I had not forgotten about my visit to Cézanne's studio and was able to learn that it was for sale, the price somewhere in the neighborhood of $25,000, which didn't seem very much for a solid two-story house standing on an acre or so of gently sloping land with a fine view of Aix. It occurred to me that the money needed could probably be raised quite easily by appealing to rich collectors if I were able to get together a prestigious committee of patrons in whose name I could make an appeal for funds to purchase the studio and transform it into a memorial museum. After consulting with the Cultural Attaché at the French embassy, who promised both moral and secretarial support, I got busy on this project. The first person whose support I solicited was the most eminent Cézanne scholar then, and still active, today, John Rewald. All the other people I approached were forthcoming with encouragement and funds. The necessary money poured in, and on the eleventh of June I sailed aboard the *Ile de France*, having been away more than a year.

There was a Cézanne exhibition that summer at the Musée Granet, the municipal museum of Aix-en-Provence, opening June 29, the first exhibition of his work ever to be held in his native city, forty-seven years too late for him to see it. Douglas Cooper by this time was splendidly installed in the Château de Castille, living there with his incomparable collection of Cubist masterpieces, plus fine watercolors by Klee, a Matisse drawing over the guest-room bathtub, and an oil sketch by Giacometti in the downstairs toilet. In addition to the château, Douglas had now acquired a companion younger than Lord Amulree, an Englishman named John Richardson, a handsome, energetic, entertaining fellow of about thirty—Douglas being some dozen years older—who until then had taken only timid steps as a scholar of contemporary art but under his friend's tutelage very quickly learned a lot, gained confidence, and soon started publishing the writings that were eventually to make him famous, culminating in a definitive biography of Picasso. Douglas was

capable of unusual charm and wit but at the same time could without apparent provocation be intolerably rude and offensive. It seemed to his friends that he was sometimes unforgivably unkind to John, snapping at him when he had expressed an opinion, "Shut up, John, you don't know anything." But John earned admiration not only for his writings but also for his tolerance and good humor, and it is perfectly possible that when the two men were alone together Douglas behaved like an angel, albeit one exceedingly overweight. I was invited to spend a few days at the château during the time of the Cézanne exhibition and much enjoyed my stay. The Baron de Castille had married a member of the famed Rohan family and, elated by this brilliant alliance, had caused to be carved all over his colonnaded castle the interlaced initials *CR*, which happened also, of course, to correspond to the surnames of the present occupants, a coincidence which in their happy moments they were pleased to consider an auspicious instance of predestination.

On the first of August, I went to Villefranche with Bernard and his father, there to spend the rest of the summer, and one evening I did go to Vallauris to have dinner with Picasso, Françoise, and the children, including Maya, daughter of the long-ago mistress Marie-Thérèse Walter. But I did not see them again. Though this was the time when the final rupture must have been imminent, I felt no malaise that evening. Picasso, in fact, was exceptionally jolly, very pleased by the success of his recent exhibition in Rome.

In mid-September, I returned to Castille for a five-day visit, arriving just as Fernand Léger departed. He had just put the finishing touches to an enormous canvas executed to cover the entire wall of the second-floor landing of the château's grand staircase. John said that Nadia Léger had actually painted more of the picture than her husband. It could never be counted a masterpiece, but Douglas was giggly with satisfaction all the same.

The purchase of the Cézanne studio had now been accomplished and repair of the interior was under way, but a very irksome and entirely unexpected difficulty had arisen. To collect money in the United States for the acquisition and restoration of the studio had been easy; to persuade some French organization or institution to assume responsibility for its future maintenance seemed impossible. The national museums, pleading poverty, didn't want it, nor did the *département* of the Bouches-

du-Rhône or the municipality of Aix-en-Provence. The Musée Granet
in Aix was then directed by an incompetent humbug called Louis Malbos,
who was no help at all. I didn't know quite where to turn. Douglas was
predictably contemptuous of French museums, of all museums, in fact,
since he was director of none, and said that I might as well keep the
studio for myself. John said that that would never do, as the French like
nothing more in the world than to have the value of their national
patrimony increased at neither cost nor inconvenience to themselves.

A day after my arrival at Castille, Douglas announced that we had
all three been invited to lunch the following day by Dora Maar. She
spent her summers in a village called Ménerbes about an hour away in
the Vaucluse, her house there a gift from Picasso, and people were
rarely, if ever, invited to it. Even Douglas, who had known Dora since
before the war, had never been inside, and was therefore quite elated
at the prospect. His car was a black Citroën, which he drove with demonic
recklessness, laughing like a screech owl at the consternation of other
motorists. The day, a Wednesday, was thrilling, one of those rare,
gleaming, golden days that sometimes accompany the autumnal equinox
in temperate climes, the sky azure as thirteenth-century enamel and
intoxicating breezes flowing from the summit of Mont Ventoux, etched
sharp in the northern distance, while on gilded hilltops tiny towns and
the cyclopean keeps of dilapidated châteaux glimmered in the Provençal
sunshine. The wind was alive with scents of pine and thyme, roadside
ditches drowned in late-blooming aster and diamond rivulets, and merely
to breathe the rushing air was an ecstasy.

Beyond the market town of Cavaillon on the east bank of the Du-
rance, the valley narrowed and low mountains with rocky outcroppings
rose up on either side, forming the area known as the Lubéron, extending
as far as Apt or somewhat beyond, a distance of about twenty miles. On
the higher slopes and ridges affording some strategic vantage stood the
villages of the region, some with ramparts and fortresses, these at the
time either wholly or partially in ruins. Despite the rich farmlands and
vineyards in the bottom of the valley, an aura of enchanted abandonment,
as if they were forgotten both by history and by incentive, seemed to
emanate from those secluded, silent places.

"There it is!" cried Douglas, gesturing flamboyantly as the car
pitched around a curve, scattering gravel alongside, and we took a narrow

road to the right. Ménerbes stood above on a long spine of rock, in relief against the sky. At one tip of the hilltop rose the overgrown towers and tumbledown walls of a medieval citadel; at the other, a church with a square, stunted belfry; and between, the village itself, suspended at the brink of a sharp slope, many of its houses large but looking badly neglected, their façades jumbled together and all the color of the sun-burned fields below. Here and there the metallic tuft of a pine hung above the silhouette of rooftops. The aspect was austere, almost forbid-ding, but romantic at the same time, and enticing.

"That's Dora's house up there, right in the center of the village," Douglas went on, "with the green shutters and the square gable at the top." We turned left along a dirt road that rose steeply along the front of the slope. Halfway up, there was a sharp U-turn, and here Douglas pointed out the retaining walls of a property recently purchased by a painter just then beginning to become well known, Nicolas de Staël, of whose works, however, he was at pains to emphasize, he entertained no high opinion. At the top of the road there was a sharp, difficult turn to the right; then we drove up a further incline about a hundred yards to Dora's house and parked just beyond it in front of a sagging garage door. The house was large, three stories in height, with about twenty windows, most of these with shutters closed, but the façade was starkly unadorned save for a handsome doorway of cut stone with Ionic pilasters at either side and an arched pediment above. The masonry was in poor repair, in places cratered and fissured, doors and shutters badly in need of repainting. Grass grew between the several stone steps leading to the door. A rusty iron bellpull hung to the right of the doorway and Douglas gave it a couple of yanks. Immediately the right-hand half of the doorway creaked open, Dora stepped outside, smiling, jerked the door shut behind her, said how pleased she was to see us in Ménerbes, and held out her hand to be shaken by all three of us. She must have been waiting just behind the door, or perhaps had been on the lookout from an upper window for our arrival. It was clear that we were not to be invited inside. Her hair was done up in a silk scarf and she held a purse in her left hand.

There were no proper facilities for entertaining in her house, she explained, and so she intended to invite us for lunch at a little restaurant down in the valley at a place called Les Beaumettes. This surprise was

obviously not a welcome one to Douglas, and I, too, felt a twinge of disappointed curiosity. The restaurant at Les Beaumettes couldn't have been more modest. We ate outside on a narrow terrace set just above the main highway between Cavaillon and Apt, along which in that era there was very little traffic. Dora had ordered the entire meal in advance and promised that it would be excellent. It was. For aperitif, we began with a liter of icy white wine, the bottle of which bore no label. Then came a truffle omelette, followed by roast lamb with foie-gras sauce, salad, cheeses, almond cake, coffee, and several unlabeled bottles of red wine. I sat facing Dora. She was smiling. Here, I thought, is someone I've never seen before, a total stranger, mysterious, the radiance of her gaze amazing. The trumpet cigarette holder came into frequent use, and sometimes a tiny avalanche of ash cascaded down the silk slope of her breasts. We were all talking. And it was also as though I'd never before noticed the exquisite birdsong quiver of her voice, unique, an enchantment. This was one of those moments that seemed to define the universe forever by the piercing delight of the present. We talked about a thousand things but principally about Picasso. "Talking about him, we're talking about ourselves," said Douglas, "because if anyone remembers us after we die, it will be because we knew him."

"Oh, I'd much rather talk about the cinema or the weather," Dora said, "but I have to talk about Picasso, because people expect it, because nobody knows as much about him as I do."

I said I'd give a lot to live a hundred years to see what happened to Picasso's reputation and fame. Might it all wither away and come to nothing? Remember Guido Reni. No chance of that, Dora said, for the commitment of dealers, collectors, and museum curators was already too great, there could be no turning back now. And Douglas said that this was the Picasso century, he was the greatest figure of the century, greater even than Einstein or Freud.

"Poor century!" said Dora. She was not sparing in bitterly critical remarks about Picasso. Numerous were the instances of Picasso's unscrupulous cynicism, she said, seeking advantage wherever he could find it and in the face of egregious miscalculation never uttering a murmur of compunction or even of regret. Douglas grumbled but did not demur. We were all rather drunk. It was glorious, and we had been sitting there by the roadside for a couple of hours. After the coffee the proprietor

brought us tiny glasses of fiery *eau de vie*. The afternoon was the color of topaz.

Douglas remarked that Ida Chagall and her husband, Franz Meyer, had a house not far away in a town called Gordes, where her father had hidden for a time early in the war before making his escape to New York. What a good idea it would be to drop in on Ida. Absolutely, said Dora, as she'd never seen the inside of Ida's house. John said yes, and I at that point felt that anything we did would be too good to be true. Dora made a sign to the proprietor but no bill was presented; then we all got into Douglas's car and sped away.

Gordes was a jumble of honey-colored houses stacked like a Cubist construction upon the hilltop, with a sleepy château facing an empty square, and we had a little trouble locating Ida's house, which was down a very steep street on the far side of the hill. She was at home, seemed genuinely delighted by our unannounced visit, and invited us inside, where we found her husband and an art critic named Charles Estienne, who also owned a house in Gordes. Ida was buxom and jolly, with auburn hair, making up by vivacity what she lacked in beauty, sly in her smile and given to histrionic gestures, in this rather like her famous father, with whom I had been invited to dinner in Nice that August by Curt Valentin. Franz was Swiss, quiet, polite, a museum curator, evidently content to let his wife claim all the attention. (He later left her.) Charles Estienne had the white face of a ferret and was the only one who did not appear pleased by the unexpected arrival of his boisterous, flamboyant colleague Monsieur Cooper. It was quite possible Douglas had denounced him in print. Ida's house was large, with high windows and ceilings, and simple, adequate furniture, but no paintings by Chagall were to be seen. There was a neglected garden outside. We were all given a glass of wine. Standing by the windows looking onto the garden, we talked. Ida said that her father was much annoyed because the street in Vence on which he lived had been renamed Avenue Henri Matisse, as the chapel of some Dominican nuns who had nursed him during a grave illness, now entirely decorated by the elderly painter, stood quite nearby on the same thoroughfare. Douglas said that in similar circumstances Picasso would move. "Papa plans to," said Ida, but nine years later, when I took my mother to have tea with him, he still hadn't, though eventually, aged over eighty, he did.

Pretty soon the golden day began to turn pale blue. Douglas said it was time to leave, as we had to take Dora back to Ménerbes and then drive an hour to arrive at Castille in time for dinner. Whereupon Ida said that she had always longed to see Dora's house and why not seize this opportunity for a neighborly visit—oh, of the utmost informality to be sure, no drinks or lingering, just a casual look around, assuming that it would cause no inconvenience. Dora was plainly nonplussed, her reluctance conspicuous, but it was equally evident that no courteous alternative existed, so she said that that would be fine, and after all it was only a quarter of an hour away; but the shine went out of her eye. All the rest of us were delighted. We drove across the valley toward the sunset, Ida, Franz, and Estienne following in the Meyers' car.

Dora unlocked her front door with unmistakable distaste, but no one spoke up to afford her an alternative to the unwelcome predicament. We all followed her inside. Facing the entrance was a broad staircase, the walls whitewashed, and to the left a kitchen, very sparsely equipped, where a striped gray cat was mewing. "Yes, yes, Moumoune," Dora said, leaning down to caress her pet, but it slunk under a cupboard. "Of course," said Dora, "she is not accustomed to strangers." Nor, certainly, by implication, was the house. We went up to the second floor, to a large salon to the right of the landing, with windows overlooking the valley and onto a garden, also a door with glass panes in the far corner leading into it. The furnishings looked like things abandoned there long before by some hasty departure: a few mismatched chairs, a long table, lopsided armoire, and decrepit horsehair sofa. "As you see," said Dora, "I'm not equipped for receiving." She led us across the landing into a large room which had once, probably in the eighteenth century, been a library, its shelves now all broken and hanging askew. To the rear were several other, smaller rooms, but the ceilings had long since collapsed and she had closed them off, needing little space for herself. Through a farther door was the room she used as a studio, which she would not show us, it being in disorder. Douglas insisted that he would love to see her work. "No," she said, as she was in a period of transition and had nothing to show.

"A pity," said Ida.

Then she offered to give us a look at the bedrooms on the floor above, one at either end of the house, separated by the landing and one

additional room in between. Only a simple bed, chair, table, and cup-
board furnished each of these three bedrooms, but two makeshift bath-
rooms had been installed in corners of small rooms at the back, Dora
explaining that if ever she were so imprudent as to have a guest she
wanted to be completely independent. I took note with some surprise of
the word "imprudent," wondering how it might apply to the eventuality
evoked. And how could I have dreamed that within a year I would know?
We went back downstairs to the barren salon. "The place is practically
a ruin, I realize," Dora said. "But in fine weather it is a delightful refuge.
Next year I'm going to make some curtains. I have the material already,
got it for next to nothing."

"Really, it's a wonderful place," said John. "Has all sorts of
possibilities."

"Picasso got it in exchange for a painting, you know," said Douglas.

"Oh, really?" said Ida. "I always thought it was for a drawing."

"Too bad I have nothing to offer by way of refreshment," Dora said
shortly.

"Don't give it a thought, darling," Ida rejoined. "Sad to see the
walls so bare. No pictures by Picasso stuck away in a closet?"

"No, not a single one."

Then Douglas said it was time we must be going, and indeed the
lemon sky beyond Mont Ventoux was colliding with twilight. At the door
we all shook hands one by one. I said how happy the day had been,
and Dora smiled. She said, "Perhaps I shall see you in Paris in the
autumn. Do telephone me."

I promised I would, and the promise seemed bound to certainty by
the ecstatic clarity of the day. I was still a little drunk.

Douglas stayed behind with Dora on the doorstep while the rest of
us went down the sloping street to the cars left parked by the parapet
overlooking the twilit valley.

"I feel so sorry for Dora," Ida said.

"But she seems much better now," Charles Estienne observed.

"How can she be?" said Ida.

They got into their car and drove away, leaving John and me to
wait for Douglas. He came along soon, casting oversized shadows beneath
the lone streetlight suddenly turned on. We careened away into the dusk.

He had been concerned about Dora, Douglas said, as she was a

woman alone in the world without material security, and that was why
he had wanted to talk in private with her for a few minutes. She had no
family save an aged father, a retired architect, who was even to some
extent probably dependent on his daughter. Of course, she had a fortune
in paintings and drawings by Picasso, gifts to her from the artist, and
had been known to sell one or two from time to time, but all of these
were mementos of a lost love, each no doubt associated in some inex-
pressibly intimate way with the great experience of her lifetime, therefore
precious beyond material calculation. As it happened, though, many of
her Picassos were unsigned, for it was the artist's usual practice to sign
only the works that he sold, and this fact constituted something of a
deduction in the value of Dora's hoard, Picasso's willingness to sign
previously unsigned pictures being notoriously subject to caprice. How-
ever, this was all a matter of vigilance, tact, and a flair for appraising
the artist's moods. The point was that Dora did occasionally sell, and
Douglas felt that the many important Picassos already in his possession
represented a reassuring advantage.

It was dark then. We had reached the outskirts of Cavaillon. Doug-
las drove at his customary reckless pace, with John beside him, while
in the back seat I wondered whether the solitary former mistress of the
great painter might not, after all, still look forward to some experience
in her lifetime to make the mementos of Picasso's lost love not less
valuable, certainly, but just a little less precious. And I thought that
maybe Douglas was mainly concerned about their value.

He continued to talk about her as we drove across the Durance
toward Avignon, and in the speeding dark as the invisible countryside
fled backward, Dora's story, that part of it which Douglas knew, seemed
to become the whole life of our journey. Daughter of a Yugoslav father
and a French mother, born in 1907, she had grown up in Argentina,
where her father was busy building important parts of Buenos Aires.
But she was back in Paris, her birthplace, before the age of twenty,
beautiful, intellectual, a liberated woman before women started talking
about the shackles of sexuality, and she had taken a lover while her
contemporaries were still strumming their mandolins in the gardens of
the Palais Galliéra. He was a fellow called Louis Chavance, a friend of
the surrealists and writer of film scenarios. This liaison did not last, and
Chavance had bad luck in his career. Dora frequented Montparnasse,

its cafés, the Dôme, Rotonde, and Sélect, where everyone congregated
who liked license to live the artistic life, and inevitably she made the
acquaintance of the artists and writers of the moment, some well known
already, others to become so eventually, and the moment happened to
be the heyday of Surrealism. Something of an anarchist by nature, Dora
embraced with exuberant piety the Surrealist doctrine of behavior freed
from conscious constraint and bourgeois convention. Though never an
official member of the Group, she signed the occasional manifesto and
got her portrait made by the photographer laureate of the movement, a
goatish fellow from Philadelphia named Man Ray.

"A humbug and a windbag," Douglas said.

Dora herself decided to take up photography as a serious means of
self-expression, to which she aspired to a high degree, and bought herself
a couple of cameras, dark-room equipment, an enlarger, tripod lights
—all the professional gear. In this, as in everything else, she did not
for an instant mean to be taken lightly, and she produced in fact some
arresting, original images, some of these even reproduced in the exotic
little magazines of that imaginative era. Douglas remembered running
into her here and there, at Lise and Paul Deharme's or in some smoky
bistro, always spirited and provocative but already utterly self-possessed,
aged twenty-five or -six. Then her existence took a turn. She became
the mistress of a writer very well known and much respected in Parisian
circles, a former Surrealist named Georges Bataille. He was older than
Dora, married to a beautiful actress named Sylvia and father of a young
daughter, Laurence, but any sort of sexual inhibition in that milieu was
by definition taboo. Being Bataille's mistress must have entailed an
extraordinary tutelage in the arcana of sexuality, for the topic that ob-
sessively absorbed his lifelong exertions as an author was precisely the
riddle of eroticism. Connoisseur of pornography and philosopher of carnal
desire, he believed in the deliberate transgression of all sexual limitations
and the imperative need to transgress ever further, going even beyond
what seemed tolerable or conceivable.

It was very quiet in the car. "And yet he was the most charming
man you could hope to meet," said Douglas.

Bataille's erotic obsession and will to transgress naturally induced
a concomitant reflex of guilt, an acknowledgment of the legacy of suf-
fering, indeed, as the very genesis of desire, and a terror of death as

the ultimate incentive to the act of love. No wonder Bataille titled one of his best-known works *The Tears of Eros*. All this naturally added up to quite a heady education in the quirks of sexuality for a young woman not yet thirty. Douglas uttered a high-pitched squeal of hilarity. And I wondered whether quirks of some sort might not constitute an aspect of his own originality. But Dora was not your run-of-the-mill mistress of an artistic celebrity. There were plenty of lively, willing, witty, and creative young women, camp followers of the Surrealist vanguard, like Lise Deharme, Valentine Hugo, Meret Oppenheim, Leonor Fini, et al., none of whom in life or in art ever went beyond mediocrity. Dora possessed the temperament, the personal greatness for the major ordeal. She proved this by holding her own with, and against, Picasso for a decade. It was probably Eluard who introduced them, sometime in 1936, very likely in the spring. Her power is patent in the scores of portraits Picasso painted of her, and by extension in the dramatically intense works, including *Guernica*, that he painted during the years of their affair. It was, of course, a major coup for her to become *maîtresse en titre* to the monarch of twentieth-century art, and certainly she relished all the perquisites and the fawning deference that went with her regal status. Her lover's glory nullified what disadvantage might have been seen in a quarter of a century's difference in age. Still, Picasso maintained his semi-independence. They never actually lived under the same roof. He continued to see his wife and one former mistress, Marie-Thérèse, mother of his daughter. Dora was intelligent and courageous enough to be tolerant. And no doubt she assumed—incorrectly—that a man well past sixty would not embark on a love affair with a girl young enough to be his granddaughter.

So the sudden revelation of Françoise Gilot's ascendancy was dreadful for Dora. She suffered a nervous collapse. Her friends thought she might go mad, commit suicide. One day she was found sitting naked in the stairway of her apartment building, to the consternation of a wedding party coming down from an upper floor. And then there was an appalling outburst of hysteria in a movie theater, the police were summoned, and she was taken to the psychiatric hospital of Sainte-Anne in the fourteenth arrondissement. Once one was committed to that place, it was not so easy to get out. She was subjected to a series of electroshock treatments, not unlike artificially induced epileptic convulsions, better left unde-

scribed. Eluard was outraged and insisted that Picasso do something. Jacques Lacan, a friend of all of them and already an eminent psychoanalyst though not yet so famous as he later became, was enlisted to help. He got Dora out of the madhouse and put her in a private clinic. Later she underwent analysis with him. That seemed to do her good. She became quite mystic, passed through a Buddhist phase, and now, people said, had become devoutly Catholic, the religion of her French mother if not her Yugoslav father. And she seemed to have arisen from the abyss. She went out, saw old friends, appeared to be the familiar Dora of happy days. Well, to be sure, no other man had come along to take Picasso's place in her life, which was certainly how the artist preferred things to be. He liked his abandoned women to pine for him in solitude, his occasional appearances therefore like dispensations of celestial compassion. A vigorous woman in her mid-forties and versed in the anomalies of sensuality, Dora had nonetheless probably been alone for seven long years. The man she saw most often was Balthus, but everybody knew that he liked only very young girls, his most recent paramour having been none other than Laurence Bataille, the teenage daughter of Dora's former lover, so that Balthus was nearly her son-in-law. And Sylvia, Bataille's former wife, was now married to Lacan, which also made everyone's situation a bit bizarre, much to the liking of Lacan, at least, who enjoyed peculiarity-prone imbroglios in his milieu.

"Lonely, I should have thought," Douglas said, "terribly lonely she must be. I pity her, poor Dora, with only Picasso's ghost and God to keep her company in that sinister house."

Lonely, yes, I thought, no doubt lonely, but in her solitude immaculate and intact, alluring, like all those portraits painted of her by Picasso, because the solitude was likewise his creation, his largesse, bearing the imperishable imprint of his genius. So was she not, after all, after the electroshocks, the psychoanalysis, and the seven long years of days and nights, winters and summers, was she not in her own right still something of a goddess? An immortal, her image enshrined in the great museum-palaces of the world. Her beauty unimpaired. The radiance of her gaze. The nightingale cadenza of her speech. I thought it grossly presumptuous of Douglas to dare to pity her, Douglas who had nothing to offer to posterity but his shrewd purchase of masterpieces

and his knowledge of art history, who had never himself been instrumental to the fructification of genius. The car's three passengers were silent now; there was no more talk of Dora. We were passing through Argilliers, the village nearest Castille, and I found to my surprise that I resented Douglas's pity.

Two days later I returned to Paris, and ten days afterward left on a trip to Italy, Greece, and Egypt. After a fortnight in Greece, I went on to Egypt on the eighteenth of October. There were no tourists, the country still unrestful in the aftermath of the military coup d'état which had overthrown King Farouk more than a year before. But on the verandah of my hotel facing the Pyramids I frequently saw William Faulkner seated in a rocking chair with a tumbler of whisky in his hand. He was there to lend a hand, or a name, to the scenario of some otiose super-production being filmed in the land of the Pharaohs. I longed to speak to him but didn't dare. Having visited Cairo and the sights of Giza, Saqqara, and Memphis, I boarded the night train for Luxor.

Only one hotel was open in Luxor, and only two other persons were registered there, an English couple, Egyptologists. I went to Karnak, Deir El-Bahari, the Valley of the Kings, etc., etc., sites properly destined to leave one speechless, especially when visited alone. I keenly felt the immensity of the past. It intensified my sense of remoteness, isolation, solitude, and at night along the bank of the Nile, where oil lamps glimmered behind the shutters of dilapidated mansions, I longed for some comprehending soul to commune with. In short, I was overwhelmed by the spiritual magnitude of Egypt and wanted to escape from it.

Through the kindness of an Egyptian friend in Paris I had made the acquaintance while in Cairo of a German Egyptologist named Ludwig Keimer. Though short of money, I hoped to acquire one or two authentic Egyptian antiquities. Keimer advised me to wait until I reached Luxor and there to visit the shop of an old fellow called Sayed Molattam, a shrewd but dependable veteran of great days long past who had known both Carter and Carnarvon. Through his humble shop had passed prodigious treasures. As I had been sent by Keimer, Molattam was forthcoming, and some of the things from chests in the rear rooms of his dingy premises were treasures indeed, which even today I remember in tantalizing detail. But I could afford none of these. So I had to be content with a wooden Osiris about a foot high with most of its original gilding

and bronze attributes intact, a fine though late object which Molattam let me have for next to nothing out of consideration for Keimer. I bought it for myself, but not very long afterward realized that it would be better off elsewhere and gave it to Giacometti. Then there was one other object in Molattam's shop that I peculiarly set my heart on, a turquoise-blue faience cartouche ring, exquisitely delicate, fragile, and intact. It just fit my little finger, though I was aware without Molattam's warning that it had never been meant to be worn but was a symbol, an adornment of the spirit for the eternity of the netherworld. I could not afford it even at the trifling price set by the amiable old dealer, but I bought it anyway. He said that it had been found at Deir El-Bahari.

For lack of money I had to forgo the trip to Aswan and Abu Simbel. How often during these travels, whether climbing up to the stadium at Delphi or to the summit of the Great Pyramid at Giza, viewing the glories and grandeurs from the vantage points of my solitary journey, I had thought of that golden afternoon in Provence, and sometimes it had seemed to me that I was seated on the steps of the Parthenon or dining on the roof of the Semiramis Hotel, contemplating Schliemann's treasure or the funerary masterpieces of Tutankhamen solely in order one day to discover my experiences by exploring them with someone else. At all events, I knew perfectly well, and had known from the very first moment I saw it in Sayed Molattam's dusty tray, that I had bought the ring for Dora.

CHAPTER

EIGHT

ODE. 18-55. I knew it by heart already but held back for a few days from calling. For fear of what? Some sixth or seventh sense akin to that which can perceive from the aspect of a single tendril in a forest that the forest is not at all what it seems. Just as I now find it arduous and troubling, though I've read and reread all the diaries, notes, and letters of that entire period, to start the story which the past desires to tell. Dora would be furious. To be sure, she often was. And yet she wanted even her fury to be bequeathed to posterity and never doubted that it would be, that, in fact, it already had been.

At that time I was living carefully on my allowance, augmenting it occasionally by a bit of art peddling. In those leisurely years before direct transatlantic dialing, the fax machine, and the Concorde, the art markets in New York and Paris were not yet homogenized, prices on the Left Bank consistently lower than on Fifty-seventh Street, or even on the Right Bank, and reasonably good pictures in plentiful supply, so that it was easy for someone like me who went regularly around the galleries for my own pleasure, hoping to find for myself the occasional sketch by Delacroix or Daubigny, to spot a picture beyond my means that I could turn over to a dealer in New York, earning a nice ten percent for having done next to nothing. Of that, indeed, I did a good deal, and many more fine things passed through my hands than ever I was able to hold on to. This peripheral activity, long since ended, had the unfor-

tunate effect of making the collector's mania more manic than it might
otherwise have been. My friends poked fun at it, but were impressed
when I found for five dollars at the flea market a drawing by Giulio
Romano, a study for one of the lunettes in the Palazzo del Te, bearing
the collection stamps of Benjamin West and Sir Thomas Lawrence. And
Bernard thought it clever of me to earn extra money by running casual
errands, as it were, for Curt Valentin, Pierre Matisse, and Eugene Thaw.

I had no home, however, in which to house the few pictures and
objects of my "collection." Returning from Egypt at the end of October
1953, I moved provisionally into the guest room of a friend's apartment
while searching for lodgings of my own.

I called Dora only after several days, which seemed to make my
eagerness safer, and from a telephone booth, which seemed to assure a
certain neutrality. Recognizing her voice instantly, I nonetheless asked
whether she was in, and when she said it was she I said, "This is James
Lord. Do you remember me?"

She laughed. Oh yes, she remembered me. Well, I said, I'd like
to see her. Had just returned from a trip to Greece and Egypt; otherwise,
would have called before. She herself, she rejoined, had not been in
Paris very long, having lingered late into October at Ménerbes to work,
but she'd be glad to see me. When? Soon, very soon, but perhaps not
immediately, because she saw very few people, she said, going out
seldom, usually in bed at nine, for the sake of her work, you see,
inflexible self-discipline being essential to all accomplishment. Natu-
rally. Then at her convenience, needless to say. Next week, perhaps.
Yes, next week, certainly. But what day? Tuesday? Or Thursday might
be preferable, though Lise Deharme would be having a cocktail party.
Unless . . . Unless I wanted to come around this very evening before
dinner for a quick drink, very briefly, just to say hello. I instantly said
yes, and the excitement was astonishing. Eight o'clock, then. *A tout à
l'heure*, she said, her voice rising, lingering on the last syllable, a song.

She opened the door at once. We shook hands. Immediately there
was the sense of shining friendliness I had felt six weeks before. But
now we were alone. She took my raincoat, tossed it onto a chair in the
small salon, going ahead of me into the large room where the massive
bed stood. Everything was ready. A fire flickered yellow and orange in
the fireplace, all the portraits of her by Picasso were in their places,
and a bottle of Scotch, two glasses, a blue glass bowl filled with nuts,

and bottles of Perrier water were set out on a low table. We took our places in the Empire armchairs before the fire. Without asking, she prepared our drinks, saying she had never been to Egypt, or Greece, or traveled much at all except in Argentina as a girl, because Picasso didn't care to travel. Once when they were in the South of France he had said, "Let's go to Florence and look at all those masterpieces." But hardly had they reached Genoa before he said that they were all a bore, Botticelli, Raphael, Michelangelo, the rest, and he wouldn't give one Cézanne for the lot, and he had a Cézanne, so they turned right around and went back to where they'd come from. But it must be miraculous, she said, to stand in the hypostyle hall at Karnak.

"I've brought you a souvenir from there," I said, taking from my pocket the poor pasteboard box provided by Sayed Molattam.

She exclaimed over the ring, admiring its color and finesse, had seen one very similar in the Louvre, she said, and I realized that in fact I had made her a fine gift, and was delighted to see her pleasure so spontaneous and keen. It fit her second finger perfectly, but she knew that it was too fragile to wear. "Come," she said, "and I'll put it in my private museum." This was in the salon, a large mahogany bookcase with double glass doors. On the shelves inside were some large books and a collection of objects: a bronze bust of Dora, obviously by Picasso, a hand cast in bronze and several large matchboxes with drawings on them by Picasso, plus a Picassian menagerie of animals and birds made of wood, paper, plaster, metal. "He doesn't know how to stop making things," she said. "It must be terrible for him. Of course, it's terrible for us as well." I was startled to seem to be included as one for whom this ceaseless compulsion might be terrible, and wondered at the abruptness of the assumption. She put the ring in front of the bust, closed the door, and locked it. Returning to the fireplace, she poured another drink for us both, remarking, "Or maybe you should be making the drinks. It's a thing men do. Living alone, one loses one's *savoir vivre*." She laughed. "I hope you haven't told anyone that you brought me a ring."

I blushed and said no, but surprise was stronger than embarrassment, and a certain malaise.

"Because you know how malicious people can be—Lise, Marie-Laure—their own lives being so far from ideal."

I didn't know, and Dora had been insistent that my visit should be

brief. Should I not be running along? Only if I had some previous
engagement, which I hadn't. She was perfectly free, she said, and not
far away happened to be a pleasant little restaurant, its fare inexpensive
and adequate, offering free the added delectation of a splendid portrait
of the proprietor and his son by Balthus, painted before the war to
compensate for countless unpaid repasts. She asked me questions about
myself, my writing, my interest in art, my family, the past, the future,
questions that might have been troubling had the sympathy of the listener
not seemed as transparent as her gaze. So I tried to reply as she wished.
And we had another drink. She was smoking most of this while, per-
forming each time the routine of the trumpet cigarette holder and silver
lighter, their manipulation practically a symbolic ritual, bursts of ash
occasionally cascading down her bodice. The cat now and then went
slinking by and she would caress it. "I once had a little dog," she said,
"but it was stolen. I never liked cats. But Picasso gave me this cat after
the dog was stolen, so I had to keep her. He knew that. Because she
was his gift, and my likes or dislikes made no difference."

Thinking it odd that Dora should tell me this, I said nothing but
assumed she might be a little drunk. I was. Never before had I had the
feeling that we were being truly ourselves with each other. She must
have had her reason, conscious or unconscious, for divulging the origin
of Moumoune, but I didn't worry about it then. What mattered was the
moment, the sense of intimacy, also perhaps that the presence of the
cat had been revealed to be the work of Picasso.

We walked to the nearby restaurant, a narrow room, noisy and
smoky, the Balthus portrait superb but the proprietor no longer the
handsome, slender man of fifteen years before. He knew Dora, gave us
a good table, and brought a bottle of red wine without being asked. The
food was mediocre and irrelevant. We talked and talked. About art.
About Greece and Egypt. And about ourselves. We were important.
Dora undoubtedly was, anyway, being already a historical personage,
her visage even then a contemporary prototype of aesthetic admiration
and learning. And I was her interlocutor, her accomplice all evening in
laughter, and the *sine qua non* of high aspiration. It didn't matter what
we were talking about, and I wrote down next to nothing save the story
of Moumoune. Picasso was mentioned occasionally, which seemed as
natural as daylight after sunrise. The proprietor's name was Roger. He

asked Dora what she thought the painting by Balthus would be worth. I was shocked by the seeming vulgarity of the question but Dora appeared to accept it as perfectly natural, said that there was next to no market and that he'd better wait twenty-five years. Picasso, however, she added, owned a very fine painting by Balthus, and he seldom made mistakes. Roger brought us another bottle of wine, but it was time to leave. Dora made no motion to participate in payment of the bill, and I was glad. I walked back with her to the rue de Savoie. At the door she said I might call her again if I wished. So I answered that I hoped we might meet soon. Her work took precedence over social divertissements, I should understand. Yes, certainly, I understood. Then we shook hands, and as she turned away in the shadow of the heavy porte cochere she thanked me for the ring from Egypt and said that of course it was an amulet, which symbolized something, evidence of sensitivity on my part, which she was glad to recognize, and then the door swung shut behind her.

Walking away, I was elated. And yet there had been a trace of condescension in her tone. Obviously, my gift had been singularly appropriate. Perhaps it had been a talisman of the great Hatshepsut herself. That, I thought, would surely please Dora. I turned to the right, toward the Seine. There were lights in the awe-inspiring windows.

•

My motorcycling days were over; I experienced, as a consequence, not the slightest sense of genital insecurity. On the contrary. Buying a little automobile buoyed my feelings of manly initiative. It was a secondhand black four-horsepower Renault. These were the very smallest, cheapest cars to be had in France, capable of transporting four persons, plus a very small amount of baggage beneath the front hood, the motor being in the rear, but incapable of conveying anyone at all very far or very fast in any degree of comfort, being low and cramped, with windows that slid halfway open but did not roll down. Of course I was delighted with this vehicle. In Paris in the mid-fifties there was next to no traffic, never a jam, and one could park absolutely anywhere at will. From the center of the city to the meadowland countryside was barely half an hour. To have a car, plus a small income, and to live in Paris in modest comfort: this was paradise. It's true I was thirty, had as yet produced no work of the least distinction, and had no convincing reason to believe

that I ever would. But maybe by some genetic oddity a willful faith in the power of words to triumph over infinite odds had been passed down to me by those two remote ancestors who had staked their lives on it. I wrote every day. A day without writing pinched the pretentious Puritan conscience. And then I had finally realized that, after all, I was not as ugly as I had felt since the age of fifteen, with the consoling consequence that I became more successful at seeking promiscuous oblivion in the embraces of boys whose names in my diary no longer evoke a tremor of memory. The car was a great asset in this pursuit.

·

A word or two should be said about Lise Deharme. Her contribution to the story of the era was negligible, but her desire to deserve attention so passionate and effusive that people accepted her self-importance as authentic evidence of originality, even of talent, even of intelligence and wit. What she did possess was charm and a comfortable fortune, which she gladly squandered to promote the illusion that her salon was a seedbed of creative and social significance, its most eminent bloom, if not her own, being that of her most intimate friends. A sort of all-duty, avant-garde, *dernier cri* Madame Verdurin. And it's true that Lise did gather together an acceptably distinguished little group. At one time or another, Picasso and Dora went to her house, as did Aragon, Giacometti, Georges Hugnet and a lot of the Surrealist gang, of whom the leader, André Breton, had sighed for Lise in vain. One also met Marie-Laure de Noailles and the occasional princess, plus the promising young foreigner such as Truman Capote or Peter Matthiessen, all of them pleasantly cultivated by a crowd of people, like Bernard and myself, flattered to be in the company of one another. Lise was petite, dark, not beautiful, but chic in the most effective sense, with flashing eyes and a throaty, resonant voice. Paul Deharme was now dead, but she kept his name though married to a well-dressed, affable man named Jacques Parsons, whose principal husbandly activity seemed to be taking for walks a mangy poodle called Ramsay. Lise had helped to ease the introduction of Dora into Picasso's life as *maîtresse en titre,* and the painter had given her a rather ordinary little watercolor in exchange for some bauble that Dora coveted. In an out-of-the-way corner of the salon hung a drawing in colored pencil that Lise called a Picamaar, saying it had been drawn

half by Dora and half by Picasso. She also insisted that the rusty little pistol on her mantelpiece was the fateful one that had been fired at Rimbaud in Brussels. The walls were covered with paintings and drawings, and in a violet velvet frame was an autographed photograph of Oscar Wilde. One window was almost entirely obscured by an immense, baroque tropical plant. Indeed, the atmosphere *chez* Lise did sometimes evoke the hothouse. Who, if anyone, thrived in it is a matter of conjecture that nobody is likely to elucidate.

•

My impulse was to telephone Dora the very next day, but I didn't want to give the impression of being pushy. To wait was not difficult, for Bernard had lots of friends, many of whom became mine, and he was a wonderful organizer of entertaining soirées. To sit up half the night talking about sincerity or Lautréamont or the Reichstag fire or who did what to whom in bed was agreeably commonplace. So I waited for two days.

She was brusque. People were constantly calling her, she said, most of them because of an involvement now entirely a thing of the past and nobody else's business in any case. "My relations with the rest of the world for the rest of my life do not depend on the fact that I was once acquainted with Picasso," she declared. "No, no, of course not," I said. I felt nonplussed, however, as it seemed that somehow I might be at fault, whereas I had meant only to please. She said she was very busy, her work, etc. And so I replied that I would telephone at some other time, when more convenient. Very well, said Dora, and that was that. *Au revoir.* I was left feeling rebuffed, surprised, and, though I had not the slightest right to grievance, disgruntled. That should have forewarned me. But I felt quite safe within my egocentric freedom. And yet the fascination persisted like an ache repeatedly palpated to make sure that it aches. I imagined Picasso must have experienced the same sensation and thought I'd ask him the next time we met. His portraits of Dora, especially the one in the striped blouse, seemed to verify my surmise.

Lise received weekly, at least, and we all went as a matter of course without being invited, even if only for half an hour. And half an hour sometimes seemed a tomb of time. Nobody could sit down, as the crowd

was too dense. The hubbub precluded niceties of conversation, though that was supposed to be the principal purpose of our presence. The drinks were dry Martinis, inducing drunkenness in a hurry. And it was always boiling hot. And the very next time that Bernard and I came into Lise's salon, two or three days after the vexing telephone call, there was Dora flourishing her cigarette holder in animated talk with Marie-Laure and Oscar Dominguez. I said hello. They greeted me quite affably but continued their talk, which concerned Picasso, whom Dominguez had recently seen. Oscar was Marie-Laure's lover, a peripheral Surrealist painter from the Canary Islands, a huge man, exceptionally ugly, with a hydrocephalic head—but no atrophy of the brain—frequently drunk and aggressive, prone to foul language and melancholic brooding. He was best known at this time for having blinded in one eye during a prewar brawl his fellow Surrealist Victor Brauner, for having survived during the Occupation by forging Picassos for the Nazi market, and for having exhibited his penis during the fashionable soirée of a prim decorator named Henri Samuel. He could make one laugh sometimes and Marie-Laure doted on him. Dora, very interested to hear about Picasso, paid no attention to me, and Bernard was busy talking to a distinguished lady author, one of the judges of the Prix Femina, while Lise and her current magician were holding forth for a group around the fireplace. The apartment windows looked out onto the façade of the Hôtel des Invalides, said by Lise to be the most beautiful stone landscape in the world. I knew she would have said the same had she lived on the Place Vendôme or in the Palais-Royal.

"I've been expecting you to call," said Dora. She had left the others and stood by me at the window.

"But you said you were so busy," I retorted rather sourly. "And bothered by people calling. I didn't want to make myself a nuisance."

She laughed gaily. "You must be over thirty," she said. "Don't behave like a child. Call me in the morning and we'll go out to dinner." Then she was gone.

I called her in the morning. We went out to dinner that same evening to a restaurant at the corner of the rue Christine and the rue des Grands-Augustins. It was called *A la Reine Christine* in memory of the Swedish queen, a homely little place, inexpensive and wholesome, the dining room upstairs. We went there often. So our true friendship, if that is

what it was, began then, in that second week of November, not long, in fact, before my thirty-first birthday. Not long, in fact, before her forty-sixth, November 22, though of course I didn't know that then. But it was at the same time something other than a friendship. Not altogether a romance and yet romantic. "When with her," I wrote, "one feels at an extraordinary altitude." The rhythm of our communications and meetings accelerated rapidly, momentum, it seemed, generated by its own naturalness. We met almost always at her apartment, where I very soon felt myself at home, then went to dine in one of the many small restaurants of the neighborhood. And sometimes others dined with us, Bernard, Balthus, Marie-Laure and Oscar, André Masson and his wife Rose, Georges and Peggy Bernier, Lucian Freud or Théo Léger. There were lively outings, jokes and pranks, also conversations meant to be taken seriously, after which once in a while Marie-Laure would ask us back to her house to drink champagne in the octagonal salon where her portrait by Picasso hung next to a masterpiece by Goya, the portrait of his son called *The Young Man in Gray*.

Théo Léger was a Belgian poet, a close friend of both Dora and Marie-Laure, a man nearer Dora's age than mine, homosexual, good-looking but weak. Having inherited independent means, he wrote an occasional verse, read, saw his friends, his psychoanalyst, and mused upon the emptiness of his life. For some reason, the result of an obscure hurt or disappointment in youth, he was incapable of forming any deep attachment and yet suffered from loneliness. He subjected himself nonetheless to occasional protracted periods of solitude in remote, inhospitable places. His poetry was without distinction, but he did not attempt other forms of literary work. He was charming, amusing when not dejected, and ever ready to pay sympathetic attentions to those who wanted them, especially to ladies who also had sentimental troubles they wished to talk about. Théo and I had a brief affair, unsatisfactory of course. I assumed that he would not mention this to Dora, but he did tell her something that was in a way—symbolically, at least—worse.

I took it for granted all the same that Dora must have recognized what my sexual disposition was. There were many homosexuals in that peculiarly Parisian world of high culture and high society, now totally extinct, which still lingered on in the fifties. Some of them were the lovers, not to say husbands, of women as well as of men, a fact well

recognized if not well advertised, making for a decided complexity of amatory intrigue. Dora certainly knew all this, though she never mentioned it in my presence, and it is a truism that people are wondrously endowed with blindness to what they do not wish to see. However, she several times inquired about my friendship with Bernard in such a manner as plainly to be asking whether it might be more than Platonic. I was able honestly to have her understand that it was not, for by that time such was the truth. The truth, however, need not comprise utter candor, and seldom does. In all my life the only person I've known to be utterly candid was Giacometti, but he was prepared, as very few are, to pay the price. Dora herself was anything but candid, capable at the same time of shrewd sincerity and outspoken frankness. Today I wonder whether it was not wrong of me to fail to make absolutely clear to Dora from the first that I would never be capable of an enduring passionate attachment to a woman. However, I hadn't then made that entirely clear even to myself, and I suppose that Dora would not have wanted at the outset to entertain uncertainties about what might or might not be forthcoming from the attentions of a young man who enthusiastically presented himself as an admirer. And there was no ambiguity about the enthusiasm of my admiration.

Picasso had often visited Dora at the rue de Savoie, had sat in the same chair I sat in, looked at his portraits of her, and lamented the ordeal of the creative life. On the wall beside the chair were half a dozen random specks or splashes of paint which Picasso by addition of a few pencil scratches had wittily transformed into spiders, cockroaches, and imaginary beetles. Several years later, when Dora at last had her apartment repainted, she carefully preserved from obliteration these trivial graffiti attesting to the great painter's casual intimacy; I thought it pathetic to have preserved such insignificant doodles as if they could redeem from loss and ignominy the remembrance of past magic. We spoke often of Picasso, very often. The creative life had, in fact, been an ordeal for him, Dora felt, recalling one day when she found him in tears in his studio. Asked why he was crying, he replied that it was impossible to explain save by saying, "Life is too terrible. Life is too terrible." But he possessed the wizardry to make it terrible for others as well. Joy and happiness were not useful to his art. Sadness—for himself and for others—brought out the best in Picasso. There was often

a bleak bitterness in what she said about him. "Everyone expected me to kill myself after he left me, even Picasso expected it, and the main reason I didn't do it was to deprive him of the satisfaction. One of the last times I saw him I said to him, 'People are going to think I'm a poor unfortunate creature, but you are the misfortune, and I'm leaving it with you.' " His cruelty, his destructiveness, his perversity, his deceit, his guile, all were present in his works. She said that he sometimes said, "The worse I make them, the more people like them." It was a *mot*, of course, everything with him was a fabrication, but it was a *mauvais mot*, she thought, because his most heartfelt longing had always been to attain the eminence of his greatest artistic, and most especially Spanish, fore-bears, an eminence he felt never to be his. That was why he worked so hard, produced so much. He used to say, "Since I couldn't reach the topmost measure in the scale of values, I destroyed the scale." It's true he turned it topsy-turvy to an extent nobody else did. Once when he and Dora were in the country together, Picasso had noticed a particularly unusual and beautiful flower and remarked, "To have made something like that, God must be someone in my style." And in fact, Dora said, though his remark was a blasphemy, living with Picasso had been like living at the center of the universe, thrilling and frightening, exalting, humbling all at the same time. And contributing profoundly to one's faith in a Supreme Being.

When we went out with others for dinner, it was an accepted practice that the bill should be divided equally among all present, ladies also paying their share, regardless of the actual cost of what each person had eaten or drunk, an arrangement both equitable and sensible, I thought. When I was alone with Dora, it was invariably I who paid for both. Though I recognized this as the social norm, it bothered me, because I felt that she derived a somewhat perverse pleasure from my compliance with this convention of masculine tribute to feminine daintiness, as if she were exercising a power which her whim alone made effective. At the same time I was happy to feel that she might want to compel me to do as she pleased. Still, the bother remained. She was older than I, after all, certainly more affluent, and a woman with a past, though I ought never to have entertained the thought. Money, I learned, was much on her mind.

One evening as we were leaving her apartment, she complained of

the nuisance of having to lock the door so carefully, all three locks, each with a separate key. "But it pays to take the trouble," she said. "I have a fortune hanging on my walls and nothing is insured. How much do you think they're worth, the pictures I have hanging now?"

"I don't know. I hadn't thought, really. A lot." I had thought, of course, but I didn't want to confess that I'd looked at her Picassos with an appraiser's eye.

"Oh, I was under the impression you were a part-time dealer," she said. "You ought to have an idea. I believe it's sensible to keep abreast of the latest prices."

"Well, I'm just sort of an amateur peddler," I said. "Anyway, the value of a work of art doesn't always depend on how much money can be got for it."

"Ridiculous!" she cried. "I advise you not to speak to me that way. Remember that I know far more than you do about what makes art valuable."

"Yes," I murmured, stricken. It's true my remark had been fatuous, but I didn't feel it deserved so stinging a reprimand. I said nothing more until we were in the car en route to the Right Bank.

"Don't sulk," she said.

"I'm not sulking," I replied, "only paying attention to where we're going." But I was pleased she acknowledged there might have been cause to sulk, because in fact my silence had been decidedly resentful.

"I am not a capricious person," Dora declared. "What I said was not intended to scold. It was an expression of my esteem for you, and your remark was unworthy of esteem."

"I suppose it was," I said, willing to be in the wrong, maybe even glad to be.

"Nobody cares whether pictures are beautiful," she said. "It's selling them that's important. Picasso taught me that. I'll tell you something. This very afternoon a man came to see me. He wanted to buy something. A Picasso, needless to say, not a Dora Maar. Nobody is in the least interested in my paintings. He sat down and I gave him a drink and then he said, 'What would you do if I were to rape you?' "

"It's not possible!" I exclaimed.

"Since I tell you, it is. But I didn't react at all. I said, 'Let's talk business if that's what you came for. How much money did you bring?'

He was so surprised he took three million francs in cash out of his pockets and put them on the table. Then I said, 'Nothing here is for sale.' He took out another million and said, 'I'll take that small portrait of you.' But I said no. 'You're pretty cagy,' he said. I told him to pick up his money and leave. So he stood up. A ridiculous situation. A man I've known for years. And again he said, 'What if I were to rape you?' He was standing right in front of my chair, so I said, 'Please give me a cigarette.' Then there was nothing he could do. He took his money and we talked about the weather till he left."

"How fantastic," I said. "You have strong nerves."

"Not really. I was terrified. But it's a matter of will. One day the telephone rang and when I said hello nobody spoke but I could sense a presence at the other end of the line, and instead of saying hello over and over, I decided to exercise my will and wait. I waited without saying a word, waited for half an hour or more, and the other person waited, too, till finally he said, 'You win.' How I laughed. The strange thing is that it was the same man who threatened to rape me this afternoon."

"That," I admitted, "is certainly strange, yes."

"You must never tell anyone any of this. But you haven't answered my question. How much do you think they're worth, the Picassos on my walls?"

"Half a million dollars," I guessed. "Maybe more."

"Much more," she said, gesturing emphatically with the cigarette holder, scattering ash across the dashboard. "And I'll tell you why. Because they're mine. On the walls of a gallery maybe they're worth only half a million. On the walls of Picasso's mistress they're worth a premium, the premium of history. A Fragonard, for example, that be- longed to Madame de Pompadour is worth much more than one that belonged to Madame Dupont. I've sold quite a few things through the years, and I always get the premium. Picasso also taught me that money is unimportant but that one must consider it absolutely vital to prevent it from killing you."

It did not kill Dora.

She told me that she owned many more works by Picasso than were to be seen on her walls. They were stored in a bank vault, and she said she would show them to me sometime. The prospect was exciting, and yet accompanied by a peculiar sense of malaise, as if the suggestion

were in reality the first hint of something eventually to become a ticklish issue. It was odd. This, too, was exciting.

In March of the previous year Stalin had died, an event, I felt, that could hardly help cheering the world. A week later a portrait by Picasso of the deceased tyrant, looking more like Pancho Villa than like Joseph Dzhugashvili, had appeared on the front page of a Communist newspaper called *Les Lettres Françaises*, beneath the hortatory headline *"What We Owe to Stalin"* and accompanied by articles of fulsome lamentation by Aragon, Frédéric Joliot-Curie, and other accredited toadies. I thought the drawing slapdash and the rest lamentable but didn't much care one way or another. The Party regulars cared, however, and cared with a vengeance. Quite a ludicrous scandal was caused by Picasso's mortuary portrait. The artist was violently criticized for his disrespectful depiction of the late dictator. The Soviet embassy protested. The Central Committee of the French Party published its "categorical disapproval," and a quantity of bitterly critical letters appeared in the Communist newspapers. The artist was hounded by journalists and apparently felt rather bewildered by the storm of hostility that one little drawing could provoke. Still, he was no stranger to controversy, having cohabited in comfort with it for close to half a century. Perhaps he neither knew nor cared what Stalin, his despotic regime and implacable exactions, had meant to the Russian people and to the world. Dora and I talked about it.

How was it possible, I wondered, that an artist so jealous of his own freedom and integrity could submit without retaliation to philistine attacks from such dishonorable critics.

"It's simple," Dora said. "He's a coward. He would submit to anything to be able to keep on painting, and he knows that what matters in the end is not whether people say good things or bad things about you. What matters is to be talked about."

"But why doesn't he resign from the Party if they don't like what he does? Remember how they criticized *The Massacre in Korea*."

"He'll never resign. He's too sentimental and too cynical. Those people did him favors. They are powerful, and he likes power. But it's all irrelevant anyway. Picasso is more important than Communism. He knows it and they know it. His magic is greater than theirs. He's stronger than we are. Even if you wanted to attack him, you couldn't. There are too many unassailable interests that would prevent it."

"Yet the Communists attack him."

"That's the proof of their weakness."

Dora was not weak.

Though but casually concerned with political affairs, as I have said, I was nonetheless not entirely apolitical and had never doubted that Communism was a detestable and pernicious system of government. So I couldn't help feeling that Picasso's status as an apologist and propagandist for this system must mask some fateful flaw in the artist, some frailty or shame that someday might issue from hiding and tarnish his glory. Dora did not agree.

"His sincerity is like his work," she said. "The style changes. But the basic Picasso is true to itself, and you can be sure that he believes in the ideal of Communism just the way you believe that President Lincoln freed the slaves."

"But Lincoln did free the slaves," I objected.

"Precisely. And if ever you were to suggest that Picasso's Communism was a sham, nobody would agree and you'd put yourself badly in the wrong."

"Would you say I was in the wrong?" I asked.

"Oh, what I say," she murmured, "what I say is subject to a different order of understanding."

"Which is?"

"Which has to do with faith, piety, the pursuit of grace and an acceptance of the teachings and disciplines of the Church."

"I can see that that would make a difference," I said without much conviction.

"It transforms the universe," said Dora.

"But the Communists condemn religion."

"They will be forgiven."

"And Picasso?"

"Oh, his forgiveness will be his punishment."

She evidently had an answer to everything, and in her silvery voice nothing she said seemed dogmatic or tendentious. It was as if she were singing all alone in the world of art and humanity solely for the exquisite sake of her song, and I was enchanted. The more I saw of her, the more I wanted to see of her, and this apparently did not displease her. To please her, indeed, presently became what most I wanted when, waking

in the morning, I appraised the potential good of each day. It did not occur to me, however, that I might have no idea of what I was doing. And I took little stock of the religious element.

Bernard and other friends, not knowing any more than I did what to make of the rapid evolution of my friendship with Dora, made fun of it. They said I was interested in her only because she provided vicarious experience with Picasso, because her house was filled with his paintings, because intimacy with her might compensate for the lack of intimacy with him. She had excited him and stimulated his genius more than I ever would, more, perhaps, than any other person. Was it possible that I sought somehow to profit, to stimulate and to excite? Did I aspire to become a sort of living doppelgänger of Picasso? And then maybe one fine day I would become the happy possessor of some of those wonderful works of art? All this, I vigorously objected, was patently absurd. Dora and I were the simplest of friends. No bizarre illusion, I insisted, murky motive, or perverse aspiration entered for one instant into my relationship with her. I was categorical, so emphatic, indeed, that even I, credulous as a newborn ewe, supposed that something very out of the ordinary did draw us together, after all. True, we were both preoccupied with Picasso, though hardly in comparable terms, and talked about him very often, but we also talked about ourselves, our past lives, our future expectations and hopes, our friends and all the gossip of our milieu. Dora was a perspicacious fancier of gossip.

Her childhood and early youth had been unhappy. Shy, wistful, a dreamer, she had had no experience of the privacy essential to a young girl. The door to her bedroom had been set with glass panes covered by a flimsy curtain, so that her parents could come at any moment to peer in and see what she was doing. By the same token, she was able to see what went on outside and had been woefully unprepared for the adult battles she was obliged to witness. And when a lull occurred in the parental warfare, as Dora was an only child, her mother came to confide in her the wrongs that provoked so much hostility. Compelled to become the confidante of her own mother, she had profoundly ambivalent feelings toward both parents. Because her father was employed as an architect in Argentina, she spent most of her early youth there; hence, the Spanish she spoke with Picasso. "My father," she used to say, "is the only architect who failed to make a fortune in Buenos Aires. All he got was

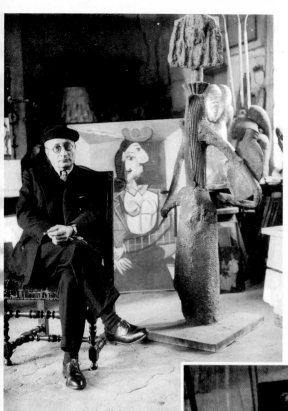

(above) Jaime Sabartés [*James Lord*]. *(below)* Picasso in his studio

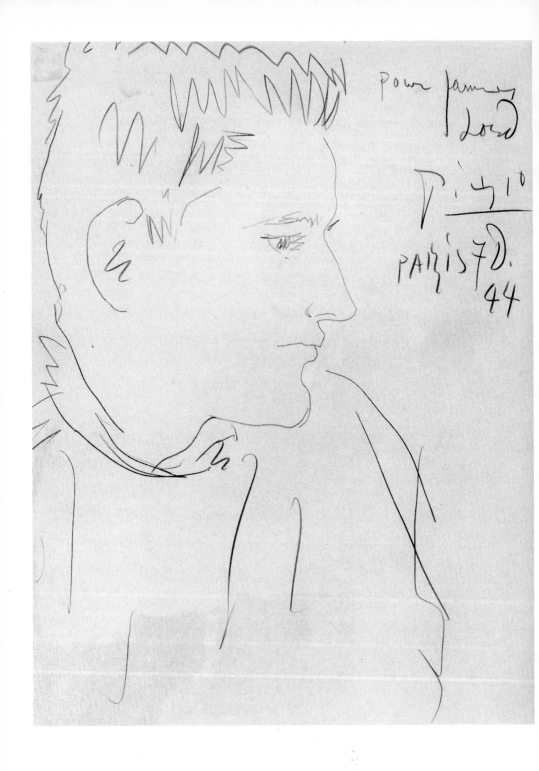

(above) First portrait of James by Picasso *[Arphot]*. *(opposite top)* Portrait of Dora with cigarette holder by Picasso *[Arphot]*. *(bottom)* Dora with cigarette holder *[Izis]*

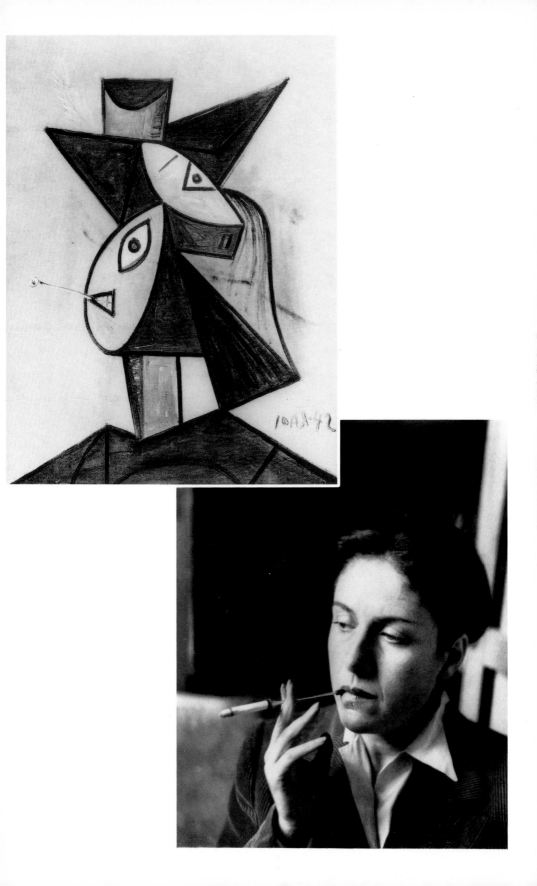

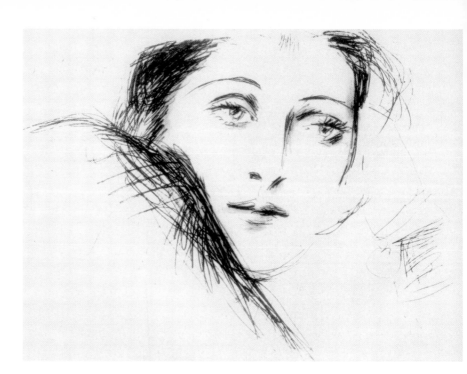

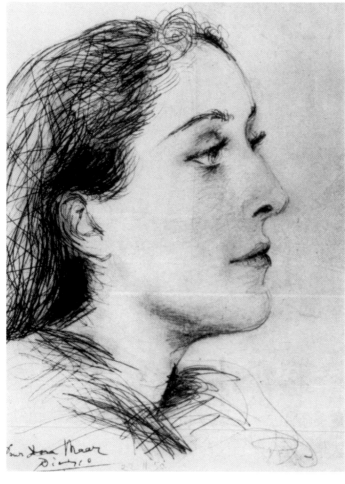

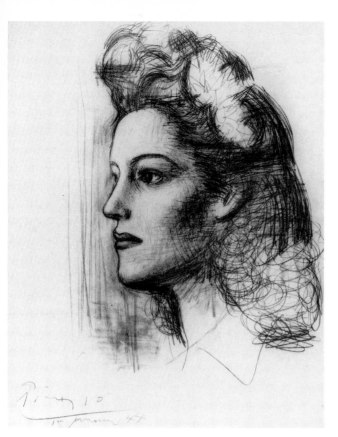

(opposite top) Portrait of Dora in 1937 by Picasso [*Arphot*]. *(bottom)* Portrait of Dora by Picasso, *c.* 1944 [*Arphot*]. *(above top)* Portrait of Inès by Picasso [*Arphot*]. *(bottom) Charnel House* (early version) [*Arphot*]

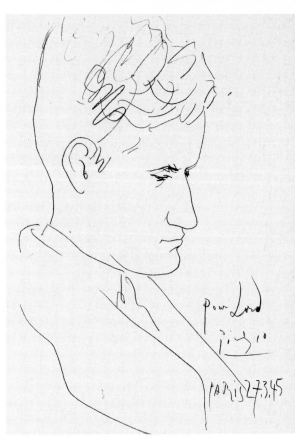

(top) Second portrait of James
by Picasso [*Arphot*]. *(bottom)*
Picasso drawing of man on
ball. *(opposite)* Picasso and
James photographed by Dora
in front of Picasso's car [*Dora
Maar*]

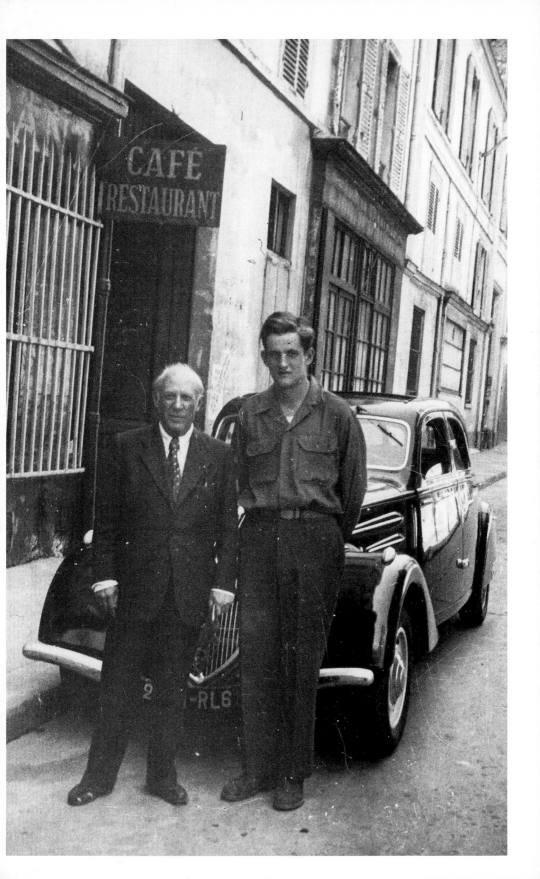

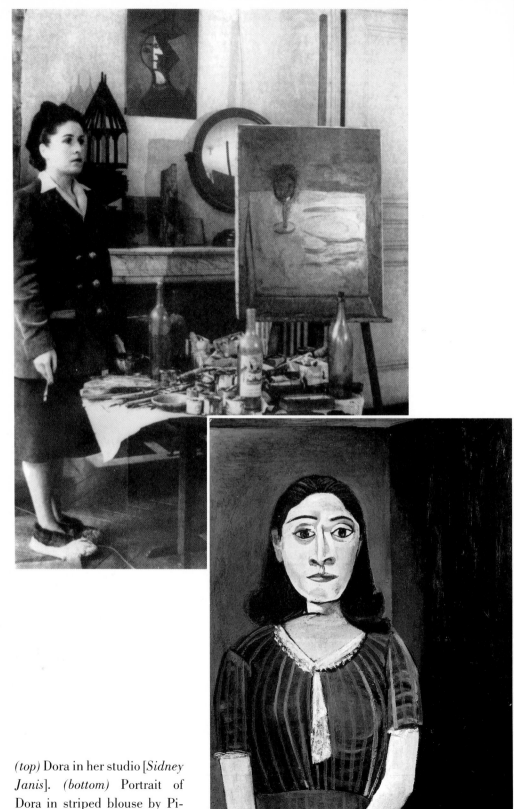

(top) Dora in her studio [*Sidney Janis*]. *(bottom)* Portrait of Dora in striped blouse by Picasso [*Arphot*]

a decoration from the Emperor Franz-Josef for having designed the Austro-Hungarian legation." She didn't say much about her intimate life save to mention that when she was taken to meet Georges Bataille for the first time he had been found in a sub-cellar filled to overflowing with pornography which he joyfully displayed. Her parents naturally had been appalled by the liaison with Picasso, his fame—notoriety, said the mother—proving no compensation for the irregularity of the situation. There were scenes, especially with the mother, her father remaining aloof, since Dora appeared to be his wife's ally. Not a tonic environment.

"There were times," Dora said, "when I even wished my mother would die. We had such appalling disputes. And no faith to save her, no will, nothing to make her ruthless. Unlike me. Without ever knowing what she wanted from life, she knew she hadn't received it. Picasso couldn't stand her, of course. And yet it was awful when she did die. One night we were talking on the telephone, arguing terribly, and then suddenly she stopped talking. It was during the Occupation, and after the curfew. When I went around the next morning, I found her dead on the floor with the telephone in her hand." She stopped speaking for a moment and waved her hand in the air. "And Picasso made a circus of it, coming and going with his friends, Sabartés, Marcel, it was revolting. In order to belittle death, you see, because he's so terrified of it." She pointed to the portrait of herself in the green-and-orange-striped dress. "He was working on that picture at the time. A travesty."

It had been Picasso's desire, she said, that her portrait be painted by Cocteau, whom they were seeing quite often then, as Eluard, his enemy, was in hiding. Picasso had requested this repeatedly, stipulating that what he wanted was a purely linear painting in black on a primed canvas of good size. This was the sort of thing, he said, that Cocteau did best. The day was set, and Cocteau arrived after lunch on a bicycle, as other means of transport were rare during the war. He'd had some trouble maintaining his equilibrium in the wind while steering with one hand and with the other holding on to a canvas of more than medium dimensions (92 by 73 centimeters). But it arrived without accident, and the author-artist spent the entire afternoon working on the portrait while Dora posed and Picasso watched. By nightfall—this was in the autumn and dusk came early—the portrait was finished. Picasso pronounced it a masterpiece, and Dora herself was pleased, feeling that Cocteau had

represented her in a more tranquil and attractive manner than was usual with her lover. So they all had a drink and Cocteau departed highly gratified. No sooner had he gone, however, than Picasso said, "The portrait is very good, it's true, a very good Cocteau, but there's one little detail that could be made better. It's nothing. Jean will never notice." And he took a paintbrush and changed just a line or two. She couldn't even remember where. But then, of course, he said, "Now it's an entirely different picture. To make things right, it has to be changed just a little bit more." He worked on it for half an hour, and then there remained next to nothing of what Cocteau had done, whereupon he said, "Well, it was a perfectly terrible picture, anyway. I'll have to take it to my place and finish it properly." Which he did. But Dora insisted that the painting was, in any case, a fraud. She had never in her life owned a green-and-orange-striped dress and her features were pure invention. Besides, even Picasso was not above altering his own work to suit someone else's view. In his finished version there had been at the upper right a small window, to which Dora objected, saying that it made the room in which she sat look like a prison cell, so Picasso painted over the window to please her.

This story brought to my mind the infinitesimal liberty I had long ago taken with Picasso's first portrait of me, a negligible infringement compared with Picasso's total desecration of the portrait he had—like me—persistently solicited. But I did not confuse the two instances of license and said nothing to Dora, aware that the will to make works of art more artistic than the original creator made them can lead to folly.

Embarrassment ensued. Cocteau, not seeing his portrait in the model's house, made inquiries, said he would like to have a photograph as a souvenir. Dora put him off as politely as possible for quite some time, hoping he would forget, but Cocteau was persistent. Finally she had to tell him what had happened, his consequent annoyance both predictable and legitimate. Where Picasso was concerned, however, almost everyone set aside normal feelings and humbly submitted to caprices and indignities. It made one wonder what perverse or supernatural power he possessed. "Sometimes," Dora said, "he would exclaim, 'I'm God, I'm God.' But then you realized that in God's presence there would never be any doubt about who He was, and you would wonder whether Picasso in reality wasn't the other one."

What had happened to the Cocteau portrait had also happened to a bust of Dora by the Spanish sculptor Apelles Fenosa, a friend of Picasso of long standing. That he should do a bust of Dora had been not at all his idea but Picasso's, who insisted upon it, insisted upon paying handsomely for it, as Fenosa was invariably short of money, and who once again was present while the model posed and the sculptor worked. The bust was not large, finished in an afternoon, and Picasso praised it with much warmth. Hardly had Fenosa left Dora's apartment, however, when Picasso complained that one or two insignificant details could be bettered. The clay still being malleable, he set about bettering them, and of course in an hour had created an entirely different sculpture, later cast in bronze.* This time Dora was able to prevent the betrayed artist from learning of what had happened to his creation.

There was no doubt that her feelings about Picasso's portraits of her were profoundly ambivalent. She told me that one summer day during the war he had painted a nude portrait of Eluard's wife, Nusch,† in tones of gray—head, shoulders, and breasts—which had pleased him so well that the very next day he had called Dora into his studio and promptly painted a portrait of her,‡ also nude and in tones of gray, very similar to the first, then made a gift to each model of her portrait. "A monstrously insensitive thing to do," she said. "Or deliberately intended to mock and offend. When things were finished between us, that was the very first picture I sold. I couldn't wait to be rid of it. Anyway, all his portraits of me are lies. They're all Picassos, not one is Dora Maar."

"But they live," I said. "All over the world they hang in museums, thousands of art books are filled with them, and people say, 'That's Dora Maar.' They recognize you and in a hundred years they will see you still. You will never be forgotten."

"Do you think I care?" she exclaimed. "Does Madame Cézanne care? Does Saskia Rembrandt care? Remember that I, too, am an artist. I, too, am familiar with the auspices of posterity. And over Picasso I have the advantage of faith. He doubts. That's why he can never stop."

Dora definitely did not seem to doubt. Sometimes she spoke of herself as an artist with such self-assurance that I wondered what ex-

* *Sculptures of Picasso* (Paris: Editions du Chêne, 1949), Nos. 154 and 155.
† Zervos, Vol. 11, No. 274.
‡ Zervos, Vol. 11, No. 273.

planation she could possibly think of for the failure of the public to recognize her merit. The paintings that she was doing then were mostly landscapes, imaginary views of uninhabited mountainsides, executed very freely with brush and palette knife in somber colors. I knew that dealers came to see her but supposed they were interested only in the possible acquisition of a Picasso or two. There was no mention of exhibiting her own work. However, she had an answer for everything, or so I thought then.

"I must dwell apart in the desert," she said. "I want to create an aura of mystery about my work. People must long to see it. I'm still too famous as Picasso's mistress to be accepted as a painter."

If ambivalent about the portraits Picasso had painted of her, Dora, it began to seem to me, was ambivalent about quite a few other things as well. The cat, Moumoune, for example. Sometimes she stroked it and murmured endearments; at others she exclaimed, "How I hate that beast!"

We went for drives through the nearby countryside in the little car. Few situations create such a sense of confident intimacy as being enclosed for a relatively prolonged period with one other person in a moving automobile, and we had numerous personal conversations while she smoked and I drove. One November afternoon, when the autumnal sun shone hazily on the few remaining leaves, we were out some distance to the west of Paris in a region called the Vallée de Chevreuse. Dora proposed to show me a historic house in a nearby village called Le Tremblay. She showed me the way, which I thought surprising since she didn't know how to drive, often complaining of the inconvenience this caused, especially at Ménerbes, where she was obliged to travel about on a motorbike. She once suggested that I might teach her to drive, to which I naturally agreed—with misgivings—but no more was said about it. Le Tremblay was a picturesque little place and the historic house an imposing one of cut stone, with tall pillars at either side of the gateway. It had been the country residence of the legendary picture dealer Ambroise Vollard, who had first exhibited Cézanne, had amassed the works of Gauguin, van Gogh, Renoir, Rouault, many others, and very early exhibited and purchased Picasso's works of the Blue and Rose periods. Certainly the most canny and successful dealer of his time, he was famous for dropping off to sleep, or pretending to, while prospective

clients considered the few paintings he reluctantly implied that he might be prepared to part with. He was masterful in his maneuvers with clients, and Picasso, who painted a superb Cubist portrait of him in 1910—promptly sold for a packet—tried to emulate his wiles in his own negotiations with dealers, including Vollard himself. As a matter of fact, the house in Le Tremblay had sometimes been loaned by Vollard to Picasso, who painted quite a few pictures there, none of which, however, he left behind as tokens of appreciation for the dealer's hospitality. Vollard's portrait had also been painted by Cézanne, Renoir, Bonnard, and a host of lesser figures. I felt that Dora had been thoughtful and understanding in taking the trouble to point out to me a place of piquant anecdotal interest. I was naïve then, and obviously still am.

The secret of the silver cigarette lighter was revealed because in those days I was also a smoker. One evening after dinner, having set her cigarette fastidiously into the trumpet holder, Dora took the lighter from her purse and lit her cigarette. Before she could replace it, I had put my own cigarette between my lips and reached across the table to remove the lighter from her fingers. To my surprise, there was a perceptible resistance, accompanied by a startled glance of annoyance, but after an instant she allowed me to take the lighter from her. It was a standard Dunhill model of those years, upright and engine-turned, with a flip top and roller thumb-piece to ignite the spark. I lit my cigarette and handed it back to her.

She laughed. "You pride yourself on being so observant," she said. "Yet you have just had in your hands one of my most treasured possessions and you didn't even notice what makes it precious to me." Her tone was highly condescending.

Annoyed, I said, "I only wanted to light my cigarette, not appraise your treasures. Let me see it again."

Dora smiled, handing back the lighter, and I recognized immediately what it was that made the object precious to her. And to him. On the surface of the flip top was engraved a tiny portrait of Dora, unmistakably the work of Picasso, typical of the double-profile portraits executed in the late thirties. Despite the diminutive dimensions, there was extraordinary power in the portrayal. "It's beautiful," I said, giving it back.

That was not its only value, she explained. Picasso had never been

a great giver of gifts. Of paintings and drawings, yes, but those, though precious, were things that poured inevitably from his fingers and required no demonstrative consideration of the desires and pleasures of the recipient. To receive the gift of a Picasso from Picasso cost the donor no thought and little native generosity while at the same time placing the recipient under a very considerable obligation to be grateful, a state of affairs always pleasurable to the artist. On the other hand, it was quite out of character for him, who loved to receive gifts, and it represented an effort of signal importance if he took the time and trouble to vary his daily routine by going to a shop for the express purpose of selecting a gift which he hoped would be pleasing to the recipient. The silver cigarette lighter was one of the very rare presents he had ever gone out of his way to purchase and embellish especially for her. The paintings and drawings had all come her way, she said, because she had happened to be as it were in the line of production. "I never asked him for anything," she asserted. "Some people were abject in their solicitations. Eluard was always after something. But I never asked for a thing. And I prize the cigarette lighter because it cost him at least a visit to the Place Vendôme." She told me that once when she had accompanied Picasso to the studio of Lacourière, the foremost printer of engravings and etchings, a single print had been pulled from the top of the lighter, Lacourière using his thumbnail to get the impression. That print must be around somewhere, she said, though she couldn't recall quite where, but if she ever came across it she would give it to me. If that would bring me pleasure.

"Very much," I said, and although I knew that her suggestion did not represent a promise, my heart leapt up in my chest at the prospect of acquisition, and I was ashamed.

IT WAS in the mornings that we so often spoke on the telephone, sometimes for an hour or more, having as a rule nothing of moment to say, and although we might already have planned to see one another that same evening. But a telephone conversation, different as it may be from the sort that takes place in a speeding automobile, also offers a unique sense of intimacy, the disembodied voice conveying by inflection and tempo thoughts and feelings that might not be readily expressed face to face. For this to happen it is of course necessary that the persons at either end of the line be devoted to that variety of converse. Dora was, and I gladly took the liking from her.

One morning not long before Christmas Dora said, "What have you been doing to make yourself so attractive to Théo Léger?"

"Nothing," I answered. "Why?"

She said that she had seen Théo the day before and he had talked about me as if I were the most intelligent, charming, amusing person on earth. I was surprised and somewhat alarmed. My affair with Théo was then more or less at an end. It would be embarrassing to have Dora learn of it now, might even endanger my friendship with her, so I said that maybe Théo had only wanted to see whether she would argue with him. Dora said she never argued with anyone, but added that she wondered at the same time whether Théo might not be in love with me.

"I certainly hope not!" I exclaimed.

"Would it be so surprising?" she asked.

"It would be undesirable," I asserted, intending my tone to terminate the topic. It did. Still, I wondered whether it was in fact Théo's talk that had decided Dora to introduce between us the issue of sexual ambiguity, not something I had any desire to discuss with her.

Théo lived in a spacious apartment in the rue des Beaux-Arts and had decided that year to give a large party on Christmas Eve. About twenty people were to be there, Dora and I among them, and consequently there was the matter of gifts to be decided. I have always liked giving presents, paying for friends' dinners and vacations. I had by this time already given several presents to Dora, the ring from Deir El-Bahari, a square of ancient Coptic textile, a rather battered but authentic medieval wooden Madonna, and a number of trinkets. So far, however, I had received nothing in return, a fact not at all disturbing, for my gift-giving impulse has not been accompanied by a desire for material recompense. Fabulous gifts, to be sure, have been given to me in my lifetime, all of them by artists, and I have never felt the least embarrassment about accepting them, though the present of an inexpensive bauble from an intimate friend can cause qualms as well as pleasure.

For Théo I found a rare edition of Saint-John Perse, which was easy, but for Dora I knew the choice would be difficult. I wanted something personal, almost intimate, but not at all presumptuous. With Dora I had from the first been aware that one must avoid the least semblance of presumption. I don't know how I happened upon my choice. At the moment it seemed just right. A mirror. I had spent quite a lot of time searching aimlessly here and there and came unexpectedly upon this mirror in the rue Saint-Honoré in a shop specializing in old-fashioned jewelry and secondhand silver. It was not a wall mirror but a silver hand-held one, oval, with a tapering handle and a design of exotic flowers and dragonflies in raised relief on the back, a mirror of the sort to be kept by a lady on her dressing table and used to appraise the state of her appearance before confronting the world. It cost rather more than I ought to have spent. But I was satisfied that the choice was good, and after a day or two it seemed nearly ideal symbolically when I remembered that mirrors of similar shape appear in many works by Picasso, though in none, I thought, of the period when Dora was his mistress.

All the while I was concerned with finding a gift for Dora, it never

occurred to me that she might be preoccupied by a similar concern. And I'm not at all sure she was. Nonetheless, a few days before December 24, she rather irritably remarked that no doubt she should be searching for some kind of present to give me at the party. Not at all, I said. She should feel no obligation whatever to give me anything. To which she tartly retorted that, naturally, no obligation existed. It would please her to please me, that was all. But the problem was that she couldn't think of a thing to fill the bill. That nonplussed me. An artist herself, after all, she ought not to have known an instant's uncertainty. The matter was doubly troubling to her, she insisted, because I had already been so generous in making gifts to her. However, she had too much esteem for me to compromise with the obvious by offering a necktie, a scarf, a book, a bottle of cologne, or what-have-you. If she were to give anything, it must be something in every respect worthy. I wholeheartedly agreed but did not say so. The galling fact, she added, was that she found herself utterly unable to imagine what would be just right. I said we need not discuss the question any further, and we didn't. I gave it some thought all the same and failed to arrive even at the suspicion of a suspicion of why Dora's imagination could not tell her what would be just right.

Théo had gone to quite a lot of trouble. His apartment was decorated with gold and crimson streamers, bunches of holly, silver stars; there were several round tables with gilt chairs, candles everywhere, and in the dining room a copious buffet of smoked salmon, cold meats, tarts and cakes, wines, champagne, a waiter in a white jacket to serve. At least half of the guests were people I did not know, artists and writers older than I, the best-known being a ceremonious little man named Pierre-Jean Jouve, a poet revered by the happy very few, accompanied by his wife, Blanche, a psychoanalyst, whose interminable treatment of Théo was no tribute to the profession. Under the tree were gifts for every guest, each wrapped in gold paper—pencil sharpeners, key chains, celluloid birds and beasts, seashells, and toy automobiles. Everyone was very jolly, opening all these little packages, casting the gold paper into the air. My gift was not a knickknack but a rare volume of reproductions of drawings by Picasso, published in a limited edition in 1926, with an original lithograph as a frontispiece. It contained quite a few drawings of handsome ballet dancers in alluring, if not amorous, poses,

some of these the very images I had had in mind when I asked Picasso to do a portrait of Roger and me together.

"I just happened to have it," Théo said, "and thought it might please."

"It does," I exclaimed, delighted, kissing Théo on both cheeks.

Dora said, "Very handsome." She had received a fluffy yellow chick that chirped and hopped when wound up.

Théo seemed very satisfied with Saint-John Perse and returned my kisses.

It was with some apprehension, of which I did not recognize the reason, that I had hesitated to present Dora with her gift, having left it in the pocket of my trench coat, and before fetching it I waited a bit while we drank some champagne and the party eddied around us.

She gestured with her cigarette holder toward the volume prudently tucked under my left arm. "The obvious thing," she said. "Théo is a sweetheart, isn't he? But I suppose your most casual acquaintance would know that anything having to do with Picasso would be enough."

Enough what, I didn't know. But I was not the only person present whose adequate satisfaction Picasso might mysteriously have provided. Going to the entry hall, I wrapped the book in my trench coat and brought back Dora's gift.

Her crimson nails tore at the tissue paper with girlish élan. "A speculum!" she exclaimed, brandishing it in the candlelight, turning it this way and that but never, I noticed, gazing into it. She said it was very beautiful, rare, certainly costly, probably by Lalique, that I should never have gone to such an extravagance, especially as this multiplied her sense of guilt at having been unable to think of anything for me.

"I don't know how to thank you," she said. She did not kiss me on the cheeks but patted my arm as she had frequently taken to doing lately, with the rather automatic manner, I thought, customary to displays of affection for Moumoune. "But I shall have to be especially careful," she added. "Think of the misfortune if I should break it."

I dismissed that worry with a wave, whereupon it was time to have supper. We sat at the table with Marie-Laure and Oscar, the latter very drunk and the conversation ribald. We all laughed and laughed. Afterwards the guests wandered about, chatting and drinking and playing with the toys received as gifts. Oscar was not the only one intoxicated.

The waiter continually came around with freshly opened bottles of champagne. I strolled into the salon, and there was Dora, seated by herself on a couch, cigarette in one hand, an empty glass in the other. I sat down beside her.

She said, "I'm glad to see you." But she didn't seem glad. The front of her dress was flecked with cigarette ashes. I wondered whether she might not be a bit drunk. "I have something to say to you," she announced. "But you mustn't make the mistake of taking this personally. It's entirely abstract."

"I understand," I said.

"I'm not at all satisfied with our relationship." She raised her chin and gazed calmly at me with her gleaming eyes.

"I don't understand," I said.

"No. That's just it. And if you don't, how can I make you? I've been disappointed. But how could you understand? Not that it makes a great difference to me. It's for you. At first I had no idea you were so superficial and frivolous."

What could I say? The consternation was like an implosion of my vitals. And yet she seemed to possess the right and the truth. Still, I did attempt to say something.

"No!" she said sharply. "Please don't apologize. You have done nothing to me. As I said, this is not personal. Perhaps I feel the frustration of a certain disappointed intuition, nothing more. And that's all in a day's work, you might say. Dear James. I seemed to make out a potential in you, something out of the ordinary, perhaps even profound. I thought you took seriously the challenge of becoming an artist. But pay no attention to what I say. I'm being presumptuous."

"No, no, you're not," I protested. "I appreciate your concern. Believe me. To disappoint you is what I want least in the world."

"Don't be absurd!" said Dora. "Kindly refrain from taking liberties with what I say. I told you this was not personal. I'm not at all disappointed. How could I be? It was merely a surprise to discover you are the sort of person to indulge in idle chitchat, flatteries, and gossip with people like Marie-Laure and Théo." Her cigarette had gone out and the last cascade of ash scattered down her corsage, but she held the trumpet between her teeth, and when she spoke, it waggled. "Not that it matters." She sat stock-still and stared straight in front of her.

She was drunk, I thought. But that made no difference, did it? Perhaps, made the difference worse. I told her that I was at heart very timid and endeavored to conceal it. How could I have known, I asked, what she would deem frivolous and superficial in the world of Marie-Laure, Lise, Théo et al.

"Please," she murmured, "don't be tiresome." She took the cigarette holder from her mouth and devoted her entire attention to extracting the extinct butt from the bell. This accomplished, she said, "Our friendship is not at stake."

And I had assumed it was. I, too, must have been drunk, and the relief of her reassurance flashed through my veins like quicksilver, when in fact I should for the first time have felt serious presentiments of futility.

By then the party was preparing to be over. Thanks were yet again proffered, people put on their expensive coats, and it was nearly two in the morning. Dora smiled. "It had never occurred to me," she said, "to wonder just what it was that Picasso saw in you."

"Is it never too late to talk about him?" I asked.

"Always too late," Dora said.

I took her home, accompanied her to her porte cochere. As we said good night she raised her hand, touched my cheek, and said, "I'm really very fond of you." Then she was gone.

Needless to say, I had myself often wondered what it was Picasso saw in me, and not only Picasso but also Giacometti, Balthus, and the many lesser artists with whom I have been friendly throughout my life. Oh, I wanted to be their friend, to admire them, to deserve their consideration, certainly, and artists do appreciate esteem. But there was something more. I don't know what it was, or is.

I had never mentioned to Dora, or to anybody else, the extravagant prediction Picasso had once made for my future. But if Dora really wondered what he could have seen in me, I thought that perhaps his prediction would tell her something. The next time we met, two or three days later, I described the scene and repeated what Picasso had said.

"You poor dear!" she exclaimed. "And naturally you believed that if he predicted a future for you that would astonish us all, then it would surely come true. And naturally you couldn't have been expected to realize that his praise is poison. When he predicts great things for

someone, he knows that he is diminishing the likelihood of anything great ever coming along, because his very prediction seems like the great thing already, and the wretched person in question may plod through his whole lifetime with nothing but Picasso's empty prediction to be proud of. Mediocrity is his best friend, because it cannot detract from him, so he'll do anything to encourage it."

To say the least, I was shocked by this indictment, and shamed, because the truth is that occasionally through the years I had mused upon the great artist's prediction and thought that it might be self-fulfilling in some peculiar way.

"That's terrible," I said.

"Genius needs no apology," said Dora.

She had a manner of making pronouncements that brooked no contradiction, and yet it sometimes seemed that she was pointedly contradicting herself. She could, and often did, condemn Picasso severely, then in virtually the same breath marvel at his virtues.

Dora's real name was Theodora Markovitch, and I supposed that she had made the modification in order to emphasize differences, if not misunderstandings, with her parents and to assert her own distinctive identity. It seemed peculiarly apt to learn that the forename Theodora means "Gift of God," for as we came to know one another better she grew increasingly forthcoming about her faith and the supreme importance to her of the Church. She went very often to Mass, I knew, and to confession as well, I assumed, and on Fridays made something of a fuss about eating only fish. None of this was in the least objectionable to me, but I found it difficult to respond with conviction to Dora's occasional discourses about the necessity of tending to one's spiritual fitness and of striving for salvation. She mentioned from time to time that she felt it her responsibility to write regularly to Picasso, urging him to shun sin and worry about the state of his soul. It amused me to imagine what must have been the humor of that inveterate pagan when perusing these missives, but I did not smile at the moment. I had been brought up a Protestant, not even serious in that belief, and neither of my parents had any convictions concerning a personal divinity, a possible hereafter, or the good of wondering about God. However, I made no demur when Dora talked about religion. I made no demur, it seems, when she talked about anything at all.

On New Year's Day, 1954, we had arranged to have dinner some-
where. I went first, as usual, to the rue de Savoie for a drink. The tray
of bottles and glasses was set out on the low table in front of the fireplace.
"I'll just have to get the ice," she said, going to the door that gave into
a corridor leading, I knew, to the kitchen, which I had never seen. After
a moment—it seemed a mere courtesy, after all—I called out to her,
"I'll give you a helping hand," and went along the corridor.

"No, no," she cried. "I'm very capable of managing alone."

But by that time I was in the kitchen. It was a perfectly ordinary
kitchen, with a few copper pots hung on the walls, a stove, sink, re-
frigerator, and showed not the slightest sign of being used save by the
cat, whose half-eaten bowl of food sat on the floor. Dora stood by the
sink with a tray of ice cubes in her hand. "This is the kitchen," she
said.

I took the tray of ice cubes from her hand and let the warm water
run over it.

She said, "Do you have any idea what an honor it is for you to be
allowed in this kitchen?"

The ice cubes started clattering from the tray into the sink. I had
no answer to such a question.

"Do you realize that the only other person who has ever set foot in
this kitchen is Picasso?"

But what was the honor? Not for an instant could I have been
conceived as a substitute for Picasso. Or was the high distinction to be
considered one more cost of the admission to her intimacy? However,
she was obviously annoyed by the intrusion, as if at any price I would
not be deserving. I put the ice cubes into a cut-glass bowl and went
back to the salon. Not a word more was said about the kitchen. After
that, I occasionally went in there without arousing the slightest
excitement.

•

My mania for collecting was at this time, I think, more intense
than at any other, and among the many kinds of works of art or artifacts
that excited me were examples of Roman glass, then being uncovered
in enormous quantities in Asia Minor, little sought after and relatively
cheap. The forms of these fragile vessels, some of them thin as paper

and no heavier, were of remarkable delicacy and variety, while millennia underground had imparted to many of them exquisite patinas of pearly, violet, and emerald iridescence. I can hardly define the passionate delight experienced when acquiring yet another of these beautiful creations which seemed to defy time by having survived intact for a hundred generations. In this delight, I presume, as in all the ineffable pleasures sought and savored by a collector, there was probably a sexual element. Eventually I accumulated close to fifty bottles, vases, beakers, cups, and vials before at last the passion lost its irrational power. Of the numerous shops which sold Roman glass, the one I visited most often was called Le Véel, located on the Left Bank at 19 Quai Malaquais. It was there one day in January that I found a smallish bottle rather ordinary in form but with a thrilling patina of purple shading to peacock blue and viridian. The thrill of that color, like something almost unattainable, the glimpse of a unique butterfly in a virgin forest, determined the price, which, as with many of my acquisitions, was higher than I could afford, and I bought it immediately. Planning, as so often now, to have dinner that evening with Dora, I took the bottle along with me, wrapped in cotton inside a wooden box, to share the thrill with her, thereby, of course, enhancing it.

To make my effect, I waited until we were seated by the fireplace with our drinks, then opened the box and unwrapped the miraculous bottle, holding it forward for Dora to admire and take between her fingers. If anything, her admiration seemed more rapturous even than my own, making my extravagance seem my due, and she exclaimed over the beauty of the object while turning it between her fingertips. I never thought to make her a gift of it but so much enjoyed her approval of my acquisition that I suggested she might keep it here in her apartment for a while to appreciate in tranquillity its perfection. She was hesitant, fearful of the object's fragility, but I insisted, and then she said she would be happy to have it for a week or so, as thus my love of beauty would keep her company. It was a subtle and complimentary sentiment. However, she added, in order to preserve the precious thing from harm she would put it into her little museum, the glass-fronted bookcase, and rose to do so. The unlocked door did not open easily, she had to tug at it, and in doing this, she made an instinctive movement with her other hand, loosening her hold on the bottle, which fell to the floor, smashed

into tiny gleaming shards and a momentary cloud of iridescent dust.

"Oh, how awful!" she cried.

It was. I felt the fall in the pit of my belly. But I said, "Never mind. It doesn't matter."

"Here," she said, reaching inside the bookcase, "take this. Picasso made it for me during the war." And she put into my hands a small object of wood, wire, and plaster representing a bird in flight, a miraculous, simple example of the artist's ability to transmute the most unlikely materials into a self-evident work of art.*

It was beautiful, strange, but above all natural. The sense of loss instantly became elation. I protested, however, that the gesture was unnecessary, excessive. Dora replied that it was high time I had a gift from her, anyway, and that she understood why something by Picasso would be most fitting. She laughed. "After all," she said, "he brought us together. In order to show me yet again that the whole world was in love with him. That day in the restaurant your emotion was touching, made me furious but was touching. And he did your portrait to show that he, too, had a heart. Believe me, he doesn't do portraits as a passing favor for just anybody."

"And when I asked him to do another, he did it, too," I said.

"That shows he saw something in your face," she said, "who knows what? Maybe the prediction he made about your future was his magic to protect him from what he saw. Maybe he saw something of himself. Often he only saw what he saw by making it into art. A frightening predicament. And that's why he's so reluctant to sell so much of what he's done, and why he never, never throws anything away."

The wood and plaster bird, bound together by wire, about five inches long, had two strands of wire beneath it and, when held by the longer of these, wavered back and forth, seemed almost to take flight. I was overjoyed.

Then it was time to go out for dinner, Dora saying she would later gather up the fragments of the bottle and save them as a souvenir. She did, and bought a small butterfly box to keep them in, and I suppose she has them still. I took the Picasso bird with me to the restaurant. Dora warned me to be very prudent in handling it—a warning of which

* *Sculpture de Picasso* (Paris: Editions du Chêne, 1949), No. 130.

I had no need—and her tone made it plain that the broken bottle had occasioned a munificence of rare aesthetic, and other, import. Of that also I had no need to be notified. However, I didn't think at the time, and don't believe now—despite the bird's unforgiving fate—that Dora regretted her impulsive act of reparation.

One of the puerile frailties of almost every collector, the beginner in particular, is a plaguing itch to have his possessions, and most especially his latest acquisitions, commended by the public eye. Of the hundreds of sculptures made by Picasso, the little bird given me that evening by Dora was one of the least important or interesting, a demonstration more of his facility for the transfiguration of materials than of his power to devise a property of vision uniquely his own but universal. However, it was imbued with his magic. The excitement of physical contact with it, and a sentimental gratitude for Dora's impromptu generosity, coursed like intoxication through my awareness in the mild dark, and when I had left her at her door, I had no inclination to go home.

I went to the Reine Blanche, a late-night bar frequented by homosexuals and people who liked the late night, located on the Boulevard Saint-Germain directly opposite the Café de Flore, a place where I could be fairly sure of running into one or two acquaintances. And indeed several people were there whom I knew, though only one of them was to make any difference and therefore I didn't note the names of the others. Théo Léger was the one who would matter. We had a little conversation while I drank a *vin chaud*, told him of my evening with Dora, and showed him the Picasso bird. Despite the failure of our brief affair, we had, I thought, remained friendly, even affectionate, and I saw him regularly at Marie-Laure's, Lise's, at the parties and in the cafés we all went to. In fact, our failure as lovers, I felt, was due to his emotional indecision, not mine, and therefore I might expect nothing but benevolence from him. Still, I believe life must be more profitable for the credulous dreamer than for his opposite. Théo didn't think much of the bird, handled it carelessly, and said, "It doesn't sing Picasso's music, does it?" Some friend of Théo whom I didn't know happened also to be present and Théo handed him the bird. He also opined that its song was inaudibly Picassian but expressed admiration for my ingenuity in contriving to receive a gift from Dora Maar, let alone a bibelot by Picasso, and passed the object along to yet another friend for curiosity's

sake. So the bird passed through several hands and Picasso's name followed it around the bar for five or ten minutes before I could get it back. Though I was annoyed at the blasé indifference to my acquisition, my own delight in it was unimpaired. To me it sang Picasso's music with the entrancement of all time. As soon as I managed to retrieve the object from alien hands—intact, thank God—I left the bar, went home, placing the bird on the table beside my bed, and to sleep.

Every Thursday morning Dora received the visit of a Russian woman who gave her a manicure and pedicure, and during these sessions, which lasted for about an hour, beginning punctually at eleven, she liked to talk on the telephone, because the Russian was unusually loquacious and if Dora was conversing with someone else her manicurist was compelled to remain silent, an ordeal made more irksome by the fact that she was not only talkative but inquisitive, indeed prying. And even I at that early stage realized how fiercely Dora detested the thought that her private life and personal affairs might become public knowledge. Contradictory in this, as in so much else, she nevertheless was quite content to let the manicurist know of her privileged relationship with the greatest artist of the century, and not above hinting that perhaps, after all, both privilege and relationship continued to this day despite ubiquitous newspaper accounts of Picasso's amorous vicissitudes. It amused her to make remarks in front of her manicurist deliberately intended to create ambiguous impressions and impart a fantasy idea of the existence of the woman whose fingernails were being painted. Consequently, it was a convention of those Thursday-morning telephone conversations that not everything Dora said need be taken seriously or even understood. I wondered whether these whimsical improvisations varied according to the person at the other end of the line or were devised for the imagination of the manicurist alone. The day after the gift of the Picasso bird happened to be a Thursday. When by eleven-thirty my phone had not rung I dialed ODE. 18-55. Dora answered immediately and in response to my hello said, "I can't speak to you now, I'm very busy."

"I'll call you later," I said.

"Later will not be convenient," she brusquely retorted. "You must understand that I'm a very busy person, and I can't take time to see everyone who calls me on the telephone. But probably we will run into one another one of these days. Goodbye." And she hung up.

The convention of non-seriousness notwithstanding, I was taken aback by the tartness of her tone and the abruptness of the goodbye. However, I wrote in my journal and worked at my novel until lunchtime before calling her back. "Is the manicurist gone?" I asked.

"Yes." Then silence.

I waited for her to say something further. When a minute had passed, it seemed that she must be expecting me to resume the conversation. I said, "Do we have dinner together this evening?"

Her reply did not come immediately, but when she spoke, it was in a muted tone of voice I had not heard before. "I'm not sure that I wish to see you again," she said.

"But why in the world not?" I cried.

There was once more a long pause, during which I determined not to speak first. Then Dora said something to the effect of being humiliated by the obligation of having to explain what should be crystal-clear. I said it was pitch-dark to me. That brought the light. I had been guilty of gross indelicacy, she said, had degraded something pure and precious, had proved unworthy of her confidence. But what in the world could I have done that was so terrible? It was simple. I had paraded in a public place—and what a public!—and what a place!—the object which should have represented to me everything that was most private, personal, intimate, and least to be made vulgar and paltry by being passed around among people who couldn't possibly understand its aesthetic value and symbolic significance. She had wanted to show her esteem and prove her friendship by making me a worthy and important gift. She had for a long time pondered, she said, what would be most appropriate and pleasing. Oh, I mustn't imagine that the choice had been made on the spur of the moment. Not at all. The broken bottle had merely been a little pretext to make more discreet a gift chosen well before with discrimination and solicitude. None of this, of course, was it possible that I had understood when leaving her, or I could never have made my way immediately to a dive where the lowest possible denominator of appreciation might be assumed to prevail.

"Definitely as low," I said, "as the loyal tact of our good friend Théo."

But Théo, she maintained, had been quite as taken aback by my indelicacy as any person of fine feeling would be, and had, in fact, only

with regret and for the sake of their friendship told her what he had witnessed.

Well, it was perfectly true, I said, that I had been too elated by her munificence to go straight home to bed. Meeting Théo in a late-night bar, I would have been positively perverse not to show him the thing which demonstrated the kindness and generosity of our mutual friend. And it was Théo who had passed the bird into other hands, not I. His strictures concerning its song I kept—with some difficulty—to myself. And if Dora had been offended, I was very sorry.

"Don't be ridiculous," she said. "Our relations are not such that I could possibly be offended by anything you do. Surprised, yes, even shocked, no more than that. You must forgive me now, I'm very busy. If you like, you may call me in a few days. Then perhaps my surprise will have changed to indifference. I'm a very easygoing person, you know."

So we said goodbye. I was distressed. I was indignant, angry at Théo's perfidy, and thought I had been most unfairly used by a person not in the least easygoing. And yet the fascination I felt for Dora was not diminished. On the contrary. Perhaps I was drawn to her more powerfully even than before. How to explain? The bird's song sounded to me irresistibly compelling still.

Dora had allowed that I might call her in a few days if I liked, but after the scalding rebukes—and dubious intimations—to which I had been subjected I felt that care for the continuation of our friendship should be left up to the one who had doubted her desire to continue it. I determined to wait, knowing that with Dora the wait for anything to be gained by time could be close to endless. But I guessed that she might judge me by my pertinacity. Anyway, I had other friends, some of them rather neglected because of such frequent outings with Dora. I didn't think it would be very long. It was eleven days. But there was a surprise. It was the gift of a Picasso to me that had brought about our pseudo-estrangement, a gift from Picasso to Dora that ended it.

Her call came early. I was barely dressed. "The most extraordinary thing!" she exclaimed. "You must come here at once." Her voice bore excitement and impatience over the wire, and not the slightest suggestion of past strictures or reproaches. I said I would come but asked what was the urgency. "I need you," she replied. That in itself was most extraor-

dinary. She explained that that morning at eight o'clock the doorbell had rung and she had found on her landing three hulking deliverymen with an enormous wooden crate which now stood in her entrance hall, addressed to her by an unmistakable hand and marked: *Expéditeur Picasso, Vallauris*. It was the first gift she had received from him for years, she said, the first sign from him, indeed, she had had for a very long time, and at such a dramatic moment in his life, when his mistress was said to have abandoned and repudiated him, taking with her their two children. What might not be conceivable? He has never been all alone, she said. I thought—and I should have thought of it infinitely sooner—that, after the horrors and the humiliations, perhaps, after the loss and the panic, she might against all odds still cling to an expectation of what she felt to be rightfully hers.

Dora said that she could not possibly open the large crate by herself, needed help, and wanted me to come as soon as I could. It excited me. Wanted me, moreover, she said, to be present to behold the emergence from its enormous box of this offering from Picasso, which must by its very size be an object of particular importance. Not a painting, because the crate was almost square. A sculpture, then, perhaps? And to think of the last thing he had given her, a small drawing of herself* presented on her birthday several years before under circumstances so cruelly humiliating that she could never bring herself to reveal them (and never did). I guessed what she was offering, and it thrilled me, and I said I would be there as soon as possible.

The crate, indeed, was very large, approximately a cube, measuring about a meter all around, and there was no mistaking the hand which had painted in large black letters the names of sender and addressee. I could see why Dora had felt that help was needed. A large hammer, pliers, a chisel, and three screwdrivers had already been set out. Dora was agog. But getting the crate open was no easy job, as if the packers had ingeniously put their box together with malicious intent to make it difficult to take apart. After some twenty minutes of laborious prying, pounding, wedging, pulling of nails, and screeching of wood, during which Dora said the neighbors would think the house was being demolished, I managed to remove one side of the box and loosen the top.

* Catalogue of Picasso Exhibition, Arles, Musée Réattu, No. 64, Plate 27.

Inside was an object entirely wrapped up in brown paper and held in place by triangular cardboard wedges. Dora admonished me to take care, as perhaps the object was fragile and an impetuous yank might irreparably damage it. With Picasso, who could tell what unconventional materials or haphazard odds and ends had gone into the creation of a work of art? Why, even some of his prized paintings had been executed with ordinary house paint. So I very tenderly edged the object from its crate. Dora and I knelt together on the tile floor to peel away the brown paper. What we uncovered would have been laughable had it not been preposterous, grotesque, and, of course, a deliberate provocation.

It was a chair. But an overt mockery of a chair. And not for one instant was it thinkable as a creation of Picasso. The skeleton was of thin steel rods welded together and painted black, the seat and back of coarse rope crisscrossed between the rods, the whole thing both too broad and too deep and the ropes too widely spaced for any imaginable comfort, and the ludicrous, cumbersome effect consummated by two disproportionately large, unpainted wooden balls affixed at a very awkward height to the tops of the rods in front. Inelegant, ungainly, crude, and, in a word, ugly, this parody of a chair could not conceivably have any use save to waste space and to assert the blatant specificity of its ugliness. There was no communication of any sort from Picasso to be found in the crate or among the wrappings, though we searched thoroughly twice. The chair had been sent by him, that was all. Why he had chosen such a bizarre, useless gift seemed incomprehensible.

But Dora was determined to put upon the matter as alluring a visage as possible. Not a nuance of disappointment appeared, and she behaved quite as if the artist had sent her his most recent masterpiece. Picasso, after all, she said, being Picasso, had reasons for his actions which the rest of us could not be expected to grasp, and a gift from him, no matter what its superficial semblance, bestowed a distinction and bore a symbolic meaning which would become clear only in the course of time. I was perfectly willing to go along with this view, though I didn't believe it expressed Dora's true feeling. My suspicion was that she must be furious to have summoned a witness to be present for the receipt of something she had expected to be wonderful but which had turned out to be ridiculous. Still, I may have been mistaken, for as yet I knew next to nothing of Dora in her posture as a saint. She said that she would

leave the chair where it stood in her entrance hall, adding that thus it might serve as a sort of introduction to Picasso, he, to be sure, having desired that it should have a place in her home.

•

In the rue de Marignan there was a bookshop called Les Quatre Chemins, its proprietor a genial and highly cultivated man named Wladimir Walter. Not technically a dealer, he nonetheless always had a few choice items, usually drawings, in his closet, and I had bought several things from him already, notably the Tahitian charcoal by Gauguin. He knew of my passionate interest in Cézanne and all about the efforts I was making to save the studio at Aix-en-Provence. One afternoon in February he showed me in a book on Cézanne by Vollard a photograph of a large drawing of a reclining nude youth,* a work of the artist's early years, certainly made from a live model in an academy, the only work he executed which could be seen as a feeling response to the sexual component of male beauty, a view which would undoubtedly have outraged the repressed and choleric artist. This drawing, Walter said, might be obtainable for about five hundred dollars and he wondered whether I would be interested.

I was. Fervently. It was a wonderfully strong work, executed in black crayon with the intense vigor of Cézanne's early style, and the youth was both virile and beautiful. Walter then told me that the drawing belonged to Paul Gachet *fils*, son of the sympathetic doctor who had befriended Pissarro, Cézanne, and, in his final tormented months, van Gogh, who painted two masterly portraits of him. Most of the Gachet collection had already been given or promised to the Louvre, but there were a few drawings and etchings left over. If I was interested in the Cézanne youth, Walter said, he would talk to Paul Gachet and see what could be done. This might take a few days. The acquisitive, like the sexual, fever is especially fervid when one is young, and I slept badly for two or three nights, dreaming of the drawing which united so powerfully in a single image several of my most vital passions. Finally Walter called to tell me that if I came to see him the next afternoon I could

* Reproduced in *The Drawings of Paul Cézanne: A Catalogue Raisonné* by Adrien Chappuis (Greenwich, Conn.: New York Graphic Society, 1973), No. 101.

receive the drawing directly from the hands of its eminent owner. Mon-
sieur Gachet was tall, genteel, and rather courtly, attired all in black,
with a white goatee, and must then have been about eighty, a very
"green" eighty, as the French would say. The drawing was propped on
a shelf in Walter's office, thrilling. We sat down beside it and talked
for half an hour. The old man's voice was throaty and vibrant, and he
most particularly liked talking about van Gogh, referring to him invar-
iably as "Vincent." He had seen him almost daily during those last
months, and now praised not only his genius but also his simplicity,
sweetness of spirit, and generosity, and recalled how he had sat by the
dying painter's bedside in the wretched garret room above the Auvers
Café all through the long night of July 28, 1890, while van Gogh pain-
fully, as he had lived, died, and the unforgettable grief of the bereaved
brother afterwards.

To celebrate this momentous acquisition, Bernard and I went out
for a fine dinner at the Escargot, then one of the city's finest restaurants.
I took the drawing along and propped it on a chair opposite our table.
It confronted us as a presence admirable, desirable, unattainable, tran-
scendent, ideal as a host, representative of longings, even of aspirations,
which by their very hopelessness compelled hope. I don't suppose Ber-
nard felt so. He was inclined to be flippant about my preoccupation with
genius. Already then I admired Cézanne for somewhat the same reasons
I later learned to be those of Giacometti, whom I was just at that time
getting to know: the fortitude to make failure the yardstick of achieve-
ment, and the sanity to discern that the greatness of art is its unim-
portance.

Naturally, I took the drawing to show to Dora, who was much
impressed by it and astutely perceived similarities with Tintoretto, which
would have pleased Cézanne. If she was responsive also to the beauty
and nudity of the young man, she gave no sign. But she was too subtle
to be unaware of a rapport between images and desires. Georges Bataille,
after all, had been her tutor, and Picasso her master, and both of them
excelled in perceiving passions not presumed to be perceptible.

Occasionally we dined with Marie-Laure and Oscar, both of whom
Dora had known during her decade as Picasso's *maîtresse en titre*. One
of the restaurants we frequented was a modest place in the rue Mazarine
called Chez Georges, made pleasant by the excellent cuisine and exu-

berant *bonhomie* of the proprietor, a fleshy Russian well-disposed toward the eccentricities of artists. Oscar was usually drunk and Marie-Laure herself in those days often a bit inebriated, Dora and I also prone to drink more than necessary. One evening toward the end of our dinner Oscar tore several long strips off the paper table covering, twisted them into baroque shapes, inserted these into the mouth of an empty wine bottle, and, bellowing picturesque obscenities, set them afire. A quick plume of flames flared up. The diners at adjoining tables made exclamations of alarm, and Marie-Laure, though clearly amused, remonstrated with her obstreperous boyfriend, who responded by dumping a pot of mustard onto the fire and making disobliging comments about the anatomy of his mistress. The little conflagration duly extinguished, our table was an ugly mess of ashes and mustard. Dora crossly observed that Oscar was not fit company for a public occasion.

"Don't put on airs, sweetie," he said. "We all know that when Picasso shit you saved the toilet paper."

"Really, Oscar," I exclaimed, "you go too far." Dora's face was ashen with anger. I said to Marie-Laure, "Can't you do something?"

"Yes, Putchie," she said, "be a pet."

Oscar, seated opposite me, leaned across the filthy table, his protuberant eyes and pomegranate nose incarnadine, and said, "Do you and Dora fuck?" And when sullen silence ensued, he turned to Marie-Laure and roared, "Pansies, Putchie. I told you. All the unattached females are going for pansies. You will, too, when Oscarito croaks. And why not? If it's not in a boy, pansies don't care whether the hole's in a girl or a goat. Everybody's happy. Dora, my darling, I'll tell you what we'll do. We'll put you and James in a locked room together, naked, with your arms tied behind your backs, and a swatch of tissue paper pasted over Dora's cunt, and we'll only let you out when the tissue paper's pierced. What do you say?"

"I say good evening," said Dora, rising, "and remind you, Oscar, my poor old friend, that Picasso forgave you for all the fakes you made of his work during the war."

"That was my contribution to the Resistance," said Oscar.

"Let's hope the hostilities are over," Dora added. She said goodbye warmly to Marie-Laure and turned to depart. I followed.

We walked back to the river in silence and turned right along the

Quai de Conti in front of the Institute and the Mint toward the Pont Neuf. At last I said, "That was appalling."

"I've known so many humiliations," she murmured. "But this evening was unique. Oscar is pathological, of course, his brain malformed at birth, and the obsession with Picasso a feature of his malady. It won't have a happy ending. But this evening his delusion was to offend Picasso through my relationship with you, because Oscar naturally believes that after Picasso should come only sackcloth and ashes. And Picasso thinks so, too."

I was glad that this conversation took place in the saving neutrality of night. "I'm very sorry," I said, "if I added in any way to the trouble."

A trill of laughter rippled across the darkness. "Oh, there's no trouble," Dora said, "so long as I'm willing to make the sacrifice."

"What sacrifice?" I stupidly asked.

"Has it even occurred to you," she inquired, "that everyone assumes you're my lover?"

It hadn't. What had occurred to me was only that Dora might assume that our relationship should eventually come to that. The rest seemed irrelevant. I said, "Oscar is a madman. And people always gossip."

"I used to think they were one-quarter animal and three-quarters human," she said. "But I'm willing to make the sacrifice. It's because I believe in you, my dear James."

"Thank you. I don't know how to tell you how grateful I feel. And I only hope I won't disappoint you."

We had turned right from the river into the rue des Grands-Augustins and in a moment would be passing *his* house. Again she laughed. "Have no fear of that," she said. "Our worlds, yours and mine, are not united to such a decisive extent."

That left me speechless. Then what was it she believed in? And yet I never doubted her sincerity.

It was not cold and we had come to the corner where almost ten years before I had seen Dora for the first time. As we walked in silence down the narrow sidewalk I remembered watching her and Picasso stride away from me that winter afternoon along the same sidewalk and how she had started to talk the moment we parted, her voice increasing in volume and velocity as they moved away, and I realized that Picasso must have invited me to lunch that day deliberately to provoke and

exasperate her. The thought upset me. For her, not for myself. But what could I do? Being hardly of her world, which was the truth, I felt sympathy, compassion, shame. Then we had reached her door and said good night. She held out her hand. I took it, at the same time leaning down to her cheek to give her a kiss. But she turned her face aside very quickly to avoid it, pushing open the heavy door, and went inside. The evening had been both absurd and beautiful, moving, mysterious. Four years later Oscar committed suicide, and what drove him to do so, if one can ever elucidate such a somber purpose, was surely in part his morbid obsession with Picasso.

•

Among the people we sometimes saw at this time were a couple named Georges and Peggy Bernier. She was a leggy, pretty American, daughter of a judge from Philadelphia, and was much concerned with the world of art and literature. He had known the Surrealists, was exceptionally literate and very learned about art, if not actually erudite, highly entertaining and informative as a conversationalist. Already then they were planning to publish an art review, entitled *L'Oeil*, the first issue of which appeared in January 1955, offering pieces by Douglas Cooper, Kahnweiler, Cyril Connolly, and myself, an article on Giacometti. *L'Oeil* sustained for several years an exceptional standard of cultural originality and artistic refinement. Georges and Peggy one evening invited Dora and me to dinner. Also in the party were a youngish painter called Philippe Bonnet and a woman named Monique Schneider-Maunoury, editorial secretary of *L'Oeil*.

We met at Dora's apartment. It astounds me now to recall how easily and often she welcomed guests to her home then, though it's odd, too, to realize that never once was a meal served there. We had drinks, of which there were always plenty, in front of the fireplace, as usual, then went to a nearby restaurant, ate dinner, drank a good deal of wine, and did a lot of talking. It was probably Chez Georges, but my notebook doesn't say. Then Monique suggested that we should all adjourn to her apartment for a nightcap. It was in the rue du Bac, a picturesque, spacious lodging. Bottles of brandy and other liqueurs were brought by Monique on a tray and set down within reach of us all. Dora, I noticed, drank Mirabelle, perhaps the most potent of the liqueurs. I took brandy.

The room soon filled with cigarette smoke as the talk grew louder and louder. But nobody talked to me. Dora and Philippe Bonnet were engrossed in the technicalities of oil paint and its advantages or disadvantages as compared with gouache and watercolor, while the three others discussed the myriad details, especially financial, relative to a sensational debut for their magazine. I lounged sulkily on a large couch which was probably Monique's bed, though my annoyance was much allayed by the mesmerizing loveliness of a tiny Vuillard portrait of a bearded man that hung above a lamp. I stared and stared at that little painting until I felt almost physically incorporated into its pale golden continuum, made even more beautiful, I presume, by the brandy I kept on sipping. Ever so slowly thus the evening lapsed into night, and then it was three o'clock in the morning. We all stood up at once and the leave-takings were mumbled.

As we went out through the courtyard, Dora leaned firmly against me but did not lurch or stumble. "I'm quite all right," she said. "A little walk, a little air to clear my head. I feel wide awake. And you?"

"Everything is fine," I said.

We went to the car. I helped her in and then we sat side by side for a moment, waiting, as if at the brink of opportunity. I was aware that it was not for me to take the initiative.

"It's too late," she said, "or too early to go home. So where shall we go?"

I suggested Versailles. But the gardens would be closed. Malmaison. The same drawback. Fontainebleau. Likewise. Then why not Chartres, where at least we could admire the cathedral at dawn? Yes, yes, that pleased her, a place of pilgrimage, dedicated to the Virgin, where even the druids in antiquity were said to have assembled from all over Gaul. And she had been there only once before, long ago, before the war, and had but a glimpse of the cathedral.

"What a beautiful idea," she said. "To go all alone in the middle of the night. We'll be like children, won't we, and everything will be as if for the very first time, won't it, dear James?" She put her hand on my cheek for a moment.

I said yes, everything would be like that.

We drove through the Bois, leafless trees aligned along deserted avenues, and across the bridge at Saint-Cloud. Beyond the tunnel came

the cool humus odor of the countryside. Dora smoked cigarettes. There were no other vehicles on the road. After the valley where the little airdrome lies, the highway mounted to a low ridge where there was a turning to the right. We didn't take it, but I remembered having been that way once before with Dora, the day we went to Le Tremblay, and I asked whether she, too, remembered. She did.

"How I hate that house!" she exclaimed. "Vollard was such a pimp, would do anything to get a painting or a few etchings. He loaned the house to Picasso, who installed his mistress there, the woman he knew before me, Marie-Thérèse, with their daughter, Maya. And he used to go out there often for weekends, leaving me alone in Paris. Sometimes I would take a taxi there. To see what I could see. Nothing. And yet behind those walls I knew Picasso was there with her and the little girl. Oh, he made no secret of it. But I had my revenge in works of art. The paintings and drawings I made him give me to compensate. I remember one night after a big party at Marie-Laure's. It was in June, almost dawn. I felt so alone I got into a taxi and told the driver to take me out of Paris. The trees were like balloons ready to float up in the sunrise. I told him to take me to Le Tremblay. This was after the separation. But I'd been there so often. And Vollard was dead, and Picasso was in the Midi, but I'd been there before so often. It must have seemed very strange. A young woman in an evening gown weeping in the back seat of a taxi at six o'clock in the morning, driving through the countryside. And after we left Le Tremblay the driver said, 'Please don't cry. It makes me think of when my wife died.' He was quite old, and we stopped in Versailles on the way back for coffee. Now it's like another life."

"Yes," I said.

"Don't be unkind," she murmured, putting her hand for a moment on my thigh.

"I'm very happy," I said.

She removed her hand and lit another cigarette. Chartres is only fifty miles from Paris, but the little car was not fast and presently there came a slight dwindling of darkness upon the dark, a shadow gliding over the night, while out of the dimness beyond our yellow headlights a vague horizon began to hover over the void, and veins of cloud drifted upward, taking faint color from far ahead of us, and a vast plain started to loom round about as dawn lifted over the world.

I said, "The sky seems to be dragging the earth up out of its darkness, doesn't it. You can physically feel the effort as you watch."

"How beautiful," said Dora, "what you just said. The heavens bringing us light, enlightenment. Grace. Sometimes I think I understand you, dear James, and I, too, am happy."

Embarrassed, ashamed, I didn't answer. We drove onward. The sun had risen in shoals of clouds, showing silver on their bellies as they turned bottom up, floating toward the surface of the sky. I did not want to feel responsible for her feelings, or to be offered any prerogative so far as she was concerned. All I wanted was that she should acknowledge a fondness for me. It was wrong, but I didn't reason with my desire. The Beauce plain, flat, fallow, folding over the occasional thicket, stretched all around, undisturbed by bird or breeze. Then far, far ahead, merged almost in imagining anticipation, appeared the pale spires above the fields. Dora exclaimed at the sight.

She said that her only previous visit to Chartres must have been seventeen years before. With Picasso. He had been eager for her to see the cathedral, as he particularly admired it, but she had been reluctant, an anarchist then, unwilling to admire anything admired by accredited connoisseurs, and said she'd prefer to see the Renault factory at Billancourt. Picasso insisted, so they went, but when they reached the cathedral she refused to get out of the car, glanced disdainfully through the window and said, "So what?" Picasso was furious. On the way back to Paris they had a terrible dispute. She was toying with a little penknife, a plaything from her childhood that she was especially fond of, and he snatched it from her hand and flung it out onto the roadside.

We drove down the slope below the cathedral in the empty white morning, then up through the inert town and around the corner that brings you suddenly before the whole edifice striving upward into the sky. I've made that turn many times and usually it leaves one silent.

Getting out of the cramped car, she walked ahead by herself toward the indescribable façade, as if by precedent, and I followed, wishing to seem no more impressed by the cathedral than by her contemplation of it, especially in consideration of the previous visit. We stood together in silence, looking up at the Christ in majesty above the main portal.

"There's nothing one can say, is there?" I said.

"One can pray," said Dora.

Embarrassed, rebuked, I said, "About the beauty."

"That *is* the beauty," said Dora sharply. "The rest is simply plea-
sure."

"And art."

"Sometimes you are impossible," she exclaimed, turning away so
abruptly that the purse hanging by its strap over her right elbow snapped
open and some of its contents, a wallet, a lipstick, one or two other
things, fell to the ground. I hurried to help her pick them up, but she
was quicker than I to retrieve her possessions and snapped the purse
shut again.

We walked around the cathedral toward the former archbishop's
palace, now a museum. In lofty trees birds were wakening, their tentative
twitterings anticipatory of morning. From the invisible valley rose a few
bravado barks.

"I don't suppose the cathedral will be open for another hour," Dora
said. She would have been happy to light a candle. To see the famous
windows. Perhaps it would be possible to find a café and have a cup of
coffee. But no. Everything was shut. The porter at the Hôtel de France
was surly. Even the buffet at the railway station had not yet opened, so
we agreed to go back to Paris. There we would find fresh croissants and
coffee.

"You think I'm still drunk, don't you?" she said.

"No," I replied too quickly. "I never thought that."

"But I was. Please forgive me. I spoke very brusquely to you. I
have no right to."

"You do have the right," I said.

"But I don't want such a right. It isn't fitting."

"I give it to you just by being your friend, so it must be."

She said that it wasn't, and that the rights of friendship had to be
put to continuous tests, severe and of perfect sincerity.

Thinking to make things easier, not to say more reasonable, I
remarked that nobody was perfect.

"But one should strive to be!" she exclaimed. "Otherwise, life is
completely rotten."

To this there was obviously no answer, and I was startled by the
personal emphasis of her tone, as if she were admonishing me. I didn't
like it and wondered about the mutability of her concept of the rights

conferred by friendship. At the same time I felt elated at the familiarity implied by her caustic admonition. In short, I didn't know where I was but only wanted to be there with her. She smoked cigarettes in silence. I drove on. Pretty soon we were in Paris, stopping at a café near the Porte d'Orléans to have croissants and coffee. I would have preferred chocolate, but Dora gave the order. We didn't talk much. Then I drove her home. It was after eight when I got into bed.

In the late afternoon I was awakened by the ringing telephone. It was Dora. She said that something terrible had happened. She had lost her cigarette lighter, the silver one with her portrait engraved on its top by Picasso, a possession of priceless sentimental value to her. She had searched for it everywhere in her apartment. It was nowhere to be found. Was it possible she had dropped it in the café at the Porte d'Orléans, or even when her purse had fallen open in Chartres? She couldn't recall whether on the way back to Paris she had used the lighter or matches, as she habitually carried both. Or might it have slipped out of her purse in the car? Her only hope was that it was in the car. At the café or in the street at Chartres there would be next to no chance of recovery. She implored me to go at once to search the car with scrupulous care and call her back immediately. I said I would.

The four-horsepower Renault was a very cheaply made vehicle, all of its fittings welded tightly into place, providing next to no room for any maneuver not essential to driving the car or sitting in it but leaving nonetheless tiny waste spaces and crevices around the seats and controls that were virtually inaccessible, impossible even to see into. A quick inspection gave not a glimpse of the lighter. A contortionist would have been required to make a thorough search, and I felt annoyed with Dora for having been so negligent. If the lighter was in fact so precious to her, she might have been expected to take unusual care of it. Besides, it symbolized a contradiction. As a souvenir of Picasso, who had ruthlessly abandoned her and whom she frequently criticized with almost vengeful vehemence, *should* it have seemed precious? Even with Picasso's engraving on its top, it had scarcely any intrinsic value. Why did Dora deem its loss terrible? One might have expected she'd be glad to be rid of that reminder of an intimacy betrayed. I would have been happy to go to Dunhill's and buy her another, though I knew perfectly well it would not seem an adequate replacement, or even a welcome

one, and might, indeed, be regarded as presumptuous, and I rather resented being compelled to pry and peer on my hands and knees through the cramped interior of the car. I found nothing. To my surprise, the fruitlessness of the search quite pleased me. I looked forward to telling Dora that her priceless souvenir was truly lost. It suddenly occurred to me to wonder whether the lighter seemed valuable to her solely because Picasso would resent its loss, and I remembered her teasing him with that intimation during our long-ago lunch together. Then was it possible, if so, that in her unpredictable and unexplored heart she lived on still in the hope that Picasso might return to her? Especially now that separation from Françoise Gilot appeared certain. The notion was preposterous but annoying.

On my way back upstairs in the elevator, preparing with some satisfaction to announce the lighter lost forever, it occurred to me that perhaps I had been a little too pleased not to find it and should search more diligently, with a flashlight and tools. After all, her disappointment would seem to reflect a failure on my part, and the last thing I wanted was to fail her. So I found a flashlight, a screwdriver, and some pliers and went back to the car. Without the flashlight, and even with it, had not its beam been directed at a very rakish angle, I never would have glimpsed the faint silver gleam in the depths of a groove between the front seats. So the lighter was there. To fish it out, however, took a good half hour of ticklish toying with improvised wire hooks. When I finally had the actual object in my hand, I was tempted to throw it into the mouth of the sewer just adjacent to my car. Then I thought that I might keep it. Nobody would know, and perhaps what had been so precious to Dora might in time for reasons almost comparable become precious to me as well. But what was hers, after all, I wanted to be hers.

"It took you forever to find it" were her very first words when I reported recovery. So I said that it hadn't been easy either to locate or to extricate. She thanked me, of course, and said that I had profoundly relieved her mind. I must understand that after so many losses, sacrifices, vexations, etc. Yes, I said, and asked whether she wanted me to bring it to her immediately.

"No," she said. "Just keep it safe till the next time we meet. And I want to show my gratitude. I'll give you the proof of the engraving on top. It's tiny but very beautiful. And unique."

I had expected we might dine together, but Dora said that she was expecting the director of an American museum.

"What does he want?"

"What does everyone want?" she exclaimed. "Don't be so naïve. What do you think? Are you jealous of anyone else who wants to talk to me about Picasso?"

"Not at all. Sometimes I wonder how you'd react if I spoke to you the way you sometimes speak to me."

Dora laughed. "Why, I'd jump on you like a tigress," she exclaimed. "Call me in the morning, and remember it's the day of the manicurist."

When I returned the lighter to her, she gazed at it as if with wonder, turning it over and over between her fingers, but said nothing about it specifically and did not thank me. Instead, she remarked, "By the way, I haven't been able to find the little proof I promised you. But it's around somewhere. Don't worry. You lose nothing by waiting."

I was not worried. I was nettled. Not so much because of the tiny etching promised but not given, though, to be sure, I would have been delighted to have it, as because of the plain fact that she made free with me so casually and would never have behaved toward me as she did had I not allowed it, had I not in some way wanted it, had I not—but I didn't know how—actually provoked it. There was an explanation, of course, but the logic of it was that it should be as yet unintelligible to me.

In those days, as I recall, it was not essential to one's prestige or enjoyment to go skiing at Easter. If one could afford to go away at all, it was usually to some quiet place in the country. So my pleasure was multiplied by the excitement of surprise when without any preparatory hint Dora one evening said, "I've been thinking of going down for a few weeks to Ménerbes for Easter. Would you like to come with me?"

"I'd adore it!" I exclaimed and that was the impulsive truth. I gave not a thought to what I'd said, to what it meant or to what her invitation meant. The mere idea of being with Dora in Ménerbes in her house was the be-all and end-all of thinking as well as of feeling.

She said that I must have no great expectations of having a good time, that the house was far from luxurious, as I might recall, indeed austere, that it would be cold and the winds would blow, that there were no distractions of any sort, that I would be left wholly on my own to

work or do as I pleased, and that I must respect her entire independence to do likewise. Under no circumstances should I suppose that she might provide entertainment.

I assured her that she would find me both self-reliant and undemanding, and I believed that to be true. But it seemed that her invitation had been followed almost too quickly by a warning, as if the expectations that required cautioning were her own. However, the elementary felicities of friendship would certainly provide us with all the entertainment anyone could hope for, I said.

"Good," she said. "Then that's settled. We can arrange the details later."

Details occurred to me the very next morning. In Ménerbes in Dora's house, given her by Picasso, I would be alone not only with her but with the ambiguity, amounting at times, I felt, almost to ambivalence, of our relationship to one another and to the preoccupation with Picasso which enthralled us both and which in that place might be expected to have unforeseeable effects. And what would people assume if we went away alone together to sojourn in that isolated place? What would Dora herself assume in view of her readiness to make a sacrifice because of her belief in me? Was her invitation the test to which this belief must be put?

A troubling dilemma, it seemed, might be in the offing, and I had no wish to be responsible. My simple desire was to go with Dora to Ménerbes, enjoy there a tranquil, amicable few weeks, work on my novel, go to Aix to find out what progress was being made on the renovation of Cézanne's studio, and—why not?—possibly run over to visit Cocteau on Cap-Ferrat and see Picasso in Vallauris. Was this not innocent enough? Of what potential for trouble ought I personally to beware? I discussed the matter with Bernard. To him it was simple. Dora's invitation might not represent a challenge but certainly left open the eventuality of a crisis. This would hinge upon my intelligent and fastidious avoidance of any evolution in our relationship that could concede to Dora prerogatives which I might be unwilling, unwise, or unable to indulge. In short, was I prepared to become her lover, remembering who the previous one had been and what traumatic consequences had come of their separation? I was willing, I was prepared. I had certainly thought of the possibility, given Dora's own rather equivocal evocation of it, and despite my undeviating sexual attraction toward men, I com-

placently realized that I could make myself sexually satisfying to a woman as well (complacency confirmed by a heterosexual liaison carried on for close to a year in 1948). However, I thought I knew Dora well enough to realize that it would be foolhardy to encourage her to assume that my compliance to any expectation of hers might ever be taken for granted. I was already well acquainted with the quicksands of empathetic kindness. So I thought it would be prudent to proceed on the assumption that we were to remain friends only. Despite possible dissatisfaction on both sides. In that event, said Bernard, I must exert every care to make sure I never by any error of sympathy or failure of intuition gave her an opportunity, which at the moment she might even welcome, to make herself ridiculous. The advice was excellent. But of course I hadn't the slightest idea of how to follow it, providing, indeed, a fair chance for complications.

All in the world I wanted was to travel with Dora to the never-never land which I felt sure was her habitation.

C H A P T E R

T E N

WE LEFT Paris on the fifth of April, a Monday, in midmorning. I had
one suitcase, Dora three, plus a wicker basket for Moumoune, who
scratched, meowed, and whined most of the time. Before we reached
Fontainebleau, it had begun to rain. There were no superhighways then.
One followed Route N7 all the way, and with the little Renault it was
unthinkable to make the entire trip in a single day. We were to spend
the night in Lyons, where I had already reserved two rooms at the Hôtel
Royal. In some little town we stopped at a bistro for lunch, and it was
while we were eating that Dora suggested we make a slight detour to
say hello to Balthus in his newly found château.

 It was no secret that the painter, still known only to the happy few,
had for a couple of years been scouring France for a residence fit to
house his seigneurial self-esteem. A château, in short. These were going
begging at the time, but Balthus was congenitally short of cash, and
needed to rent, not buy. He had recently found something in an out-of-
the-way corner of the Nièvre, somewhere between Avallon and Autun,
a run-down place called Chassy, near the hamlet of Blismes, and there
he was installed with a housekeeper-poetess by the name of Léna Le-
clercq, a young woman prepared to scrub floors, cook meals, run errands,
wash, polish, and repair while the artist serenely put paint to canvas in
his studio. How were we to find this remote spot, I wondered, with
Blismes not even on the map? Dora was unconcerned. We would ask

directions along the way, and one always found what one was looking
for if persistent enough. Maybe, I suggested, it would be a good idea
to telephone. She laughed. Balthus could barely afford electricity, let
alone a telephone. I liked Balthus and admired his painting, of which
I'd seen little, but the prospect of combing the rather desolate countryside
under a chilly rain didn't much appeal to me. Dora dismissed my hes-
itation, said we'd only stay for a cup of tea and that Balthus would be
overjoyed to have a visit in his lonely hideaway. Besides, she'd helped
him in his hunt, proposing, in fact, a beautiful little château in Ménerbes
for sale for a song, but even that had proved too expensive, so the place
had been bought six months before by another, more successful painter
named Nicolas de Staël, no relation to the renowned lady of letters.

So we set out after lunch, leaving the main road at Avallon, stopping
here and there to ask directions. Nobody had ever heard of Blismes,
not to mention Chassy, but we kept on in the direction of Autun, and
in the dreary town of Château-Chinon luckily chanced upon an ancient
geezer who contemptuously informed us that we'd come too far, gone
right through Blismes without even knowing it, passing in full view of
Chassy, which he described, in any case, as not worth demolition, which
was the only reason it still stood, long since uninhabited save, it was
said, lately by some Parisian lunatic and his slut. Dora thanked this
person very politely, and we went back the way we'd come. Chassy,
indeed, was by no means what one looked for as the archetype of a
château, being merely a big, bare-faced house with bulky, round towers
at each corner, the approach via the muddy yard of a very ordinary farm,
from the shed of which a red-faced woman stared at us with suspicion.
We parked at the front door, knocked, received no response, and, finding
the door unlocked, went inside. The interior was no more imposing than
the exterior and there was next to no furniture. Vast, unheated rooms,
cold as January. After wandering about for a few minutes, opening several
doors, we found Balthus and Léna seated at a small table in the kitchen.
A single light bulb hung on a wire from the high ceiling, and several
buckets and caldrons were set here and there to catch the drops of water
that fell steadily from leaks overhead. The artist and his housekeeper
did not seem a bit pleased to be found in this cheerless setting, drinking
tea from chipped cups. Dora obviously sensed that our impromptu in-
trusion might, after all, have been a gaffe and said that we had merely

stopped to say hello and would immediately be once more on our way. But Balthus insisted we also have a cup of tea, and Léna halfheartedly reiterated the invitation. It took a bit of doing to find two more cups and chairs, still we did have some tea, while Balthus with his well-practiced charm soon made it seem that we had been impatiently expected.

Presently the artist proposed to show us his studio, and we quickly accepted, aware that the offer represented a singular privilege. It was on the floor above, to the left of the wide staircase, and the wall immediately to the left on entering was occupied by a huge painting, almost ten feet high and as many wide, a view of a Parisian alley with six or seven quizzical figures and a white dog, since become famous as the artist's masterpiece, entitled *Le Passage du Commerce-Saint-André*. It was then nearly finished, having been worked on for almost two years, but there were certain details, the postures of certain figures which still did not satisfy the painter, and he explained these in some detail— principally to Dora—while I studied the picture with admiration in silence. The studio was rather a mess, the floor littered with scraps of paper, some of them drawings. Other paintings, most of them turned to the wall, were posed at random here and there. The visit was not prolonged, as Balthus announced himself very dissatisfied with the big painting, both reluctant and eager to hand it over to the collectors to whom it was promised, of whom he spoke with contempt. He escorted us to the car, insisting that on our way back to Paris we must stop with him for the night, as by that time he would be quite equipped to receive guests. Dora said that that was an excellent idea, with which I could only concur, whereupon we departed in the rain, while Moumoune furiously went on meowing and clawing in her basket.

En route to Lyons, Dora expressed doubt about the contemporary viability of masterpieces, maintaining there had been none, and none possible, since *Guernica*, which, as a matter of fact, she had had a hand in creating, having helped Picasso to paint the lines that indicate hair on the horse's body. And Picasso was also an admirer of Balthus, owned a beautiful picture by him of two children, painted before the war. She, too, possessed a small painting which Balthus had given her as a gesture of thanks for her help in cleaning up his Paris studio before the move to Chassy. But it was unsigned, and she was having trouble getting the capricious painter to sign it. That had always been a bother with Picasso,

too, for it had seldom been difficult to persuade him to give things but next to impossible to get them signed, which was his malicious way of making a gift without entirely giving it. Etc. More talk about Picasso's perversities.

It was nightfall by the time we reached Lyons and found our hotel, on the main square of the town. The rooms were along the same corridor but not adjoining. We had dinner in the hotel dining room, talked about Balthus's strange but courageous resolve to live in such a remote, austere, uncomfortable excuse for a château, and Dora said that, perhaps, the concept of a masterpiece was not altogether passé. When we went upstairs afterwards there was but an instant's hesitation in the corridor, only long enough for both of us to think that we were alone together in a provincial hotel, where anything that happened could happen without the world being any the wiser. Then I took her hand, kissed her on the cheek and said good night, and she turned away quickly to go to her room, and I was satisfied that what had happened was what the situation wanted.

At Valence in the morning the rain ceased. The clouds lifted after Montélimar and we drove onward toward Orange between fields white and pink with the bloom of almond and cherry trees. The poplars were turning green and the willows pale yellow. Out of the sun the wind was chilly but not really cold. We arrived in Ménerbes well before sunset.

I had forgotten how run-down, dilapidated, and comfortless the house was. Of twelve or fifteen rooms, only four or five were habitable. On the top floor were the three bedrooms, plus two bathrooms and the toilet, the only one in the house. Dora's room was to the right of the staircase, mine to the left beyond the intermediate room. We threw back the shutters and the wind was frigid. In the distance rose a mountain capped with snow. "Mont Ventoux," she said. The furnishings were sparse, homely, of local manufacture. There was no heating of any kind. Beyond my bedroom, a bathroom had been installed in a smaller room. She remarked that the water, at least, would be boiling hot. And the kitchen could be made comfortably warm in any weather, so that was where we could spend our time as long as it stayed cool outside. She offered to show me her studio. It was on the main floor, beyond the ruined library, a large, barren room with a couple of easels and scores of canvases turned to the wall. For a moment I was fearful that every

one of these might be presented for my appreciation, but only five or six were casually displayed, landscapes of wild, mountainous country, vibrant, romantic, somber. I supposed that she would sooner or later give me one and felt pleased at the prospect. One corner of the studio was walled off, a narrow door with an antiquated lock leading into it. Dora laughed. "That is the secret closet," she said, "where I keep all my most precious possessions."

I unpacked my few clothes and put them into a cupboard in the bathroom. The shelves were covered with newspaper, I noticed, editions of *Le Provençal* from the previous August, and the few coat hangers were of the cheapest raw wood. The cake of soap on the basin was half its original size, and the towels were thin and rough. The luxury of Ménerbes was clearly not to be material or physical, but that didn't trouble me. The house offered a different order of grandeur.

"Watch out for scorpions," warned Dora. "The place is infested with them. Shake out your shoes in the morning before putting them on. Oh, their sting's not fatal, but I'm told that for a few hours you can almost wish it were." She laughed. "I've never been stung myself, and Moumoune plays with them. Picasso's sign is Scorpio, of course."

We had dinner in a café at the foot of the hill, as there were no provisions in the house. A maid named Artemis would appear in the morning, and it was she who would do marketing, housekeeping, laundry, and a modicum of cooking. She was short, fat, and a widow not yet aged forty. Her name much amused Dora, especially by its association with chastity and the jealously guarded virginity of attendant nymphs. "Those things are no laughing matter around here," she said. "Picasso and Françoise came to stay here in 1946, and they made a spectacle of themselves, kissing in public, a man old enough to be her grandfather putting flowers in her hair. People in the village were very shocked. The Riviera was the right place for them."

We walked back up the hill under the Milky Way and the village was as silent as the Sahara. When she unlocked the front door with its giant iron key, the echo in the white staircase sounded like a tocsin, and this was indeed the moment I had been awaiting with malaise. How would we take leave of one another at the instant of parting under her roof alone together in this lonely house for the first time? The aura of the very first night would be superimposed on all that followed. At the

top of the staircase, in front of Dora's bedroom door, which stood open, there came a very specific pause between us, a sudden and uncertain silence, a defining hesitation which can only have been what both of us had expected. It was the instant which I had believed would be categorical, when the subtlest gesture one way or another might determine things forever, and I had been afraid but had no time to be now. Bending quickly toward her, I kissed her cheek, pressing her hand at the same time, said good night, and did not wait for the instant to have a sequel. The choice had not been difficult, but as I turned away I felt shaken. And yet who was I to take for granted what may have been sheer presumption on my part? My room was freezing cold, but there were plenty of cheap blankets and I slept wonderfully.

Artemis was in the staircase with a mop and bucket when I came down, a swarthy, black-eyed, black-haired woman the shape of a barrel, attired completely in black. Her greeting was dour, inspection searching and, I felt, censorious. The kitchen, though gloomy, was warm. There were but two windows set high up in the wall and crisscrossed with iron bars. From the center of the vaulted ceiling a single bulb hung on a wire. Dora sat sipping tea at a large table covered in green oilcloth. There was fresh bread, butter, and apricot jam. She was wearing a quilted jacket lined with down, which made her look twice her size, and she said it was called the Eskimo coat. She hoped I would be happy here, she said, for this was not a house that till now had been associated with much happiness.

I assured her that my contentment could be taken for granted.

The house's origins were ancient, but it had been renovated and enlarged after the Restoration by someone called the Général Baron Robert, who had also given his name to the street in front of his mansion. One hoped that this individual might have been the seductive Robert of *The Charterhouse of Parma*, but that seemed unlikely. Still, a sense of romantic grandeur, however ramshackle now, did prevail. And then there was the prestigious association with Picasso. During the war Dora had felt a craving for rural pleasures while unable to leave Paris and had frequently said how much she would enjoy having a house in the country. A man who came occasionally to Picasso's studio had recently bought a house in Provence, a part of France then unvisited by people who had no business there, and nearly untouched by contemporary corruption.

But hardly had he begun to make this house habitable before his wife was killed in an auto accident and he now felt intolerable despondency the moment he crossed the threshold, and wanted only to be rid of the place. He wondered whether Picasso might not be interested in having it and said that as payment he would gladly accept a painting of the artist's choice. Picasso, always amused by barter, asked what the house looked like, whereupon the man produced a snapshot from his wallet. After glancing at it for a moment, the painter handed the snapshot to Dora and said, "Here is your house in the country." The former owner was invited to take his pick of paintings in the studio, and he chose a rather large recent still life. "Making this a very expensive residence," Dora remarked, "at today's prices."

But they had been unable to visit the house until the war was over. In the summer of 1945 they went south together and in considerable discomfort spent a week or so at Ménerbes.

"Did he do any painting while you were here?" I asked.

Dora laughed. "He painted the toilet seat. There was an antiquated wooden toilet seat in those days, and he painted it green, decorated with flowers. Naturally I had it replaced with more modern conveniences as soon as I began living here and had proper bathrooms installed."

"And what became of the Picasso toilet seat?"

"Why, I threw it out, of course. Even for Picasso, even for me, there is a limit to idolatry. And how like him to select that spot to paint when he might perfectly well have decorated the walls in the salon. After all, the house was his gift. That suggests the spirit in which he gave it. He made a few drawings, too, but trifles."

A year later, when the artist had definitively broken with Dora and was living openly with Françoise in the rue des Grands-Augustins, he came around one day to the rue de Savoie and asked Dora for the keys to the house in Ménerbes, as he wanted to go there with Françoise for a holiday. Whether Dora might have planned to use her own house for her own holiday evidently was irrelevant. "I was an idiot at the time," she said, "so I gave him the keys. And when he came to return them I asked him whether he'd done any work while there and he said, 'Yes, a lot, but I didn't leave anything when departing.' "

Ménerbes was about halfway between two sizable towns, Cavaillon and Apt. We drove to Apt that first day to go marketing and do errands.

I carried the large straw basket, and when it was full, Dora said that she would leave me for a moment, as she wished to go into the cathedral. She was gone for an hour, more than enough time for me to become indignantly impatient. Not a murmur of apology or excuse was forthcoming, however. En route back to Ménerbes along the narrow, curvaceous roads, she said, "Sometimes, when I confess, and I say to the priest that I have nothing to confess to, I wonder whether he believes me."

"Isn't he compelled to?" I asked.

"You know nothing about it," she replied. "If only you did. Sin, you see, is not necessarily something one is sure of. The priest grants absolution as forgiveness for doubt."

But I didn't want to know. Her superiority embarrassed and humiliated me. I asked her whether she had ever called Picasso by his first name, and she said, "Never." She said there was nothing more elevating than to call a great man by the name he has made glorious. Was it thinkable to call Beethoven Ludwig?

We ate all our meals in the kitchen, and when it was too cold in my room I wrote there. Dora painted with gloves on, wearing the Eskimo coat. She said that within a few days everyone would know we were there, and that it was a nuisance. Nicolas de Staël would tell Douglas Cooper and John Richardson, who would tell Picasso. Ida Chagall might turn up. And then there was a couple named Tony and Thérèse Mayer who had a house near the church. He had some cultural position at the French embassy in London. They were bound to extend invitations that it would be impossible to refuse. Ménerbes had never been heard of when she first arrived there. Picasso's transitory presence had changed everything. Now she was someone of consequence in the village. People observed. People talked. People made assumptions. "Your presence here," she said, "makes me a different person."

"But *we* are unchanged," I said.

"You know nothing whatever about suffering," she said.

She possessed an infallible capacity for representing me to myself as superficial and naïve, which I resented and accepted and, in fact, appreciated as evidence of her esteem and affection. It was quite true that I knew nothing about suffering, although the subject and constitution of it were often on my mind. Moreover, I enjoyed her assumption that

she had every right to put me in the wrong. Then I could show my resentment by driving ahead in sullen silence.

"I think it would be nice for you to teach me to drive," she said. She had a motorbike in her barn; it was useful for errands and sketching expeditions in the countryside, but a car would be better. I told her I'd be happy to teach her.

Nicolas de Staël came without telephoning in advance. Dora had met him through Braque during the war. He was very tall, stocky, in his early forties, with a shock of dark hair, a prominent nose, and tobacco-stained teeth. He enjoyed talking about painting and held strong opinions as to what was possible for a contemporary artist and what was not, opinions with which Dora on the whole agreed. I don't think she would have had the temerity to disagree with him. Besides, he felt that abstract painting was passé and Dora definitely believed that only the representational mode was viable now. It's odd that she much later produced quantities of large abstract pictures, but that was when things were very different between us, and I never would have presumed to ask what had caused the change. We saw Nicolas fairly frequently during those weeks of early spring. His house, a small château, stood by itself at the western end of the village, approached by a horseshoe gradient and stone portico that gave it rather an air, and was perched above the surrounding country in a pine grove held up by massive retaining walls. The interior was austere, with vaulted ceilings on the ground floor, but Nicolas had made the place attractive by painting some of the rooms bright blue or brick red. There were plenty of his drawings and paintings on the walls. I didn't care much for them, but I liked him, went to see him occasionally by myself, and he gave me a book about his work by someone called Pierre Lecuire that contained a couple of original etchings, a gift which considerably annoyed Dora, as she did not receive a copy. She said that Nicolas did not understand Provence and would not profit from his stay in this part of the country, but she could hardly have foreseen that he would kill himself in Antibes a year later.

Dora and I talked about Picasso every day. In much of what she said, of which I regrettably recorded all too little, there was bitterness, resentment, a dwelling on the faults and callousness of the man, only occasionally some reference to his greatness as an artist. We talked about him so often that it gradually began to seem intolerable to keep

repeating his name, Picasso, Picasso, Picasso, Picasso, like an incantation that possessed some perhaps malign magic, which it did in a sense, because that name evoked in the world connotations and misapprehensions having nothing to do with art or with personal knowledge of the artist, and the intrusion of the world's ignorance seemed to cast doubt upon the legitimacy of our privileged conversations. So we agreed upon a pseudonym to protect ourselves in re Picasso from the vulgar world, to make certain our world was one that could not be intruded upon—that kept its secrets—and to guarantee our understanding. "*Le cher et beau*" is what we called him. It was certainly Dora's choice, as in French the expression is a colloquial one which does not necessarily signify that the adjectives dear and handsome are literally applicable but may merely imply a fond familiarity or even a slightly cynical ridicule, and after a while we called him simply the C and B.

"He claims he can draw as well as Raphael," she said. "True. But it's only a witticism. To draw as well as Raphael is never to *do* as well, because when Raphael made a drawing it was unlike any ever done before. That's why Raphael is Raphael."

In the evenings, seated at the kitchen table after dinner and wine, smoking cigarettes, we talked not only about the C and B but also about many other things, about art and the state of the world, politics, and a good deal about religion. Dora excelled in conversation, possessed a very well organized mentality, and could marshal ideas with tactical expertise. It was religion, its nature and necessity, that most engaged her conviction and passion. I could hardly respond with anything like empathy or insight, especially as Dora's religion was strict Roman Catholicism, even including papal infallibility, and my Protestant conditioning precluded concord in this realm at least. I wondered how vital for Dora such concord so far as I was concerned might have been, aware at the same time that my curiosity was vain and unworthy. And yet I enjoyed the talks about religion, liked the peremptory self-assurance with which she expressed her faith. If I could not agree with her beliefs, I did very feelingly believe in her.

"You seem to have an almost physical possession of truth," I said, "as if it were something you could hold in your hand and use like a box of matches."

"That's it exactly," Dora said. "But they are not my matches. They exist only so long as the meaning of the world is God."

Well, maybe it is, but I couldn't comprehend it. Of the three fundamental attitudes toward existence—aesthetic, ethical, and religious—it was the first that for me represented the surest approach to mysticism and thus exemplified the relation between life and ethics. Dora believed in art, in its temporal contingent of immortality, but at the same time maintained that it provided only an attitude to make bearable the ineluctable pinch of suffering and anxiety. She despised the bourgeois superficiality that made art a standard of social discrimination or, even worse, a commercial commodity degrading to the object, its creator, and its purveyor. Of her own purity of purpose and lucidity of judgment there appeared to be not one iota of uncertainty. I had never encountered a person so proud. But then . . . in the glory of her faith and her intimacy with genius, was there not matter for pride?

And after the hours of talk we would go upstairs together, Dora always in the lead, and when we came to the landing at the top, outside her bedroom door, I would lean toward her, while she tranquilly waited, and kiss her on the cheek—it was a ritual now—without the least misgiving or regret. She would place her fingertips against my cheek, my neck, my hair. And we would say good night. One evening, when she had some difficulty closing a shutter against the wind, she called me back to do it for her, which I was conscious of doing with virile efficacy. Then I again kissed her, while over her shoulder I looked down upon the immaculate, quilted horizon of her bed, and suddenly felt a quivering of physical possibility. But it frightened me and I held on to her arms to keep me secure. "Dear James," she murmured. Then the surge had abruptly ceased, so quickly it was a shock, and I went to my room.

There was a table in the center of Dora's bedroom, a straight chair in front of it, and upon the table a large notebook always lay open. Sometime early in our stay Dora had pointedly drawn my attention to it and told me that it was her journal. Very personal and private, she said, since her most intimate thoughts and emotions were set forth therein. Its permanent place was there on the table so that she could always have it at hand in case of desire on the spur of the moment to record some affecting detail. As it would happen in the natural course of things that I would often be alone in the house, she asked me to give her my word of honor that I would never steal a glance at this secret document. I immediately gave it, of course, and without the slightest disingenuous-

ness. Frequent, indeed, were the occasions when I might have read
Dora's journal, even if only the passages visible without my touching
the notebook itself, for fear she might have placed it in such a way that
the slightest touch would later be perceptible, for I definitely thought
her capable of such cunning. The door to her bedroom always stood
open in her absence, and the notebook lay on the table. But I didn't
want to learn her intimate feelings and thoughts, especially by stealth,
although her intimacy was very precious to me and I was neither afraid
nor ashamed of stealth. Maybe I was afraid of what I might learn. I
think so, because when Dora said that if provoked she could leap like
a tigress, I believed her. It occurred to me, needless to say, that if she
so specifically, pointedly drew my attention to her journal and the op-
portunities I would have to read it, she may in fact have wanted me to
do so, and that was yet another reason for avoiding it. Naturally I never
told her that I, too, kept a journal, nor did I leave it open on the table
in my room but, on the contrary, after each entry locked it in my suitcase
in the bathroom closet. What I wrote about Dora then, like what I am
writing about her now, most of which is lifted from the journal, didn't,
and doesn't, seem of a nature to offend or even to annoy, but I felt at
the time that she would very much dislike being written about at all.
And I was right. She gloried in the stark, cruel intimacy of Picasso's
portraits of her even when she denounced them as mendacious and
artificial, but a picture, despite the facile maxim, is definitely not the
equivalent of words, whether few or many. Dora wanted to be historic
without a history.

I never regretted not having read her journal. What I learned about
her by living with her told me enough, told me, I sometimes thought,
too much, more than I wanted to know, more than she would have wanted
anyone to know. But now, remembering the notebook on the table, I
wonder whether it has survived. Always an inveterate preserver of relics
and memorabilia, like Picasso's spiders and cockroaches, she would
nonetheless be reluctant, I think, to entrust to the tact of strangers the
secrets of her soul. I agree with her. To tell the story of my relations
with Picasso, Dora, and others seems my legitimate prerogative, but the
footnotes and appendixes of my own life I'd be embarrassed and ashamed
to perpetuate, which is why I destroy all raw materials, some very raw
indeed, as soon as I have finished with them. To me one of the most

moving literary events of modern times is Henry James's great bonfire
of personal papers in 1909.

Dora was exactly fifteen years older than I, having been born in
the year of the *Demoiselles d'Avignon*, 1907, her birthday November 22,
only five days apart from mine, the twenty-seventh. So in that springtime
of 1954 she was forty-six, I thirty-one. And between those two stages
of life there is a difference more profound than a decade and a half
would create twenty years later, for example, especially when the older
one is the woman and the younger an individual whose adolescence has
been abnormally prolonged not only by homosexuality but by the freedom
and easiness of his existence. I didn't dwell on Dora's age or sense that
as friends it made for much inequality between us. The inequality—
existential, intellectual, and moral—was made very clear on the basis
of her superior experience and access to revealed wisdom. This was at
times violently exasperating. Dora, however, was not indifferent to her
physique or to the mature beauty which she still possessed. She used
cosmetics sparingly but was never without them, even in the early morn-
ing, and despite the absence of the manicurist her fingernails remained
impeccably filed and crimson. That I never saw her ministering to her
appearance goes without saying, but I did hear her. Her figure had
always been ample, a feature very attractive to Picasso, but by this time
she had grown more fleshy than was becoming, particularly in hips,
buttocks, and thighs, consequently had undertaken a regime of calis-
thenics to combat this condition and was diligently conscientious about
performing these exercises every afternoon in her bathroom. Her deep
breathing and gasps of exertion were very audible from the staircase or
any nearby room, even my own if the door was open. Only once, with
some embarrassment, did she explain at the very beginning of our stay
what this stertorous respiration signified. In my callow, supercilious
egotism I listened to the sounds of her exercising with condescension,
thinking it rather pitiful that she should struggle and strain virtually in
public to achieve a result ultimately unattainable. This contemptible
attitude was peculiarly contradictory, because at the same time I never
ceased to be under the spell of her beauty, the lambent gleam of her
gaze, the bird-of-paradise voice, the aristocratic tilt of head, all the aura
of tense serenity and power and pathos so poignantly portrayed by Pi-
casso.

The weather had turned warm and every day the sun shone down into the valley. In the garden bloomed white, yellow, and purple flowers. Dora knew of a field on a side road beyond Gordes on the way to Apt where millions of white narcissi grew wild; she suggested we drive over there and pick some. The little Renault had a sunroof that slid open. It was almost like summer. As we drove, the breeze seemed to lift us into the sky with sweetness, and at the crossroads the willow trees' leaves were silver. She knew the way. The field was like a pure white cloud drifting in the green sky. She grasped my arm. The fragrance was dazzling when we got out and stood in front of that bewildering profusion, hundreds of thousands, millions of pure white narcissi rippling under the sun. We ran into the midst of them together, striding through the starry flowers as if they were surf. I picked a handful and held them out to her. She laughed. There were so many, truly millions. It was an ecstasy, bending above the cool flowers, snapping their stems, the sap flowing over my hands like water, their radiance in my face a mirror, and I thought without shame of the myth, its veracity and intoxication, the painting by Caravaggio. And when we had gathered such huge bouquets we could no longer hold them, we threw them onto the rear seat of the car. Until it was full, and Dora cried, "Enough, enough! We won't have vases and jars and bottles to put them all into." So we stood in the sun at the edge of the field in the pristine gleam of the flowers and she took my hand. "You could never tell that a single one was missing," she said, and it was true, the flowery surface appeared untouched, untrampled, immaculate. So we drove back to Ménerbes with our perfumed cargo. She pressed her fingertips gently upon my cheek and said, "I don't know, really, why I've gotten into this habit." And indeed there were not enough vases, pitchers, jugs, or jars in the house to hold all the flowers. We put them in every room and on the landings of the staircase and the whole house was filled with their fragrance.

Everyone who could have been in the least interested in our presence doubtless did learn of it fairly soon. Dora said she felt it only right to call Douglas, as he was very touchy and might be put out, he a permanent resident and she only an occasional one. But he was not in the least put out, was leaving for London the very next day, would return, however, in a fortnight, when he hoped that we would come to dinner whenever we liked, stay the night if we wished, feel free to make ourselves quite at home. So we had dinner with Nicolas de Staël and

accepted an invitation from Tony and Thérèse Mayer. Their house was only five minutes' walk from Dora's up the ill-lit street across the square in front of the *hôtel de ville* and along toward the church. It was far better furnished and more comfortably installed than the Maison du Général Baron Robert. Though plain and unpretentious, there was an air of elegance about it, the few pieces of antique furniture authentic, and welcoming flames in the fireplace. Both Thérèse and Tony were smallish in stature and possessed that vivacity of speech and quick sociability so often characteristic of such persons. They were immediately most cordial to me and obviously on terms of long-standing familiarity with Dora. Food and wine were excellent and plentiful, conversation animated, and I was made to feel as intrinsic an element of the party as anyone else, so I delightedly indulged in the freedom, talked without restraint, drank a bit too much, and had a thoroughly good time. We were still at the table when midnight tolled from the discordant town clock. Dora said it was time to go. But I protested. A few sips of marc still lay in the hollow of my glass, and Thérèse and Tony also insisted it would be a pity to terminate such an enjoyable soirée for the convention of midnight. We stayed on for half an hour, the only people, Thérèse said, still awake in all the Vaucluse.

Indeed, it was totally still as we walked back along the narrow street. I said what a delightful evening we had had.

"Your conduct was absolutely intolerable," said Dora. "Not only your rude refusal to leave when I suggested it. But throughout the entire evening."

"I don't understand you at all," I said. "I was only the way I always am."

"Precisely!" she exclaimed. "And that's just the way you shouldn't be when with strangers. You don't know Tony and Thérèse at all, and yet in front of them you behaved as if we were the most intimate of friends, showing me not the slightest deference, taking me completely for granted. What do you suppose they will think?"

"Does it matter?" I irritably asked.

"It matters," she cried. "It matters as much as anything can matter. And if you can't understand why that is, then maybe I've been mistaken from the beginning."

She said nothing more, nor did I. I was angry, felt put upon, unjustly accused, and now sufficiently sure of my status to allow some displeasure

to show. When we reached her house, we went upstairs in the usual order, but there was no kiss outside her bedroom door that night. I went straight to my room, closing the doors firmly but not noisily behind me.

It was the next morning that I found the scorpion in my shoe. I had heeded the warning, had seen a few of the nasty, crab-like insects around the house, and had tried to kill them, but they were quick to retreat into the crevices where they dwelt. This one, however, falling from my shoe to the center of the bedroom floor, had no crevice to escape into and remained where it was, adopting a posture of attack, with claws raised and venomous, ribbed tail curved aloft. I remembered that the scorpion was Picasso's astrological sign and Dora's having said that its sting, though not fatal, was so painful it could make one wish to die. It seemed a peculiar coincidence that I should have found this malevolent creature in my shoe on the morrow of our quarrel. I had heard that the scorpion was one of the rare species wont to commit suicide, stinging itself to death whenever confronted by fire. So I lit a match and held it down close to the creature's head, though not close enough to burn it, and indeed it arched its tail forward and struck itself repeatedly with the venomous sting at the top of its segmented thorax. This did not seem to kill it, however, for it scuttled backward from the flame which nearly scorched my fingers. I tried another match, with the same results, and yet another. The suicidal impulse seemed genuine, but death did not ensue, and I was suddenly, disagreeably conscious of the childish impulse to tear the wings off flies, dismember grasshoppers, and molest small, defenseless insects. I stepped on the scorpion with the shoe in which it had hidden, gathered up its remains with the burned matches in a scrap of paper, and threw it all out the window. But I was not unaware that there had been a certain sexual excitement in the deliberate torment of that scorpion.

I found Dora in the kitchen. She said, "Thérèse has already called to say that she found you utterly charming."

I said something self-deprecating, then there was no further mention of the previous evening, and a few days later we went with the Mayers to a restaurant in Cavaillon for dinner.

•

Dora riding out on her motorbike to make watercolors in the countryside, I thought, looked rather ludicrous, her hair done up in a woolen

scarf and with a sack slung over her shoulder, decidedly too old for that kind of conveyance. Even I would no longer have been willing to be seen whizzing around on a motorcycle. And so it did happen that I was often alone in the house, since Artemis usually departed soon after lunch. This left me tranquil hours to work on my novel, work I was encouraged to pursue all the more conscientiously as I received news while there that an English publisher seemed ready to bring out my previous book. When not writing, I went for drives to the other haunting and deserted little villages of the valley, Gordes, Goult, Roussillon, Bonnieux, Lacoste, where the ruins of the château of the Marquis de Sade clung precariously to the hilltop. Or I wandered around the garden and throughout the house, looked at all the paintings in Dora's studios, picking out the one I would select when she offered me my choice. And of course I was inevitably drawn to the door of the secret closet, aquiver with curiosity as to what treasures or secrets it could contain. Careful inspection of the lock indicated that it was of a very ordinary type which might be opened by a considerable variety of keys, so one afternoon when Dora had gone sputtering off on the motorbike I collected all the keys from the doors and drawers and closets in the house and started to try them one after another. I must have had a score of keys, but the third or fourth did the trick. Gray light fell from a small barred window set high up in the wall and dust-encrusted spiderwebs hung over and upon an incongruous collection of junk—broken kitchen utensils, lengths of rusted wire, misshapen oddments of scrap iron, fragments of antiquated bathroom fixtures, and bits and pieces of unidentifiable metal, pottery, and glass. On a shelf facing the door rested a small black portfolio containing three slight and smallish sketches in India ink, clearly by Picasso, though unsigned, views of rooms in the house. And that was all there was in the secret closet, a baffling and preposterous mess. I had a lot more trouble getting the collection of keys back into their correct locks than I'd had in penetrating Dora's mysterious secret.

"You ought to go and pay Picasso a visit," she said one day.

I objected that it was impossible ever to be sure he would receive one, and Vallauris was a long way to go just to be told that the artist was busy.

"You write him a letter," Dora said. "Tell him that you're staying here with me. He probably knows it already anyway. You'll see. He'll

receive you. And we can send him a present. There's nothing he likes more than to receive a present."

I agreed to write, adding that I could also arrange to spend an evening with Cocteau while on the coast and then stop in Aix-en-Provence on my way back to see how the renovation of Cézanne's studio was progressing.

Dora had not forgotten my promise to teach her to drive and was determined to hold me to it. I thought the business would be easy, because it had been easy for me to learn, taught by my father when I was fifteen. As she was intelligent, she quickly understood the basic operative functions and maneuvers. A car, however, is not driven by intelligence but by the habitual, instinctive interaction of motor relations between eyes and muscles conditioned through long experience, and it is a fact which I did not yet understand that these relations are far easier to master for a young person than for an adult. There was, luckily, very little traffic on the roads around Ménerbes, but when Dora was at the wheel I was always prepared to seize it if collision threatened. Time after time I showed her how to shift into first, then release the clutch while cautiously pressing down on the gas. The car would lurch and stall and then we would have to start over again. I was patient, reassuring, composed. It was Dora, usually so self-assured and authoritative, who showed irritation and impatience. Obviously, she disliked being the one whose faculties required training, to which she would have to submit meekly in order to attain the desired outcome, and I sensed that she particularly disliked submitting to instruction from me. And yet she stubbornly insisted on it. To try to teach a skill to someone who has no aptitude for it is exasperating. Oddly enough, though exasperated, I enjoyed the driving lessons. Her perseverance, her willful pride in it, seemed to bestow upon me a measure of power and superiority which were not mine under any other circumstances. When I told her to do this or that but not the other, she had no option but to obey, and this plainly irked.

By obstinate tenacity she made progress, gradually learning not to take her foot all the way off the clutch while pressing down on the gas pedal, to apply the brake gently, and to shift gears without stalling. There were still plenty of chaotic lurches, jerks, and sudden stops, but I began to believe that one day she would actually be able to drive, and

felt quite satisfied with my skill and patience as an instructor. Until the day of the accident. It was raining, and I never should have allowed her to drive when the roads, surfaced in smooth asphalt, were slippery. We were going toward Cavaillon by the side road, approaching a crossroads where there was a farm, and as an exercise I thought it a good idea to tell her to turn right, which would take us to the main highway, so I said, "Turn right at the crossroads." She obediently did so, but took the turn too sharply, swerved toward the roadside, and to compensate stamped down on the brake, causing the little car to veer into a skid, and in an instant we had plunged rear-end first into the ditch on the left-hand side of the road. The impact was not violent, as we had not been going very fast. Still, I was afraid Dora might be physically shaken and psychically shocked, so I put my arm around her and said, "Don't be upset. It's all right. Everything is all right."

Whereupon she turned, pushing away my arm, and said, "I'm not in the least upset. And of course everything is all right. What you'd better do is go and find somebody to pull us out of this ridiculous ditch."

I went, and by extraordinary good fortune found the proprietor of the nearby farm, a genial, white-haired codger much amused by our mishap, who willingly harnessed a team of two horses and had the little Renault back on the road in a few minutes, Dora never having gotten out into the rain, only shifting herself to the passenger seat. The farmer refused to accept any payment for his kindness and trouble. A few days later I stopped there and gave him a couple of bottles of wine, which he laughingly accepted. The plunge into the ditch seemed not to have damaged the car but simply covered it with mud and weeds, and after a few tentative coughs it started up and rolled away without the least malfunction. I remarked that we had been very lucky, to which Dora retorted that she had known much worse. I did not ask for details. At all events, that was the end of the driving lessons. She never mentioned them again, nor did I.

I wrote to Picasso, telling him that I was staying in Ménerbes with Dora, that I might come to Vallauris the following week on Wednesday or Thursday and hoped that it would be possible to see him. I also called Cocteau to invite myself for dinner at Madame Weisweiller's villa. With his infallible affability he said that Wednesday evening would be fine, offering also to engage a room for me at the Grand Hôtel du Cap-Ferrat,

which was nearly next door to the villa. Among the numerous artists whose help of one sort or another I had solicited in the campaign to save Cézanne's studio was Henri Matisse, who had been singularly forthcoming and generous, and so I arranged by telephone with his daughter to call on him when passing through Nice. I then made an appointment to meet with the people at the University of Aix-en-Provence responsible for overseeing the renovation of the studio, and my plans were all in order.

This suited Dora perfectly, as she expected a visit from her old friend Catherine Dudley, and it would almost coincide with my absence, for Catherine was to arrive on the Tuesday.

Sometimes we went to the movies in Cavaillon. One evening, on our way back to Ménerbes, it happened that the moon was full, shedding its nacreous light upon the snowy almond trees, silver fields, and tawny villages, and the wind felt almost warm. Dora said that such a lovely night was unique, would never recur just as we saw it then; thus, we should make the most of it while we were able to, and she knew an ideal spot from which to admire the view, an abandoned village called Oppède-le-Vieux, with a château in ruins above it. This was off to the right. We had to leave the car at the entrance to the village and climb up steep, uneven streets between tumble-down houses in the moonlight. There was a church apparently not quite as abandoned as the rest, then the ruined château beyond, and we clambered up a little way to the remains of a wall where we could sit, and the view across the valley by the light of the enormous moon was truly unique, the silence immense. The air up there was a little chilly, though, and I asked Dora if she would like to have my jacket. She said no, just to put my arm around her shoulders. For some time we sat there without speaking, until at last Dora said that there was no eternity for us, after all, that we would die and the moon nonetheless shine just as it shone now. But as long as we both lived, I said, this unique moment would live, too, timeless and changeless, because we would remember it and always keep the moment alive just as it then was for us both. Dora sighed. She didn't answer but put her hand over mine. We stayed there for some time longer but eventually went back down to the car and drove home. Before going to bed, I looked for a long time out of my window down into the valley, and wished that what I had said could be true.

Dora seemed excited by the prospect of my visit to Picasso and made much of the necessity of finding an appropriate present that she could send him. We had lengthy discussions about what would be just right. It must not be costly or precious but must be rare and, above all, unexpected, an object both surprising and practical. The question was puzzling, and I could see that Dora was preoccupied by it. The object she finally decided upon definitely surprised me. Dora knew Picasso infinitely better than I did; therefore, I supposed that her choice would please him. It was the rusted, twisted, broken blade of a shovel to which a splintered bit of the wooden haft still adhered. I recognized it at once as one of the items of junk from the secret closet. Very satisfied with her choice, Dora felt certain it would please Picasso and thought he might very well put it to use in one of the sculptures he often fashioned of oddments rescued from the public dump. She wrapped it in brown paper, tied it up in heavy twine, and wrote in india ink: *Pour Picasso, Vallauris, A.M., expéditeur Dora Maar, Ménerbes, Vaucluse.*

If I left Vallauris on Wednesday, Dora said, I must be sure to be back in Ménerbes by Friday evening, because it took some time to close up the house, and we wouldn't want to be hurried in our departure on the Sunday. This was the first mention of departure, and we had by that time been in Ménerbes barely two weeks, though it seemed to have been far longer. I expressed some astonishment, in which a nuance of annoyance must have been perceptible, for Dora brusquely observed that she had important things to do in Paris and could not contemplate idling away her time indefinitely in the country. Moreover, it was all arranged. We would spend Sunday night at Castille with Douglas and John, Monday at Chassy with Balthus, which would save the expense of hotels and two dinners en route, a very welcome economy. She had already spoken to Douglas and a telegram in due time could be sent to Balthus. The house, after all, was Dora's, and I her guest. Consequently, my acquiescence in plans about which I had not been consulted could be taken for granted. It seemed a deliberate ploy to irritate and offend, doubly so in that I was unable to respond.

I had taken a decided dislike to Moumoune. She was a sly, suspicious, evasive animal, aloof and indifferent as only cats can be. Even with Dora she was distant, seldom approaching for caresses or signs of affection and exceedingly particular about what she would eat. At first

I had endeavored to show some care for her, but she must have sensed my insincerity, because she shied away whenever I tried to pat her. And one afternoon when Dora was out I encountered her on the third-floor landing of the staircase. Meaning to be indulgent and good-natured, I leaned down to give her a pat, whereupon she lashed out with one of her paws and drew blood on the back of my hand. The pain was instantaneous, so I gave the cat a brutal kick that sent her flying down the staircase with a strident meow. I was delighted at what I'd done, not remorseful in the least, and aware that symbolic associations attached to brutality toward a woman's pet cat. The scratches did not prove very deep. I ran cold water over them, poured on some eau de cologne, wrapped the hand in a handkerchief. The blood stopped flowing before Dora came home, but she naturally noticed the scratches, laughed, and said, "I see you've been making love to Moumoune."

Catherine Dudley was American, from Chicago, had lived in Paris since the twenties, and knew all the people in the art world there. Though not an artist herself, she had had many lovers, including the Bulgarian painter Pascin, but had never married. She lived with her sister Dorothy in a large apartment looking out onto the dome of the Institute. They were thought to be rich but lived modestly. Catherine had been visiting somewhere along the Riviera and would be traveling from there by bus, which came only as far as Bonnieux, about ten kilometers distant, where we would have to go and fetch her. She was waiting for us in a café, drinking a cup of hot chocolate. Older than Dora, gray-haired, she may have been close to sixty at the time, probably had never been beautiful, but had a personal elegance and élan all her own. One felt immediately that she could be counted upon under almost any circumstances to be sporting, outspoken, easy to like. Her only luggage was a much-worn canvas satchel. As we drove back to Ménerbes she told Dora with great satisfaction that she had arranged to rent for relatively little a pleasant house at the water's edge on the island of Porquerolles for the month of July. In Ménerbes she was to occupy the bedroom adjacent to mine but share the bathroom with Dora, at least for the one night before my departure. And she would be gone by the time I returned, obliged to take a taxi as far as Cavaillon, an expense both she and Dora deplored.

Dora was not a very good cook. The diet at Ménerbes had been monotonous, though perfectly wholesome, despite the fact that Artemis

prepared some of the food. For Catherine, however, a special effort had been made—pâté, rack of lamb, new potatoes, and lemon tart, with an excellent wine, not the *vin ordinaire* we usually drank. And it was very jolly. I suddenly realized that this was the first time we had had a guest in the house for a meal. Nicolas and the Mayers had come for drinks before we went to dine in a restaurant, but this was a special occasion, and I soon became aware that Catherine had known Dora and Picasso well when they were together. This became even plainer when Dora made a bitterly critical comment about Picasso's shortcomings as a father, his mistreatment of his son, Paulo.

"You shouldn't speak about him that way," said Catherine. "After all, you owe everything to Picasso."

"Nonsense!" cried Dora angrily. "I owe him nothing. In truth, it's the other way around. He used me for his art. He used me unmercifully. Just look at the so-called portraits of me he painted."

"Which you treasure," Catherine remarked.

"Well, of course I do," Dora said. "Is there any choice?"

"Have you heard that a large selection of his works from Russia is coming to Paris?" said Catherine. "Pictures none of us have ever seen. To be exhibited at the Maison de la Pensée Française, a Communist den, needless to say."

"What do I care?" Dora exclaimed. "I've seen enough Picassos to last me a hundred lifetimes. Well, of course I care, but I have to say I don't. It's so intolerable that everyone is in love with Picasso. James is going to Vallauris tomorrow to woo him."

"Bearing a gift from you," I said.

"How humiliating," sighed Dora.

The drive over the mountains toward the coast the next day was tedious and slow, especially at the wheel of a four-horsepower Renault. I reached Cap-Ferrat by the end of the afternoon, going directly to the Villa Santo Sospir at the tip of the cape, a smallish house set amid sumptuous gardens where Cocteau lived with his boyfriend Edouard Dermit, known to all as Doudou, and their host Francine Weisweiller, a beautiful young woman whose immensely rich husband permitted her to live as she pleased and himself to do likewise. Just what *modus vivendi* prevailed among the three inhabitants of the Villa Santo Sospir nobody knew, but tantalizing speculation abounded, not of much interest to me,

as Cocteau was the only one of the trio I found truly appealing, though I was not insensitive to the muscular allure of Doudou. The four of us had dinner together and afterwards sat on the terrace, chatting and drinking ice-cold pear liqueur. Francine's favorite flower was the tuberose; there were vases of them all around the villa and their haunting odor filled the dark. Cocteau was intrigued by the prospect of my visit to Picasso the next day, almost envious, I thought, and entrusted me with pressing messages of affection and the promise of an imminent visit. It was late when I went to the nearby hotel.

April now was almost over and the following morning seemed next door to summer. Driving to Vallauris to see Picasso, I felt the exhilaration of the sun and the sea and the air like a flood in my veins. I left the car by the roadside and walked up the unkempt slope, hugging Dora's parcel under my arm. La Galloise was as small and ugly as ever and I went up the outside staircase to the front door with greater confidence than I would ordinarily have felt when presenting myself on Picasso's threshold. In response to my knocking, an elderly woman appeared, unknown to me, and wearily inquired my business. It was then some time after eleven o'clock. Giving my name, I told the woman that I had in hand for Monsieur Picasso a parcel to be delivered in person. She closed the door but came back promptly to let me in. Picasso's bedroom was to the left of the doorway. He was sitting up, torso nude, in a vast brass bedstead that creaked melodiously as he gestured to me, brushing aside newspapers, letters, etc., to sit down on the edge of it.

"Well," he said, "it's a long time since we've seen one another. You neglect old friends."

I protested that, after all, our last meeting had been only the previous August, eight months before.

"So now you're living with Dora in Ménerbes?"

"Yes, and I've brought you this gift from her." I handed over the parcel.

Picasso weighed it between his hands and pressed the wrapping paper, as if trying to guess what was inside. "Very generous of little Dora," he said. "But it's only fair. I sent her a present not long ago. Rather a sizable one. Have you seen it?"

I said I had. Then he asked whether by chance I'd been present when the crate was opened.

"Indeed!" I exclaimed. "I did the job myself, a damned hard one it was, too, took forever."

Picasso was seized by a convulsion of hilarity, whinnying his high, vibrant laugh. Then he said, "That carpenter is a wizard. I told him the thing should be very secure. Who knows what furtive hands might be tempted to open a box bearing my name. And the contents must justify the trouble. So you did succeed in opening the crate?"

"Eventually."

"And the contents? How did little Dora take to the contents?"

"Oh, any gift from you would have pleased her very much."

"She thought that chair a thing of beauty?"

"She was very pleased."

"And you, my little Lord, what did you think of it?"

"To tell the truth, I thought it absolutely hideous, ugly beyond comparison, and in addition far too big."

"Isn't it!" cried Picasso. "Isn't it the very ugliest thing anybody ever saw!" And he burst out laughing again. "A young Englishman who lives here makes them. I bought several. In addition to being extremely uncomfortable, they ruin any room you put one in. So I thought I'd send a few to people I know, and they would never want to get rid of them because I'd sent them. Still, it's not an idle joke. Don't think ill of me. A gift of ugliness is challenging. For example, the uglier my paintings become, the more people are eager to buy them. But I must see what my darling has sent to me." He daintily pulled at the knotted twine with his long fingernails, unfolding the wrapping paper with exaggerated care, extracting from it the rusty shovel blade, which he turned over and over, nodding thoughtfully as he inspected it. "Yes," he murmured. "Yes. Adorable Dora. She would have had to select something just right. I'm sure she gave a great deal of thought to it. Something unique, priceless." He spoke apparently in all seriousness, and I was afraid that he might ask my opinion, but he didn't, only continued turning the object in his hands and nodding. "So you will please tell Dora that I am very grateful. Very, very grateful. You won't forget, will you?"

I promised not to.

"Life is vile," he said, dropping the shovel onto the tile floor, where it came down with a violent crash. "How old are you, my little Lord?"

"Thirty-one."

"I'm not surprised. And tell me, how is darling Dora?"

"Very well. She's a wonderful person. I admire her so much. Her intelligence. Her integrity. I've never known anyone like her."

"Neither have I," said Picasso. "Never known anyone so—what can one say?—so convenient. She was anything you wanted, a dog, a mouse, a bird, an idea, a thunderstorm. That's a great advantage when falling in love. Wouldn't you say so?"

"I hadn't considered it in that way."

"It appears, people say, she has become very worried about her soul. Is that so?"

"I think it is. She goes to Mass often and talks about religion."

"And writes me letters telling me to think about salvation. But that's God's business, not hers." On the wall behind Picasso's bed hung a small painting of a woman in *grisaille* that looked like his interpretation of a Cranach.* It was beautiful, and I was tempted to ask him to send it as a gift to Dora, but I didn't dare. Also tacked up was a reproduction of a recent painting by Nicolas de Staël, apparently torn from a magazine. I remarked that Nicolas also lived in Ménerbes, where we had seen him occasionally, and said that he would be happy to know that his work was admired in this house. "It's not!" exclaimed Picasso. "I keep that reproduction there to remind myself every morning that painting can be shit, nothing but shit. And what about Ménerbes, the house I gave her. Is it habitable?"

I assured him that it was, though many of the rooms were in a state of dusty disrepair. Picasso snorted and shook his head, declaring that it was a scandal to neglect needed repairs, that the house possessed a potential for real splendor but Dora was too stingy to pay for that. It occurred to me that maybe she preferred to keep the place as it had been when he and she were there together. But I said that repairs were expensive, too expensive, perhaps, for Dora.

Picasso slapped his bed emphatically. "She has plenty of resources," he declared. "I should know. Enough of my things to last a lifetime. She squeezed me like a sponge to get them. And cash comes first. Generosity is not her forte. Maybe it's her virtue. Have you come across many scorpions?"

* Apparently not in Zervos.

"A few."

"They love to hide in the toilet. Be careful. One sting on the balls and you'd be a eunuch for life." He laughed. "I painted the toilet seat to give it a Pompeian air, and so Dora could sit on my work while she shits."

I told him that more modern toilet fixtures had since been installed. And what about his painted seat? He wanted to know, and I felt he deserved to, so I told him Dora had thrown it away.

"No respect for the past, tradition, history, only for the Pope's piss," he said irritably. "So tell me, how is your friend Bernard, the one you often came to the beach with."

I said that Bernard was fine.

"He had the body of a saint by Greco. You still see him, then?"

"Yes. I have something I want to ask you, a favor."

"For him?"

"No. For Cézanne." I explained what efforts were being made, had already been made, to restore Cézanne's studio and make it a museum dedicated to the memory of the father of modern painting. Help, however, was still needed, and I had thought that if he would make a lithograph to be sold for the benefit of the studio it could bring a substantial sum. Would he do this as a gesture of homage to an artist who had meant so much not only to him personally but to almost every major artist of the succeeding generation?

"No," Picasso said. He wouldn't do it. And if I wanted his opinion, he said that the best thing that could be done with Cézanne's studio would be to give it to a young artist to work in. I disagreed, and was indignant, though I tried not to show it, thinking of all the lithographs he'd done for the Communist Party, for his own exhibitions, for bullfights, and any number of other events. Museums, after all, were important, I maintained, even so small a museum as one where the principal exhibit would be spiritual, and, as everyone knew, museums were congenitally short of money.

"Well, if they've got no money," said Picasso, "let them go to work."

I considered it a callous, cynical remark, especially since Picasso's own museum in Antibes was a going concern, but made no reply. In the decades since, however, I have often thought of Picasso's remark

and wondered whether he wasn't speaking with uncanny prescience, for the world's museums have, indeed, gone to work with a vengeance, have become big businesses, and vengeance is truly the appropriate word for the will with which they have utterly transformed their status and purpose in relation not only to the public they profess to serve but even to the concept of civilization which they are supposed to exemplify.

Suddenly the door to the right of the bed flew open and Françoise Gilot, fully dressed, strode into the room. She greeted me with more friendliness, I thought, than had been her custom, explaining that she had come south for Easter so that her children could see their father. I was staying in Ménerbes, she knew, with Dora, and she said she hoped the house was in better repair now than when she had stayed in it eight years previously, the year before Claude was born.

"The only thing she's done has been to throw out my toilet seat," said Picasso. "Now nobody can shit except by necessity." Abruptly tossing aside the bedclothes, the artist leapt out of bed, remarkably agile for a man over seventy, snatched from the floor the rusty shovel blade and flung it out of the open window.

Françoise, obviously accustomed, and indifferent, to such displays of petulant behavior, paid no attention to Picasso's ill humor and inquired instead about my stay in Provence. I told her I was enchanted by Ménerbes and the surrounding countryside and would be sorry to leave so soon.

Picasso by this time had hopped back into bed. "Leaving already?" he asked. "When?"

"On Sunday. We're going to spend that night at Douglas Cooper's place, and then on Monday we'll go on and stay the next night with Balthus at Chassy. Have you ever been to Douglas's? He has a fantastic collection of your pictures."

"I know, I know," grumbled Picasso. "He never ceases imploring me to make him a visit, but I never have. Why, if I went to see every person who has a couple of my things I'd be on the road night and day like a gypsy caravan. Besides, Douglas is perverse and eccentric. It's brave of you to spend a night under his roof, but for Dora that represents a saving, and maybe she hopes that Douglas can help her pretend to be an artist."

Françoise then said goodbye and that she hoped we might meet again soon.

When she had left the room, Picasso said, "Have you become famous?"

I said I hadn't.

"Did you see the way she walked out of here?" he said. "Not a gesture of endearment. Not a flicker of pity. Well, goodbye, little Lord. Give me a kiss."

Grasping me by the shoulders, he kissed me on either cheek. I got up from the bed, and he said, "You'll tell Dora that my soul is in no danger and my conscience like that of the sparrows at Alviano."

I said I would and went out. It was only on my way back down the hillside that I realized I had quite forgotten to deliver the message from Cocteau, but thought that neither man needed me for friendship's go-between after thirty-five years of ups and downs.

From a café in Vallauris, where I had a poor lunch, I telephoned Matisse's daughter Marguerite, who told me I could see her father that afternoon about five o'clock. His apartment was in an enormous building, once a hotel called the Regina, commanding a far view of the sea and set in gardens on the hillside above Nice. I was punctual, greeted by Marguerite Duthuit, a small, smartly attired, businesslike woman of about sixty. Matisse, she told me, was in bed—I knew that he was an invalid—but would receive me all the same. He had been the first artist to respond favorably to my appeals on behalf of Cézanne. Two years before, without any sort of introduction or knowledge of me, he had sent a large charcoal drawing to me personally as a gift for the Cézanne gallery in the Aix Museum, which I was also attempting to help. It seems in retrospect an amusing coincidence to have seen in their beds on the same day the two greatest artists of the century. Matisse was very unlike Picasso in appearance, in demeanor, in attitude, with none of the verve and nervous agility of the younger man. He was propped up on pillows, had a rolling desk in front of him covered with books and papers, and on the wall to the left of the bed hung a smallish painting by Picasso, a brightly colored still life of the war period. He was bald but with a neatly trimmed white beard, and he wore glasses. Though amiable, he was formal, obviously desirous to make my visit as brief as courtesy could condone. So I explained my hope that he would consent to make a lithograph which could be sold in order to raise additional money for the renovation and maintenance of Cézanne's studio. He immediately agreed, adding that he had on hand plenty of lithographic transfer paper

and crayons, therefore would be able to satisfy my request promptly and would send the print to Fernand Mourlot, the printer, in Paris, with whom it would be up to me to make further arrangements. I thanked him. He said that for Cézanne there was nothing he would not happily do, Cézanne having done so much for him. Then Marguerite Duthuit made a move toward the door which plainly indicated that the interview was over. Having again thanked Matisse for his kindness and generosity, to which he politely replied that he appreciated both my visit and my initiative, I went out. His daughter took me to the door. I never saw Matisse again; he was dead before the end of the year.

He kept his promise, however, made the lithograph and sent it to Mourlot in Paris. What became of it I never knew; my plans to raise money through the sale of an album of original prints by various artists came to nothing. The artists I approached, except Picasso, were all cordial and willing, including Léger, Rouault, Dufy, Jacques Villon, Giacometti, André Masson, and Max Ernst, but I could not find a bookseller or publisher in France prepared to underwrite the printing and sale of the projected album, which would ultimately have cost the publisher nothing, as I deemed it normal that his initial outlay should be covered by, and even a modest profit derived from, a certain number of albums reserved for him. This was my introduction to the fact that the French are prone to cry alarm if they think their national patrimony is threatened but are reluctant to pay for its preservation. Every penny for the acquisition and renovation of Cézanne's studio came from American pockets. And maybe, after all, there is something symbolically apposite in this, for I am told that today the studio has 45,000 visitors a year. It, too, has gone to work. In my naïveté I had thought that the place was being preserved for the occasional passerby to whom the artist's "little sensation" and the front of Vollard's shirt represented spiritual values that only the occasional passerby could discern or revere. I still think so.

Having spent the night in Aix at the Hôtel de la Mule Noire, the next day I visited the studio; the work in progress seemed satisfactory. I also met with the people at the university, who had somewhat reluctantly agreed to accept responsibility for maintenance of the small building. (It has long since been transferred to the municipality.) I was told that the studio's inauguration date had already been set, July 8, as it coin-

cided with the opening of an exhibition of drawings by American artists, at which the American ambassador, then Douglas Dillon, would be present, and so he could also be present at the official opening of Cézanne's studio, which had been saved by the donations from America. These arrangements suited me, and anyway I was informed, not consulted, so I was free to return to Ménerbes.

"Well?" said Dora as soon as I came into the house. She was in the kitchen, drinking tea under the light bulb. "How was the C and B? Tell me." There had been no trouble about getting in to see him, and I'd found him in bed, I told her. "Didn't I say that he'd surely receive you if he knew you were coming from me?" she said. "And then what? And then what? What did he say about my gift? Tell me."

"He said he liked it," I said.

She put a cigarette into her holder and lit it, puffing pensively. "Is that all?" she asked. "What were his exact words? You must remember. Everybody remembers everything Picasso says."

"He said it was just right," I said, "and that you must have given a lot of thought to your choice, and he said to be sure not to forget to tell you how grateful he was. And he was, I'm sure. You said yourself it was just the sort of thing to please him."

"Nonsense!" she cried, and the cigarette holder was trembling between her clenched teeth. "He didn't like it, and he wasn't grateful. I know. I know him better than anyone. You're different, dear James. But Picasso was not pleased. Oh, if he had been pleased, then who knows what the world might come to. But he has the most fantastic memory. He certainly wasn't grateful." She stood up abruptly, and Moumoune, who had been lying near her chair, leapt away in alarm, whereupon Dora snatched from the table a floret of cauliflower and flung it at her, exclaiming, "You hateful beast. Will you never die and leave me in peace?" Then she left the room.

During dinner there was further talk of my visit to the C and B; not a word, however, about Dora's gift. I tried to make my account as innocuous as possible, omitting any reference to the toilet seat, repairs to the house, or the presence of Françoise. I did venture to report that the C and B had little esteem for the paintings of our friend Nicolas. Dora said that he was right, that time would show their superficiality. I asked her about the sparrows at Alviano.

"Don't tell me that the *cher et beau* mentioned *them*," she said.

I assured her that he hadn't, that I had come across a reference to them in a book I was reading and been puzzled by it. She knew all about the sparrows, and I felt certain Picasso must have known she would. They referred to a celebrated incident in the life of St. Francis of Assisi, who in the purity and innocence and fortitude of his faith had once been found by his followers preaching to the sparrows in a place called Alviano. Fortunately, this instance of spiritual virtue led us away from talk of the C and B and into a lengthy discussion of the origins of a religion of love. It was in the unquestioning and disciplined acceptance of practices rather than in the certainty of beliefs per se, she said, that the essence of religion resided. Must this mean, I asked, that access to the City of God had to be attained via the rites, sacraments, and observances of the Church? That was putting it very superficially, Dora said, but, basically, the meaning of the world could not be learned by any other means. I told her that it was quite impossible for me to conceive of so exclusive an imperative.

"You can't imagine how sad it is," she said, "to see somebody that you care for teetering on the brink of the abyss and be powerless to help him."

"Is it so grave?" I asked.

"Yes and no," she said. "Everything depends on one's relation to mystery and the incomprehensible certainty that is its interest."

Cézanne, I said, had undoubtedly sustained a close relation to both the mystery and its interest. Dora agreed, adding complacently that he had been devout. I knew that. She had not inquired about the studio, which I realized might seem a fatuous topic, so I told her all about my visit to Aix, the work in the studio, and the inauguration date of July 8.

She said, "Once, when Picasso came to look at my work, he said, 'You paint better than Cézanne.' You can imagine how elated I felt, because the C and B didn't pass out compliments like candy. And then half an hour later he said, 'Cézanne never painted anything but shit.' That was his way of creating negation. His most treasured possessions are a couple of paintings by Cézanne."

"He refused to do anything to help with the studio."

"That would have been too honorable, you understand, whereas

nothing is too good for those infamous Communists. I don't suppose it occurred to him to send me a gift."

"He didn't."

"I told you he wasn't grateful. But I have a present for you, a souvenir of your stay in Ménerbes. I'll give it to you in the morning."

It was a small pen-and-ink sketch of a mountain landscape, signed *amicalement, Dora Maar*, not at all what I had selected for myself when inspecting the paintings in her studio. Nonetheless, I made a perfectly creditable show of sentimental gratitude and later gave the drawing to a mutual friend.

Closing up the house prior to departure was a painstaking ritual. It contained not a single item that a self-respecting burglar would bother about, but I learned why there were so many keys, all to locks in working order, and where there were no locks there were latches and bolts and bars, which had to be attentively inspected and tested, not once but twice and in some cases three times. I thought so much meticulous solicitude for the safety of a nearly empty house absurd, but of course there was more to it than that, a numbing melancholy, for what Dora wanted to protect and keep safe, I supposed, was precisely what no one could possibly steal, the ruin and desolation of the house as it was, the decaying reassurance of its past, and of her own, the very air that long ago had been breathed by someone who would never again cross this threshold. Her treasure was all of this nothingness, and to keep it secure, unthreatened, invulnerable, no protection could be too painstaking. That she accepted me to participate, to collaborate in this ritual, was a sudden revelation of the passion she must have believed me either possessed of already or one day capable of. And I must say that this surmise was of a kind that I had never known or felt before, an overpowering rush of gratitude and tenderness that was like a transfiguration. Twenty-four hours passed before we were ready to leave, with all our luggage, plus Moumoune, stowed in the little car, and when we set out for the Château de Castille, it was already twilight.

En route Dora remarked, "What a pity it is to realize that this evening there is no chance of meeting someone with a beautiful soul."

But hadn't every soul, I asked, the elemental beauty of its mere existence?

As an abstraction, she said, naturally. But beauty, being a creation,

requires the labor of love, of self-denial, the suppression of pride and the leap into the unknowable, which is faith.

I said I couldn't understand, to which she replied that this was because I, like Douglas, like the C and B himself, for that matter, conceived of art as the most wonderful thing on earth.

"Look at that tree," she said, pointing to a perfectly ordinary one by the roadside. "To you it is just a tree, commonplace as can be. If Picasso painted it, it would become an object of veneration. To a person who has faith, it is a miracle in itself; it embodies the entire world, visible, tangible, and every living thing on earth, you and me, and all the universe, imaginable and unimaginable, the most mysterious galaxies and solar systems that no astronomer will ever get a glimpse of."

I was astonished by the passion of her eloquence, and moved as never before, though this was not the first time by any means that we had had conversations of this kind. I don't know why. Perhaps it was because we were leaving Ménerbes, and I had a powerful sense of something precious to us both that remained behind in that shuttered, locked, impenetrable house. I couldn't say what.

After a moment, however, I said, "It must transform the world. To see so much, to live with that kind of sight, it must transform the world and make it so much, much more wonderful to live in."

"That, my dear James," she said, holding her hand up to my cheek, "is the whole why and wherefore."

"Is it very difficult?"

"Very."

Then we drove on for a long time in silence, until Castille was not very far, and Dora said she hoped that Douglas would not have invited any other guests for the evening. She was apprehensive, however, as she had seen posters advertising a corrida for that afternoon at Nîmes, the first of the season, which Douglas and John were sure to attend. And who knew whom they might invite back to the château for dinner. Neither of us mentioned the name of the conceivable guest we both thought of at once, but I then recalled with discomfort that in Vallauris I had fatuously divulged our plans and itinerary. But Picasso had emphatically expressed his reluctance to visit Castille, hadn't he?

When we drove into the courtyard of the château there among the other cars stood the black limousine, the Hispano-Suiza, huge and fu-

nereal as a hearse, which we both instantly recognized as the sure sign that the C and B must be inside. I felt both alarmed and elated.

"He's come because I'm coming," Dora exclaimed at once. "He knew. He had to know. Did you tell him?"

"I'm sorry. I did mention that we were going to stay the night here, yes. I never thought."

"Of course he came for me. Are you afraid?"

"Not at all." But it was because I didn't know what there could possibly be to be afraid of that I felt uneasy.

"So we go in!" she exclaimed, getting out of the car.

We went inside under the pillared portico and through the entrance hall, where I noticed a large, showy landscape by Nicolas de Staël hanging opposite the staircase. The door to the principal salon was to the right. Dora went ahead, I following. There were quite a few people in the room, seven in all, but it was Picasso who inevitably occupied the center of attention. As we came in, he jumped up and cried, "Well . . . are you married?"

"No," said Dora with equanimity. "Only engaged."

Douglas came forward to greet us, but Picasso was quicker, grasping Dora's hands and kissing her on the mouth. "Dora, my darling, what a surprise to find you here. I had no idea when Douglas invited me."

"Isn't that nice!" she said.

Over his shoulder, as he led Dora to a sofa in front of the fireplace, Picasso said hello to me. The others were Douglas and John, Picasso's son Paulo, an art critic and museum curator named Jean Leymarie with his wife, and an English writer on the arts, especially the ballet, named Richard Buckle, the only person I didn't know. I shook hands all around. John gave me a drink. There was a rustle of talk, but all attention focused upon Picasso and Dora.

"You're looking in fine form," she said.

"If you could see how I see myself," he said, "it would break your heart."

"Oh, I'm sure it would," she said.

"My darling," he murmured, kneading her hands between his.

They had, indeed, all been to the bullfight in Nîmes, a novillada, so-called because the bulls were only three-year-olds, and it had been especially noteworthy due to the brilliant cape work of a young Mexican

named Miguel Ángel. Picasso predicted that this young man would astonish the world by his bravery. (It didn't happen, for he was later badly gored in Seville, and that accident spoiled his career.)

The walls of this room, a large one, were hung only with paintings by Picasso, works of many different periods, a most imposing display. "Not bad," he said, gesturing around. "My children. Whether good or bad, they go out and lead lives of their own, never disappoint or bring shame to the parent."

Paulo uttered a guttural snort but did not speak.

"And you have quite a few of them in your care, my love," he said to Dora.

"Oh, a real orphanage," she replied fiercely.

I was seated at the opposite side of the fireplace from Picasso. He took out a cigarette, put it between his lips, and as he lit it he winked at me, then in an exaggerated gesture of mockery which none of the others could see he tossed the match onto the floor. I burst out laughing.

Picasso pointed at me. "The laughter of the chimpanzee," he said loudly.

Whereupon all the others save Dora also laughed, and I blushed.

"Tell me, my darling," he said to Dora, pointing again. "What is it that you see in him?"

She gazed at me curiously for a moment. "An interest," she said. "He is charming, intelligent, handsome. And besides, don't you think he may do something to amaze us all someday?"

"Never," said Picasso. "He's far too old, not in the least famous. No, no, his doings will never cause us the slightest surprise."

Douglas, who himself enjoyed inflicting embarrassment, giggled stridently, while the others simply stared, including Dora, upon whose expression a veil of ambiguity appeared to have been drawn. She was holding Picasso's hand, and I was keenly aware that what had once existed between them existed and would continue to exist—for her, at least—always. This awareness was both exciting and bitter, exciting because it seemed to draw me closer to Picasso, bitter because Dora became more remote. Yet I was glad for her sake and felt no resentment toward him.

John was friendly. We talked about Nicolas de Staël. The painting in the hall had been a gift. Douglas declared that Nicolas was destined for remarkable things and asked the opinion of Picasso, who said, "He'll

be talked about." We had another drink. There was desultory conversation. Then it was time for dinner.

The library was left in semi-darkness that evening because hung only with paintings by Braque. The dining room beyond was not very large, with a vaulted, painted ceiling and a marble table just ample enough to seat the nine guests, seven men and but two women. Douglas sat at the head of the table, putting Picasso to his right in the place of honor, an overt slight to Dora, in which she would have concurred, I suppose, and her to his left, me beside her, Paulo next to his father, John at the other end of the table, Buckle and the Leymaries in between. An elderly woman in black served. The food and wine, as one might have expected, were excellent and copious, conversation consequently lively, much of it devoted to the war in Indochina and the dire outlook for the besieged French troops at Dien Bien Phu, which fell just thirteen days later. Picasso made some remark about the beneficial effect of clearing away all that colonial rot and the salutary prospect of replacing it with an efficient, popular Communist regime. Douglas said that this would certainly be a blessing to all concerned.

The conversation meandered. Sometime toward the middle of the meal I mentioned an exhibition of sketches by Boudin which I had seen in Nice three days before. These sketches, many of them of the sky and clouds, the majority small in size, had greatly impressed me by their subtlety of color and delicacy of execution allied to a boldness of vision and grandeur of effect despite their limited format. I alluded to all this and added that it had been a surprise to see work so much more daring and interesting by a painter who had become well known for pictures of sailing vessels and elegant ladies seated on the beach.

Picasso brought his fist down on the table with a loud bang. "What idiocy!" he shouted. "Why, Boudin never painted anything that a baboon couldn't have done a thousand times better. And we have to sit here and listen to you, my poor little Lord, trying to tell us that Boudin was an artist when our eyes tell us he was a twentieth-rate handyman. It gives me the urge to throw up my dinner. I used to think you knew something about art, that you had eyes to see with, but now I realize you know nothing, see nothing, feel nothing, understand nothing, and, in short, *are* nothing." And all the while he spoke, his black eyes glared at me with piercing animosity.

Paralyzed by this incomprehensible outburst, I did not respond.

For a minute or more, indeed, as if to emphasize the ferocity of Picasso's attack, no one at the table spoke. I looked at Dora. Her eyes were fixed on her plate. Douglas was smiling broadly. Then the conversation gradually resumed. We were served salad and dessert. Enraged and humiliated, I didn't utter one word.

When the dinner was finished and we had all returned to the salon, Douglas announced that the moment had come to sign the book. The château book, a volume bound in red leather, lay on a console beside the French windows leading into the garden. Picasso was invited to sign first, take an entire page and make a drawing, which didn't seem an excessive request inasmuch as the walls were covered with his paintings. He took the fountain pen with a flourish, then hesitated, saying he didn't know what to draw. But after a moment of sly suspense he said that Castille was famed for its columns and consequently a column would be the most fitting thing to draw, which he proceeded to do, his drawing consisting simply of two vertical lines, with curlicues suggesting a capital at the top of the shaft, a drawing very close to insolence in its slightness, and he signed his name at the bottom of the page. The rest of us were requested to sign on the facing page, the fountain pen passing from hand to hand, coming to me last, I thought, because Picasso's treatment had made me the pariah of the soirée. Everyone else had turned away. I signed my name and closed the book. But then, amused to glance once more at Picasso's trivial drawing, I opened the book again and discovered that the ink of my signature had not been quite dry when the book was shut, with the result that a small blot from my name now disfigured Picasso's sketch. Pleased by this involuntary iconoclasm, which I did not for an instant consider a symbolic retaliation for what had occurred at the dinner table, I again closed the guest book and turned to join the others.

I took a side chair and sat down to the right of the fireplace. Picasso seated himself at the end of the sofa beside me. But I feigned to be unaware of his presence. The others were now talking about twentieth-century literature, and presently mention was made of Gertrude Stein. Douglas expressed a contemptuous opinion of her writings and a ribald derision of her person. I protested, insisting that some, though admittedly not all, of her work was valid and valuable and that she had been admired as an individual by many of the eminent intellectual figures of her time.

Whereupon, to my astonishment, Picasso patted me affably, even affectionately, on the arm and said, "You're quite right, my little Lord. Gertrude was an extraordinary being. If she came into a room, suddenly it was full even when it was empty. And she understood painting. She bought my pictures when no one else wanted any. She was a friend. And she was a writer of the first importance. Think what she did. Well before Joyce. You're quite right," he repeated, patting me again. "You're intelligent, Lord. Gertrude had rare qualities. And Alice, too. Alice and Gertrude were the same person in a way, only different parts. Poor Alice. It must not be very amusing for her now day by day. I guess she's having money troubles. A pity. She had to sell a batch of my old drawings. Some weren't signed, so they were brought to me to be signed, and I signed them. I was glad to do that to help Alice."

Leymarie asked Picasso what he was working on at present.

"Caricatures of myself," he said. "I'm a monkey, a dwarf, anything you please, a man with a mask. My existence is a shambles. Do you know that this is the first time I've ever been without a woman in my life? In the morning when I wake up I sometimes say to myself, 'You can't be Picasso.' " He turned to Dora, who was seated beside him, and took her hand. "Dora, my love, has that ever happened to you?" he asked.

"It happened so often," she said, "and for so long that I became someone else."

"Is it true? I don't believe it," he declared. "I see you today as you always were. Come," he said, rising, drawing her up with him by the hand. "I have something to say to you that is for you alone, that I don't want the others to hear, too personal, too intimate. You know how people distort and misconstrue." He put his arm around her shoulders and led her away toward a far corner of the salon. It was a large room. They went slowly, while the rest of us watched in indiscreet silence. And then they reached the corner of the room, where there was a prolonged pause as we waited for Picasso to murmur into Dora's ear whatever was too intimate, too personal for us to hear, although I suppose that everyone had the same notion of what this might be, and that Dora expected it, too. But all of a sudden, having pronounced not a word, Picasso whirled around on his toe and strode back across the salon, leaving Dora alone in the far corner, where she remained a minute in

stark solitude before being obliged to return alone across the breadth of the room without the slightest saving grace. It was a painful and odious moment.

Picasso was talking now about his pleasure at having resurrected the ancient Hispano-Suiza and how convenient it was to have his son as a chauffeur. They had never gotten along better, he said, now that an automobile had become the basis of their affection.

"So you're going to stay with Balthus," he said to me. "You and Dora and Balthus and some baby girl in his sinister castle. It sounds amusing. Why don't Paulo and I come along. I like Balthus and he likes me. Never mind that he's not a noble, he has an aristocratic hand. Nobody can paint a portrait the way he can. His portrait of Miró is a masterpiece. Let's leave right now. We'll drive all night, stopping in the restaurants of all-night truck drivers, talking to them about their child-hoods in the Côtes du Nord, drinking a little Calvados with them, and at dawn the roadsides will be blanketed with wildflowers. We'll get out and sit in the flowers, eating garlic sausage and drinking terrible red wine, and Balthus and his child bride will welcome us with joy. Dora, my love," he went on, turning to her, "what do you say? It would be exciting, it would be adventuresome. Who knows? We might get lost en route and have to spend the night sleeping in the hay. Somewhere in the wilds of Burgundy. And in the morning we'll go together to the village chapel to pray. It's such a long time since you've had a ride in the old Hispano, and little Lord can drive along behind us with the luggage. It would be exactly like old times, the times we drove around the Côte, staying in Mougins at the Hôtel du Vaste Horizon. You haven't forgotten, have you, my love?"

"I haven't forgotten," said Dora.

"And wouldn't Balthus be overjoyed to greet us in his Dracula château?"

She smiled. "Oh yes, overjoyed."

"And you? And you?"

She was tempted, I could see, for, after all, even after what had happened a few minutes before, this was Picasso imploring her. She was the whole focus and center of his attention as he fixed the famous eyes upon her. And beyond their inscrutable gaze, perhaps, the masterpiece of portraiture already existed, waiting only for the miracle of his per-formance to bring forth immortality.

Then she turned to me. "I was traveling with James," she said. "What do you say? It's true that Balthus would be pleased. And we could stop in Autun to see the cathedral sculpture."

"James!" shouted Picasso. "Why, you aren't even married, said so yourself. You travel with him. Then travel with him. Paulo, come," he said, rising abruptly and dragging his son bodily from his chair. "I'm an old man, it's late and it's a long way to Vallauris. We go." He strode vigorously to the door, saying good night to no one, aware, no doubt, that the others would follow, which they all did. Save Dora and I.

I went to her at once and put my arms around her. "He was so terrible, terrible!" I exclaimed. "I'm so sorry, Dora. It was terrible for you. How could he?"

"Oh, I've known worse, much worse," she said. "But he was terrible to you also, and there was nothing I could do to prevent it. I regretted it, my dear James. From him there is no defense."

I held her close and kissed her on the cheek and said I didn't care about myself. It was she who mattered, nobody else. The whole evening had been devised around her, for her, and Picasso would never have come to Castille had he not known she would be there.

But she said no, that I had been just as important, that Picasso had come for me just as much as for her. Otherwise, he never would have bothered to attack me, for he attacked only those who made a difference to him. "It's very flattering to have had Picasso react so directly and violently toward you," she said. "It proves that you are *someone*."

I knew that I was the only one who could ever prove that, but it was certainly true that for ten years Picasso had been essential to my personal mythology. However, I could not confess that to Dora.

Then the others returned one by one, having made their farewells to the artist and his chauffeur-son. There was an awkwardness, nothing to be said about the only topic anyone wanted to talk about. Leymarie and his wife went on their way, while the rest of us retired to separate thoughts and bedrooms.

I sat up half the night, "furiously resentful at the contemptible behavior of P," to record in detail what had happened. The next morning we left early. It was several hours before we could begin to be ourselves toward each other as we had been prior to the arrival at Castille.

Not once did we mention what had happened that evening. I never saw Picasso again, nor did Dora, but he was not absent from our lives.

Within six weeks he had openly established himself with a new mistress, Jacqueline Roque, a woman he eventually married after the death of his unhappy first wife. Picasso, Douglas, and John became great friends after that evening.

We arrived at Chassy before nightfall and found reasonably comfortable guest rooms prepared in the chilly and still almost empty château. Balthus did not offer to show us the studio again. Léna had prepared a good dinner and we spent a pleasant evening, extreme contrast to the previous one. Dora said we had seen Picasso, nothing more. Balthus in his aristocratic drawl voiced a low opinion of Douglas's aesthetic discrimination. We went to bed early.

The next day, the twenty-seventh, after just three weeks' absence, we arrived back in Paris. What Dora felt about our sojourn alone together I naturally could not surmise. As for me, it was a cause for exaltation.

NONETHELESS, I must say that when I set down Dora and her suit-cases, and most especially Moumoune in her pestilential basket, at their front door and drove off in the suddenly very empty car, I felt a tide of relief. As I thought of our sojourn, it suddenly seemed that I had been capable of a significant achievement. Alone with the elation of it, I could appreciate it all the more.

The most urgent order of business, however, was to find a place to live, as I was obliged to relinquish my former lodging. After an excess of searching, I found, for a price I could afford, a small furnished room, with adjacent bath, in a large apartment on the Avenue Georges Mandel, far from the Left Bank to which I had always been accustomed. Still, it promised tranquillity, which was what I prized most. This apartment was the home of an elderly woman and her plain daughter, whose dec-orative tastes were ostentatiously Oriental. Chinese lanterns, lacquered tables and chests, vases, idols, prints in bamboo frames crowded the rooms and corridors. For some odd reason, the telephone was in the dining room, and I was allowed to use it with the understanding that I should record every call in a tiny notebook provided for that purpose so as to pay for each one. Several aquariums in this room were occupied by variegated fish with flimsy, fan-shaped fins, and while I talked into the antiquated instrument, I could watch them languidly navigating among sunken castles and plastic mermaids. I hung my Cézanne youth,

a couple of Picasso etchings, and a few other items on my walls, put the Picasso bird on my bureau, bought a card table to write on, and without success endeavored to feel at home.

Not having seen or spoken to her for several days since our return, I called Dora to announce the location and phone number of my new residence, where I was alone almost all the time during weekdays, a grouchy maid present in mid-afternoon for only an hour, mother and daughter both absent at some obscure employ until early evening. Our relations were of the most perfunctory. Dora responded neither with interest nor with good cheer to my news. She was very busy, she said, had quantities of people to see and important matters to attend to, something I should have realized, and consequently she had no idea when it might be convenient for us to meet. However, we could resort to the telephone sometime at our leisure. Stunned, I said that this was obviously so, or that we might run into one another in Lise Deharme's salon or at one of Marie-Laure's lunches. Whereupon we said goodbye. I looked at the tropical fish hovering in their transparent captivity and knew that it would be I who must obey Dora's rule of convenience.

It's true that people will talk. My friends in Paris had not been sparing in gossip about Dora and me during our absence. And I found that many of them took it for granted that a woman of forty-six and a man of thirty-one spending three weeks alone together in a remote village will have the sort of relationship that gossip likes to label an affair. Bernard believed me when I assured him that the fact was otherwise, but even he, I sensed, would have been sufficiently amused by an intimation that Dora and I were lovers to overlook the drawback of factuality. Now, everyone I knew in Paris, if interested at all, was aware of my homosexuality, but this did not deter anyone from supposing that a heterosexual affair would be perfectly plausible, and the supposition must have been doubly titillating because no man since Picasso had been Dora's lover. The gossip was false, but I did truly aspire to have a place in Dora's life, an important place, in no way comparable to Picasso's yet important enough to be unique. Nor was I indifferent to the enduring importance to us both of Picasso, very different in each case, but essential to our importance to one another, though we never talked about this. Dora's fascination lay very much in her reticence, her ambiguity, her pride. It would be fatuous to fail to acknowledge that

she had transformed my relation to myself. When people insinuated that taking Picasso's place in the life of a woman so remarkable must be, to say the least, exciting, I felt bound to admit—even to myself—that it was.

Then it was May. For once the Parisian springtime was luminous, warm—day after day under the gleaming chestnut trees and in the rainbow spray of the fountains on the Place de la Concorde. I knew that it was miraculous merely to be in Paris, and the rest was beyond conjecture. I didn't run into Dora at Lise Deharme's; people smiled when I said I had no idea where she was. Almost a week went by, which I felt was enough, for I did realize that the most intense feeling, whether mystic or emotional, requires for the cultivation of its intensity a right to privacy, secrecy, even to duplicity.

When she answered the phone, I inquired, in order to be polite and to emphasize a certain formality, whether Madame Dora Maar was at home.

"Barely," she said, as she was just on her way out the door to go to tea.

I asked where. She said, "With someone."

It had been a long time since our return, I said; it seemed a long time, anyway, and I wondered when we might meet. She hadn't a minute to herself, she sighed, so many people wanting to see her, but if I liked we might meet later in the afternoon. Yes, I said, yes, wherever she liked, aware that I was revealing too much but that the real need for mystery was hers. She told me to come to the corner of the Boulevard Suchet and the Avenue Ingres at six o'clock. We could meet there and go somewhere nearby for a drink, some café there in the sixteenth arrondissement, though not for long, no more than an hour. I agreed.

She was late. Waiting, walking back and forth impatiently under the trees of the fashionable neighborhood, I felt a fool, the anxious, angry, disappointed boy, wondering how long I should decently persevere. It was more than twenty minutes. She came on foot from some distance. Recognizing her before a single one of her features became distinct, I ran to greet her, thinking how breathless, impulsive, and happy this must seem. She nodded calmly while we shook hands, not bothering to remove her glove, and I remembered our very first meeting. She had been far away just now, I remarked, from the place where she

had asked me to wait. Why? She hadn't wanted me to be seen hopping first on one foot, then on the other, she said, right in front of the house where she was taking tea.

I had never before seen her so beautifully, elegantly attired. Her dress was of black velvet, with a swath of mink stole over one shoulder, and she was wearing a hat, a small black satin oval tilted elegantly to the right side of her head. Around her neck were a number of gold chains, and she had on earrings.

When we were in the car, I remarked that I had never before seen her wearing a hat.

She smiled. "I didn't wear it to please you," she said.

"That's not what I thought," I said. "That's not it at all."

"Of course it is," she murmured. "But the matter is of no importance."

We went to a café on the Place du Trocadéro, the Eiffel Tower silhouetted against the sunset and Marshal Foch between the trees on his bronze horse. She told me about people she had seen, a lunch at Marie-Laure's—and, in fact, the person with whom she had had tea on the Boulevard Suchet was the man who had once threatened to rape her. I expressed surprise at her willingness to see him again. "Oh," she said, "there's nothing to fear. It's not my body he'd like to violate. It's my Picassos. And I may permit him to. I do have to sell things now and then. You remember the sketchbook with the drawings of me as a bird and the portrait in colored crayon. I must have shown it to you."

"You have never shown me anything."

"Really? That's ridiculous. What an oversight. Because I have the most remarkable things, things such as nobody has ever seen."

I didn't doubt it, feeling equally sure it was no accident the remarkable things had been seen by nobody, and I suspected she was taunting me, for she often made fun of my collecting mania. But what of her own passion for the proud possession of her portraits? That was a craze, perhaps, in which we were truly united, a union of the civilized self sustaining a vital tension—which alone makes life worth living—with the hidden resources of the inner, savage self. Oh, I was willing to be taunted by her, happy to be, even as I observed a beautiful blond boy passing along the sidewalk and felt the elemental twinge. We talked about Rubens, Balthus, the C and B, and Jacques Lacan, the psychoan-

alyst, who owned a house in the country to which Dora had been invited the following Sunday for lunch. She would be happy, she said, to take me along if that would amuse me. Lacan was himself something of a collector and possessed a number of remarkable things. His wife, Sylvia, was André Masson's sister-in-law. Besides, it would be far more convenient to be driven to the country than to take a train. I said that I would be delighted. Lacan was not yet the celebrated cult figure he later became, but he already enjoyed appreciable prestige in Paris as a brilliant, if eccentric, caretaker of the psyche. I remembered that Dora had been his patient after the break with Picasso. Meanwhile, darkness, the luxury of early evening, encircled the Trocadéro. Dora was drinking Dubonnet. She ordered another, lit a cigarette, and said that we would have to think of a place to dine.

•

Guitrancourt was the name of the country village where Lacan had his house, a simple but spacious, tasteful place set in an ample garden. We were the only guests. The lunch was prepared by the two women of the house, a young daughter named Judith, and her mother, Sylvia, then still as beautiful as she had been while she was married to Georges Bataille during her too brief career as an actress, when she starred in one of Jean Renoir's masterpieces, *Une Partie de Campagne*. There were numerous paintings by Masson, none of them very good. Lacan was attired in a flamboyant outfit that would have suited a racetrack tout more happily than an arcane mender of minds. During most of the meal he attentively studied a large volume propped beside his plate, turning the pages with meticulous deliberation as he ate and occasionally making notes on a small pad. Now and again he made some remark, and the fall of Dien Bien Phu, which had taken place the day before, was mentioned, but most of the talk went on between Dora and Sylvia, who, after all, had Bataille as a common denominator, so to speak, of their pasts. The atmosphere was anything but festive. After lunch we were escorted outside to a separate, small building, Lacan's studio. Dora whispered to me, "He'll show off his Courbet." In a heavy gilt frame to the right of the door hung a sketchy abstraction, on a brown background, by Masson. And indeed Lacan, addressing himself virtually for the first time to me, said, "Now I'm going to show you something extraordinary."

The Masson was painted on a thin panel which slid to the left out of the frame, revealing behind it a detailed and very beautifully painted close-up study of the genitalia of a fleshy, almost corpulent female. I made the exclamations of admiration obviously expected, wondering at the same time whether Lacan might not have provided this surprise in sly supposition that the image would hardly be one to rouse my sexual excitement. There were several other mediocre paintings by Masson, a small, extraordinary study of a skull by Giacometti, and a large, dull, late Monet of a willow tree. Lacan had brought with him his volume from the dining room and soon settled at his desk, saying goodbye to Dora and me with a courtesy so exaggerated as to be almost rude. We went back to the house, chatted a little longer with Sylvia, and presently departed, no hint of impolite haste perceptible.

The gleaming afternoon was at its zenith. This was only the ninth of May, but the subtle air felt like June; the day was diaphanous and infinite. For a while we drove along in silence. I said, "Dr. Lacan is not your everyday medical man, is he?"

"Oh no," Dora said. "He is the supreme arbiter of the hopeless case."

Did she mean herself? The fields and groves were adrift in gold, the green grass, too, like silk. It was she who suggested that we stop and stroll. Crossing the meadow screened from the road by a stand of poplars, we sat down on the velvet ground, as if by previous agreement. Dora lay back in the grass, so I did likewise, vividly aware of her eyes on me. I had grown almost accustomed to the eloquence of her gaze. Not that I minded it. On the contrary. And sometimes I looked into her face. Yet there was a feeling of tension, because I believed I understood what the gaze said, and I wanted to please her. Because I did feel genuine affection—more than that, too, a veneration and devotion—for her, and I sensed that she represented a closer approach to the fully lived life than I had ever known or might reasonably hope for. Still, there was the heartless drag of nature on me. And on her. I was thinking of my work, which had brought me so little satisfaction.

"The awful thing about growing old," I said, "is that disappointment becomes a habit."

"That's not it at all," she said.

"What is it?"

"You change races. As if, for example, in the United States you had always been white, and then one day you woke up and found yourself a Negro."

"I said something stupid."

"No. Superficial."

"That's worse."

"Far worse." But then she touched my head and for a few moments gently smoothed back my hair, and I felt a well-being so extraordinary that it seemed to satisfy a self of whom I had never been conscious.

"You know," I hesitantly brought out, "I want you to know that nobody I have ever known has meant to me what you do."

"Then we are friends," she said.

But I was a coward. I was afraid of making the gesture that naturally would lead into the domain which I knew myself too weak and selfish to traverse. So I said, "And more, and more." Which was itself an irrevocable gesture, and I knew Dora to be far more astute and awake to nuances of meaning than I was. It would have been easy to make a physical pretense. But then what? My own peace of mind, to which she contributed so much, was my ambition, and I still conceived of myself as a creative individual.

"You must be happy," she said.

How wonderful it would be, I said, if she and I could go to Egypt together, to Luxor, Karnak, Cairo, where we might watch the sunset from the roof of the Semiramis Hotel, while feluccas floated on the crimson river and four thousand years of civilization flowed past just as the Nile still did to this day.

"We need not go nearly so far," said Dora, plucking a flower from the field.

"But I *am* happy," I said.

She placed the flower on my chest. Then we said nothing more and after a time went back to the car to return to Paris.

•

Moumoune fell ill, refused to eat, vomited blood, lay inert in a corner. I expressed surprise that Dora had not taken her at once to a veterinarian. "Maybe it's too late," she said.

The cat, however, was still alive.

"Once," Dora said, "I was sitting here in the apartment in the dark in tears and Moumoune came to me and licked my fingers and I said to her, 'I'll never, never abandon you,' and I kissed her."

"We must take her to the veterinarian at once," I said.

It was in the fourteenth arrondissement, the veterinarian's office a shabby, dirty, smelly, noisy place, whining and barking and mewing very audible behind flimsy partitions and also from the pitiable creatures held on the knees of the several people already there before us, all women of a certain age. Dora held Moumoune on her knees, too, and her distaste for the circumstances was patent. Mine, too. The veterinarian, when our turn came, was an exceptionally handsome young man who paid not the slightest attention to either of us, handled Moumoune with extraordinary gentleness, and after ten minutes' examination said that it would be necessary to operate *in extremis*, that very evening, and that the chances of saving her were little better than fifty-fifty. So we left her there.

As we drove back to the rue de Savoie, Dora said, "I suppose you hope she'll die."

"That's untrue!" I exclaimed. "Why should I?"

She turned slowly toward me until her cigarette in its holder almost touched my cheek and said, "Jealousy."

For an instant I almost detested her. The imputation seemed so gross. And yet I did detest the cat and had once given her a brutal kick, from which—who could tell?—this present malady might have developed. "That's absurd," I said.

"I didn't mean what you think."

"It was because Picasso gave you Moumoune," I said.

Dora laughed. "Not at all. Moumoune's life is dear to me because all life is equally precious and unique."

I had no wish to argue with her, even though I was unfairly made to appear in the wrong. Dora had told me that her father, the architect, was still living. He resided in a hotel facing the Seine, the Palais d'Orsay, annexed to a defunct railroad station. Dora dutifully had dinner with him once a week, often on Sunday and always in the dining room of the Hôtel Lutétia, a fifteen-minute stroll up the Boulevard Raspail. Monsieur Markovitch being a fussy and irascible client, a meal with which he failed to find some fault was so rare as to constitute in itself almost a

defect, and vociferous complaints so consistently the rule, that the head-waiter at the Lutétia invariably responded with the same gestures of resignation, sighing, "Monsieur Markovitch is always right." Dora thought this ritual most amusing, though she complained of her father's tyrannical and captious temperament. And I wondered whether there wasn't a lot of the father in the daughter, who perhaps hankered to hear on her own account the headwaiter's phrase.

Moumoune recovered, came home with a bandage around her mid-dle, and I thought her as disagreeable a creature as ever.

Our telephone conversations, I felt, often had no relation to time, while I sat on an uncomfortable Chinese chair in the dining room of the hushed apartment, watching the watery hover of the tropical fish as we talked. I can't imagine what we can have found to talk about at such length. But for those to whom the sound of another's voice is itself a delectation there can hardly be an excess of it. And I never have heard another voice to compare with Dora's. This, to be sure, sometimes stressed the sharpness of her irritability; yet the melody remained.

One morning she told me that she must be brief because she was expecting a visit from Kahnweiler, the man who had been Picasso's principal dealer for nearly half a century. He was coming to see some things that she had decided to sell. "Picasso's?" I asked. What else had she? she replied. "What things?" I asked. Oh, she answered, indiffer-ently, just a few things, a few drawings, a sketchbook, nothing I had ever seen. "I've never seen anything!" I exclaimed.

"Why, my walls are covered with things," she said.

"Not the most remarkable things, the things nobody has ever seen that you promised to show me someday."

"Someday, someday. There are things that nobody has any right to see, secret things, and no promise applies to those. Besides, why must you see everything? Is seeing akin to breathing? So vital? It's not pos-session, you know. Anyway, you're in no position to buy, are you?"

I admitted that I was not, which seemed a sort of surrender, an admission forced from me, cause for resentment. Her power was superior, yes, and constituted part of my happiness.

She added that Kahnweiler was notoriously stingy, dealings with him always protracted; consequently, she could very well show me the drawings and sketchbook that evening.

My resentment vanished, replaced by a less honorable feeling, a sense of accrued advantage.

The drawings were three or four, of the double-profile variety dating from about 1940, hasty sketches not of much interest or value, I thought, paying them little attention. The sketchbook, however, was an exceptional item, the kind of thing collectors, and dealers, dream of. Not large or voluminous, measuring about twelve by ten inches, it contained only eight drawings on heavy white paper, but all were exceptional, all but one, the last, portraits of Dora.* The first was the finest, virtually a painting, India ink wash with brilliant heightening in colored crayon. Then there were four full-face pencil portraits, severe and staring, very strong, two drawings of Dora with the body of a bird and horns, Dora in short as a harpy, and finally a bird with the head of a minotaur, which was perhaps to be viewed as a representation of the artist himself. And there between the last pages of the sketchbook was tucked a tiny scrap of paper with an image pressed into it, also a portrait of Dora, which I recognized instantly as the unique proof taken from the engraving on the top of her cigarette lighter. She snatched it from the sketchbook, exclaiming that she'd quite forgotten it was there, and put it inside the glass-fronted bookcase, from which all the things had been brought out. Perhaps she had forgotten her promise to give it to me. Perhaps her promise had never been intended to lead to a gift but rather meant to prompt one. With Dora, nothing was necessarily what it seemed. Anyway, the tiny engraving was a trifle.

I realized that I was trembling and tried to conceal it. This was the acquisitive fever. None of the drawings was signed, nor was there any evidence whatever in the sketchbook that they were the work of Picasso save the patent manifestation of his hand. But I assumed that it would not be difficult to obtain signatures, though perhaps necessary to pay for them. I asked Dora. It would depend on who made the request, she said. And had Kahnweiler made an offer, I inquired. Yes and no. He was definitely interested, but would prefer to acquire the sketchbook only, not the drawings, though willing, should Dora insist, to buy the drawings also if a satisfactory price for the lot could be agreed upon. Dora had named a figure, which Kahnweiler considered excessive, asking

* Zervos, Vol. 11, Nos. 98–105.

for time to reflect upon a counter-offer. So things stood. Did this mean that Kahnweiler had been granted an option?

"I have never granted anyone the right to make a decision concerning my future," Dora said. That, I believe, was very likely untrue.

Then maybe, I said, she would allow me an opportunity to buy the sketchbook. If I could borrow the money, I might be able to sell the seven lesser drawings at prices sufficient to cover the entire cost, allowing me to keep the finest portrait of Dora for myself. Well, why in the world not, she said. Moreover, since we were friends, she would not insist that I buy the drawings as well as the sketchbook or pay the price she had asked Kahnweiler, a price she knew to be too high but necessary as a prelude to bargaining. When Kahnweiler made his offer, she would let me have the sketchbook for only 25 percent more than he was willing to pay, which would represent a saving for me of 25 percent on the retail price, since dealers invariably at least doubled their purchase prices. It would be a transaction of gratifying benefit to us both, a prospect obviously relished by her. And I immediately wondered whether her pleasure, if the transaction ever took place, would be merely monetary.

I said we would naturally have to wait to see what Kahnweiler offered and passed the sketchbook back to her, knowing that I would never again hold it in my hands. The proverbial French expression *prix d'ami* had undergone a rather melancholy metamorphosis of meaning. Nonetheless, that night, as I endeavored to fall asleep, the portrait of Dora hovered in the forefront of my imagination, and longing kept me awake, longing and frustration mingled inextricably in my feeling for the person and the desire for her portrait. To my astonishment, I thought that I would rather forgo possession than bargain for it in the currency of sentiment.

There was a lot more talk of the drawings and sketchbook, and I participated in it for fantasy's sake. But inevitably in the end she sold everything to Kahnweiler at his price. Picasso, she said, recalled to the last sou the pittances paid him by Kahnweiler in the early years, and one of his reasons for keeping him on as a dealer was to be able to torment him in revenge for hard-fisted transactions forty years in the past.

Sometimes we went to the movies. All of us went often to the movies in those days, far more frequently than today, when the criteria for

entertainment have undergone such violent transformations. And one evening Dora and I decided to see a film called *Roman Holiday*, starring Audrey Hepburn and Gregory Peck. It is the story of a princess on holiday, incognito, and her love affair with a commoner, a romance destined to renunciation and grief due to the insuperable difference in status and fortune, etc., and rising to a shrewd play on emotion at the end. In the car on the way back to the rue de Savoie I remarked that it was high-quality trash. Oh, of course, said Dora, it wasn't "The Death of Ivan Ilyich," and yet there was a profound relevance to human life all the same. What, she asked, might be the feelings of someone like Princess Margaret, for example, on seeing that film, when she, after all, was compelled to accept that heartless destiny as the rule of her life? And, certainly, there were many other serious human situations that could be comparably cruel, hopeless love affairs being as banal but real as the sun and the moon. That was true, I agreed, and then we were in front of her house. Getting out of the car, I went with her to the door, and there as I leaned to kiss her on the cheek I saw that her eyes were filled with tears, brilliant as glass in the dim streetlight, but she turned away quickly and went inside, leaving me alone with the motor of the car muttering behind me. It would have been inconceivable, I knew, for me to have followed her.

Still, as I drove back to the Avenue Georges Mandel, I felt that I could not leave things as they were. Some kind of initiative seemed to be mine, though I didn't think I'd done anything to incur a responsibility, but I wanted her to believe in my affection. So I thought to write a letter. I took a good deal of trouble over it, pondering how well-intentioned, tender, and sympathetic it should be without creating false impressions. I told her how the moments we spent together were for me unlike any others I had known, vivifying, delightful, endearing, and that I was certain she had had a beneficial effect on my creative aspirations. (Even then, perhaps, I vaguely surmised—as did she!—that someday I would sit down to write what I am writing now. Otherwise, why would I have recorded it all so carefully and preserved the record for so long?) And I signed the letter "with my most affectionate thoughts," wondering at the same time whether this was the right expression, whether it might not foster undue faith and expectations, involving me to a degree beyond the fit of the circumstances. However, it was late at night and my thoughts

were decidedly most affectionate, so I put the letter into an envelope, addressed it, and pasted on enough stamps to have it go by special delivery, *exprès*, meaning Dora would have it the next day by noon. The night was mild. I walked up the avenue to the mailbox. There I hesitated, holding the letter between my face and the box. Farther along in the dancing shadows on a bench under the chestnut trees, two young couples were talking and laughing. A taxi driver drowsed on his wheel at a nearby rank. I hesitated for a long time. It seemed long, and I wondered whether the young lovers on the bench had noticed me and were curious to know why I stood there hesitating to entrust my letter to the future. But the moment was the moment, and it had its own *élan vital*. I dropped the letter into the box. As I walked away, I glanced back and saw that the lovers were, in fact, watching. So I had had an audience. The truth is that my affection for Dora was honest and strong and beyond definition. It must have been at about this time that I began to think I might ask her to marry me.

In the morning I awaited the ring of the telephone. In vain. In the afternoon, likewise. Nothing, while for a long time I watched the futile wafting from nowhere to nowhere of the tropical fish, but after my letter I thought I'd be damned if I'd call her first, and I dined with Bernard, who warned against mirages of gratification based on erroneous concepts of self.

But she did call the next morning, explaining that the day before she had been far too busy for social niceties. She thanked me for the letter, a thoughtful attention of the sort that ladies always appreciate, and nicely phrased in French, she added, a real writer's letter. These were not the expressions of pleasure and appreciation I had expected and hoped for. How often I found myself unsuccessfully striving to comprehend her sentiments, her expectations, if any. But then she suggested, as the afternoon promised to be fine, we might meet when we'd finished working, go for a drive in the Parc de Saint-Cloud, and dine somewhere in the suburbs.

The park was feathery greenery, a Fragonard, she said, so would I stop for her to make a sketch. She got out but told me to wait in the car. I watched her strolling under the vault of leaves with such supreme *savoir vivre* that her authority over the place and the time appeared absolute. Her sketch was made on the flyleaf of a book she'd been

carrying, a squiggly view of the principal vista, not in the least like Fragonard. And when she came back to the car she tore it out of the book and handed it to me, a souvenir, she said, of a precious moment. I thanked her. She said, "I owe you so much I could never hope to repay."

Astonished, I said, "What? You owe me nothing. Really, it's the other way around."

"No, no. You saved Moumoune's life. Without you, I never would have taken her to the veterinarian. And so much more, I can't say. I would have been inconsolable if I'd let her die. It has nothing to do with the C and B."

"Still, we never escape from him, do we?"

"Never. And, you know, it wasn't enough for him, being Picasso. He wanted to be loved for himself."

We drove out of the park and through valleys to a town called Marnes-la-Coquette, where there was a good restaurant. The proprietor let it be known that at some time in the past he had played the bassoon, and once in an orchestra directed by Toscanini. There was a photograph on the wall of the tyrannical Maestro. We had a good meal and quite a lot to drink. Driving back, we got lost and had eventually to return via Versailles. Dora was smoking, as usual. There was some silence. Then she said, "Are you satisfied with our relations?"

I felt myself flush. Glad of the dark, I said, "Why do you ask? It seems such a strange question. Is there any reason I should not be?"

"Probably you should not care."

"But I do. I wrote it in my letter. Of course I'm satisfied with our relations. Why do you ask such a question?" But I suspected her reason, and felt a vital concern to avoid acknowledging it.

"Oh," she murmured, "I only said that as the headwaiter in a restaurant might say 'Are you satisfied with your dinner?' "

"Then," I said, "I'd have to answer, 'I've never known anything to compare with it.' " But my throat was choked with sadness.

One evening in a bar I met a magnificent Swedish youth called Bengt Hammerind, with hair so golden it was almost white, bluer eyes than the finest faience, and bright Northern blood in his cheeks, bashful about his beauty, aged twenty-two, and if his face was Adonis, his physique was Hercules. Like most Scandinavians, he spoke excellent English. He was in Paris studying political science in the rue Saint-

Guillaume, had been there almost a year and planned to return to Sweden a few weeks later to continue his studies at Uppsala, after which he expected eventually to go into the diplomatic service. I didn't learn all of this at once, of course, but little by little as we chatted about one thing or another, and I was benumbed by his beauty and the sweet simplicity of his manner, and astounded by the fact that he appeared to find me appealing. As it began to grow late, he asked whether I would like to come back with him to the apartment where he lived in the rue de Franqueville. Though small, it had two rooms on the ground floor, one of them opening on a patch of garden, tastefully arranged, suggesting a sufficiency of money, with framed reproductions of the *St. Sebastian* of Botticelli and *The Young Man with the Glove* by Titian. He was timid and formal at first, gave me a drink and asked whether I would enjoy listening to some music. He had a passion for the British contralto Kathleen Ferrier, her career romantically curtailed by an early death less than a year before, and especially for her rendition of *Che farò senza Euridice*, which was an instant antidote to his timidity. We made love almost till dawn while he played that haunting, impassioned aria again and again. It seemed we had hardly gone to sleep before his alarm clock clanged. He had to go to school. So we got dressed and I drove him to the corner of the Boulevard Saint-Germain and the rue Saint-Guillaume, where we had breakfast in a café. It was he who suggested that we meet again, that very evening, for dinner if possible. I said yes, certainly. We agreed on a café on the Place de l'Alma—I didn't want my friends to see him—and then he went off with his books and a devastating smile under the trees of the boulevard.

I thought I had never known a Paris more miraculously beautiful than it was that morning. Fatigued from so little sleep, I yet felt an energy, an excitement singing through my limbs, and Gluck's sublime melody echoing through my head with the memory of Bengt's beauty transmuted into a ferocious ardor. And what I wanted most at that moment was to do something to demonstrate my devotion to Dora. Surprise her. Please her. It was a desire impelled by the pure delight of the morning and my certainty that Dora's pleasure would be as genuine as my own. Driving to the flower market on the Ile de la Cité, I bought an enormous blue hydrangea and went with it straight to the rue de Savoie, not troubling to telephone, though it was barely ten in the morning.

I was right. The pleasure was clear in her face when she opened

the door. She exclaimed. I carried the plant into her salon and set it down on the floor. Apparently she had been working, for she was wearing a painting smock and her hair was done up in a scarf. She thanked me. For the flowers and for the surprise. Then, to my amazement, she said that she had never seen me looking so handsome. How strange, I said, for I had always considered myself, with some regret, to be unusually plain. Well, she added, I was in any case handsome, but this morning exceptionally so. I must have blushed, because she said, "No false modesty, please. As you see, I'm working. Shall we have dinner this evening?"

I said I couldn't, having promised to dine with Bernard, whom of late I'd rather neglected. But why not lunch instead? We could cross the Pont Neuf and go to the Vert Galant, then an excellent restaurant. Why not? Dora said yes. That left me just time to go home, take a short nap, shower, shave, and return punctually to the rue de Savoie.

She was ready, beautifully dressed, with the satin hat on her head. She said she had had the impression I liked it. Then she exclaimed, "Oh, my dear, dear James, I have a confession to make. You'll think I'm intolerably careless. You remember that beautiful blue ring you brought me from Egypt. Well, sometimes when I was alone I would wear it, never outside, only here in the apartment, and then one day a man came to see me, a dealer, nobody of consequence. I forgot that I was wearing that ring, and when it came time for him to leave, we shook hands. Maybe he was angry because I wouldn't sell him anything. His grip was so strong it broke the ring to pieces. I could have wept. But I've kept the pieces. Look!" She opened the glass-fronted bookcase and took out a small enamel box, in which, to be sure, were the four or five fragments of the brilliant blue ring from the far-away shop in Luxor.

"Never mind," I said. "Maybe someday I'll find another."

"I've had bad luck with rings," said Dora sadly. "But here. Take this. I've been meaning to give it to you for ever so long." And she picked up and handed to me the tiny engraving made from the top of her cigarette lighter. Though minute, and unsigned, it was clearly a portrait of Dora by Picasso.* I took her into my arms and kissed her

* Reproduced in *Picasso: Peintre-Graveur* by Brigitte Baer (Bern: Kornfeld, 1986), Vol. 3, No. 709.

cheek. Elated by the gift, which I carefully put into my wallet, I none-theless couldn't help reflecting that the two small works by Picasso which she had given me had come as a consequence of the destruction of things which I had entrusted or given to her, and it didn't seem dishonorable to wonder whether I would have received anything at all, had nothing been broken. I remembered Picasso saying that Dora was not by nature generous, and thought that he would know, having, by the evidence of her walls, been lavish with her. But I didn't care. My delight meant more to me at that moment than the truth.

We walked to the Pont Neuf, and on the way Dora told me the story of a ring Picasso had given her. It was a cabochon ruby set in gold and agate and had belonged to Lise Deharme, a jewel Dora coveted so passionately—but likewise much prized by Lise—that she persuaded Picasso to offer a watercolor in exchange for it. This tactic worked, and both women were delighted with their acquisitions. But a year or two later, when Dora and Picasso one day were strolling on the Pont Neuf, they had a bitter altercation in the course of which the artist reproached his mistress for having prevailed on him to give a work of art in exchange for a bauble, whereupon Dora took the ring from her finger and threw it into the Seine, silencing her lover. She later regretted having been so impulsive. A few months afterwards the riverbed at that spot was being dredged, heaps of malodorous mud were dumped onto the quay, and for several days Dora haunted the spot, poking through the mud with a spade purchased at the Samaritaine, in hopes of recovering her ring. But it was lost for good. And through Picasso's fault, she said, so she kept at him until he created a ring of his own design for her. Too precious and fragile to wear, which of course was his revenge. However, she had bought for herself a star sapphire set in agate, reminder of the artist's lost gift, and almost always wore it. We went to the Vert Galant and had a delicious lunch in the sun and drank white wine.

•

Bengt seemed an adolescent, he laughed so spontaneously and leapt about like an acrobat in the little apartment. In fact, he was more mature about himself and the adventure of his life than I was. He didn't worry about the uncertainty of the future or of his participation in it on his terms. At twenty-two he might almost have been an ambassador

already. I inferred that his family must be rich and he an only child. And his sexuality appeared not in the least to entail a sense of guilt. The song sung by Kathleen Ferrier that second night was by Brahms, *Gestillte Sehnsucht*, with piano and viola accompaniment. I have all the arias by her that he ever played, and sometimes I listen to them now. There were several by Mahler, including *Das Lied von der Erde*. All this music was rather mournful, making a strangely incongruous accompaniment to the mutual rapture of our love-making. However, it was the only trace I observed in him of the famous Scandinavian melancholy, that and the fact that he drank rather more than a boy his age usually will. I didn't mention my affair with Bengt to anyone. He asked me questions about my life in Paris, which I answered more or less truthfully, while he told me about his student friends and the silly pranks they thought fun. There were evenings when we didn't see each other. I found to my annoyance that I missed him, and thought that one weekend we might drive down the Loire Valley and visit a few châteaux.

Bernard was petulant. He complained about being neglected, which was actually but a maneuver to affirm his rights to a pride of place in my existence. He wanted to see more of Dora, and she was quite as eager to see more of him. I, however, did not relish being talked about and analyzed by them. She was also curious about Bernard's family, their bourgeois eccentricities, and particularly what they said about her and our relationship. Did they belittle her as an older woman? I reproved her for a question concerning people with whom she was barely acquainted. Bernard was excited to try to make me say whether or not I was in love with Dora. When I refused, when I insisted that I didn't even know where I stood with her, he assumed that I was putting him off. Everybody, he said, took it for granted that we were having an affair and thought it fine for us both.

One Sunday Dora went by herself to the country for lunch. To the Lacans, I thought, but did not deign to inquire. She said she would be back by six-thirty at the latest and that we could spend the evening together, go to a movie. I worked at my writing, felt content, happy at the prospect of the evening. At six, I called. No answer. At six-fifteen, again no answer, and I dialed the number every fifteen minutes after that, becoming more and more irritated, almost worried. It was nearly

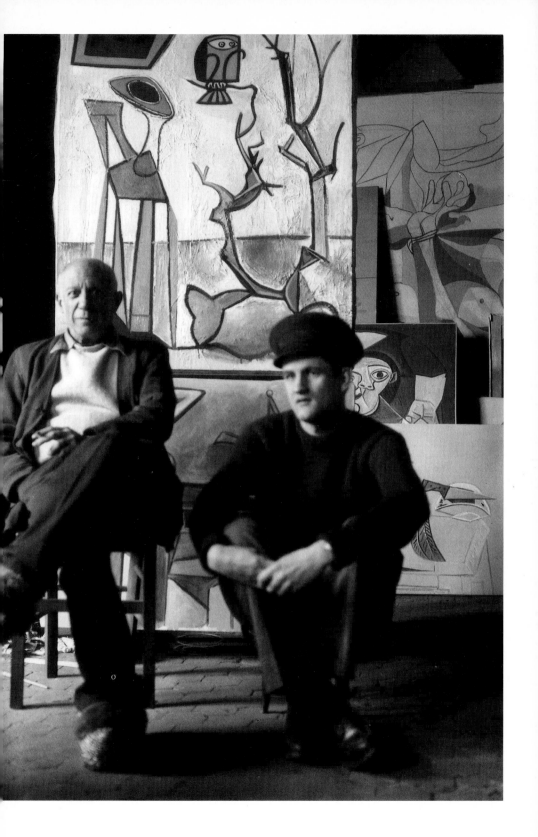

Picasso, James with sailor hat, and painting of owl, 1947 [*Jaime Sabartés*]

Unfinished painting by Cézanne [*photo courtesy of P. Pétridès*]

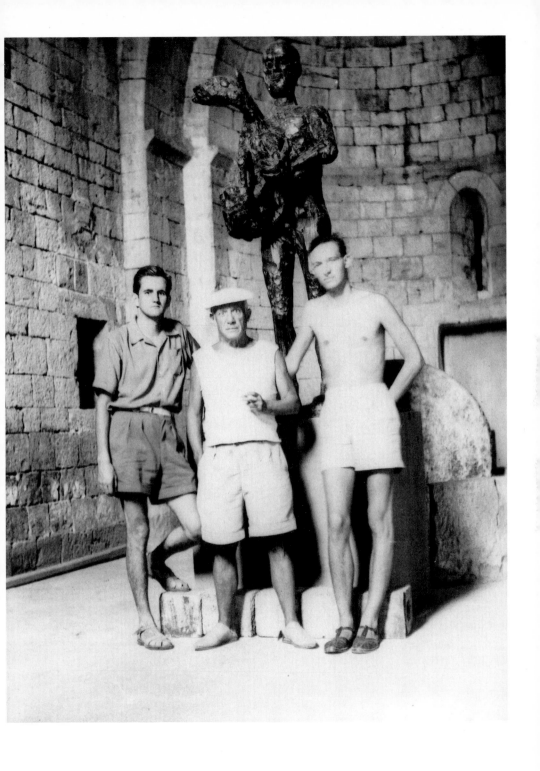

Picasso, James, and Bernard with *Man with a Lamb* in chapel in
Vallauris before inauguration of sculpture in town square

(opposite top) Château de Castille (before renovation) [*James Lord*].
(bottom) Ménerbes, aerial view (arrow points to Dora's house) [*Photo Cellard, Lyons*]. *(above)* Dora in doorway of her house at Ménerbes
[*James Lord*]

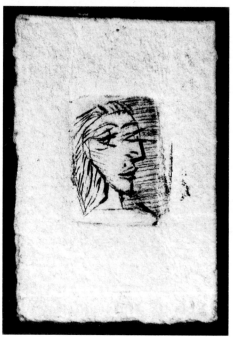

(above top) Wood and plaster bird by Picasso [*Arphot*]. *(bottom)* Picasso etching on Dora's cigarette lighter [*Arphot*]. *(opposite top)* Drawing of nude youth by Cézanne [*photo courtesy of Wladimir Walter*]. *(bottom)* Drawing by Dora of James seated on bench under fig tree in the garden at Ménerbes [*Arphot*]

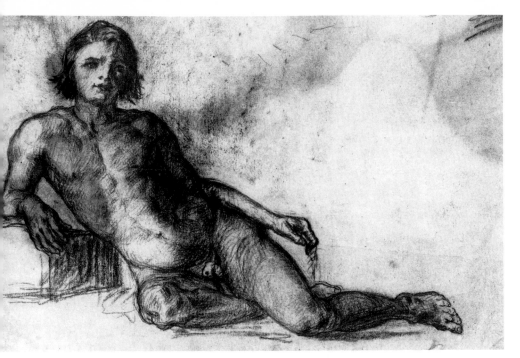

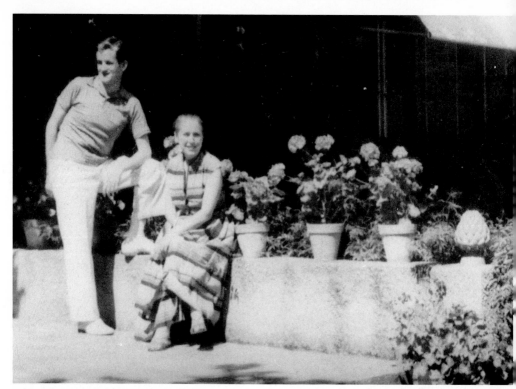

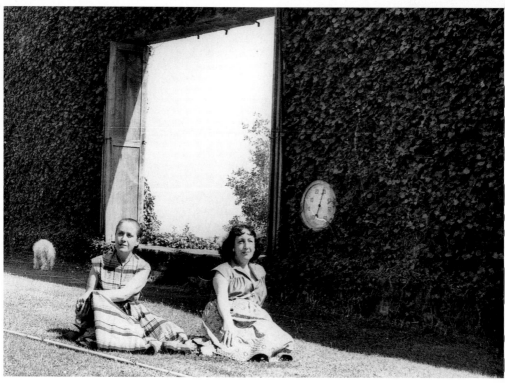

(above) Dora and James at Saint-Bernard [*Marie-Laure de Noailles*].
(below) Dora and Marie-Laure at Saint-Bernard [*James Lord*]

eight by the time she finally answered. "Well," I said, "what a long day."

"Long and tiring," she said. "I'm too tired now to go to the movies."

"All right."

"But we might have an early dinner."

"All right."

"Don't take that injured tone."

"I'm not."

"Yes, you are, as if you had some rights."

"I'm not, I tell you."

"Yes, you are, as if you had some rights."

"You're crazy," I said. "I'm not taking an injured tone at all."

"We'll talk about that."

So I drove to the rue de Savoie at once, arriving confident, smiling, content, nonetheless. But she drew back brusquely when I went to kiss her. "Don't you dare!" she cried. "Don't you dare ever again to say I'm crazy."

Then I realized the grossness of my gaffe. We had a lengthy discussion, leading to nothing. She insisted that I behaved toward her as if I had rights, as if our friendship permitted liberties. "But you're not my father," she said, "you're not my husband, you're not my family at all, only a friend I met through Picasso, and through Picasso it would not be easy to say what manner of meetings were my lot."

I was shaken, deeply disturbed, embarrassed. "What can I say?" I said. "Let's go have dinner."

In the staircase I hugged and kissed her. She didn't resist. We went to a familiar restaurant on the Right Bank and during dinner there was no sense of tension. After we had come back to the rue de Savoie, I held her hands in the car for some time without speaking, but when I went with her to the door she turned her head aside as I bent to kiss her.

I drove from there straight to the rue de Franqueville, though no prearrangement had been made for that evening. With Bengt it was clear that I had rights. I think it was the *Alto Rhapsody* we listened to for hours that night.

The next day I had a quantity of wearisome errands to do but thought of taking Dora some flowers. Several telephone calls, however, got no

answer. I tried to work and found I couldn't. Finally at six-thirty she answered the phone, saying she had been hard at work all day long. So she had, after all, been at home. Cautious, I said, "I admire your powers of concentration, not answering the telephone all day."

"Work demands discipline," she said. And we couldn't see each other that evening, she added. A previous engagement. I resented it in spite of myself.

Bengt, too, was busy; also Bernard, and other friends' telephones rang in vain. I wandered around the familiar cafés but found no faces to go with them, felt lonely, sorry for myself, and resentfully went home, well aware of my puerility and conceit.

Still, the following day I repeatedly telephoned, never getting an answer. In the evening I was invited to a cocktail party at the apartment-studio of a lady named Henriette Groll, a corpulent, congenial person who did a bit of painting and enjoyed giving large but modest parties which were pleasurably attended by crowds of artists, authors, and adequate conversationalists, hubbub at a premium. In the throng I found myself chatting with Lise Deharme, who asked for news of Dora. I replied with some asperity that I was in no position to provide the news wanted. Having known Dora far longer than I had, Lise must realize, I said, that the lady was not a person one could count on, news of her therefore scarce and unreliable. And I added, being Picasso's mistress must have given her an exaggerated sense of her importance. True, there was the season of madness to be taken into account. But even it, perhaps, had contributed to pride, caprice, and secrecy. So naturally there was no news, I concluded, realizing too late that maybe I had spoken with excessive resentment. Lise laughed, however, said that Dora had always been a woman of moods, and asked when I'd seen her last. Oh, two days before, I replied. Such recent contact, Lise remarked, should ordinarily have supplied plenty of news. Was it possible, she inquired, that I was in the habit of seeing Dora more frequently. Sometimes, I admitted. And thus could be subject to disappointments? Lise possessed exceptional charm, upon occasion could even create an impression of compassionate warmth. She put her hand against my cheek. "I see, my dear," she said, "that you are afflicted. But that's what comes of giving one's self to solitary, complicated ladies."

This was saying more than I had reason or heart to hear, and it

was simple to lose Lise in the crowd. But I knew that Dora must have been invited, that she must assume I would be present. And yet she did not appear. Deliberately, I imagine, to make her absence an issue and a provocation. It had been foolish to speak so openly to Lise. I regretted it, but the fault, I felt, was not mine. Bernard and several other friends were there, and we went to dinner in a wonderful restaurant called Les Ministères in the rue du Bac, where the food was plentiful and cheap, the proprietress motherly, and the decor unchanged since before '14.

Dora called the next morning, as natural as the sunshine itself. She had been here, had been there, seen Marie-Laure, Man Ray, André and Rose Masson, Balthus, a host of other people, very surprised, in fact, not to have seen me at Carmen Baron's party. She must have known that I wouldn't be invited. It was only later that I became friendly with Carmen, an inveterate and vivacious giver of parties for artists, widow of the art dealer Pierre Colle. And only half an hour before in the rue Dauphine, Dora added, she had run into Catherine Dudley, who had invited her to dinner and suggested that I come along, an invitation she had taken the liberty of accepting on my behalf, hoping I would not regard it as excessive. I didn't.

Catherine and Dorothy's apartment was large, disorderly, charming, the view of the Institute dome grandiose. There were a lot of paintings, a large Miró, a Pascin, a still life by Dora, and others I couldn't identify. We ate at a long, narrow, marble-topped table that had come from some now deceased bistro. Catherine mentioned that she was greatly looking forward to spending the month of July by the seaside, literally but a few steps from the water, on the island of Porquerolles in her pleasant rented house and asked Dora whether she wouldn't like to share it with her, adding that a half share of the rent would be but a trifle. Dora said that there was nothing she enjoyed more than swimming in the sea. But was the house sufficiently spacious? Oh, spacious enough for all of us, said Catherine, though in fact Dorothy was not planning to come, and she would be glad of the company. Well, it sounded very tempting, Dora rather wistfully said, very tempting indeed, but—and to my astonishment she turned toward me—she wondered whether it would be tempting to James. There had never been the slightest intimation that Dora contemplated my spending the summer, or any part of it, with her. I had wondered, to be sure, whether the suggestion might come, and the

prospect of returning to Ménerbes with her was exciting. I had thought of it as a kind of consummation. I didn't know what kind, but the sense of a finality was strong. Bernard was planning a trip to Scandinavia and northern Germany and had urged me to join him. I had avoided committing myself. Thus, it was easy to say yes, that I was tempted, very tempted. So it was settled, then. For the month of July, Dora and I would share with Catherine the house on the island, and divide the rent. What would happen in August was unclear, but I stipulated that, as for myself, I couldn't arrive in Porquerolles before July 8, since that date had been selected for the inauguration of Cézanne's studio in Aix.

I don't think I would have gone to Sweden in any case, despite the dominance of beauty and the power of desire. Fate certainly selected its juxtapositions with uncanny finesse, however, for it was the very next day that Bengt proposed I accompany him that summer to Uppsala, where, after all, I could write just as well as anywhere else, and he could easily find a pleasant apartment for us to live in. Material worries would evidently not be a bother. The Northern evenings remained light till eleven o'clock, while from surrounding pine woods an immense fragrance fell through the air. Stockholm lay only fifty miles distant and Sweden was very tolerant of homosexual relationships. We had not explored in words our feelings for each other. It had been physical passion that had spoken till now, and it had spoken with conviction. I told him that I could not give an answer at once, having to consider various other eventualities. "That's all right," he said, "because you know that I love you." He said it as simply as good morning, and I couldn't answer but attempted to by enfolding him in my arms. Kathleen Ferrier was singing *Che farò senza Euridice*, and when next I looked into his face I felt I could see beyond the unbelievable blue of those eyes that the music told him what he must have expected it to. But he said nothing. We continued to see each other, more passionate, if possible, than ever. I finally had to tell him that there was no chance of my coming to Sweden. He left Paris ten days before I did, and that last night there were no songs but some tears.

On the ninth of June there was a gala soirée at the Maison de la Pensée Française, a Communist cultural center housed in a mansion in the rue de l'Elysée, to celebrate the inauguration of an exhibition of paintings by Picasso on loan from Moscow and Leningrad, works never

seen in France since before the First World War. It had been announced that the artist would be present. I went with Dora. "He won't come," she said. "He always says that saying yes is the easiest way of saying no." And he didn't. The display of his genius on the walls was magnificent, however. There was a dense crowd, in it a lot of people we knew, so that Dora and I were frequently separated, chatting with one friend or another. We stayed till nearly midnight. As we went out, it seemed to me that she was more silent and tense than circumstances might have warranted, and I thought perhaps Picasso's absence had disappointed her. No sooner were we alone together in the street than she burst out, "How dare you expose me to ridicule and gossip?"

I said I didn't know what she meant.

"People make everything sordid," she said. "I was talking to Lise just now and she said, 'Ha, ha, I saw a young man the other day at Henriette Groll's who is in love with you and was very depressed about it.' What truth is there in that? Did you see Lise at Henriette Groll's?"

I admitted I had, that Lise had asked for news of her and that I had had to reply I had none to give, not having seen her for several days, and that was all.

"But why," Dora demanded, "should she say that the young man was in love with me?"

We were walking under the trees of the Avenue Gabriel toward the parked car. I threw up my hands. The gesture gave me a moment. What did she expect, or desire, me to say? I had not been insincere in talking to Lise. It had been naïve and ill-advised, and yet I couldn't help wondering whether Dora's annoyance was a genuine expression of her feelings, and what, in fact, might constitute the ridicule she objected to. It is a fact, moreover, that gossip may be the very reverse of malicious. So I said, "Oh, Lise. You know very well she'd say anything to make a quid pro quo. And the supposition of a love affair is the most banal pretext for deceptive chitchat. Isn't it so?"

"Do you imagine me a beginner?" she asked. "But Lise, you know, played a part in the debut of my friendship with Picasso, our camouflage, you might say. And to have her taunt me with all his paintings as witnesses, as it were, well, that was too much. And of course you are to blame."

She was right. Still, I said, "How am I?"

"Just by being present. My dear James, don't play the role of the perfect innocent. And what assumptions do you suppose people will make when we spend all the summer together?"

I replied that the only assumptions to be considered would be the ones made by us. She had said *all* the summer as easily as lighting a cigarette, taking for granted my compliance. She knew what discretionary power was hers, and I didn't answer, because I was delighted by my own sense of power and knew better than to let this show. Besides, we had reached the little black car. I said something about the splendid Picassos. Dora said that Picasso's glory would one day be incomprehensible, no more godlike than the skeleton of some extinct bird of prey.

During that winter I had seen Ida Chagall occasionally, finding her more companionable and less affected than her father, whom I had also run into a few times here or there. Consequently, it was no surprise when she called me some time in mid-June to invite me to a party she was giving in honor of her papa. She was inviting Dora also, of course, and suggested that we might as well come together, as she lived on the Ile de la Cité at 35 Quai de l'Horloge, not ten minutes' walk across the Pont Neuf from the rue de Savoie. It wouldn't present any difficulty, she presumed, for us to make the arrangement, as it was said that we saw something of each other. I acknowledged that we did, adding—to go her one better—that we would be in Ménerbes together for the summer and hoped to see her there. In the house given in exchange for a painting by Picasso.

"She treated that man abominably, you know," said Ida.

I didn't answer, hoping silence would signify disagreement and indignation. Ida Chagall, however, was not one to be deterred from speaking her mind by anybody's indignation.

"No understanding of an artist's nature," she went on. "Dora wanted to be immortalized, yes, but she didn't want to pay the price, which was no higher than a little share of suffering. So now she's turned to the Church, which provides painless immortality. Very convenient. While Picasso suffers in solitude. But I shouldn't be saying all this to you, should I? I'm madly fond of Dora. So intelligent. But so proud. And what is it that the Bible says about pride and a fall? Please forgive me for speaking so frankly. It's the Russian temperament. Then I'll expect you both on Monday, the twenty-second, at about seven o'clock."

What Ida had said left me pensive, if not altogether surprised. What

I thought, however, was that Ida probably spoke the truth but from motives that were in all likelihood dubious, and therefore perhaps I should have expressed more surprise, indeed been argumentative in Dora's defense.

The twenty-second was unseasonably hot. Ida's house stood on the north side of the island, tall and narrow, with steep flights of stairs from floor to floor leading to small rooms with low ceilings. Dora and I arrived late. The house was already crowded, some of the guests even then spilling out onto the sidewalk under the poplar trees. Waiters in white jackets followed, passing trays of drinks and platters of hors d'oeuvres, and attracted by this manifestation of plenty on a public thoroughfare, a few of the tramps of the neighborhood had exuberantly joined the party, their presence adding to the jollity. We said hello to a few people, then went inside and upstairs. I took a glass of champagne. Chagall was surrounded by a circle of admirers, but he left them to greet Dora, holding his head to one side and waving his hands as he kissed her. "My little nightingale," he called her. She made as if to introduce me, but he said, "I already know your young man." And then to me he said, "You still like Chagall, do you?"

I said yes, certainly, of course.

"I'll tell you something, my little bird," Chagall said to Dora, drawing her to one side by the arm but glancing at the same time slyly toward me. He laughed as he whispered into Dora's ear. She smiled and also glanced at me. So I moved away.

Douglas Cooper in a preposterous plaid suit stood by the window. He said, "I have a bone to pick with your lady friend." Nor did he have to wait very long to do so, as Dora soon joined us. "You sold those drawings to that skinflint Kahnweiler," he said, "when I'd have paid you much more, and now I'll have to pay him more than the much more. It's too bad of you."

"But you know I never have mercenary dealings with friends," she protested.

"I know nothing of the kind," said Douglas.

Dora downed her glass of champagne and turned aside in search of another. I went with her. "Do you know what Chagall said?" she asked. "He said you were so charming and handsome that if he were a woman he'd fall in love with you. What do you think of that?"

What I thought was that Dora should never have repeated Chagall's

remark, especially to me, and that probably she'd already had a little too much to drink. I said, "It's very flattering."

"But then, unfortunately," Dora remarked, "Chagall is a man. And it's a pity he hasn't painted a decent picture for at least twenty-five years. Picasso was merciless with him, but he always came back, hoping for a crumb of praise, poor man."

We ate quite a lot of sandwiches, drank a good deal more champagne, and then were talking to the critic Charles Estienne, and Dora said to him, "You'll never guess what Chagall just said about James. He said he was so charming and handsome that if he were a woman he'd fall in love with him."

Estienne glanced at me with quizzical sympathy but made no comment.

"Chagall is an artist admired by all the world," said Dora.

Estienne agreed and sidled away into the perspiring crowd. For a time we chatted with James Johnson Sweeney, then still director of New York's Guggenheim Museum. He was preparing a Giacometti exhibition for the following year and asked my advice. Dora invited him to pay her a visit.

Marie-Laure de Noailles and Oscar Dominguez were there, the latter plastered. Marie-Laure was vaunting the quality of her own Chagall, a large painting called *The Green Pig*, indeed superb, but painted more than thirty years before.

Oscar patted Chagall on the head, a gesture plainly displeasing to the recipient. To me he said, "Hello, lover."

Ida came possessively to her father, whispered, and with apologetic smiles began to lead him away. As he went, he patted me on the cheek and said, "This party is for me, which means I am its plaything."

Marie-Laure said to me, "I wasn't aware you knew Chagall."

"Oh, we all know him," bawled Oscar, "the old faker, so sly he bids up the prices of his own pictures at auction so the market will follow suit. But he'd shit his pants if Picasso said boo. And who wouldn't? We are all ants and Picasso is strolling alone down the sidewalk of the world, stepping on us, and we don't even know it, stepping on us all."

I made some mild demur to this excessive metaphor.

"We know you, too, pretty boy," roared Oscar. "How would you like a big cock in the ass?"

"Putchie, really," said Marie-Laure, obviously much amused by her lover's misbehavior.

Dora frowned, turned aside, and took another glass of champagne from a passing tray.

Douglas grasped my arm. It had been very careless of me, he said, to allow Dora to sell that sketchbook to Kahnweiler. I protested that the decision had hardly been mine to make. "Oh, duckie," Douglas said with his slight lisp, "if that's the case, then you're wasting time. With all those Picassos to covet, you might be a little more considerate of Dora's happiness."

Offended by this insinuation, I replied that my friendship with Dora had nothing to do with her Picassos or her sometime relations with him. I knew this to be untrue, and that Douglas would not believe it. Still, I was startled when he said, "I will pay the premium. Remember that, my dear." And I realized that he meant the disparagement to be unmistakable.

Dora was talking to an American collector from New York named Louis Stern. She handed me her glass, which was empty, asking me to get her some more champagne. This took a little time, as the room was more crowded than ever and I had to talk to a few people on the way. When I came back, Dora was explaining the ambivalent relationship between Picasso and Braque. She took the glass and said, "Thank you, my darling," as if nothing to anyone could have seemed more commonplace.

Louis said it had been a pleasure to chat with Miss Maar, that he appreciated her invitation and looked forward to seeing her at her home the next afternoon at five.

I said he'd seemed a bore.

Dora retorted she'd found him utterly charming.

And what, I inquired, was he coming to see her about?

"Are you *still* jealous of everyone who wants to talk to me about Picasso?" she demanded, the cigarette holder scattering ash, while from her glass some champagne spilled. She swayed slightly, and I held her arm. "Why do you let me drink so much, my darling," she said. "I should give it up, give up cigarettes and everything else. To be dedicated. I'm painting a little picture of Christ in the Garden. Oh, James, sometimes I feel so alone."

I didn't say anything, but it was plainly time to leave, so I guided Dora gently by the elbow toward the staircase. Ida was stationed there, saying goodbye to her guests. Her papa had disappeared. Outside, it was now dark. Dora said to Ida, "Can you guess what your father said about James. He said he was so charming and handsome that if he were a woman he'd fall in love with him."

"Papa is so sensible," said Ida, smiling at me with amused ambiguity.

Then we went down into the street, where a few tramps were still hopefully lounging by the parapet above the river, one of them mouthing some mournful melody. Dora was unsteady on her feet. I held her firmly by her right arm as we went back across the Pont Neuf and turned left along the quay. She pointed to one of the apartment buildings, saying that Kahnweiler lived there, his apartment filled with Picassos. When we came to her house, I asked whether I should come up with her to her door, to which she irritably replied of course not, being quite able to take care of herself, and added, "Wasn't that really a perfectly detestable party? Both Ida and her father are such hypocrites. It's true that Marc is always trying to make up to Picasso, but the C and B won't have anything to do with him. Everybody wants to possess a piece of Picasso, even you."

I didn't deny it, kissed her on the cheek, and went away in the empty street without reply.

•

Bernard inevitably had seen something of Dora, and had learned something of our relationship, but by no means everything. As he had come to know her, he had decided he didn't like her. She was profoundly ambivalent, he said, miserly, vain, and domineering. Her exceptional charm and intelligence, however, he readily acknowledged. What he said, I realized, was true. And there was more to her than that. What most troubled me at the time was the tight-fisted way with money, and the perverse affectation of generosity. Surely she knew that I had far less money than she, yet it was I who always paid for our meals together. She rejoiced in receiving presents, and I gave her many, some of them objects of trifling value, others more considerable. She repeatedly remarked that she in turn was anxious to give me something, some gift of

consequence, but invariably added that to select the appropriate thing, an offering certain to please, was beyond her poor powers of discernment. Oh, but she had the desire very much on her mind, she would add. Then it was up to me to maintain that the matter was of no importance, this falsehood doubly galling inasmuch as we both knew what would be certain to please but were constrained by that very knowledge to feign indifference and ignorance. Moreover, it was true that I loved Dora for herself.

Catherine Dudley was elated at the prospect of her month by the edge of the sea. We had dinner with her a few days before her departure. She intended to take up residence in the rented house promptly on July 1. We would join her there via the late-afternoon boat a week afterwards; the inauguration of Cézanne's renovated studio would take place in the morning of July 8, followed by an official luncheon. Catherine enthusiastically assured us that we would be delighted by the house, its complete privacy and convenience. There would be separate bedrooms for each of us, though but a single bathroom, which would necessitate merely a modicum of planning. She said she would be at the landing to meet the late-afternoon boat on July 8. And by all means we were to bring with us materials for our work, as there were no distractions on the island save the pleasures of the beach and a couple of good restaurants. Dora pronounced herself very well satisfied with the prospect, grateful for Catherine's generous disposition to share her house, and eager to benefit from the salubrious effects of vigorous swimming in the sea morning and afternoon. As for myself, I couldn't help wondering how pleased I would be to find myself alone with two women for several weeks on an obscure island. I echoed Dora's sentiments, however.

We planned to leave for Ménerbes on the fifth of July, traveling this time by way of Le Puy-en-Velay, a town where in the Middle Ages a shrine to the Virgin had been a major place of pilgrimage. Dora especially wanted to visit the cathedral there. I gave up my room in the apartment on the Avenue Georges Mandel, moving my possessions and myself into a spare room in the spacious apartment of Bernard's parents in Neuilly. There I felt sure my things would be safe, but I was somewhat concerned about the Picasso bird in wood and plaster, an object extremely fragile, and so asked Dora whether I might entrust it to her for safekeeping during the summer, to be placed in the glass-fronted book-

case from which it had originally come. There it would be kept company by the bronze bust of Dora and a quantity of other creations by Picasso. She agreed and I felt reassured concerning its future. I also asked whether I might bring with me to Ménerbes the Cézanne drawing of the nude youth. It represented to me a sort of icon of aspirations and desires which I wanted to keep near. It would honor her house, she said, and hang in the salon. I had foreseen having it in my bedroom but made no demur.

Bernard was peevish and disgruntled because I planned to spend the entire summer apart from him. Our love affair had been finished for years, but he continued to feel that our continuing friendship imposed responsibilities and obligations. After visiting northern Germany and Denmark, he might perhaps cruise down the Rhine with a friend named Robert Lander, and was insistent that I should join him somewhere in Switzerland or Germany before the fine weather was over. I said I would like to but made no promise, mentioning none of this to Dora. And so she and I set out on the morning of the fifth, a very hot one, for Le Puy-en-Velay. I was astonished by the quantity of her luggage. In addition to Moumoune's basket, a new one, she had fourteen other items of varying size. I had only three suitcases, none large. It was a tour de force to fit all this into the little Renault and still leave room for two passengers, but I managed to do it, rather pleased with my dexterity, while Dora looked on as if any fool could have done the job just as well.

C H A P T E R

T W E L V E

LE PUY is notable mainly for two towering spines of rock in the city center, atop one of which stands a huge, very ugly bronze statue of the Virgin, atop the other a small Romanesque church. The twelfth-century cathedral is large but not great; there are a few fine Gothic buildings, and the rest is quite ordinary. Dora was delighted, having always wanted to visit this well-known place of pilgrimage. Oddly enough, I failed to record the name of the hotel where we spent the night, or anything else about what we did or said, except that Dora insisted on hearing Mass in the morning while I waited irritably in the car with Moumoune.

Ménerbes in the summer sunshine up there against the airborne sky looked like an illustration awaiting some romantic fiction. I was also in love with the *place*: the musty familiarity of the house, the view from my bedroom windows across the valley toward that table-topped hill, the unkempt garden with its fig tree and its star-flowered jasmine vine climbing the wall, even the dim, stale kitchen beneath its vaulted ceiling.

Dora strode through the rooms. There was no sense throwing open every single shutter, preparing the house for the summer, unpacking all our luggage, she said, as we would spend only two nights here before joining Catherine in Porquerolles. But she must get around to making the curtains for the salon, because she already had the fabric, which had cost her nothing, or next to nothing. That would be her first project after our seaside vacation. Oh, to restore the house entirely to its grand

original condition would be very gratifying, but far beyond her poor re-
sources, alas.

"Picasso would have liked you to," I said.

"You are sadly mistaken, my poor darling," she exclaimed. "If
anyone knows what Picasso would like, it's I. Devastation is his priority.
He used to say, 'Goya began something, and I bring it to an end.' You
will see that he was right."

We stayed in Ménerbes only thirty-six hours and had our meals in
the café-restaurant at the foot of the escarpment on the north side of the
village. No use to waste money stocking up on food for such a short
stay, Dora said. I paid the bills. No use to have Artemis in, either.
There would be plenty of time for cleaning the house when we returned
in August.

Dora did not care to be present at the inauguration of Cézanne's
studio, a display of seeming indifference which I rather resented, con-
sidering the occasion especially significant, not only because of the
efforts I had expended but also, and even more, because of the symbolic
amplitude of Cézanne's work and life for everyone who cared anything
about the spiritual itinerary of our time. Yet she had made something
of a ceremony of hanging in her salon the drawing of the nude youth
which I had brought with me. Perhaps, I thought, she was reluctant to
be seen with me at an official function where people were sure to rec-
ognize her. And I knew better than to try to persuade. She said she
would take care of Moumoune, watch over the car, which, to be sure,
crammed with luggage, would have been a tempting target for theft, and
have lunch in some bistro. I mustn't linger too long at the luncheon,
she warned, because we had rather a long drive to Giens, where one em-
barked for Porquerolles, and must on no account miss the last boat. So
I walked up the hill to the studio by myself.

There was a considerable crowd, the American ambassador, the
French Minister of the Interior, numerous officials of Aix-en-Provence
and its university, even a few people who admired and understood the
artist whose solitary retreat, birthplace of many masterpieces, henceforth
was to become a public place. In this throng I knew almost no one, and
there were but two or three persons I could call friends: the painter
André Masson, whom I promised to call later in the summer, Douglas
Cooper, and John Richardson. There were several speeches, and it was

mentioned that "the contributions of American admirers of Paul Cé-
zanne" had provided for the purchase and renovation of his studio.

Leaving the luncheon promptly proved easy and a pleasure. Dora
was seated on a bench near the parked car smoking a cigarette, with
Moumoune on her lap. We departed immediately. She inquired about
the ceremonies, expressing satisfaction at having declined to be present.
I told her that I'd seen André Masson and promised him that we might
all meet later in the summer. Dora frowned, saying that I'd better not
take too much for granted, as she might not care to see anyone later in
the summer. Then she told me about her lunch. Having bought some
bread and pâté, she made herself a very ample sandwich, ate it sitting
on the bench where I'd found her, followed by one café filtre in a bar,
total cost negligible. And she expected that, as this would be our first
night on the island, Catherine would feel constrained to invite us to
dinner in a restaurant there, a further economy. The more I knew her,
the more I found it difficult to admit to myself that Dora was as miserly
about money as she manifestly was. I could accept the premise that this
was a symptom of something other than itself, but it was disturbing,
because whatever hid behind the symptom seemed to operate at my
expense. I might have guessed why, but I wanted only to idolize Dora.

The drive from Aix to Giens was not very long, after all. We passed
through Hyères, where Dora pointed out the hilltop château of Marie-
Laure de Noailles, remarking that if we had had time we would certainly
have been welcomed there for a meal. At the embarkation point we
unloaded the car, then I left it in a lot where for three weeks it would
bake in the Riviera heat. The Porquerolles boat was small, old, battered,
like the boatman himself, who grumbled at the large quantity of our
luggage, including the irate Moumoune, which he was compelled to stow
aboard. Fortunately, the island of Porquerolles is barely a mile from the
coast, the boat ride lasting only about fifteen minutes. How she loved
the sea, Dora said, evoking the wonderful passage in Xenophon when
his harried troops come to the crest of a hill and give shouts of joy as
they catch sight at last of the felicitous waters. Catherine was on the
dock, waving, and had had the foresight to engage a man with a handcart
to transport our luggage. She, too, expressed some surprise at the quan-
tity of it. Dora said that she had brought but the basic necessities, no
more. Catherine did not insist. We followed the cart.

The instant I set eyes on the house, I guessed that our sojourn in it would turn out to be a disaster. To be sure, it stood by itself on the sand against a tall thicket of bamboo only a few yards from the water. But it was far too small to provide either convenience or privacy for three people. Perhaps promiscuity would not trouble Catherine, but I was certain it would exasperate Dora, and though I knew I would have no say in any arrangements, I thought there would probably be none to my liking. The house was painted pale pink, its façade provided with one door and two windows. The door opened into a hallway furnished with a table and chairs, at the rear of which were a small bathroom, the toilet, and a kitchen crammed into what had obviously once been a closet. To the right, double doors opened into a bedroom of average dimensions, a single door giving access to another bedroom considerably more spacious. This, the most agreeable room, would be Dora's, Catherine announced. James's, entirely private, was located at the rear of the house. Dora surveyed the premises with some doubt, at once perceiving that she could neither enter nor leave her room without passing through Catherine's, an unacceptable situation. Catherine had anticipated that this might displease and had foreseen a remedy, a makeshift remedy, but the only feasible alternative. Dora would come and go through her window, not the door. From the bedroom floor to the window ledge, however, was a height of more than two feet, while from the ledge to the ground outside was a drop of about five feet, making entrance and exit something of an athletic challenge. But this, too, cunning Catherine had anticipated, and during the previous week she had collected a quantity of empty wooden packing cases with which to construct a set of steps both inside and outside. Dora's countenance underwent a further darkening. Nonetheless, having unpacked not so much as a bathing suit, we set about constructing this rickety facility. It was preposterous in appearance, as the packing cases were of different sizes, even colors, and, projecting from the front of the house beneath the window, made a sizable mini-ziggurat. Yet it worked. Dora tried it several times, her footfalls on the empty cases pounding with embarrassing reverberation. Catherine had obviously gone to quite a lot of trouble, and Dora was obliged to put the best face she could manage on the circumstances. She said that the steps would do very nicely. Then we went to see my room. It was around at the back, reached by a narrow path between house and bamboo, a small, dim, damp, drab room fur-

nished with a cot, table, chest of drawers, and one chair, though it did boast the luxury of a cracked and rust-stained, dripping sink in one corner. A single window opened upon the bamboo thicket, which cut off so much light from the room that it was necessary to turn on the one lamp, its bulb so weak, I immediately saw, that reading by it would be impossible. The concrete floor was gritty with sand. I pretended—rather successfully, I thought—to be delighted by these accommodations. Dora remarked that men were always better lodged than women. Catherine suggested that we all go for a swim.

The water was delicious, transparent, warm but invigorating, calm, with shimmering sand on the bottom and tiny fish in the shallows. Dora was clearly delighted. Attired in an unbecoming one-piece black suit of pre-war style which did nothing to conceal her excess flesh, she swam vigorously back and forth, chopping the water with practiced strokes, oblivious to all else, and in her pleasure, her evident sense of physical identification with the sea, as I watched her, it could almost seem that she embodied a reincarnation of some ancient deity of the deeps, and that she was aware of this, deriving from it supernatural power and arcane self-confidence. I was strangely moved; indeed, physically excited. But this did not last long. Presently we went back to the house. The towel on the bar beside the sink in my gloomy room was like cardboard.

Hardly had I finished dressing when there came several light, almost surreptitious taps on my door. It was Dora. She came in, closed the door quietly behind her, and held her finger to her lips, pointing upward to the ceiling, which consisted only of rough rafters supporting the wooden floor of Catherine's room.

"I detest this place," she whispered.

I said, "Well, now that we're here . . ."

She said that it was absolutely out of the question for her to spend one instant more than necessary under these intolerable, ridiculous conditions and that it had been exceedingly irresponsible of Catherine to place her in such a situation. She was determined to leave the very next morning. I protested—without enthusiasm or much conviction— that we had given Catherine our word and that perhaps after a few days we would become accustomed to the minor inconveniences. Besides, there was the wonderful proximity of the water.

"We can drive to the sea from Ménerbes," said Dora. "I have

decided to leave in the morning, and that's my last word in the matter.
I count on you to accompany me. After all, it would be ridiculous for
you to stay on here alone with an old woman who is barely an ac-
quaintance."

I agreed, of course, reiterating nonetheless that it was rather a tough
tack to take with Catherine. Oh, but we would still pay our share of the
rent, Dora protested, and so Catherine would have the whole place to
herself for half price, not at all a losing proposition.

However . . . however, she added, there was, to be sure, one
decidedly ticklish aspect to the business. And that was, in a word,
friendship. She and Catherine had known one another for a couple of
decades, anyway, known one another through thick and thin, the Dudley
sisters having been among Dora's most kindhearted and practical friends
during those catastrophic days after Picasso abandoned her. Thus, it
would be a bit awkward, solely on her account, to go back on her promise
to spend all of July in this terrible house. Next to no awkwardness, on
the other hand, would attach to our abrupt withdrawal if all responsibility
for it should be mine. Mine? I was taken aback, to say the least. Yes,
said Dora. If she told Catherine that I refused to stay, it would seem
perfectly natural, assumptions about our relationship being what they
had to be, that we must leave together. And what difference, after all,
could it make to me? I was no friend of Catherine. And certainly I would
be far more comfortable in my airy room at Ménerbes than in this dank
hole. That was true, I had to admit. Still, it took my breath away to
experience the imperious serenity with which Dora dictated my willing-
ness to feign guilt for her sake. Guilt, perhaps, of not a very grave order,
though had it been at her expense I felt the perspective would have been
different, but guilt all the same, and naturally I later wondered, and
lengthily debated in writing, by what uncanny clairvoyance Dora knew
that she could make free with a lifelong predisposition. I agreed, of
course, not even considering at the moment the significance of my will-
ingness to please her, and her desire to be pleased, by a falsehood. But
I wondered whether this might not alter the ambiguous equilibrium of
our relations.

Dora was pleased. She had never doubted, she said, that I would
agree to such a sensible solution to this contretemps. She would im-
mediately inform Catherine of our decision. And as soon as I was ready,

I could come around to the front of the house, where we would have a drink or two before going along to dine in the best restaurant on the island, Catherine having kindly invited us, as Dora had shrewdly predicted. All I need do, she added in parting, a snap for someone as given as I to playing various roles, would be to personify a spoiled and sulky young lout. And she laughed heartily as she shut the door. I didn't at all like this final touch to Dora's plot.

The scapegoat of the occasion, I didn't expect to be spared some censure, and I wasn't. We sat on rusty metal chairs in front of the house, drinking whisky while the sun set, and Catherine remarked that a young fellow like me, American, moreover, might have been expected to put up with accommodations a little less luxurious than the Hôtel du Cap d'Antibes. Oh, Dora quickly interposed, it was not an issue of luxury, not at all, but rather the problem of surroundings satisfactorily conducive to creative endeavor. And James was extremely fussy concerning these. Catherine made some caustic comment about the relation between fuss and results, and I did not find it difficult to sulk, though my annoyance was aimed less at Catherine than at Dora, who laughed and drank and seemed cheerfully willing to humor a trying companion. The restaurant was within walking distance. Catherine was beautifully attired in a white silk shirt and a finely pleated violet skirt that swirled elegantly around her as we walked under the pine trees. Dora, who had on a commonplace flowered frock, was outspoken in her admiration of the skirt, dwelling at length on its finesse and chic. Catherine, transparently pleased by the compliments, was pleased even more to boast that she had gotten the skirt for next to nothing on sale at Grès Jeunes Filles.

The restaurant by the seaside was excellent. I enjoyed the meal, at least. The two ladies for the most part talked to each other, recalling old and good times, reminiscing about people I'd never heard of, and Dora more than once reiterated her admiration of the violet skirt. Catherine lamented the dearth of companionable men in their milieu, all the ones they'd long ago known now either married, dead, or demented, a very sad situation for single ladies such as she. Dora pensively conceded that this was so. She also mentioned in passing that though we were not going to stay any longer than the next morning, we would, of course, insist upon paying our share of the rent as agreed. Catherine coldly rejoined that that was absolutely out of the question. If we did not stay,

we did not pay, and she would hear no more about it. Dora amicably agreed—rather too promptly, I thought—that if such was Catherine's feeling, so it would be. I was not consulted. And Catherine did insist upon paying for the dinner. On the way back to the house, she arranged for someone to come the next morning to fetch our luggage in time for the ten o'clock boat.

The cot was uncomfortable. I slept badly, thinking Dora had done us both a good turn, though the skill with which she had made the guilt entirely mine lay like an incubus upon my troubled slumbers. I remembered a recurrent fantasy of my childhood, vivid to me just before sleep, half a dream, perhaps, in which I was bound naked to a tree preparatory to some terrible torture, prelude to execution, punishment for a crime which I did not know I had committed. The memory was so intense, accompanied by a stir of sexual sensation, that I turned on the light and scribbled a note to myself—a discipline in which I persevere to this day—to be sure that I would write about it later in my journal.

Catherine accompanied us to the boat landing, attired exactly as she had been the evening before, and Dora again admired the pleated skirt. The boatman was the same who had conveyed us across the previous afternoon. He expressed surprise, almost indignation, at our return after a single night on the island, with such a large quantity of luggage. Oh, Dora said, every item of luggage had been essential for a stay of just one night. As the boat drew away from the dock, Catherine stood at the end of it, a solitary figure, waving. And when we had come out a certain distance, beyond earshot, Dora said, "Catherine is not a true friend. If she had been, she would have understood that if I liked her skirt so much, she ought to have given it to me. Besides, she said herself that it cost next to nothing."

I did not respond.

She added, "And she complains that there are so few companionable men. I present her with one on a silver platter and she's rude to him. Really, she's impossible."

I still made no comment. Catherine continued to wave at the end of the dock, a tiny violet figure against the glistening silhouette of the island. It had been a bit eccentric of her to imagine that the three of us could comfortably, companionably spend three weeks in such inconvenient circumstances, but no doubt she had been anxious to save herself

from total solitude. Her figure had not yet quite disappeared across the arm of the sea, and I felt a twinge of remorse.

When all our luggage, plus Moumoune, had once again been stowed in the little car, Dora said it would be a good idea to telephone Marie-Laure, who was sure to invite us to lunch at her château, which, moreover, I would doubtless enjoy seeing, as it was a unique house and filled with wonderful works of art. I gladly agreed, wondering nonetheless whether Dora had calculated in advance the cash saving of another free meal, even one she might not have paid for herself. Marie-Laure did invite us and we set out for her domain.

The Château Saint-Bernard was an undistinguished Cubist extravaganza of reinforced concrete set atop a high hill within the ancient walls of a Saracen fortress. It had been designed in the late twenties by a fashionable architect named Mallet-Stevens, contained something like fifty rooms, and was surrounded by vast gardens. The private road leading to this hilltop estate was steeply serpentine and in poor repair. But once inside the gate, one entered a world of lush and exotic vegetation, gurgling fountains, *rocaille*, velvety lawn, an aura of untrammeled luxury. Marie-Laure seemed very pleased by our fortuitous arrival, at once urging that we stay for more than a meal, a few days at least. But Dora insisted that urgent commitments awaited her in Ménerbes, that she had come down to the coast for but a single night out of special consideration for her old friend Catherine. The only other guests at Saint-Bernard just then were Oscar, of course, and a young American composer, a protégé of Marie-Laure, whom I had known already for several years in Paris, named Ned Rorem. So we were five at the round table; enough food was served to feed ten, and it was remarkable, the wine less extraordinary. We had coffee on the terrace. Ned showed me around the downstairs rooms, where the walls were crowded with pictures by Picasso, Juan Gris, Klee, Tanguy, de Chirico, Masson, Max Ernst, etc., etc. There was a large library. Out of Dora's hearing, Ned said that anytime I wanted to get away from Ménerbes for a little change he was certain Marie-Laure would be happy to have me, and I was pleased to have the opportunity for evasion assured, should it become desirable. Dora was in a hurry to be on the way, so we left, promising further visits and meetings before the end of the summer, and were in Ménerbes well before sunset, having taken the back road via Lourmarin and Bonnieux

and been absent less than thirty-six hours instead of three weeks. Compared to the tranquil grandeur of Saint-Bernard, the house of the Général Baron Robert seemed very homely and austere, but I was overjoyed to be there again with Dora and felt, having thought of this again and again during the past weeks, that maybe I did desire to be with her forever. And was it not plausible that her desire might be akin to mine?

So the routine of our life together resumed in that majestic wreck of a house. I wrote either in my bedroom or in the salon, where the Cézanne youth kept me powerful company. Dora spent hours in her studio and frequently went off on her motorbike to sketch in the hills. It seemed that we talked more often and more intensely about the C and B when in Ménerbes than ever we had in Paris. She was certain he would hear—from Oscar, from Douglas, from X, Y, and Z—that we were once more here together, and it would make him furious, for he expected to exercise the prerogatives of possession even over those he abandoned. And no doubt he felt that the house, having been given by him, was his to rule over still.

"Will he never die," I said, "and leave us in peace?"

"It will be worse then," she said. "Then the real war will begin, and none of us will live long enough to see how it turns out."

I told her that Braque once, when I had been with him in his studio and some mention was made of Picasso, had said, "He used to be a great artist, but now he's only a genius."

Still, nobody would have the courage to attack him personally and publicly, Dora maintained. His legend, his magic would protect him like Mephistopheles's circle. He had once given her a drawing, a very distorted portrait of her, inscribed *For Dora Maar, Great Painter.* She understood that the inscription was no less a distortion than the image, had never shown the drawing to anyone and never would, for it, like so much else, had been a weapon in his war with art and with the world. "He used me," she said, "until he felt there was nothing left of me. The hundreds of portraits of me he painted. Then one day in his car, with that oaf Marcel listening to every word, we had the most appalling argument. Afterwards he left me at my door very, very politely, too politely, and I knew that it was all over. But I didn't know, and waited and waited. Waited for more than two weeks, when we had seen each other almost every day for years. He didn't have the courage to tell me,

expected me to die without a murmur of complaint. One day Eluard
came to see me and found me sitting in the staircase in my nightgown,
sobbing. But the monster was busy painting portraits of the girl who
would give him children. Children to destroy. I always refused to have
children by him because it would not have been an honorable way of
holding him, and too cruel to the innocent children."

•

There were mornings when I woke up with the sun dappling my
room and swore to myself that for one day, at least, we would never
once mention *his* name. I didn't know whether we hated him or loved
him, were afraid of him or sought his protection, lived for each other
by virtue of having known him or merely survived together as an outcome
of that ordeal. It was impossible to say, and I detested the uncertainty
just as I detested the memory of his odious behavior toward Dora during
the evening at Castille. And, indeed, occasionally there were days when
we never mentioned that name or even the ironic nickname.

But then there were the nights. I often dreamed about Picasso. I
still do. The situations of the dreams were extremely various, and very
often involved my longing either to seek him out in unfamiliar surround-
ings or to possess some creation from his hand. I mentioned to Dora
that I occasionally dreamed about him. She sniffed and said, "I dreamed
about him every single night without exception for more than ten years.
There were times when I dreaded going to sleep."

I could not possibly have recorded all the dreams I dreamed about
Picasso. Even had I had the initiative, most of them faded into forget-
fulness too quickly to be kept from oblivion, and that seemed just as
well. But there was one exception, an exception so signal that I had no
difficulty whatsoever in recording it. It was sexual in content. Certainly,
I have had thousands of sexually explicit dreams during my lifetime. Of
all those, this is the only one that I remember, and the only sexual
dream I ever had concerning Picasso. He stood naked before me, stat-
uesque, powerful, silent. I knelt in front of him, also naked and sexually
excited, longing to engage in intercourse. But he made no gesture either
to encourage or to reject me. I had to wait, while my desire became
almost unbearable, and the suspense seemed an orgasm perpetually
delayed. At last Picasso spoke. He said, "You have to understand that

I can't sow my seed just anywhere, at random." Whereupon he vanished. I awoke with a sense of lacerating frustration. I did not relate this dream to Dora.

After dark we used to sit out in the fragrant warmth of the garden on a very uncomfortable stone bench, listening to the somnolent murmur of the valley below, the purr of an occasional motorbike, the slow growl of a drowsy dog. A far more comfortable wooden bench was stored in the attic, Dora said, and someday if I was feeling Herculean I might bring it down. The smoke of our cigarettes made ghostly whorls in the pale illumination of the street light below the retaining wall and eddied upward into the black hood of the pine tree.

"Sometimes," Dora said, "I am so afraid for you, my darling."

"Because?"

"I would have liked to save you. Since we are friends. But then I would have had to know for sure who you are."

"Well, I would rather find that out from you than from anyone else. Has it to do with the truth in your box of matches?"

"Living with a writer is very different. You secrete yourself in the labyrinth of language, which has a life all its own, true or false, no matter. I wonder sometimes what *I* have to do with it," she said.

"Everything," I truthfully replied.

She passed her hand gently through my hair, saying at the same time, "I don't know why I've gotten into this foolish habit."

A letter arrived from Hyères, from Marie-Laure, addressed to me, concluding, "See you soon." I suggested that maybe we might call Marie-Laure, meet her in Aix for dinner, even spend a night or two at Saint-Bernard. "I have no time to waste on social frivolity," Dora said, "and you mustn't make plans for me." I had no intention of doing so. Yet there were moments when the changeless continuity of life in that uncomfortable house seemed confining and oppressive. I reminded Dora that I had promised to call the Massons in Aix. And Douglas was sure to get in touch with us. In Ménerbes itself were Tony and Thérèse Mayer, from whom we had not yet heard. "Oh, they called," Dora said, "but I put them off. I suppose it must be the difference in age. You want to see other people. I don't. I've lived through other people. You haven't."

Why did she insist on it? This was far from the first time that she had explained away something by attributing it to the difference in age

between us. To me it was irrelevant, virtually imperceptible, but I couldn't bring myself to humiliate us both by saying so. I don't believe she believed that *that* difference was one which made for any discord or disparity. She was too intelligent and experienced. She relented, however, saying that I might call the Massons. I did, and spoke to Rose, who said the music festival was presenting *Don Giovanni* on the twenty-ninth; they were going and she suggested that we, too, attend. Lacan and Sylvia would be staying with them. We could all have dinner first and go together. It would be easy for me to get free tickets, being a benefactor of the town. I told Rose she could count on us.

"Such a terrible opera," Dora said. "Oh, a musical masterpiece, sublime music, but humanly terrible. Those ruined lives. And in spite of all that, we will be enchanted, I presume."

She reminded me that I had promised to take her to the sea to go swimming. I had made no such promise, but asked how far it was. It was far, way beyond Arles, the only decent beaches being at Saintes-Maries-de-la-Mer or Piémanson. The drive would take close to two hours. We could have a picnic on the beach. I said it sounded wonderful, knowing that I would probably have to do it at least once, but determined to delay as long as possible.

She treated me like a child, I sometimes thought, and maybe that was what I wanted, having once absurdly claimed Picasso as my father, inasmuch as no psychic prohibition is more profound than that which represses filial passion for the mother. Is it possible that this is what saved Dora, too? Making it tolerable for her to take the risk of being entirely herself?

There was the incident of the bench. She had mentioned several times that in the attic stood a wooden bench far more comfortable than the stone slab in the garden where we often sat. Didn't I feel strong enough to carry it down? I am not very strong, have never cared for sports, done calisthenics, or been obsessed by physical fitness. Still, I felt no embarrassment about my physique in those days, and thought I could manage a heavy bench as well as the next man. So I said that of course I could bring it down. And I wonder to this day whether or not she knew perfectly well when she sent me for it that the bench was not the only object which I would find in the attic. As I went inside to go up there, she called a warning after me to watch out for scorpions.

The attic was the only part of the house I had never visited or felt curious about. Its entrance was a low wooden door up a few steps from the toilet at the rear of the house. Opening the door raised a whirlwind of dust, and inside, save for wisps of daylight hovering among spiderwebs beneath the eaves, it was pitch-dark. The dust gradually subsiding let in half light from the open door. I saw the bench at once, made of green planks for seat and back, held together toward either end by cast-iron supports and legs of a decorative style popular in provincial parts before World War I. Probably it had come with the house. Lifting one end, I discovered that it was very heavy. And then as abruptly as an artillery shot I became aware of the other thing in the attic, dropping the bench with a thud. It was Picasso's toilet seat. Recognition instantaneous. The old-fashioned wooden type, a plank with an oval aperture and hinged cover, both painted bright green and decorated all over with small white flowers. I picked it up, held it, turning it this way and that. It was unsigned. Who could ever have guessed that this most homely utilitarian item had been decorated by a great artist? But that was its point, and *his* point, of course. And no doubt the explanation of Dora's lie, of Picasso's ill humor, and the fact that this object had not been consecrated by admission to the secret closet. She had been unable to bring herself to throw it away: the power of art to confound human longings. It occurred to me that she might also have considered the market value of even so humble a product of genius. I put it down where it had been, never again returned to the attic, and would wager it lies there today.

The bench was not only extremely heavy but also cumbersome for one person to manage. Still, having dragged it from the attic down to the landing in front of the toilet, I managed to balance it—painfully!—across my shoulders and maneuver it down the staircase, only once or twice gouging untoward chips of plaster from the walls, through the salon and outside into the garden, where I set it in the shade of the fig tree, gasping deeply and perspiring like a miner. The day was exceptionally hot.

"Bravo!" Dora exclaimed. "I didn't dream you were such a he-man."

I was rather pleased with myself, as the effort had been greater than I might have expected successfully to carry off, and I felt that it should rightfully have made an impression. So I said something or other

to the effect that it was nothing: carrying around heavy loads like a beast of burden in the summer really didn't prove anything.

To which Dora, snatching the cigarette holder from between her lips, replied, "Really, you are a complete fool." Turned her back and went into the house.

I *felt* like a fool, having made such a vain, unprofitable display of strength I didn't in fact possess, humiliated and angry at Dora. What had I done but just what she had asked of me? But what she had asked of me was not what in her heart she wanted. I sat down on the bench in the clumped shade under the fig tree. My anger was not lasting. What I believed I wanted was to be with Dora always, free at the same time to be with myself as I wished, and I could conceive no reasonable contradiction in this. Were she to insist even that I become a Catholic, why not? God's grace encompasses the faults, does it not, even of those who *in extremis* appeal to Him. I knew she would come back sooner or later if I waited long enough.

It was less than an hour. The day had just begun to pale in the valley. She came from the house with a large portfolio under her arm and a handful of pencils in the other hand. Contemplating me as though we had not seen each other for a long time, she said, "That will do very well if you can hold the pose," and she sat down on the stone slab, taking from her portfolio a large sheet of paper. "I'll draw your portrait on the bench under the fig tree. And do try not to move. Above all, don't talk. My poor darling, you are so naïve."

I didn't have to talk. What answer was there to her dominion and pride? And then there was the excitement of submitting once more to the concentrated gaze of a portraitist. At Easter time one evening in the kitchen she had done a quick sketch of me in profile, my chin in my hand, a little like a Picasso, and given it to me, but I had not much liked it, and expected the present product to be more gratifying, given its far larger size, not to mention the circumstances. So it was easy to sit still and keep my mouth shut.

It took quite a long time, and the light had almost gone out of the garden, the shadows under the shrubs turning deep gentian, the sky amethyst beyond the mountains. Dora stood, tossing down her portfolio, paper, and pencils, exclaiming that she could do no more. I went to look. It was unlike anything else by her that I had ever seen, more

meticulously studied, detailed, and composed than was her customary style. As a portrait, however, this was of the fig tree and its typical, symbolic foliage far more than of the figure seated with his legs crossed and his left hand hung over the back of the bench, who was recognizable as a man but not particularly personalized. I could discern that it was I but doubted that this would be apparent even to someone who knew me well. The face was featureless, an egg, and the rest of the figure quite sketchy compared to the careful rendering of the suggestive leaves above. What struck me at once was the resemblance to a drawing by Cézanne, especially to certain of the very late studies of Vallier, the old painter's gardener. Whether or not the drawing was a striking likeness seemed secondary to its quality as a work of art. I said as much to Dora, mentioning also the kinship to Cézanne, thinking this would please, and added that I was very satisfied with what she had done, for I assumed that she would make me a gift of her drawing and felt that I had every right to make the assumption. In which I was regrettably mistaken. She took in my compliments with equanimity, remarking that as a quick sketch, yes, it was acceptable, no more than acceptable, and better, much better ought to be required. She slipped the page back into her portfolio, gathered up her pencils, and went back to the house. I was surprised, not disappointed. I thought I had become impervious to disappointment. All her behavior toward me bespoke her care, I thought. But I should also have been impervious to surprise.

•

"Royalty for cocktails," Dora gleefully announced one morning.
"Royalty? In Ménerbes?"
A first cousin of the Queen, the Earl of Harewood, son of the only daughter of George V, and at that time something like tenth or twelfth in succession to the throne. Thérèse Mayer had called that morning before I woke to announce that they were expecting the earl and his wife for a few days' visit and would like to bring them to Dora's house for a drink. So it was settled that they should come for a drink at noon two days hence and that afterwards we would all walk back to the Mayers' house for lunch. This was heady social agitation for a dormant place like Ménerbes. Moreover, the earl was something of a celebrity, having caused quite a stir in the royal milieu a few years before by marrying

someone inevitably regarded as "unsuitable" by the Palace, a young Jewish pianist from Vienna named Marion Stein. George Harewood was passionately devoted to serious music, had for several years been director of Covent Garden, and it was this devotion which had introduced him to Miss Stein as well as to the Mayers, themselves lifelong devotees of chamber music. Meanwhile, said Dora, the royal visit required that she should at last make the too long delayed curtains for the salon, and I could help her.

An antiquated portable sewing machine was set on the salon table, beside it a large bolt of white fabric. I was instructed to stand at the far end of the room. Dora seized the bolt and flung it toward me across the salon, the immaculate fabric unfolding like a waterfall, rustling crisply toward me through the sunlight. The first thing to do, she said, was rip it along the sharp crease where it had been folded all the way down the center, so I was to hold one end while she ripped from the other. She shook her end in a long wave and began to rip the thin cotton, her elbows jutting sideways as she tore, while the dire screech of rent threads made me shiver. I suggested that it would be best if we tried to keep the fabric as taut as possible between us.

"Oh, shut up!" she shrieked. "I know what I'm doing. Don't interfere." And she violently ripped a further, strident length of cloth. I dropped my end to the floor.

"Don't be difficult," she said. "You know I'm always in a bad humor when I do any sewing."

I knew nothing of the sort, said nothing.

"It's of no importance," Dora said. "Maybe I'd better finish this by myself. Besides, there's nothing more that you can do."

Her outbursts of ill humor no longer astonished me, and though they made me angry, at the same time they excited me, because I realized that the pretext had little or nothing to do with the real reason, which had to do with me. So I self-righteously left her alone to make her curtains. These, to my amazement, though plain and unpretentious, were completed within twenty-four hours and turned out to be quite handsome in their unadorned simplicity, with wide hems and precisely spaced pleats. I admired them. Dora said, "They're nothing. I learned to sew from an old crone in Buenos Aires, and learned fast, because whenever I made a mistake, she would prick me with a needle."

The day of the royal cocktail party, a Friday, was to be one of exceptional social activity for us, as in addition to the cocktail party and luncheon, this was the day we were to go to Aix in the evening, dine with André and Rose Masson, Jacques and Sylvia Lacan, and attend the performance of *Don Giovanni*. Dora was in a dither at the prospect of so much to do during a single day. I told her that there could be nothing to worry about: all would proceed like the simplest parade of incidents, and she would have nothing to do but be herself.

"Oh yes," she said. "I will be all right. But you. I expect you to be on your best behavior."

"That is to say?"

"What role will you be playing today?"

"Something easy. An uninteresting admirer of celebrated personages."

The earl and his countess, shepherded like frail and exotic fauna by Tony and Thérèse, arrived at twelve precisely, and everyone behaved as befitted the occasion: with consummate informality. Harewood was stocky and plain without being homely, while his wife was dark and good-looking. Dora had bought a bottle of champagne and a packet of pretzels. The guests were shown around the house and garden, making the complimentary comments *de rigueur*—dutifully, I thought, considering the palaces with which they were familiar—and the earl demonstrated his discernment by admiring the drawing of the nude youth in the salon. "A Cézanne," said Dora, without bothering to mention that it belonged to me. And after forty minutes we walked up past the town hall along the narrow street to the Mayers' house.

The lunch was good. A slight stir of air passed through the room, welcome because the day was exceptionally hot. The earl, too, it came out, much enjoyed swimming and regretted that we were too far from the sea to make an expedition practical. And at that time there was not a single swimming pool that we knew of in the region—now, I'm told, the area in all of France most massed with pools. Dora, however, knew of a very agreeable pond not far away and offered to escort the Harewoods there for a bathe whenever they wished. Tony and Thérèse didn't care for a swim. So it was agreed that the four of us would go swimming in Dora's pond two days later, taking along a picnic lunch.

Music naturally dominated a lot of the conversation. I was surprised

that Dora participated in it with ease, while I was rather left out, being unacquainted with the names of many performers famous before the war and ignorant of much musical history well known on the Continent. Thérèse politely tried to redeem me by saying, "Of course James is much too young to know who first sang in Satie's *Socrate*." And then again, "Naturally, James has never heard of Louis Durey, he's far too young." And during dessert, "A pity James isn't a generation older, our age, so he could have heard Poulenc play at Winnie de Polignac's." As a matter of fact, I think George Harewood was no older than I, if not a bit younger, but he had that air of ageless composure so characteristic of the English aristocracy. Still, I had heard of Dukas and d'Indy, and, if too late to hear Poulenc play in the mansion of the Singer sewing machine heiress, had nonetheless been present at the riotous first night of his *Mamelles de Tirésias* at the Opéra Comique.

In the white heat of the mid-afternoon Dora and I walked home from the Mayers'. She was very quiet, made no comment about the lunch or the eminent guests. As we reached her doorstep, she abruptly exclaimed, "I always knew Thérèse was no true friend. She cultivates me because of Picasso but resents the fact that I'm a person of distinction in my own right, an artist, someone who attracts the attentions of others because of what I am today, not because of what I used to be. And Thérèse is an ugly little woman well past middle age, married to a nonentity."

Astounded by this outburst, I said that Thérèse had always seemed to me considerate and kindly, anxious to please.

"But you don't matter," said Dora. "Why do you think she went on and on and on during lunch about your being so young? To flatter you? Not on your life. To humiliate me, make me seem old, exaggerate the difference in our ages, as if I cared. I don't, of course. But she doesn't know that. She thinks our relationship is the banal thing that everybody thinks it is, and if that were the truth, then maybe I'd be upset. I don't care one bit that you're a few years younger than I am. It's your good luck, in fact. You have so much still to learn."

The moment was ripe for utter acquiescence, and I was ready.

Then I reminded her that the Massons expected us shortly after six, so we would have to leave soon.

Rose and André had an attractive old house in the shade of large

sycamores a mile or two outside Aix on the Route du Tholonnet, and André's studio, set apart from the house, was a spacious new building with a spectacular view of Cézanne's mountain. This comfortable arrangement, Dora told me, had been financed by Kahnweiler, André's dealer, and was of course in Kahnweiler's name, since he never gave anything for nothing. After the death, for example, of Juan Gris, whose works had contributed very largely to his fortune, Kahnweiler had lodged his widow, Josette, who was left with next to no paintings, in a cramped, top-floor servant's room, also in the dealer's name.

We sat under the trees and had a drink. Lacan was more sociable than when I had seen him in the country near Paris, quite talkative, indeed, though the talk seemed to me rambling, skipping without logical transition from one topic to another and frequently not addressed to anyone in particular yet quite personal and certainly not lacking in charm. André was also a willing and personable talker, his topic almost always art, and he was a far more coherent and straightforward conversationalist than his brother-in-law; Rose Masson and Sylvia Lacan were sisters. He also wrote with exceptional acumen about painting, and I often thought that if he had had less verbal facility in discussing what meant most to him he might not have failed to create works of the first distinction. The ladies chatted of matters more mundane, like dinner napkins, servants, and the love affairs of their friends. I sipped my *pastis*, listened, and was satisfied to be in the company of people who had no misgivings about their importance.

The opera was performed in the open courtyard of the Archbishop's Palace. This was not my first acquaintance with *Don Giovanni*, and I feel there is no other opera of comparable profundity, the *Divine Comedy* of operas. Mindful of Dora's reservations, I tried to observe her reactions while remaining alert to what was happening on the stage, and it seemed to me that she was far more attentive to the bitterness and humiliation of Donna Elvira, the spurned mistress, than to the assault and bereavement of Donna Anna, principal victim of the profligate sinner. And when the statue of the Commendatore came stamping into the banqueting hall to end things by casting down the unrepentant Don into the flames of hell, Dora, I thought, seemed both satisfied and sad. She took a tiny handkerchief from her purse and blew her nose, turning away from me, but I saw all the same that she wiped her eyes.

We strolled back in the festival crowd past the grand mansions and the memorial fountain to Cézanne decorated with Renoir's ugly bronze bas-relief. And when we came out under the high, leafy nave of the Cours Mirabeau, everyone agreed that it would be good to have a final drink at the Deux Garçons. Though the café, Aix's oldest and best, was crowded, we were able to squeeze in, all six of us, around one tiny table, and drinks eventually materialized. We talked about the opera, Lacan maintaining that Don Ottavio was probably a repressed homosexual, whereas Giovanni's genital compulsion intimated a terror of impotence and Leporello's famous catalogue was clearly a fiction. Rose and Sylvia were critical of Zerlina's virtue, deeming her a tease. Dora said nothing.

I didn't notice the tearful lady. It was Sylvia who pointed her out. "There's the weeping woman," she said, explaining that this person was her husband's most pertinacious patient. And there, indeed, was a woman of middle age, well dressed but plain, walking back and forth in front of the café, her gaze fixed upon our table, tears streaming down her cheeks.

"Naturally she's there," said Lacan. "She was in the audience, too. I spotted her immediately, way over to the left." He laughed, adding, "If I went to Patagonia and she failed to turn up, I'd feel as if I'd never left the rue de Lille. She follows me everywhere."

Rose asked how she knew where Lacan was going, and he replied that therapy compelled him to provide his itinerary. But of course he refused to speak to her, being specifically on vacation, and that was why she wept.

Dora stood up abruptly, excused herself, and went inside the café.

Sylvia remarked that the weeping woman's presence was regrettable, considering how frequently the image of a woman in tears had appeared in Picasso's work during his liaison with Dora and how much weeping she herself had done after their separation while being treated by Lacan. He said, "But she's stabilized now. There was a time of danger. It seems to have passed. Thanks perhaps in part to you," he added, nodding at me.

I said that I had nothing whatever to do with Dora's state of mind, being a friend only, nothing more. Religion was what seemed to mean most to her, I said.

André remarked that religion was the very last recourse that anyone

who had known Dora before the drama might ever have expected her to seek. A person so intelligent, skeptical of anything that smacked of humbug, superstition, or dogmatic authority. How was it possible?

"Had to stabilize her," said Lacan, lighting a cigar shaped like a corkscrew. "Something to crystallize upon. It came to a choice between the confessional and the straightjacket."

"Picasso is cruel," said Sylvia. "His cruelty is one of the strongest elements in his work."

Dora returned to the table after some minutes, in appearance perfectly composed. By this time the conversation had become a Lacanian monologue, exposition of some theory or other with emphatic waves of the curlicue cigar. Dora announced that she and I must depart immediately, as the drive back to Ménerbes was long. Everyone stood up. Leave-takings were fond.

The night was velvety. We drove a long way in silence. I said something about the opera, to which Dora made no answer. We were already beyond Lambesc before she spoke, and then she said, "At least Lacan doesn't make a diagnosis by cutting up chickens and examining their entrails."

I laughed. She laughed, too, and then we talked easily about the opera and the evening, Rose and André, Sylvia and Lacan, agreeing that, all in all, the occasion had been pleasurable. When we came in sight of Ménerbes's street lights, which were six in number, four in an uneven line, one higher at the right end, one lower to the left, I remarked that they looked like a constellation against the black mountain flank beyond. "Ménerbes Major," Dora said, "signifying God's grace."

•

We went swimming with the Harewoods. It was not a successful outing. Dora's pond was a small circlet of brown water entirely surrounded by thickets of reeds, approached along a narrow, muddy track, not at all an inviting spot either for an invigorating swim or for a reposeful picnic afterwards. But we went through the masquerade of having a jolly outing all the same, drank two bottles of chilled white wine, which helped, then drove back to Ménerbes and never again laid eyes on the Queen's cousin. But Dora occasionally referred with satisfaction to the prestige of the occasion.

After the fiasco at the pond, Dora became more insistent about going to the seashore, maintaining that I had promised—more than once!—to drive her there, a wishful invention. But I did take her. Once. On a fiery day with high wind. The drive, indeed, was long, and I resentful, as I would have preferred to remain in Ménerbes and work on my novel.

The beach was deserted. The wind blew sand into our faces, and the water was brown. Undaunted, Dora plunged into the sea and swam far out. I paddled irritably back and forth close to the beach. She was gone quite a long time, nearly long enough to cause worry, for I could not see her head amid the rough water. Standing in the shallows, I waited. Then she came swimming vigorously back toward shore, standing up when the water reached her waist, her hair streaming, she smiling, shaking the water from her shoulders. She cried out that the water was wonderful at some distance from the shore. However, I had had enough of swimming for that day. We ate our picnic in the shade of a parasol pine and Dora said, "It was utterly absurd of Catherine to think that the three of us could live in that shack." The drive back to Ménerbes seemed endless in the afternoon furnace, and I promised myself that we would not visit the seashore again.

Meanwhile, I had received a postcard from Bernard, mailed on July 25 from Bruges, in which he said, "I want absolutely to see you at the end of August and if my friends don't prove that they are real friends, I have decided to break with them when I come back in the fall." I am exceptionally vulnerable to the application of pressure, and I had a strong feeling that pressure would be forthcoming from more than one source. At noon the cicadas' machined refrain pierced the wavering heat. I sat on the bench in the garden, beginning to wonder how all this would turn out.

Free to come and go as I pleased, particularly during the day, I had grown familiar with the romantic villages of the region, and even with Cavaillon, not romantic at all. But it was there that I ran into a romance of the transitory type familiar to men of my disposition. We met in the street, the very best place for auspicious meetings, more people to be found there than anywhere else. He was younger than I, dark, stocky, neither handsome nor ugly, but with a lively aura of sensuality. It was he who stopped in front of the shop window, having

given the glance as to which there can be no misunderstanding, and I who turned back and spoke to him. It amused and pleased him to find me an American, the United States still enjoying a postlude of brave prestige in the aftermath of the war. He lived not far away. The apartment was above a beauty parlor, two small rooms, their decoration an embarrassment. Flecks of sunlight from the closed shutters stippled the bed, and when we had finished making love we were drenched in sweet-tasting perspiration. His name was François Bodinat. Born in Cavaillon, he had spent all his life there, never been to Paris, and worked as a nurse in the local hospital. He said that he would like to see me again. That would be relatively easy during the day, I told him, but the evenings were more difficult. So we met again two or three times. Then he said that he wanted to make a dinner for me and introduce me to a couple of his friends, the two, as it happened, who ran the beauty parlor below his apartment. This would entail some scheming.

Luck being on my side, when the day set for the dinner came, Dora went out after lunch on her motorbike to sketch and said she would not be back for several hours. That was also the day when, writing at the table in the salon, I heard voices in the street outside and realized they were those of Americans. From the open window I looked down and saw in the street below a man and woman of middle age and a young fellow in a garish shirt, no doubt their son. They were exclaiming over the picturesque charm of the little town. I withdrew from the window and said to myself, "Well, shit!" for I thought their apparition a very ill omen.

So I got into the little car toward the end of the afternoon and drove to Cavaillon, leaving behind on the kitchen table a note for Dora saying that I'd gone out for a ride and would be back later. François had decorated his apartment with bouquets of gladiolus. I praised the effect and felt like a snot for my priggish hypocrisy. Everything was ready, table set, dinner prepared. The beauty parlor did not close till eight. We had plenty of time. Afterwards we went for a languorous promenade in the town. Outside a café I abruptly said that I had to go in for a moment and would be right back, leaving François on the sidewalk. The telephone, in fact, was adjacent to the toilet. I asked for the 11 at Ménerbes. Dora answered promptly. How was she feeling, I inquired. Oh, well, well enough, she said. I explained that I was in Cavaillon,

where I'd rather like to have a snack in some café, then go to the movies. An old American film with Bette Davis was playing. Would it amuse Dora to see it? I could drive back to Ménerbes and fetch her, though that would barely leave time enough for the snack. Of course, she said, she could make sandwiches for us to eat in the car, while ice cream and candy were always for sale in the movie theater. I held my breath, ready at the same time to accept any decision she made. But she said no, after all, she felt a little weary, would prefer to go to bed early. Then it was all right. We exchanged some fond banter and said we'd meet in the morning. She would leave the key on the ledge of the kitchen window to the left of the doorway.

The dinner was exceptionally good. To be sure, after the menus to which I'd become accustomed at Ménerbes, any good meal would have tasted exceptional, but François, a gentle and kindly soul, very well suited, I thought, to his profession, had taken a lot of trouble. His friends were flighty and noisy, good-natured, amused to have an exotic item like me to tell them stories of the licentious world of great cities, where homosexuality was easier to hide than in Cavaillon. But they seemed to accept with flippant fortitude the contumely surely advertised by a bull-fight-loving meridional populace. After dinner we drank coffee and some mellifluous yellow liqueur. I had my eye on my watch and my mind on the hour when the movie would be ending, my return to Ménerbes immediately thereafter imperative. An after-dinner stroll seemed the best way of preparing for an uncomplicated, if precipitous, departure. François was too good-natured to protest, but his pout showed that he had expected me to pass part of the night, at least, with him. The two others didn't care. We ambled about the unlovely town for twenty or twenty-five minutes and by no coincidence were near the theater when the spectators came from the exits. My car was parked not far away. I said that I must go. They came with me to say goodbye. And that was when my luck left me.

The key to the car was in none of my pockets. It must have been lost somewhere in the apartment. This was some little distance from the movie theater, but I felt that to appear to hurry would be crude. The two beauticians said good night to us downstairs, laughing slyly, as if the key had not been lost by accident, which Lacan would have said was childishly obvious, perhaps rightly, I thought. And we didn't have

to look very far to find it beneath the bed, on the far side, against the wall. And inevitably, both of us being on the bed at the moment of discovery, it would have been boorish to leap up and make off without responding to the gestures so well suited to our proximity that I wondered whether François hadn't foreseen the evening's denouement and found an opportunity to hide the key while I was still in the bathroom. But it is unfair to suppose him capable, as I might have been, of such subterfuge. Not that it seemed to matter, because it wasn't disagreeable, after all, to spend another thirty or forty minutes in his arms. Though not in manner so virile, he was remarkably well made and strong, a necessity, I supposed, in his work. When I finally departed, I said that I would call him someday soon, but I don't believe I ever did. At least, there is no further mention of him in the journal.

I was glad, driving back to Ménerbes, of the lost key. The night air's caress through my hair and open shirt was exciting, too, a sensual aftermath. When I came in sight of Ménerbes and looked up into the dark to see the constellation of streetlights, I was surprised, for there appeared to be seven instead of six. Coming nearer, I began to wonder. The extra light seemed to come from Dora's house. I concluded that in her thoughtfulness she had left a light on to guide me safely home. It was in the kitchen, and the key was on the window ledge as she had promised. I opened the heavy door quietly, closing it again likewise behind me, wanting, if possible, neither to waken Dora nor have her know at what a late hour I was returning.

She sat at the table in the kitchen, her chin in her hand, a smoldering cigarette in the trumpet holder. On the table in front of her were a bottle of brandy and two glasses, one of them half full. Astonished, I waited for her to speak. A moment passed before she did. Then she said, "And the movie?"

"Nothing much. Just another melodrama." Fortunately I had seen it long before and had an approximate recollection of the scenario. "Bette Davis sacrifices herself for a man who doesn't love her."

"Very banal."

"Very."

"Still, the final scene is rather effective when she drives away in the cart with the dying man."

"You've seen it, then?"

"Tonight."

That stopped me, as she had known it would. I had to wait to learn more.

"Have a brandy," she said, motioning to glass, bottle, and chair all at once. So I sat down and poured myself half a glass. Being of mediocre quality, it burned. I made a face. "You'll get used to it. I've had several. It was chilly riding back from Cavaillon on the motorbike."

"But why didn't you tell me you'd like to come? I'd have fetched you in the car."

She said my invitation had not seemed very enthusiastic, but then she'd thought it sad for one to go to the movies alone and had decided to come and join me. However, the ride from Ménerbes to Cavaillon by motorbike being long, she had arrived after the beginning of the film and was unable to find me in the dark, the theater having been crowded. When the film was over, I must have left by one of the side exits, as again she had not found me. I *had* left by a side exit, had I not? I said I had, and even a little before the end of the film, because the sequence of Bette Davis driving away from the threatened plantation toward her doom had been too long and crassly melodramatic.

"So I went for a stroll in the town," Dora said. "And you?"

It was one of those moments when only the truth can save from subterfuge the duplicity which a lie would disclose.

"What a coincidence!" I exclaimed. "After the film I, too, went for a stroll in the town. It's a wonder we didn't meet."

"Oh, yes," Dora murmured, sipping her cognac, "and the real wonder would have been if we had met but failed to notice one another."

"Then did we meet?"

"If we failed to notice one another, the wonder of it will always be a wonder, won't it?"

"True," I said, aware that now there would be no facile confrontation of fact, and willing, if that was what was wanted, to acknowledge my transgression. "All our failures give us another chance."

Dora gazed dubiously. I suppose she must have been a little drunk. "Which is?" she asked.

"For forgiveness," I said.

"Of the workaday variety, of course. Which is your salvation, as you realize."

"I'm sorry," I said, looking her full in the eyes.

"If it mattered, it wouldn't matter, you know. That's the mystery you can't be mystified by. And if I drank any more brandy, I wouldn't be, either. Now take my arm and we'll go to our rooms."

She was unsteady going up the stairs. At her door I kissed her on the cheek. She said, "We're ridiculous, my darling."

In the morning there was no mention of what had happened or been said.

•

Sonia Orwell was staying with a friend in a village called Haut-de-Cagnes near Nice. She had brought with her from London the manuscript of my novel, which had been accepted for publication by the firm that she had worked for since the demise, first, of *Horizon* and then, almost immediately afterwards, of her husband, to whom she had been married for barely sixteen weeks. It would be a good thing, Sonia wrote to me, if I should drive over to the coast so that we could together discuss in detail desirable revisions to the novel. A jaunt to the Riviera, after a lengthy month of daily sameness in Ménerbes, seemed an exhilarating prospect. If I had imagined that Dora might object to my going off by myself for a few days, I was wrong. On the contrary, she appeared positively pleased, said that it would be beneficial for us both to have a little vacation from each other, that my work naturally took precedence over personal pleasures, and that I need not feel concerned to hurry back on her account. I thought she was a little too satisfied to see me go but accepted it, as I accepted every whim or vagary of mood on her part, with as good a show of equanimity as manageable.

A word about the telephone. Dora had from the first characteristically stipulated that she had neither the means nor the inclination to pay for any long-distance calls that I might find it necessary to make. Therefore, it would be more practical, when possible, for me to use the nearby post office for that purpose. This suited me very nicely on the whole, because I could be certain that no inquisitive ear would overhear anything of a private nature I might need to say, nor would the hour, date, and destination of any call later come back to Dora on an oblong yellow slip. Consequently, I did not hesitate to call 291 at Hyères, the number of Marie-Laure's castle, ask for Ned Rorem, and tell him that

I was going over to the coast for a couple of days and, should it be convenient, would be glad to stop with them for a night or two on my way back. Nothing could be simpler, Ned replied, the only other guest at the moment being a man named Claus von Bülow, but he would have to ask Marie-Laure, so I had better call again to make sure.

I took a room at the Hôtel Gray et d'Albion in Cannes and got in touch with Sonia. She was still beautiful, aged about thirty-five, a blonde, voluptuous, with high color and fine features. Not exceptionally intelligent, yet she had great respect for those who were, cared sincerely about literature and art, and expressed this care with exceptional vivacity, patience, and good humor. Being the widow of a famous author, for whom she had probably felt more pity than passion, their marriage having taken place in the hospital where Orwell died, Sonia now benefited from a certain celebrity, which she clearly enjoyed, as well as considerable posthumous royalties. She was excellent company, funny and festive.

My novel was a mediocrity, but Sonia had had plenty of practice at being generous and ingenious with authors of mediocre ability. The house in Haut-de-Cagnes she was sharing with her friend Janetta Kee had a small back garden with a view over the valley. We spent two days out there, going over the manuscript chapter by chapter, and many felicitous touches in the book were suggested by Sonia, who particularly and predictably gave excellent advice concerning the descriptions of female characters. "Remember," she said, "that few women care as much about men being handsome as men who care about men do." When we had finished, I promised to make the necessary revisions as promptly as possible, and did.

It was Marie-Laure herself who answered the phone when I called to find out whether I might be welcome for a day or two at Saint-Bernard. She asked whether I would be coming by myself or with Dora. When I said that I was alone, she told me to come at once, adding that she had had to know about Dora because lady guests expected more luxurious accommodations than gentlemen did. She would put me, she said, in "the children's room." I arrived in the late afternoon and found my hostess in the library having tea with Ned and Claus von Bülow. Oscar, in disgrace for some all too imaginable misbehavior, was sulking in his cellar studio. I was made to feel at home immediately, as if the others,

indeed, had been awaiting me, and only me, in order to feel entirely at home with one another. That was one of the intrinsic enchantments of sojourning at Saint-Bernard. We chatted about people and their doings, some known to me, others not, the conversation constantly in flux, lively and funny.

"The children's room" was painted pink and its sole evocation of occupancy by the young was a large, hideous painting by Foujita of a school room populated by Japanese children. There was a gouache by Marcoussis in the bathroom. I telephoned Dora to tell her that I had stopped for a day or two at Marie-Laure's on my way home. She sounded decidedly surprised, as I had expected, but said that this must be very agreeable for me and asked to have her warm regards transmitted to my hostess. I should call a day in advance to inform her of my return. It wouldn't be long, anyway, I said. She didn't seem in the least annoyed by this unexpected sojourn as the guest of one of her old friends.

The timetable of the lotus-eating life is not set to the same schedule as operates in the workaday world. It was as if Saint-Bernard, its flowers, fragrances, food and wine, its frivolous chitchat and charming languor isolated behind the Saracen walls amid terraced gardens on that enchanting hilltop—as if all this existed outside the domain of clocks and calendars, and the castle, two-thirds of it in nostalgic abandonment since the war, might have been an antediluvian ocean liner from an era of forgotten extravagance, stranded on that height when the waters of incongruous fantasy receded. So I lingered on. Marie-Laure was companionable, friendly, outspoken. She was frankly inquisitive about my relationship with Dora. Like so many of her social and financial counterparts in the Western world, she was well acquainted with homosexuality and homosexuals, counting many among her friends and—by no means accidentally—among her lovers as well. She realized that I was not fundamentally attracted to women, but she also realized from her own experience that that need not preclude a love affair and its physical consummation with a woman. What she wanted to know was whether or not Dora and I had, in short, been to bed together. I said that I couldn't answer, because Dora was her friend, I but a casual acquaintance who was not entitled to intrude upon *their* intimacy. Marie-Laure laughed and said that that made Jesuitical sense. She asked me what life was like, day by day, in Ménerbes. Was the food good? Did Dora provide

entertaining social life? Was it fun to live in the shadow of Picasso? Did we talk all the time about *him*? Did we talk about religion? What did we talk about? Did we argue? Were there scenes?

In addition to being inquisitive, Marie-Laure, I sensed, was also sympathetic and sincerely interested. I may have been partially mistaken, not to say naïve, for there was malice in her. But I had been unable to unburden myself about life in Ménerbes except in my journal, so I told Marie-Laure a lot about what it was like to live in the house of the Général Baron Robert. About the toilet seat and the bench. The C and B. The truth that was in the box of matches. My teetering on the brink of the abyss. The curtains. The Earl of Harewood. Our excursion to the seashore. I told her, certainly, far too much, and I regretted it almost immediately, because my interlocutor was too conspicuously pleased, and I realized that I was betraying Dora by appearing to complain of my life with her when in fact all I really wanted was to have it go on and on indefinitely just as it was. Marie-Laure bade me to be patient, imaginative, understanding. I must never forget that I was the first man since Picasso to become emotionally important to Dora, whose emotions, after all, deserved more tolerance than my own. This conversation took place in a large salon at Saint-Bernard which had no windows but was lighted from above by a bizarre Cubist skylight which occupied almost the entire ceiling, adding to the sense of existing outside time in the stranded ocean liner. Marie-Laure was seated beside me on a capacious divan and took one of my hands between both of hers. The emotions of women, she said, were very different from those of men, and to act rightly upon this difference called for a man of exceptional intuition. I suddenly realized that she was talking to me about herself and did not, perhaps, expect my intuition to be expressed in words. Rising abruptly, I told her that I appreciated her loyal concern for Dora's good, that I would try to be worthy of the extraordinary contingency and tolerant of its crises, and that I appreciated her interest in my own situation. Marie-Laure said something gracious, but this was not the last pass made at me by the redoubtable viscountess.

Again I called the 11 at Ménerbes and told Dora that I would linger on a little longer. She said that she was working hard and barely noticed the days going by but expected that life at Hyères must be delightful. Oh, it was, I said. There were constant parties and guests. Lady Diana

Cooper had come to tea with Pamela Churchill. Georges and Nora Auric lived next door. Proust's niece, a silly woman called Susie Mante, had spent one night and sent afterwards, as a token of gratitude, an appalling alabaster horse which we pounded with hammers, afterwards burying the fragments. Etc. Etc.

And then I had been at Saint-Bernard for an entire week when Henri, the butler, came while we were having coffee on the terrace after lunch to say that I was wanted on the telephone. It could only be Dora. "You have been gone ten days," she observed. "I need to know when you intend to return. Because I might wish to make other arrangements, you understand. So if you don't intend to return within twenty-four hours, don't come back at all. I can ship your luggage to any destination you please."

"I'll be there tomorrow for lunch," I said.

"Very well," she said, and hung up.

When I went back to the terrace, Marie-Laure said, "Dora?" I nodded. "An ultimatum?" I nodded again. "So you see I was right. Don't forget what I told you. I am a very wise lady."

The drive back to Ménerbes was bliss. It seemed preposterous that I could willingly have stayed away for so long. There was a strong mistral blowing that day, the air was bright as a diamond, all the foliage of the landscape whipped and flashed in the wind, the olive trees like Roman silver, and the lavender fields threw their perfume through the morning. I sang:

> Weep no more, my lady,
> Oh, weep no more today,
> For the sun shines bright in my old Kentucky home,
> In my old Kentucky home far away.

I sang *I Married an Angel* and, from *Boris*, "*La lourde peine du crîme viendra s'abattre sur mon âme criminelle*," one of my favorite arias, though that day I felt no affinity with the guilt-obsessed tsar. In Aix I stopped and bought a box of *calissons* and an armful of flowers for Dora. It was well before lunchtime when I reached Ménerbes. The jagged old village on its steep outcropping looked like an illustration out of some archaic Book of Hours. I expected Dora after her outburst on the tele-

phone to be angry, and I knew that she knew how to make vexation explicit. But she was composed, smiling, and caressed my cheek when I kissed her.

Having arranged the flowers in an old amphora and opened the box of candy, she said, "You're always giving me presents, while I give you nothing. It doesn't seem fair. But of course you're my guest here. You don't pay a centime for food or lodging, do you? So maybe it's all even in the end." I assured her that it was.

Some letters were awaiting me, among others one from Bernard in which he said, "I will be very angry if you do not spend a good part of September with me." He suggested that we meet somewhere in Germany, and I felt that I couldn't very well refuse. Also waiting was a letter from my mother. She did not want me to travel to Germany but to America. For some months we had been discussing by mail the possibility and/ or desirability of my returning home before the end of the year, and not for a visit of a few months, as had been my custom, but for a stay sufficiently long to test the virtue of its becoming permanent. Doubtful that things would turn out so, as I had never felt an instant's pang of homesickness, I was nonetheless curious to learn what it would be like to live in New York. It had seemed natural at the time—it now seems careless, if not callous—to have talked to Dora about these eventualities, as to which she gave practical consideration and comment, and consequently she was aware that the stay not only in Ménerbes but also in Europe was to have a term. We had discussed the return to Paris. I impetuously remarked that were I to join Bernard in Germany it would be a considerable detour to do so via Paris. Then how, she inquired, was she to get back there? Well, I said, there was always the train. The Blue Train stopped in Avignon and was very luxurious. Did I think for one minute, Dora demanded, that with Moumoune and all of her luggage she was going to take a taxi to Avignon and the train, whether Blue or any color of the rainbow, from there to Paris? If so, I was gravely mistaken. She would return to the rue de Savoie by the very same conveyance, if not necessarily the same itinerary, as had brought her here. Let that be well understood. After which I was free to go to Germany, Austria, Bulgaria, or any other spot on the globe that pleased me or Bernard. And lest there be any ambiguity about these plans, Dora said, she would never see me again if I failed to drive her back to Paris.

As the issue was so crucial, of course there could be no question about my assent. I would be happy to drive her home. That was the truth, and I felt a fool for having ever mentioned the train (which would surely have been more comfortable, convenient, rapid . . . and costly). Besides, Dora remarked, it would have been imprudent to drive around the Continent with a precious drawing by Cézanne in the back seat. What remained to be settled was only the date of our departure. A Monday, Dora said. Less traffic on the highways. And as the next Monday was only four days away, the twenty-third, we would depart on the thirtieth. Less than two weeks of Ménerbes remaining. Already I felt the melancholy of departure, an intimation that the end of the summer signified the end of much else, much that I didn't want to lose. The quandary was not only of my making but in me. I didn't know how to talk about it to Dora, and yet Dora was the only person I longed to talk to about it or from whom I could hope to receive some sympathy. Which I knew I did not deserve.

Douglas called, inviting us to dinner, complaining that we had snubbed him all summer long. We had heard that since the unforgettable evening in April he had become quite chummy with Picasso, who had visited Castille more than once, while Douglas and John made it their business to drop in occasionally at La Galloise and to befriend Jacqueline, the new mistress. Dora accepted the invitation on the express condition that Picasso should not be present.

No mention had been made of the irascible outburst on the telephone, summoning me back to Ménerbes from the frivolities of Saint-Bernard. I had not forgotten it, nor, I felt certain, had Dora. But the moment of resolution could not be forced. In the lustrous dark as we drove along beyond Avignon en route to Douglas's it seemed that the time might be kind, so I said, "When I was at Marie-Laure's. Well, you know what it's like. That atmosphere of oblivious luxury. So lulling, one forgets."

Dora laughed. "Like the fly luxuriating in the oblivion of the spider's web."

I assured her that I had never felt any danger.

Which just shows how close it was, she said. Marie-Laure must have been very inquisitive—or inquisitorial—about the particulars of life in Ménerbes.

Interested, I admitted, yes, interested.

And what had she ferreted out of me? Had I told her all of Dora's secrets?

"But I don't know them," I protested.

"Everybody knows more than he knows," she said. "What is important is what exists outside of awareness. When the mind becomes conscious of a decision, it has already been made. That is the miracle of the unknowable."

But I did know, I told her, that I had stayed longer at Saint-Bernard than I really wanted to, and I was sorry for it. And I hoped that she didn't hold it against me.

Again she laughed. Hers was the upper hand, and she knew it. She said, "These are things between women. The man is not considered to be responsible. And I understand Marie-Laure very well."

So I assumed that everything was all right.

We arrived at Castille after dark, found that we were the only guests, and spent a perfectly delightful evening. Douglas was at his best, witty, learned, sympathetic, considerate of John, gallant toward Dora, amiable to me, and at pains to make us all feel free and easy in his extraordinary château. Not a word was said about Picasso, even in the room filled with superb paintings from his hand. John urged us to stay overnight, but Dora said that her cat would need attention. Still, it was after midnight when we left. I remarked on the exceptionally good time we had had. Dora agreed but added—with true sadness, she said—that Douglas was a person one could not trust and that she would never dream of becoming indebted to him by asking any sort of favor. He was treacherous and took too flagrant and perverse a pleasure in ridiculing his numerous enemies, sometimes even his friends. The one person in all the world he most revered was Picasso, and yet he was so bizarre that he might in a fit of spite or madness deliberately alienate even Picasso: a sort of suicide of his whole life as a collector and connoisseur.

Dora had decided to make some cottage cheese, which would help her to lose weight, so we went to Apt to purchase a product that would make the milk curdle more quickly. This takes a day or two, producing a large bowl of dead-white, lumpy cheese. She asked me to taste it, holding out a spoon. But I made a grimace of distaste and declined. Dora gasped irritably, exclaiming, "You're such a damned fool."

"In that case, I'll taste it," I said, taking the spoon from her hand. It was rather good. I told her that she could make a fortune by selling it from a stand on market day in Cavaillon. She laughed. Half an hour later, as we were going out from the salon into the garden, she took my hand, turning toward me, and said, "I ask your pardon for having insulted you."

"Oh, it was nothing," I protested, and in fact I had become almost accustomed to her occasional outbursts, thinking that no doubt she had cause to feel resentful.

"You've been very good to me," she said, "and sometimes I admire you so much, but at others I find you unworthy of yourself."

I told her that I didn't know just what she meant.

"It doesn't matter," she said. "You are the stronger. And it's dangerous to kick a friendship in the ribs just to see whether it's still alive."

"You mean it might be dead?" I asked.

She said she didn't know what she meant.

That same evening Dora disappeared unusually early after dinner, leaving a pile of dirty dishes in the sink for Artemis, which was not her habit. I smoked a cigarette or two, went into the garden, and from there I could see that there was a pale light in her bedroom. Not an electric light. It had to be a candle. Maybe, I thought, she was praying. But when I went up a little while later I found her door open. There was indeed a candle in a brass stick on the table, and by its light I could see that she lay outstretched on her bed. Impulsively I went inside, across to her bedside, and sat down. She did not speak. There was no sense of malaise. After a minute I said, "Are you all right?"

"Oh, yes," she replied. "I'm all right. Of course, nobody is *all* right. But I'm as right as I can expect to be with myself."

Then I stretched out beside her on the bed, and I could smell the perfume of the jasmine blossoms from the vine outside her window. We had never before been physically so close. I took her hand and held it against my chest beneath mine. "Is there something?" I asked.

"Oh," she murmured.

"Something between us," I awkwardly asked, "something that you might have desired to be different? Something *I* might be or could be, or should have been? You understand."

"I do," she said. "But you don't. My situation is so otherwise that

there could be nothing. Nothing to desire. If I had been in love with you, there might have been. But I'm not in love with you, of course, and never was." She withdrew her hand, but slowly, almost imperceptibly.

I thought how simple it would be as we lay side by side in the semi-darkness to test the truth of her statement. But it was a dishonorable thought, and already there had been much too much in my innocence to condemn. It occurred to me that she might be remembering her very different sojourn here with Picasso. After a time I said, "Then both of us are as right as we can expect to be."

"Yes, dear James," she said, caressing my hair. "To that extent, and not one millimeter farther." Then, as if she had divined my thought, she added, "Now we must sleep. And try not to dream of the C and B."

Three days before we were to leave, Dora announced that we had been invited to cocktails by a couple named Brémond, people whom she had never met. They owned a château near Apt called Les Tourettes. They also, incidentally, owned the most important newspaper published in Lyons, *Le Progrès*, founded by Madame Brémond's father, and in Paris, overlooking the Esplanade of the Invalides, had an apartment filled with wonderful pictures, especially works by Bonnard. The château, too, was said to have its share of pictures, which would make a visit there interesting. Dora thought they might be considering buying something from her, a Maar, not a Picasso, consequently had accepted the invitation for us both.

The Château des Tourettes was a large house of indeterminate style, set in the midst of miraculously green lawns, with a large swimming pool off to one side. "This is where we should have brought the earl," I said. Dora shrugged and threw her cigarette butt out of the window.

Emile and Hélène Brémond were of middle age, he rather nondescript but she stylish and attractive, vivacious, with the sheen that comes from wealth. We sat in a large salon, its windows open to distant views of valley and mountains, and were served champagne by a butler in a white jacket. The furniture was too fine for that part of the world, mahogany upholstered in pale shades of silk. There were several fine pictures. I admired the general effect, in particular a seascape of rippling violet and azure by Bonnard. Well, said Madame Brémond, if I cared about pictures, I must see the rest of the house, as there were pictures

everywhere, though not nearly so many, of course, as at the Hahnlosers' in Winterthur (snobbishly assuming that I not only would know of that collection but also, if sufficiently *comme il faut*, had seen it, which in fact I had), but enough all the same to make a stroll through diverting. Dora, she said, having seen the place before, was not invited to accompany us, and Madame Brémond murmured over her shoulder as we left the salon, "Emile, you'll keep Miss Maar entertained." This was rude, as Dora had never been in that house before, and I determined not to be polite.

The place was large and indeed there were pictures everywhere, a few of them remarkable. I didn't bother to list them, for, all in all, this was a conventional collection of slightly better than average distinction. I made the mandatory murmurs of admiration but studiedly refrained from anything like the enthusiasm to which my hostess must have been accustomed. This, however, did not faze her. I fairly soon surmised that my interest in pictures was almost irrelevant. She meant to prolong our tour of the house and, instead of talking to me about art, asked questions about myself, my life in Paris, Dora's house in Ménerbes, which she had never visited, what we had done there all summer, whom we had seen, whether we were friendly with Douglas and John, Ida Chagall, Jean Hugo, etc. I answered as impersonally as possible but could not keep from answering at all, and so our absence was conspicuously longer than might have been logical if we'd been occupied only in glancing at thirty or forty pictures.

When we came back to the salon, Madame Brémond said to Dora, "We must pay you a visit one day soon. I'd so much like to see your pictures."

"I never show to anyone," said Dora. "You'll have to wait for my next exhibition."

Madame Brémond asked when that would be, and Dora said it might be at a moment's notice, as the dealers were continually after her.

"Our young friend, however," said Madame Brémond, "must enjoy the privilege of admiring your work. Being a creative person himself. At work on a novel, he tells me."

"You're too kind," Dora said, rising to her feet abruptly and announcing that we must be leaving at once. Both Brémonds protested, adding that they had hoped we might stay for dinner. But Dora was

already on her way to the door, the rest having no choice but to follow. Farewells were tepid. As we drove away, Dora exclaimed, "The rudeness of the lady! And such condescension, knowing perfectly well I had never set foot in her house before. How could she guess what might be between us? It's incredible, because I could be crazy about you. I'm not, of course, but I could be, and I was right there. She commandeered you under my nose."

I protested that nothing had happened save a prolonged visit of the house, accompanied by some rather indiscreet personal questions, none of these, however, having to do with Dora. So there was really no cause for indignation, was there? She did not reply.

It was dark when we reached Ménerbes, the days having grown noticeably shorter. After dinner we sat out on the bench under the fig tree and the smoke from our cigarettes lay quietly on the darkness, for there was no breeze. And it was then I realized that the summer was over. A pang of nostalgia fell out of the night, and a sense of loss. But would it have been possible, I asked myself, and asked my journal, would it have been possible to live on forever under these same circumstances, would it have been the fulfillment of the future and the past? Would Dora have been amenable, after all? In what she said I had never known just what to believe. And I recalled the extraordinary multiplicity of faces and expressions in all those portraits of her by Picasso. Her hand lay on the bench. I put mine over it, and we sat there without speaking for some time. At length we went upstairs. The pause at her door. It was peculiarly like the very first night—how long before!—that we had spent together under that roof. I kissed her on the cheek and turned away to my room. As I lay in bed awaiting sleep I thought that, remorse or regret notwithstanding, I had done what I could, been as I could, and that by Dora's grace a unique beauty had pervaded our friendship.

The last two days were spent preparing to close the house. We had decided to leave very early on the Monday morning and drive all the way to Paris in a single day, traveling via the back roads through Vichy and along the Loire rather than by Lyons. Consequently, it was late when we reached the rue de Savoie, having stopped somewhere on a grassy hill for our picnic. I helped Dora carry her luggage upstairs, Moumoune, as usual, scratching and hissing. Then it was time to say

thank you. But how, I asked, could I? She said it wasn't necessary, especially since it was impossible. I could send her a postcard from Germany. The hideous chair given by Picasso still stood in her entrance hall. So I kissed her on the cheek and said we would meet again before very long. Oh yes, she said. And as she locked behind me all the locks on her door, I went downstairs, got into my car, and drove away.

LEAVING Paris four days later, I met Bernard in Basel. We drove around Switzerland for a week, and on the ninth of September found ourselves settled in Munich at the Pension Helios. The proprietress was a friendly drug addict named Frau Schmidt, a lover of Greece, tolerant of any goings-on that did not interfere with her habit. We much enjoyed ourselves in Munich, the city not yet having recovered entirely from its wartime devastation. This for some reason seemed to incline its inhabitants to unrestrained behavior, which consisted principally of drinking too much beer and, when drunk, of singing very loud songs. We visited the ugly palaces of mad, unhappy Ludwig, a quantity of Baroque churches, and went sailing on the Tegernsee. I didn't do much writing. Ménerbes, the summer spent there with Dora, and the unresolved issue of our relationship were very often in my mind. Two long letters were sent off to the rue de Savoie, also a fine sanguine drawing, probably seventeenth century, of a religious scene, which I found in a shop that specialized in drawings of all periods, an Ali Baba's cave of treasures by Cambiaso, Guercino, both Tiepolos, Subleyras, etc., plus thousands of unknowns. Both hopeful and doubtful, I had no idea whether I would receive an answer, Dora having lost none of her power, even at a distance, to fascinate by being unpredictable. But one day early in October there came a letter. I instantly recognized the handwriting and the brown ink, and realized with pleasure that I was trembling as I tore open the envelope. Within was a single sheet:

30 September
Dear James,

I can't resist a beautiful drawing and two letters but above all I ran into Henri Hell who asked me when you were returning. It concerns your novel and Plon. This must be finished with. It seems to me that those were his words. Best regards to Bernard. So until soon, I hope, your friend,*

<div align="right">

Dora

</div>

This wasn't much, I felt, but I was happy to have the letter and probably deserved nothing more. Two weeks before, I had received a telegram confirming my passage from Paris to New York on the *Liberté*, leaving Le Havre on November 12. We went to see the spot on the shore of the Starnbergsee where Ludwig and his doctor had mysteriously drowned in less than three feet of water. A cross stood on the spot. Bernard took off his shoes and socks and as a gesture of historic reverence went wading for a few minutes in the dark water.

After a month we went to Heidelberg, a city I had known and loved during the war, and where Bernard and I had spent the month of November in 1951. We stayed as before in a modest but charming *gasthaus*, on the right bank of the Neckar, called the Hirschgasse. Only a few days were spent in Heidelberg this time, and by an oversight which I do not believe can reasonably be explained away as mere carelessness, I left behind, when departing, the most precious thing I had with me: a fat, black oilcloth notebook containing my detailed journal of the months spent in Ménerbes with Dora. She remained, I felt, more precious to me than anyone else I knew. True, things between us after an absence, a hiatus, of six weeks could not be quite the same, especially with a departure across the ocean imminent. Still, I wanted to maintain between us a relationship unique, exclusive, secret, and inviolable. Then how could I rationalize the symbolic abandonment in Heidelberg? The life that Dora and I had lived together seemed to be, and was, more alive between the pages of that large notebook than it could ever hope to be elsewhere now. To have forsaken it in a boardinghouse represented a

* Henri Hell was an editor at the Plon publishing house, which was preparing to bring out a translation of my first novel.

relinquishment as to which only the unconscious could pronounce a judgment.

Of course, I didn't discover that the journal was missing until my arrival in Paris two days later. Immediately I contemplated jumping into my car and driving back, without stopping, to Heidelberg. But common sense told me that I would arrive too late and that the only hope of recovering the irreplaceable journal lay in the hands of a half-wit. I knew well the personnel and daily routine of the Hirschgasse. Most of the work of running and maintaining the place as a small hotel was done by a decidedly half-witted fellow of about thirty named Josef. It was he who made beds, cleaned the rooms, and did all the menial tasks, while general management and the kitchen were the business of the older couple who owned the place. Josef had always been very friendly toward Bernard and me, a little too friendly, I felt, given to suggestive priapic gestures which might have been welcome had he been a little less loony. During the war he had been stationed in France, the German military evidently prepared to accept recruits of very dubious aptitude, and had learned a bit of French, so he was the only person at the Hirschgasse with whom we could communicate. The journal must have been left behind somewhere in my room. Josef would find it, assume it to be valueless since it had not been taken along with the rest of my books and papers, and it would inevitably go into a bin in the cellar where old newspapers, magazines, and wastepapers of any kind were heaped preparatory to the daily lighting of the furnace. So my only hope was to telephone the Hirschgasse, describe my notebook in detail to Josef, and hope it had not already gone into the fire. That is what I did, in a paroxysm of anxiety. Josef said to call back in half an hour. When I did, he told me that the notebook was safe but would have gone into the furnace the very next morning. He would send it by mail. Needless to say, it came through safely. I sent Josef some money.

I called her. She was cordial, warm, talkative as always, and I was happy, almost surprised to hear again that trilling, birdsong voice. However, there was a difference. The aura now was of friendship, confident, affectionate, cheerful friendship, to be sure, but a rapport from which something had been taken away or forfeited or lost. I could sense it but I couldn't quite place its character and realized that I didn't want to. Being Dora's friend, I thought, and one who had shared her intimacy

more closely than anybody else for a very long time, was satisfaction enough. True, I had at moments of exaltation thought that I would like to marry her. At all events, I don't believe for a minute that she would ever have accepted. If I had read her diary, I might know. I can never sufficiently thank the prudence that kept me from peering into that forbidden volume.

We arranged to have dinner together. I went first to the apartment, where everything was just as it had always been, and we were just the same, save that, when I kissed her on the cheeks, we both must have realized that this was now nothing more than the casual social embrace so prevalent in France. In Ménerbes I had usually kissed her only on one cheek. Now we were more at ease, I felt, with one another than before, and this seemed to represent a loss. I was keenly aware of it, both for myself and for her, but it wouldn't be my place to try to say what had been lost. We had a drink. I told her about my travels, the museums, palaces, churches I had seen, landscapes and interesting people. She obviously enjoyed listening to me, and I enjoyed talking to her. She had never traveled very much. The one city she longed to visit more than any other was Venice. We were two courteous, cultivated people participating in polite conversation. We went to the Russian restaurant in the rue Mazarine for dinner. Afterwards I walked back with her to the rue de Savoie and we said we'd see one another soon again. We did.

One day in October 1954, Dora invited me to tea to look at her photographs but when I arrived said that Alice Toklas had asked her to go there so we'd go together. I was pleased, not having seen Alice since spring. Thornton Wilder was at Alice's. Delicious cookies. Wilder was stocky, with mustache, glasses, nearly bald, about sixty, very professorial, standing with hands behind back, rocking on feet, lecturing. Probably homosexual, I thought, but would have liked to hide it. Alice's apartment had gotten shabbier and shabbier but she stayed lively as ever. Gertrude was spoken of as a deity. Wilder was friendly.

Two weeks before my scheduled departure, I gave a large cocktail party, a friend having lent his apartment for the occasion, to say goodbye to all the people who had been kind to me during my years in Paris. They were about sixty guests, and everybody appeared to have a good time. The French have a reputation, had it perhaps even more positively

then, for being inhospitable to foreigners. As for myself, I never found this to be so. On the contrary. I was made extraordinarily welcome by all sorts of people. I can't say why. Maybe it was because, as with Picasso, my eagerness and happiness to become acquainted with them was from the first so passionate that conventional apathy could hardly apply.

To pack up all my books, papers, pictures, clothes, and incidental possessions was a painstaking job. I had not forgotten the wood-and-plaster sculpture of a bird by Picasso given me by Dora which I had entrusted to her for safekeeping before our summer in Ménerbes and had prepared a wooden box with cotton packing in which to transport it. Four days after the cocktail party, Dora agreed to have dinner alone with me. According to our habit, we were to have a drink first at the rue de Savoie. I brought with me the wooden box. And while we were drinking and smoking cigarettes in front of the fireplace I told her that this evening I was going to take the bird along with me, having brought just the receptacle to keep it safe.

Dora said, "I have decided to keep it."

I was stunned. "But you gave it to me," I said.

"Yes, I gave it to you," she agreed with complete composure, "and I would never dream of taking back a gift. It's yours absolutely and definitely. However, I'm going to keep it. Let's say for the time being. It will be perfectly safe with me, you needn't worry."

"But why?" I exclaimed. "After all, what's mine isn't mine unless it's physically in my possession. I don't understand."

She looked fixedly at me. "Oh, there's no need for you to understand," she said. "Let's say that I'm keeping it as a guarantee of good conduct."

"Good conduct?"

"Lest you be tempted to betray my confidence in some way unbecoming to a gentleman," she said severely. And there was no mistaking that this was a premeditated ultimatum, not a caprice.

Offended, I said, "And how might I do this? After our friendship, what makes you think I could be capable of such a thing?"

"You're a writer," she replied. "Writers can't be trusted. They write about what they know. Even novels are made up from what they know. And I don't want to be written about. And I thought if I kept the little

bird safe, it might keep me safe. But it belongs to you. You may be certain of that. And it will give me pleasure to have something that is yours to keep me company in your absence."

There was nothing I could say. I could have said a great deal. I was indignant and angry. And yet the willingness to be mistreated was strong. I didn't believe for a minute her pretext for refusing to relinquish the gift. But there was no obligation for her to be sincere. Still, my resentment hurt. I suggested that we go out to dinner. On the way we passed the glass-fronted bookcase. Looking inside, I could see the bird among the other souvenirs of Dora's life with Picasso. And then I noticed that the key was missing from its keyhole in the bookcase door, where it had always been conspicuously present. And it was that which truly infuriated me.

During dinner Dora said, "But you won't go away empty-handed. I have a present for you. Something with a very particular significance, selected after much thought."

I said that I neither needed nor expected presents, at which Dora laughed and replied that I was like everyone else on earth. She was right. Her laugh was exquisite. We laughed together, lingered in the restaurant, and drank Armagnac. I couldn't help being curious about the promised present. And for a moment there existed between us the same ease which had been the daily well-being of a few months before. It was amazing. But when we left the restaurant, it vanished.

Since my return from Germany, and prior to my departure for America, I had been staying in the apartment of Bernard's parents in Neuilly. He was shocked when I told him about Dora's refusal to give back her gift. He didn't keep it a secret. Marie-Laure said that Dora had given me a part of Picasso, which she would never have done without expecting something equivalent in return, and if her expectation had not been satisfied, then it would seem perfectly legitimate to repossess what had been given. Marie-Laure had had to learn by heart the techniques and appliances of exploiting an intimacy. Lise said that this was simply another illustration of Dora's avarice.

The day of my sailing, November 12, fell on a Friday. Dora and I agreed to dine together on the Wednesday, while Marie-Laure invited most of my friends for lunch the following day, and that evening I would have dinner alone with Bernard.

Wednesday morning was dark gray and by mid-afternoon the rain had begun to fall, classic Parisian weather for the season. Having sold without regret the little Renault, I took a taxi to the rue de Savoie at about eight. Dora seemed in excellent humor, not a bit dispirited by my impending departure for an absence of indeterminate duration. There was a fire burning. Her apartment, and all its familiar treasures, had never seemed more alluring. The tray of drinks was in the usual place on its low table, and we sat facing each other across it in the chairs we always occupied. Dora said how tedious she had always found the ocean crossing as a girl en route to and from Argentina. I found it tedious, too, and yet there was something intoxicating about the vast indifference, amounting virtually to hostility, of the ocean. And what, she asked, would I do in New York? Well, I'd do the same thing I did here, the only difference that I would be doing it in my homeland. She said that my homeland was where the men I most admired had made their home, all of them being creative personalities—Picasso, for example, and Giacometti, both born far from the city which had become theirs. Was there anyone in America to compare with them? Of course there wasn't, allowing for the exemplary exception of Faulkner, nor would there be in the decades to come.

Dora asked whether I was curious to learn what my present would be. Oh yes, very curious, I admitted, wanting to be impatient for her sake. Rising, she went into her studio, and returned at once with a large sheet of paper, rolled up and tied with a ribbon, which she handed to me. I guessed what it was, because only once had I seen her use so large a piece of paper, but I sensed she would appreciate surprise. Untying the ribbon, letting the sheet unroll, I saw I was right. It was the drawing of me seated under the fig tree on the garden bench that I had brought down with so much difficulty from the attic where Picasso's toilet seat rotted among the scorpions. I exclaimed, expressed surprise, pleasure, admiration. Dora was pleased. "It is a very special drawing," she said. "Because of the circumstances. I worked hard on it. And it must be because of you that there is the evocation of Cézanne. So you see I did ponder my choice. It would have been too easy to give you some little scrap by Picasso."

"Naturally," I said.

We went to the Reine Christine for dinner, as it was the nearest

place, the rain coming down hard then, and I held the rolled drawing close to my chest under my umbrella. We had often dined there with Balthus, so we talked about him, his château, his paintings and idiosyncrasies. Dora was coming to the lunch the next day at Marie-Laure's and said she was glad it was a Thursday, because the perverse viscountess always served meat on Fridays. We didn't linger long over our dinner. Despite the rain, I walked back with Dora to her house, kissed her good night, and said I'd see her the next day at the Place des Etats-Unis.

Perhaps I could have found a taxi at the Odéon, but the rank at Saint-Germain-des-Prés was sure, so I went there. And by the time I got there I had a pressing urge to urinate, so I went into the Café de Flore, closed my umbrella, and started up the circular stairway leading to the upper floor, where the toilets are. As I went up, another man was coming hurriedly down, brushing by me without caution on a curve of the stairway. As he passed, the tip of one of the ribs of my umbrella got caught in the folds of his overcoat, pulling me after him, while at the same time I was trying to protect the rolled drawing from harm. And before I could detach my umbrella from the stranger's coat as he continued heedlessly on his way I lost my balance on the narrow steps and fell awkwardly to one side, still trying to protect the drawing, my legs twisting underneath me. The drawing had been preserved from damage, and the stranger meanwhile, who may never have known that he had caused me to fall, had disappeared. No harm seemed to have been done save that I was ridiculously sprawled on the narrow stairway, where, fortunately, no one else came along while I struggled to my feet. As soon as I stood, however, an excruciating pain coursed up my left leg, and I found that I could not put any weight on that foot. In order to reach the top of the stairway, I had to hop from step to step, pulling myself along the banister.

By a stroke of luck I found near the top of the stairs a friend named Jean Lagrolet seated at a table with several companions. I sat down beside them and put my foot up on a chair. The ankle was already swollen. Everyone concurred that, as I fell, the ankle joint must have been twisted, causing a sprain, and the thing to be done as promptly as possible was to have the foot and ankle bound up in a very tight bandage. It was then after eleven. Fortunately, Jean had a car parked outside and

offered to drive me to the American Hospital in Neuilly, in those years the best medical facility available, where an intern would certainly be on duty. By the time we got there, the swelling was such that I had to take off my shoe, and the pain had become intense. An intern promptly appeared, inspected my ankle, said that the sprain looked like a bad one and I would probably have a couple of uncomfortable weeks. He applied an extremely tight bandage, advised me to take some aspirin for the pain, and said that as a reasonable precaution I should return in the morning for an X-ray. Jean drove me to Bernard's, where we found a little party in progress. I took some aspirin and drank a good deal of cognac, but the pain did not diminish. In fact, as the night went on, it became worse. What helped a little was the chitchat of Bernard and his friends. But the party was over by two.

All that night I lay wide awake in great pain, waiting for dawn and wondering how I would be able to travel across the ocean in this condition. Bernard's father drove me to the American Hospital for the X-ray. I awaited the results on a stretcher in a corridor. After half an hour a doctor came along and told me that I had a compound fracture of the ankle, which had doubtless been broken by the full weight of my body, wrenching the joint apart. I told the doctor that I had to attend a luncheon in about two hours and planned to leave for America the next day. He said, "You're not going to leave this hospital for ten days." His name was Méary, and I liked and trusted him at once. He explained that it was imperative to operate on my ankle the very next morning, inserting a bolt to hold the shattered bones in place until they could knit properly. And afterwards I would have to be encased in a plaster cast from toes to knee for six weeks. Meanwhile, he would prescribe some morphine to lessen the pain. That was delightful. I telephoned Bernard, asking him to tell Marie-Laure of my mishap and inform the French Line that for reasons of health I would be unable to embark the next day.

The ten days at the American Hospital were tedious. Bernard came to see me every day, often accompanied by his mother, who liked nothing in the world so much as the notion that her solicitude would alleviate the suffering or misfortune of others, when in fact it was her own misfortune and suffering, largely fanciful, which she sought to allay by such kindness as would not unduly inconvenience her. Marie-Laure also

came, bringing a handsome book on French drawings of the seventeenth century. Cocteau's visit created a stir in the hospital, as he usually contrived to let people know who he was. He told me some good jokes and stayed about fifteen minutes. Ida Chagall came, bringing a bouquet of violets, and an almost palpable sweetness, which I took to be characteristically Slav, dispelled the medical ambience so long as she was in the room. And of course most of my pals and accomplices made a visit or two. When alone, I was kept company by a bronze sculpture which had been a going-away present from Giacometti.* Bernard had brought it to the hospital and I kept it on the table by my bed. That Alberto might visit me never came into my head, as I knew that any time taken away from his work was taken with extreme reluctance. And so I was astonished one afternoon to waken from a drowse and find him seated at my bedside. He was surprised to see his sculpture on my bedside table, took it in his hands, turning it over and over, and finally said, "I should be ashamed to have given you something so miserable." As a matter of fact, the selection had been mine, for he had presented me with three or four sculptures to choose from. He stayed for nearly an hour, talking and laughing, and left only when Bernard and his mother came into the room.

I was pleased, entertained, and in some cases flattered, by the visits I received. But there was one that I awaited with greater eagerness and impatience than any other. Day after day, especially as my condition improved, I expected the knock on the door that would announce *her* visit. After all, she must have known of the accident. She had been invited to the luncheon at Marie-Laure's and surely attended, my own inability to be present having been communicated to the hostess but a couple of hours before the other guests were expected, and Bernard had told me that *everyone* was there. If Alberto, who had no telephone, had heard, how could Dora, indefatigable addict of the wire, not have known? But she did not come. It was incomprehensible. My injury, my night of pain, had been caused by the desire to preserve her gift from harm. If I had not been carrying that fragile roll of paper but only an umbrella, the accident would never have occurred. She didn't know that, to be

* *Tête de Diego*, reproduced in *Alberto Giacometti* by Reinhold Hohl (New York: Harry N. Abrams, 1971), No. 195 (photograph of another cast).

sure, but I did, and I had not forgotten the taunt about the "little scrap by Picasso." Dora was a woman who never did anything, or failed to do it, without a reason or a purpose. I knew that, and she can only have assumed that I knew it. I waited day after day in vain. It's true I could easily have called her. There was a telephone on the bedside table. But I was the one, I felt, who deserved consolation and compassion. Yet she did not come, and after a week I realized that she must deliberately have decided that she would not. Why? I could not comprehend her motive or even conceive of a legitimate one. Quite a spectrum of reasons suggest themselves today, but at the time I saw only ill will, a readiness to exacerbate my physical discomfort with a vexation of the spirit. I resented it. I brooded over it as I lay in the hospital room, and the more I brooded, the more resentful I became, until the blight of bitterness began to infect my ruminations. I thought and thought of all the annoyances Dora had inflicted upon me, the last, most egregious, and symbolic being her refusal to return the thing by Picasso, the piece of him, as it were, that she had impulsively—with *what* expectation, one wonders—given me. And gradually during the empty hours my thoughts demanded to be disclosed. Little by little, specific topics, phrases, paragraphs began, like handwriting—my own!—on the resentful walls of the hospital room, to compose a letter that I would write to her as soon as I could sit at a table. A missive to make her aware that I, too, had an authentic existence and did not fear to assert its claims.

I was released from the hospital on the nineteenth, returning to the apartment of Bernard's parents, my left leg so weighted with plaster that I had to get about on crutches. And these were the genuine, old-fashioned wooden versions that fit under the armpits, not the light, convenient, aluminum canes of today. I began my letter that afternoon. It took three days to write.

22 November 1954, Paris
Dear Dora,

To write to you when, in keeping with all appearances, I might so easily talk to you may perhaps appear contradictory. It is nothing of the sort.

There are certain things of which the very thought, in your presence, leaves me speechless. Your presence itself, in

*such circumstances, leaves me speechless. But first I must as-
sert that the grave tone which this letter will fatefully have to
assume does not in any way, however, diminish my aware-
ness of its absurdity. For the very act of showing that one
takes very seriously the serious matters of life is marked by
absurdity. But for you I have so often made myself ridiculous
in my own eyes that I may well allow myself to become so in
yours.*

*If I write to you today, it is to grant to myself in the
long run some feeling of justice and of dignity, that feeling
which you oppressed with such skill. While claiming to desire
my well-being, you knew how to subject the expression of my
nature to the needs of your pride without taking into account
the veracity of that nature or the impulses of a man who de-
voted all his good will to the affirmation of lively and honest
sentiments toward you. You once said that I approach people
a little like a child, with the same enthusiasms and perhaps
the same wiles. That is true. Such is perhaps not the way of
the world. So much the worse! It is my way. And I gain
from it, I think, more joy and good than pain and harm.
Also, I dare to say, it may be likewise for the friends who are
willing to join me in this realm freed from sham and hypoc-
risy. On the other hand, and also like a child, the conviction
of having been duped and used to other ends than those of
the most sincere feelings—this conviction leaves me with the
most profound bitterness and the most insurmountable
disdain.*

*This letter will wound you perhaps. I hope so. I hope so
for myself, but I hope so even more for you. For if it wounds
you there will be some hope still for our friendship. And you
will easily acknowledge that our friendship now barely
breathes beneath the accumulation of social formalities where
it lies. You know as well as anyone that social formalities
are made to disguise indifference. If this letter makes you
merely furious, if you desire only to tear it to shreds, to chew
it up and spit it into the fire, then we will no longer have
anything to say to one another except those polite phrases*

*which for more than two months have concealed the fact that
we are almost unable to say anything to one another. For
then it will be impossible to speak to you as an equal, and
friendship, the true thing, must be the very definition of
equality. You had it toward me. You know that. You said
things to me, you made criticisms of me, you allowed your-
self outbursts of ill humor toward me that never, never would
I have accepted from anyone else. And you even agreed that
you could hardly conceive of my speaking to you as you per-
mitted yourself to speak to me.*

*It is going to appear no doubt that by this letter I seek
to justify myself. That is so. I seek to justify all the feelings,
the time and the hope that I have devoted to our friendship. I
seek to justify all of that in my effort to preserve this friend-
ship, because it remains precious for me. But if the justifica-
tion presupposes some guilty conscience, then I seek not at all
to justify myself, because I do not have a guilty conscience.
No doubt there are wrongs on my side, but I persist in the
belief that they are superficial, that they pertain to certain
incidents but neither to my own character nor to the charac-
ter I endeavored to give to* our friendship. *This character
consists above all of sincerity, spontaneity, and innocence.*

*So I made your acquaintance. I was delighted,
charmed, interested. But, as you know, from the first you
aroused in me a certain fear. Or perhaps rather there was
something in your presence—as even today—which provoked
in me that timidity which causes a hesitation in the natural
ardor of one's feelings, or at least in the expression of these
feelings. Now you will agree without difficulty, I think, that
you are hardly one who gives herself easily to intimacy,
either in its freedoms or in its obligations. Then came the
day when at Théo's house you reproached me for my behav-
ior till then, deeming me superficial and frivolous in a rela-
tionship from which, so you said, you were disposed to expect
more. This was the first of the lectures—thereafter numerous
—that you were to deliver on the errors of my conduct to-
ward yourself and, through you, toward the entire world. I*

*detest being lectured to. But I accepted that one, and, at
heart, I was glad of it, as I took it for a sign of the esteem
and even of the affection that I hoped to engender in you for
me. Subsequently I did everything in my power to please you.
I did too much, after all, because I deliberately repressed
certain normal expressions of my nature for fear of displeas-
ing you. Thus I made you accustomed to taking me for
granted. How many times in our conversations did I swallow
instinctive, inherent responses that were on the tip of my
tongue—not for fear of saying something foolish but for fear
of contradicting a conviction you had just expressed? How
many times did you make it clear to me that it was out of
the question for me to presume to pursue any serious conver-
sation with you on a basis of equality? Why? Things are
never as simple or as complicated as they seem. More than
once I tried to clarify and, if not for our happiness at least
for our satisfaction, bring into the daylight between us the
real truth of our relations. We said to one another, "Are you
content?" and "Are you content?" If I insisted, you replied
that I could not understand, that your situation was other-
wise. Yet you showed yourself verily to me, still without ever
willingly explaining yourself—perhaps even to yourself. I
know not. You showed me the woman who had suffered
much from the life to which she had given herself with much
ardor and much hope. That suffering appeared to me beauti-
ful and noble and to have made like it the one who had had
to endure it. If I did not clearly see this woman, I nonethe-
less saw well her silhouette and perceived from time to time
the entire form, lighted like a summer landscape by the
lightning flashes of a midnight storm. And, strange as this
may appear, what I saw fascinated and enchanted me. It
even seemed to me at moments that I would like to remain
always in this landscape and that I awaited only the sunrise
to be able to settle there forever. I know very precisely what I
say here, and I affirm it. This was in the spring. —But then
the sun did not rise, and perhaps, knowing what it knew,
could not or dared not rise. The movements of celestial bod-*

*ies cannot be ordained. Those are other questions. Our
friendship remained. But I had, so it seemed, no due right of
friendship with you. Even after our Easter sojourn in Mé-
nerbes. And despite the fact that friendship may be slow to
take shape, intimacy—and we shared it—imposes undeni-
able obligations. It appeared to me that you accepted none,
while I was expected to satisfy all. I had no right to any
explanation, any remonstrance, any justification. You know
this. Must I cite examples? No! I want to spare us that hu-
miliation. All the blunders, all the failures of tact were to be
found by definition on my side. My wrong, my greatest
wrong will have been to leave you every right.*

*But there was something else. You held the Truth. You
said so one evening yourself, that you held it like a box of
matches. And you added that it was not yours. No matter!
The Truth belongs to the one who is able, who presumes,
who dares to hold it. And you held it—but for me in reality
it was hardly like a box of matches but rather like a bomb
above my head that you held it. What's to be said to one
who holds the Truth?—for It is always in the right. What's
to be said to someone one loves, or likes, who says that it is
awful to see you teetering on the brink of the abyss, knowing
how to save you and powerless to do it? —Now I tell you,
once and for all, that in my judgment Truth with a capital T
can only lead one to perdition, for it is illusion, it does not
exist. The truth is made up of tiny letters of every imaginable
shape and of unknown origin. It is the very image of life, for
the only true truth is life itself in all its multiplicity. The rest
is but loss, ruin, and solitude. Do you understand me? I be-
lieve it from the bottom of my heart, and how many times
the exasperation I felt in the presence of your truth gave way
to the despair of having to see it reared like a wall between
you and me.*

*But there was something else. I have mentioned your
pride. I am far from alone in having observed it, I believe.
The rightful esteem for oneself is noble and necessary; it is
this, in the conscience of each one of us, which makes life*

*bearable. On the other hand, pride makes life unbearable,
because nothing can satisfy it, and it tends to twist the con-
science into an instrument of contempt. Concerning you, I
think of the sentiments which animate both your work and
your relation to the world at large. Remember that if Cé-
zanne judged his contemporaries harshly, he dreamed at the
same time of exhibiting in the Salon of Bouguereau. Nothing
is ever all of a piece. It is far easier to condemn than to
comprehend. And I have often thought that the so-called
moral heights are more haughty than high. The perfection of
the soul cannot become a rule of life, because the care for
this perfection is such that it tends to reduce life to a consid-
eration far from vital. I recall with horror and sadness our
conversation one evening when we were going to dine with
Douglas, and in particular your scornful comments on Théo.
—How alone you must feel, and I muse sometimes with sad-
ness upon the solitude you seem to want to build about your-
self like a cage. Do you remember the pitiful bear we saw at
the Invalides fair? At that moment I remember having
thought of you. And, like that bear, the agitation to which
you succumb from time to time does nothing to disguise the
terrible truth of your isolation. Finally—what can you
expect?—pride is a dish to be eaten alone.*

*But there was something else. You often accused me of
being changeable. To a certain extent I am. Everyone is.
And fortunately! Uniformity is boring and unnatural. But be
aware that if I often appeared to have inexplicable changes
of mood, they seemed to me due to your own. How was I to
understand that you might suddenly be seized by ill humor
when dressing, when sewing, when doing almost anything.
And my effort to please you had all the same, in order to
succeed, to remain within the limits prescribed by my nature.
Never have I known such ambivalence. I condemn it not at
all. I would have liked only that it be comprehensible. But
you did not want to let me understand. I don't know why.
Were you afraid of me? Or, perhaps, of yourself?*

But there was something else. You took pleasure in call-

*ing me selfish. I am. I have been. I am not ashamed of it.
My selfishness is considerable and, I think, like so many
other traits of my nature comes from that childlike aspect
which you yourself defined. So far as you are concerned,
however, it seems to me I have been very little selfish. Do you
mean to refer, for example, to the fact that I had no desire
to waste whole days driving to the seashore? So be it! I was
concerned by my work, but of course the respect that I had
for mine could not be compared with that which you had for
yours. —And now has come the disheartening and painful
moment when I must speak of your avarice. For you are ava-
ricious. It is futile for you to make a joke of it, it is the
truth, you know it, I know it, everyone knows it. Never have
I known a person so attached as you to everything she pos-
sesses, nor one who thinks so constantly of money, nor who
accords so much importance to the support of material
things. I do not want to insist on this, it would be too dis-
tasteful. Yet there is an undeniable fact, which is that ava-
rice is an aspect of selfishness. It is, indeed, perhaps the most
extreme expression of selfishness, an expression which nothing
can shake, nothing oppose, nothing mitigate. And it is horri-
ble, because it, too, ineluctably adds bars to the cage of soli-
tude. Concerning avarice and selfishness there is one thing I
cannot leave unsaid. You made me a gift. Later, for reasons
we know, I entrusted it to you for safekeeping. The day that
I wished to take it back you replied that you intended to keep
it as a "guarantee of good conduct." I was stunned. By
those words you gave an importance to this object—for your-
self and for me—which no object can possess. You attributed
to me sentiments so dishonorable that I was appalled. Per-
haps you feel yourself capable of altering out of consideration
for some material gain or loss the conduct which is true to
your nature. Not I! Be assured that I would rather see that
object crushed, torn to pieces, and reduced to dust rather
than alter by so much as a gesture or a tone of voice the
expression of my character. Had you really so little respect
for me that you judged it necessary or possible to purchase a*

conduct toward yourself that would not have proceeded from a true instinct? Or were you so afraid? But of what? Finally, let's leave this matter. It is perhaps but an incident.

There. This letter becomes quite long. But I had a lot to say. It will seem to you, perhaps, at first glance, that the fact of having written and, more, of having sent this letter can only proceed from a desire to hurt you. That is not so. It hurts me. But I hope that you will feel, having read this far, throughout everything I have said—and I've said almost everything—how close to my heart our friendship remains and how much I wish that it may last forever. For that very reason I could not, and I should not, have remained silent.

I ask nothing of you. But I hope for much from you. I hope that we will see one another again. I hope that we will be able to talk freely, without constraint. I hope that our friendship will seek and will find innumerable paths of understanding more happy and satisfying than in the past. I want nothing else. I want to be able to love you. I want to rediscover all the things in you which so greatly moved and delighted me. I want you quite simply to be my friend.

We need never discuss this letter if you do not desire it. On the other hand, I am ready to discuss it as much as you might wish. If you would like to see me, you need only make a sign. I have taken the initiative of writing this letter. I will no longer take any other initiative in relation to you, I promise you this, without your having let me know that you wish it.

Dear Dora, I implore you to believe in the sincere and devoted feelings of your affectionate

James

This letter is, indeed, excessively long. I include it, however, rendered into English as faithfully as possible, because it is part of the story I set out to tell. I received no reply.

After a drab week in Neuilly, Bernard and I decided to go south, where with luck we would find some sun and clement afternoons. So we went to Aix-en-Provence and took pleasant rooms overlooking the garden

of the Hôtel de la Mule Noire, but never learned why it was named after a black mule. Our luck was wonderful. There were days when we could lunch outside, and this was the month of November. André and Rose Masson and their son Luis were still on the Route du Tholonnet. We saw them frequently. I was able to get around quite adequately on my crutches. If the day was particularly mild, we sometimes took a rather dilapidated old victoria, the only one then still in business, both horse and driver of approximately the same vintage as the vehicle, and went for drives in the surrounding countryside. Cézanne had often done likewise in his search for a satisfactory "motif," and I speculated to Bernard that we were in the ancient painter's very own carriage, driven by his enduring vision, if not by his coachman, to the sites where his genius had transfigured the world.

We became acquainted with a couple of young men—one, Wayland Dobson, English; the other, Jeannot Eicher, Swiss—who lived together in a small stone house on the side of a nearby mountain. They supported themselves by making harpsichords. Wayland had a car and was extremely kind as to driving us about. At my suggestion we went one day to Ménerbes. The sky turned gray en route. Dora's house, with all the shutters closed, looked more abandoned and dilapidated than ever. I was sorry to have come. Then one day in the Café des Deux Garçons I chanced upon Thornton Wilder, of all people, seated alone at an inside table. He had come to Aix, he explained, to work in peace and quiet on a play based upon the mythological character of Alcestis. It had been giving him trouble, but now he thought he saw his way to a satisfying conclusion. He seemed rather subdued and lonely. I suggested that he might be interested in making the acquaintance of André Masson. He responded enthusiastically, but the meeting was not a success, as each man clearly regarded the other as an individual of lesser distinction, and both, being good talkers, wanted to do all the talking. Thornton far more enjoyed an outing to the mountainside home of Wayland and Jeannot, where we had a marvelous picnic, drank a lot of wine, and listened to Berlioz's *Nuits d'Eté* until the sun went down. But more than anything else, I think, Thornton enjoyed solitary late-evening visits to a trashy bar called Chez Grandmère, near the lower end of the Cours Mirabeau, where he could observe the young soldiers from the nearby barracks getting drunk. It was clear that he never did more than look

at them, but he enjoyed talking about it. He read us the first act of the *Alcestiad* play in his hotel room and I found it very dull but made the inevitable compliments.

Just before Christmas, we returned to Paris.

Some three months later Thornton was on board ship returning to America. In a journal entry written in mid-ocean and published thirty years later, I make a surprising appearance. Like many another visitor to France, Thornton was shocked by the national penchant for parsimony, and he mentions this in relation to the work of Mauriac. Then appears the following paragraph:

*A certain young American, [X], broke his leg and came to Aix to convalesce. I had met him at tea at Alice [Toklas]'s and [he] sent me a note. [X] is a sort of less vivacious Boswell, diligently and unsuppressibly cultivating Picasso and Gide and Cocteau and Marie-Laure de Noailles, and anybody who is anybody in Paris.**

I am amused and amazed to have been described as "a sort of less vivacious Boswell." It suggests an extraordinary, almost supernatural prescience on Thornton's part. How could he have dreamed that my very first literary endeavor had been a biography and that all my writings of any consequence were to be biographical? I know that Wilder did not mean to be complimentary, but I count myself the gratified recipient of, at least, an amenity.

The night before my cast was to be removed, I dreamed that the surgeon cut through the plaster with his circular saw and then cut right down into my leg. The next morning I told Dr. Méary of my dream, and we both laughed, and then he did exactly as I had dreamed. The cut not being too deep, little blood flowed, and we laughed again. I sailed for America aboard the *Queen Elizabeth*, from Cherbourg, on January 7, 1955.

* *Journals of Thornton Wilder 1939–1961* (New Haven: Yale University Press, 1985), p. 236.

I SPENT fourteen months in America, most of them in a studio apartment
in New York at 60 East 83rd Street, though I managed to invite myself
during the worst part of the summer to Martha's Vineyard and Nantucket.
I wrote another unpublishable novel, had a couple of affairs, went to
many parties, some of them, given by Mrs. Murray Crane, the last
mergers of high society and high culture to take place so far as I know
in the United States, and I met a multitude of people. To meet so many,
some of them celebrated and distinguished, seemed as natural as the
leaves on the trees. Now that I know nearly nobody, I can't imagine how
all those people so easily became so familiar. But there they all are in
my notebooks, some of them names with no features. New York in 1955
was not the apocalyptic place it has since become, and I made an honest
effort to adapt myself to the perfectly pleasant potentialities it presented.
But it was not Paris. Its flagrant, ceremonious, implacable ugliness,
which has only become more and more hideous since, made the place
progressively dispiriting to me. And then via the mails came from across
the sea the siren song of Paris's leafy avenues, cupolas and colonnades,
the pulsing river in the city's heart, not to mention the affectionate
insistence of exotic and lovable friends that I should return posthaste to
the haunts of my true self. Irresistible insistence. Not one syllable of
it, need I say, came from Dora. I didn't expect to hear from her. But I
thought of her often, of Ménerbes, the automobile accident, her gift to

Picasso, the dinner at Douglas's, the tears after the movies, the toilet seat in the attic. I can't say what I didn't think of, and with imperturbable complacency I assumed that our friendship could not conceivably be terminated.

I told my parents that the American experiment had failed. Being people of common sense and high morale, they accepted with poise my decision to return to France. In order to meet the additional expenses, I sold a number of works of art, including the nude youth by Cézanne and the bronze by Giacometti that had been my companion in the hospital.

Among the many letters I had received urging me to return to France was one from Marie-Laure, ever a dependable and affectionate correspondent. It was written in July of 1955, and in it she said, "Dora has had an operation but is very well again. I think you should write to her. The euphoria of convalescence is propitious for reconciliations." And so I did not keep the promise I had made. Two weeks before leaving New York, I wrote to Dora.

> *New York City, 22 February 1956*
> *My dear Dora,*
>
> *I am writing you a little note this afternoon to say that a fortnight from now I will be in Paris—to say that I hope to see you—to say that the past, with its errors and its regrets, belongs only to the past—to say that I have never ceased thinking of you with esteem and a profound affection which nothing could possibly perturb.*
>
> *It would make me very happy if I could come as soon as I have arrived to embrace you affectionately, as I do now while asking you to believe in my friendship.*
>
> *James*

Embarking again on the *Queen Elizabeth*, I left New York on March 3, 1956. In Paris I saw all my old friends except Dora. If she had wanted to see me, she knew how to get in touch with me. I felt that the initiative should be hers. But when I heard nothing, I was disappointed.

After three weeks and the purchase of a new car considerably more spacious than the first, Bernard and I set off for the south, our idea

being to stay a couple of months in Florence. The nights en route were spent at random but where convenient, one of them at Castille with Douglas and John. And it was then that I saw on the mantelpiece in the salon the superb portrait of Dora by Picasso from the sketchbook with which she had tantalized me two years before.* Douglas was very proud of his new acquisition. I was envious. We also spent one night at Saint-Bernard with Marie-Laure. It took us just a week to arrive in Florence, where we were able to rent a most agreeable apartment on the top floor of the Palazzo Serristori, an enormous pile on the Pitti side of the Arno. The aged countess, a lady of ineffable charm and some malice, had known all of Europe and told amusing anecdotes. I noted her having said that a person unacquainted with the court at Saint Petersburg before 1905, when a regime of so-called austerity was imposed by the recent humiliations, could have no conception of the meaning of the word "luxury." We had a very good time in Florence, met a great many people, made the ritual pilgrimage to I Tatti, chaperoned by Harold Acton, went to numerous parties, and even gave a few.

In June we returned to France, wondering where to spend the summer, and explored the Loire Valley in search of a pleasing spot. A couple of miles from Azay-le-Rideau we found for rent a pleasant little manor house that went by the ridiculous name of Les Badinons. Not nearly so comfortable as our Florentine lodgings, it would nonetheless do for the summer. There were four or five bedrooms, so we had plenty of guests. One day in Azay, where I had gone shopping, I found myself face to face with Catherine Dudley. Cool but courteous, she explained that Alexander Calder had loaned her and Dorothy his house in the nearby village of Saché, as he was spending the summer in Connecticut. I insisted that both of them should come to lunch with us whenever they could, the choice of day being hers, the sort of invitation difficult to decline. They came the following week and it wasn't long before Catherine remarked that she still held something of a grudge against me for having compelled Dora to abandon her in Porquerolles the very next morning after our arrival, reneging not only on the promise to keep her company but also on the commitment to share the rent. I set the record straight, blaming myself nonetheless for having been too willing an

* Zervos, Vol. 11, No. 98.

accomplice to Dora's scheme. Catherine said she should have known. It wasn't a bit like Dora, after all, to cater to the caprice of anyone whomsoever. But, she said, she had made the obvious assumption. I didn't respond to that overture and resisted the temptation to mention Dora's having coveted her violet skirt. We saw the sisters a number of times, enjoying their company. Calder's house was whimsical and picturesque, modest, built beneath the outcropping of a cliff, not the mammoth hilltop building with which he later disfigured the landscape. I transformed the attic of Les Badinons into a workroom, finishing my novel among dusty and irreparable furniture, stuffed birds, and faded watercolors of the Far East. We went swimming in the Indre, and returned to Paris in mid-September.

1956 was the year of the great Rembrandt exhibitions in Holland, so we left for Amsterdam ten days later. At the Rijksmuseum were a hundred and one paintings, while the Boymans Museum in Rotterdam had on display two hundred and fifty-six drawings. This was one of the last manifestations of responsible and enlightened museum initiative before the era of explosive attendance, publicity, and merchandising put an end to old-fashioned appreciation.

Our eventual destination had from the first been Munich, where we looked forward to seeing old acquaintances and making new ones, installed once again at the Pension Helios. We arrived there on the ninth of October. Frau Schmidt emerged briefly from her pungent room and blissful stupor to greet us with warmth. We made numerous telephone calls and were soon prepared to take up our good time where we had left it two years before. The fun that autumn, however, was brutally interrupted by an international catastrophe. Just two weeks after our arrival, Hungarian students and workers took up arms against their Communist government in a revolt intended to overthrow that dictatorial regime and liberate the country from Soviet domination. At first the uprising seemed to succeed. Though fighting continued, the Soviets did not intervene, a new government was formed, and throughout Europe there was a sudden exhilarating hope that the reign of terror and infamy initiated by Stalin might ultimately be overcome. Budapest is only 350 miles from Munich. The combat seemed very close. Some of the people we knew had friends, even relatives, in Hungary. The emotion was intense. Nobody could talk of anything else. To my surprise, I was

deeply stirred by all this. I felt personally concerned. Never particularly interested in the machinery of politics, I found that these events seemed to involve my own life, awakening memories and sentiments that had lain dormant for more than a decade and that I had had no desire to revive. There was nothing I could do, but I would have liked to do something, something to show that, spiritually at least, I made common cause with men of proven valor against torturers and tyrants.

I drove back to Paris on the first of November. On the fourth, Soviet troops, supported by tanks and artillery, entered Hungary and with ruthless savagery set about crushing the incipient revolution. The freedom fighters made desperate appeals for foreign help, the eventuality of which had been allowed to seem credible by the broadcasts of Radio Free Europe. But the moment was inopportune. Nasser had just nationalized the Suez Canal, and Britain and France were preparing to take it back by force. The United States was determined to frustrate this expedition, too reminiscent of anachronistic colonial tactics. The Russians rattled their nuclear arsenal. There was no hope for the Hungarians. Tens of thousands were slaughtered in the streets, while hundreds of thousands fled west on foot in blinding snowstorms. Outrage and censure in the free world were unanimous, except, of course, in the servile Communist press such as *L'Humanité* in France, where the perishing patriots were denounced as Fascist counterrevolutionaries. There were numerous eminent Communists, however, who repudiated their allegiance and many more who demanded that the French Communist Party, the most slavishly Stalinist in the west, denounce the nefarious Soviet intervention. There was a massive demonstration in support of the Hungarians on the Champs-Elysées. Tens of thousands marched slowly up the avenue in the early evening, many of them bearing candles, and assembled around the Arc de Triomphe in silence to affirm their solidarity with the uprising and their compassion for its victims. I was one of these, the only time in my life that I have participated in such a demonstration.

As the days passed and the situation grew hopeless, I began to think that perhaps there might be something I could do. Even Aragon, knavish and feline as he was, had managed to insinuate that maybe there were grounds for protest. From the most famous, the most prestigious, the most talented member of the French Communist Party,

however, not one word had come. Picasso remained resoundingly silent. I thought his silence represented not only an outrage but a craven contradiction, and it seemed that maybe even so obscure and uninfluential a person as I might prevail upon him to take a stand. So I decided to write a letter:

Paris, November 9, 1956
Dear Picasso,

If I write to you today, if I allow myself to adopt a tone which seems foreign to the friendship and the admiration which I have always shown toward you, in the more than ten years that we have known each other, it is because that friendship and that admiration, believe me, compel me to do so.

Among the artists of our era you are the most famous, the most honored, the most enriched. Throughout the world your name is a synonym for vitality and daring in contemporary art. For millions of men your mere name evokes that admirable manifestation of the human spirit which is art. Artists are the trustees of civilization. That is a privilege but imposes a weighty, solemn, ineluctable obligation. And it is precisely of this obligation that I make free to speak to you here.

Of the details of your life the world is unacquainted with few. Thus no one, even those who would like to be, is indifferent to the fact that you are a member of the French Communist Party. For ten years you have lent the prestige of your name and the brilliance of your talent to the causes of this party. You have even endured the indignities and ignorant sarcasms of its leaders. Many then were your friends and admirers who wondered how you could do so, and why you did so. I well remember that one day you told me you had joined the Communist Party because it was necessary to belong to something and that in the end one party was as good as another. That was undoubtedly but one more of your innumerable witticisms. But it seems to me that an artist belongs first of all to the human race, especially if the human

*race is ready, as in your case, to accept and understand
him. All artists, like all men, have political opinions, all of
these conditioned by particular circumstances, but in general
artists offer their works and keep their opinions to themselves.
You have chosen to act otherwise. It was certainly your right
as a free man.*

*Long before feeling it necessary to publish your member-
ship in the Communist Party you published statements of sol-
idarity with the spirit of freedom which animates every
human being. You recorded in a signal manner your disgust
for tyrants and assassins. And you did this in the fashion
most suited to yourself, by displaying the ardor and intensity
of your talent. You etched* The Dreams and Lies of Franco,
you painted Guernica. *At that time you declared that all
your life as an artist had been but a ceaseless struggle
against reaction and the death of art. Later, and still before
having joined the Communist Party, you painted a large pic-
ture representing the horrors of the German concentration
camps.* Having then become a member of the Party, you
continued to display your talents for what you conceived—
and this sincerely, I wish to believe—to be the cause of free-
dom and human dignity. At the time of the Korean War you
painted* Massacre in Korea. *But at that time I am willing
to believe that you were sincere. And I want to believe that
you were so still when you celebrated with a picture Stalin's
birthday, then fawned upon as always by those who were
later to call him a monster and bloodthirsty madman. And
when you drew after his death the famous portrait of the dic-
tator, a work so violently denounced by those for whom it
was destined, I want to believe that you were sincere, that
you never thought of the Russian concentration camps, that
you were unaware of their massacres, their tortures, and
their tyranny over the human spirit.*

But today can you still sincerely believe that the cause

* This is mistaken. Picasso joined the Party before painting *The Charnel House*, and this picture was not inspired by photos of the Nazi camps.

*of freedom and of human dignity lies where for ten years you
have obliged yourself to place it? Today the hands of your
comrades, those you have so often clasped, are dripping with
blood; they have written once and for all in letters of iron
and fire what Communism is. And, as for the hands of Mac-
beth, no ocean on earth can cleanse them. It will be likewise
for all those who can still today shake their hands: theirs
will remain forever stained. Can you then continue in tran-
quillity to handle your brushes and fashion without remorse
the forms of your art? You have chosen to live before the
world. And it is the world today which is going to judge
your life. Can you remain silent while the cries of patriots
and the screams of innocent victims echo still among the
ruins of Budapest? Can the painter of Guernica remain indif-
ferent to the martyrdom of Hungary? If so, I say to you that
the world can remain indifferent before Guernica. Can the
man who has devoted his life to the liberty of art still place
his art at the service of human bondage? If so, I say to you
that the judgment of posterity will discern in that art the
flaws that such cynicism cannot fail to have produced.*

*I have spoken of the obligation which weighs upon art-
ists, trustees of civilization. I ask you now to discharge it.
The moment is opportune; indeed, imperative. We are far
from the day when with some dignity still and your famous
enigmatic smile on your lips you could listen to phrases con-
tradicting the entire meaning of your work, pronounced by
M. Laurent Casanova, present to inaugurate the installation
of one of your works in the square at Vallauris. I ask you
today to repudiate the errors of your political sympathies. I
ask you to make common cause once again with the suffer-
ings and the hopes of the anonymous masses of whom you
were able long ago to create such gripping and unforgettable
images. Because you have been willing to live as a symbol as
well as a man I ask you to identify a personal nobility with
the nobility of what you symbolize. I ask you to ponder at
length upon the solace which would be roused in the minds
of your admirers throughout the world were you to repudiate*

those political ties which are hateful to free men and dis-
honor the ideal of liberty. I remind you that this gesture
could cost you only the dismay of having humbly to ac-
knowledge your mistake; others have paid for this gesture
with their lives. And to fail to honor this sacrifice with a lit-
tle humility, not to acknowledge with nobility what is noble,
this can only incur the most bitter disappointment and the
most durable contempt.

Finally, I ask you to stand before the civilization which
has created you, honored you, and supported you, to judge
yourself according to the principles which have inspired your
life, and to make known this judgment to those who, like
me, ask only to love and admire you still.

James Lord

I did not leave it at that, however. Knowing Picasso to be little
prone to conduct calling for moral fortitude, conduct which might alienate
his hero-worshipers or detract from the luster of his legend, I thought
it expedient, if possible, to try to force his hand. Accordingly, I added
a postscript to my letter:

I want to tell you that writing this letter has pained me,
but you will nevertheless understand my reasons. I wish to
add that I intend to turn it over to a newspaper which might
publish it at the end of this week. If you wish to reply to me
personally, you can write to me at this address: 3 bis Boule-
vard Richard Wallace, Neuilly-sur-Seine.

This, of course, was very close to blackmail, and not a recourse of
which to be proud, but I felt then, and still feel, that both Picasso and
the circumstances deserved strong medicine. So I sent the letter to the
Villa La Californie in Cannes, where he had set himself up the previous
year with his new mistress.

Two days later I had a telephone call from Douglas Cooper. He
knew of my letter to Picasso and was seething with outrage. "You filthy
little shit," he shrieked down the line. "How dare you write that way to
Picasso? Don't you realize that nobody would dream of publishing an

attack on the greatest artist of the century by a nobody like you, a nothing, less than pig dung? I always knew you must be an agent of the CIA, a vile, contemptible, stinking cunt." And he ranted on in that vein for several more minutes, until I hung up.

What I realized at once was that Picasso in Cannes could not possibly have shown Douglas at Castille, two hundred kilometers away, a letter which he had just received. He could only have spoken to Douglas about it on the telephone. And if he had done that, he must have expected Douglas in some way to be of use. If so, he showed extraordinary lack of judgment in choosing this particular emissary. If he himself had called me and asked me to desist, I would have found it impossible to refuse.

Whether or not I could find a newspaper to publish my letter, I had no idea. But I was determined, despite Douglas's intervention, to do so. I discussed the matter with my friends. They agreed that the letter should be published and suggested that it would appear to far greater effect in a leftist paper. The one that seemed most appropriate was *Combat*, which had been founded as an underground journal by Albert Camus during the Occupation and had considerable prestige as a publication of integrity. I was able to arrange an interview with the editor, a bulky, swarthy man with an intimidating gaze, named Zedlaoui. He read a copy of my letter, then asked why I thought it deserved to be published. I said that if the letter itself did not fully answer his question, it didn't deserve publication. He stared at me hard, and I had some difficulty to keep from flinching. He said that he would publish the letter in his edition of November 17. And that is when it appeared. Five days after the publication of the letter came news that Picasso had at last contributed a whisper of inquiry to the clamor of outrage. On November 22, in the evening issue of *Le Monde*, France's most distinguished newspaper, appeared excerpts from a letter signed by Picasso and nine other persons, most of them unknown, addressed to the Central Committee of the French Communist Party and "leaked" to the press. Though tedious, it deserves to be quoted *in extenso*. The headline reads: "M. Picasso and Nine Intellectuals Denounce the 'Attacks Against Revolutionary Probity.'"

The weeks just past have exposed Communists to burning questions of conscience, which neither the Central Committee nor Humanité *have helped them to resolve. An incredible poverty of information, a veil of*

silence, ambiguities more or less deliberate, have disconcerted the mind, leaving it either disarmed or else ready to give in to all the temptations maintained on their side by our opponents.

These attacks against revolutionary probity appeared at the time of the XXth Congress, with the advent on the national and international scene of the Khrushchev report. The interpretations given of events in Poland and Hungary have finally brought to the highest pitch a confusion of which the consequences have rapidly been felt. The innumerable manifestos which circulate among intellectuals as well as among workers appear to signify that a profound malaise has spread through the whole of the Party, which the impetus of mobilization in the struggle against Fascism is unable to conceal.

Intellectual workers and dedicated seekers of truth in our creations and our work by the side of the working classes, Communists, and unable to remain indifferent to all that is done, said, and written in the name of Communism, we in our turn raise our voices to request the convocation without delay of an exceptional congress during which may be debated in their reality and in their verity the innumerable problems which present themselves to Communists today.

As if this were not enough, there follows in heavy type the following admonition: "The signers desire to 'protest in advance against any tendentious interpretation of this collective letter, against any mistrust of their fidelity to the Party and to its unity.' "

In short, this letter, itself a tissue of ambiguity and disingenuous equivocation, says nothing, addresses itself to no issue, and has no purpose but to rationalize "revolutionary probity" and assert Communist self-righteousness.

Some weeks afterwards, during which no exceptional congress was convened to debate any problem whatsoever, Picasso was interviewed by the American journalist Carlton Lake, to whom he said, "Communism represents a certain ideal in which I believe. I think that Communism works toward the realization of that ideal." But we do not learn, we never learned, what he conceived this ideal to be. That he actually swallowed the great lie of the Marxist utopia is inconceivable. That he remained serenely unaware of Communist crimes and atrocities is also impossible to believe. He had become a Communist for reasons of his

own, and Communism gradually became an element of Picassian myth-
ology which he could hardly repudiate without seeming to lose something
essential to himself, since everything pertaining to that self was essential
to it. History is unforgiving to those who are unwilling or unable to face
its facts. Picasso's gradual withdrawal from the world began at about
this time, in his mid-seventies. Courtiers and sycophants were not lack-
ing, but he saw almost nobody else, and his mistress, whom he married
in 1961, made sure that the unwelcome, including the artist's own
children, were refused admittance.

And yet . . . And yet there he was. Nobody who had ever fallen
under his spell could quite free himself from it. Certainly I couldn't. I
had long before sought him out in the belief that the propinquity of
genius might contribute to the creative longing and that my propensity
for admiration might eventually produce something worth admiring. The
portraits he had made of me at my request, giving me the illusion I
longed for of a life beyond life, remained, and still remain, possessions
I prize. And I dream of him even now from time to time.

As for my letter, I wrote it, sent it, and published it because I
believed what it said and felt that to say it was a worthy thing to do. It
occurred to me, I admit, that approval, even commendation, might
reasonably be expected, as I had done what nobody else had thought or
had the daring to do. The letter caused a stir. Excerpts from it were
published in other, mostly conservative newspapers, both in France and
abroad. The fulfillment of Picasso's prophecy, however, did not bring
the response I had expected. Dora had been right. One did not attack
Picasso with impunity. If I had in a perverse way fulfilled the artist's
long-ago prophecy that I would one day do something astonishing, I in
turn was astonished.

Of all the scoldings I received à propos of that letter, the one that
most amazed me was Giacometti's. He was severe, which was all the
more surprising in that he himself spoke very critically of Picasso, both
as a man and as an artist. And certainly he held no brief for Communism,
though in a recently published volume of his writings there is a passage
which purports to accept Communism as the ideal panacea for all of
mankind's ills. No man, however, delighted more than Alberto in con-
tradiction and self-contradiction, and in all his life he never undertook
an active political commitment. I couldn't understand why he was so

exercised over the publication of that letter. It was the only time in our acquaintance that he took me to task on a matter of principle. Perhaps he was the more ready to exempt Picasso from blame because he was so much better able than others to judge its extent. I didn't argue the issue very strenuously, but it puzzles me still, because Alberto cared more profoundly than anyone else I have known for truth, justice, and honor, and if ever those values were egregiously betrayed by duplicity, felony, and iniquity, it was on the streets of Budapest in 1956. Alberto knew this just as well as I did. Today even the perpetrators admit it.

Cocteau, ever desirous of avoiding definitive confrontations or making an issue of anything that *is* an issue, wrote me a devious, diverting, hypocritical letter, having waited until December 6 to send it. Not one word therein is said on the subject of Hungary. Picasso alone worried Cocteau, and it goes without saying that Picasso worried him infinitely more than I did. I can't resist quoting now the postscript. In the tiny apartment where he lived on the rue de Montpensier, he was looked after by a maid-factotum named Madeleine, a modest, sensible soul devoted to her employer and much gratified by vicarious participation in his renown. The postscript to Cocteau's letter of reproach read as follows: *"A simple woman, who knows nothing of us, Madeleine wept when reading your letter in the newspaper."*

Marie-Laure de Noailles also could usually be counted on to turn to derision issues that called for moral commitment beyond the spheres of social discrimination or aesthetic understanding. Her intelligence was more keen than valiant. She said, "What you have done is very grave. You have disparaged the honor of a Spaniard, you have offended the peasant Pablo Ruiz."

There were quite a few others, like Lise and Peggy Bernier and people I've not bothered to name, who berated me for having taken Picasso, as it were, in vain. With the exception of Alberto, however, there was only one person whose judgment meant anything to me, and I knew that I could hardly expect to hear from her. But I thought that as our Paris milieu was not a limitless territory we were sooner or later bound to meet. We did, albeit by my design.

In the rue de l'Université, at a spot rather out of the way for such a business, was an art gallery called Berggruen and Company. The proprietor, Heinz Berggruen, was shrewd, hard-working, a connoisseur

and honest. Surmising, I suspect, that if he exhibited some of her paintings, he might make himself an opportunity to purchase some of her Picassos, Heinz organized an exhibition of Dora's Provençal land-scapes in mid-January 1957. The usual stock in trade of the Berggruen gallery was the sure thing: drawings or paintings by Picasso, Miró, Klee, Léger, Max Ernst, Chagall, Matisse, et al., with the occasional caprice of an exhibition by such as Philippe Bonnet or Dora. Heinz was one of the first to perceive the worldwide potential for sale of original prints, and it was this that earned him a large fortune. His catalogues, always of identical format, small and rectangular, were customarily luxurious items, with original lithographs on their covers and color reproductions within. For Dora, however, he was apparently not confident enough of his opportunity to make a large investment. Her catalogue was as skimpy as any he ever produced, consisting of only six pages stapled together, a small color reproduction on the cover, and three black-and-white reproductions inside, one of these the highly distorted portrait of Dora by Picasso executed at the very end of their affair, in April 1945, bearing the inscription *For Dora Maar, Great Painter.* There is a fairly lengthy preface by Douglas Cooper in the form of a letter to Dora, in which he makes it clear that he is responding to her express request and speaks with friendly approval of her originality, her sincerity, her romantic spirit, evoking affinities to Turner and Courbet, but, characteristically, avoids ever stating that the works of Dora Maar are of fine quality or high aesthetic value. To be sure, they are not, and Dora must have known that Douglas could be counted on not to make the implication. It's odd that she asked him. For a preface in keeping with Picasso's inscription she should have requested a preface from someone like Jean Leymarie, who can always be counted on for praise and expresses it with eloquence.

After my letter to her, then my letter to Picasso, I could hardly expect that a meeting with Dora would prove pleasant. But if it were to take place in public, I could, at least, count on its being polite, and that is why I decided to attend the opening of her exhibition. Anyway, I had the courage of my convictions, and I thought that after more than two years Dora might reasonably be expected to let bygones be for the most part bygones. To help her in the achievement of tolerance I went to the rue de l'Université in the afternoon of the opening day and bought

a painting, a good-sized one, noting that only one or two other red dots indicating sales were to be seen and sure that Heinz would tell her the names of purchasers when she came to the gallery in the evening. One way, I thought, to touch Dora's heart would be by a gesture of acquisitive appreciation.

Having waited till after seven, when the presence of a sufficient crowd was assured, I went to the gallery. There were many more people than one might have expected. Dora had become a somewhat legendary personage by reason of her gradual withdrawal from the world, which as time passed would become an obsessive seclusion and make her so inaccessible that people are often astonished to learn she is still alive. She was surrounded by a close ring of friends and general public, so I waited on the other side of the gallery, confident my moment would come. It was a surprise to see her again, unchanged, the marine radiance of her gaze, the proud tilt of her head, and I couldn't imagine that twenty-six months had gone by since that evening when, to save her drawing from damage, I broke my ankle. Then across the crowded gallery she saw me, acknowledging my presence by ever so slight a nod but not the shadow of a smile. I gave a tentative, embarrassed wave but did not presume to go in her direction. The eddying of the crowd, however, brought us close to one another eventually. I held out my hand. She took it and held it long enough to be able to say, "My poor James," with a compassionate shake of her head, "you're determined to turn the whole world against you, aren't you?" Then she let go of my hand, adding, "It's a pity." And she moved away in the crowd, having said not a word about my purchase of her painting.

I DIDN'T want to turn anyone against me. It is a fact, however, that most of my writing judged worth reading has turned people against me. The reason is more serious and more elusive than a simple distaste for truths too outspoken. Creativity is a malady. Picasso knew more about this than almost anyone can bear to, and his fear of the cure finally wrought havoc with his work. One might have thought that after publishing my censorious epistle I would peacefully have ceased to be concerned with him. But I was myself slightly afflicted by the malady, and had from my youth rashly sought to be ministered to, if only in appearance, by him.

Dora was less often to be seen in the salons, cafés, and little restaurants where we all used to go. Still, she did go out occasionally, and it was to Marie-Laure's luncheon parties that she went most frequently. When we met there, as we inevitably did, she was friendly, talkative, vivacious, but there was no longer the sense of something exceptional, even extraordinary, between us that there had been before. And how could I presume? Indeed, it was simpler now, if less enthralling.

Bernard and Dora had become quite friendly, and an enduring souvenir of their friendship was forthcoming from Dora's irrepressible acquisitiveness, especially in circumstances when something can be had for next to nothing. Bernard's family owned a château in the country fifty miles east of Paris. His grandfather had been fond of this property

and had ruined it by having it remodeled in the Louis XIII style at the end of the nineteenth century. The parents cared for it only to the extent that income could be derived from surrounding farms and forests, which they sold off little by little. They seldom visited the place, and by 1957 it had fallen into considerable disrepair but still contained some furniture, plus household appointments. How Dora learned of the château and its neglected contents I cannot remember, but her acquisitive instinct was aroused. Would there be by chance, she inquired of Bernard, any linens in the family château, such things as lace curtains, tablecloths, napkins, and sheets? Oh yes, Bernard felt certain there were hampers of such things. Well, said Dora, if they proved to her liking, she would be glad to exchange a picture for some of them. Bernard, to whom lace curtains would never be of any use, agreed on the spot and when we were alone speculated as to the sort of picture he might receive. I carefully refrained from conjecture.

So we drove out of Paris one morning in March—it was like spring, crocus-yellow sunshine—and came to the Château de Monglat in about an hour. Bernard had been right about the linens. There were trunks and wicker hampers filled with them, some still wrapped in their original tissue paper and faintly fragrant from the scent of tiny cushions of lavender. Dora could barely control her excitement. I had never before seen her so feverish with satisfaction, and never afterwards saw her so. For anyone who cared about linens and laces, I suppose the thrill of opening those long-closed hampers and trunks may have seemed akin to that of entering Ali Baba's cave. Dora certainly cared about them, whereas Bernard and I didn't. With the delicate caution of an archaeologist Dora lifted layer after layer of rustling, cream-colored or stiff, pure-white folds into the daylight, and there was everything that she had said she wanted and more—curtains of intricate lace, lace tablecloths and napkins, embroidered sheets, pillowcases, towels, antimacassars, layettes, shawls, and I don't know what else. There was obviously too much. Dora asked how much she could have, and Bernard said she should take whatever she wanted that would be fair exchange for a picture. We went down several times to the car, our arms filled, until the trunk was full, and I began to be embarrassed, but then she said that that would be enough. It's true that, even as it was, we left quite a lot behind.

Dora must have been elated beyond the most extravagant of expectations, for she invited us to lunch at the best restaurant in that area in a town auspiciously named Sézanne. We drank a magnum of pre-war champagne and drove back to Paris upon a gilded cloud.

When the heaps of linens had been carried upstairs at the rue de Savoie and deposited on Dora's bed came the moment I had been dreading. Dora was ready for it. Bernard, too polite to ask what work of art might make a fair exchange, glanced around the room, its walls covered with paintings and drawings by Picasso. Dora disappeared into her studio and quickly returned, carrying a small portfolio and a couple of medium-sized landscapes, works of her own, similar to those exhibited *chez* Berggruen two months before. If Bernard's face fell, I didn't see it, as I looked out the window. If Dora observed any sign of surprise or disappointment, business came first. She proposed that Bernard choose one painting of the two, or if neither of them pleased him, he could have two smaller works on paper from the portfolio. It contained about a dozen works in watercolor or gouache, mostly in the manner of Picasso's wartime paintings, having been executed then. One was a portrait of Picasso himself in a style quite as distorted as his portraits of Dora. Bernard was tempted by the historical interest of this item, but of course, though *of* him, it was not by him, and even an unsophisticated eye could see the difference. Bernard hesitated. Or, said Dora, if none of these things was sufficiently pleasing, she would be happy to paint Bernard's portrait. That decided the matter. Bernard cared nothing for the mountain of linens, worth certainly a small drawing by Picasso, but the prospect of a portrait did appeal to him. Never, never so much as to me. He felt far more confident of his situation in the world than I did. The appeal of portraiture was therefore largely social, and Bernard is a highly social being. Dora painted him in profile in her pointillist manner, leaving part of the primed panel white. Bernard always kept this painting by his bedside and never, I think, felt that Dora had taken unfair advantage of him. He didn't care about Monglat any more than his parents did, and not long afterwards the remaining contents of the château were sold for next to nothing at auction on the premises.

Maybe it was the successful business of the linens that modified Dora's attitude, or perhaps the anesthetic of time. At all events, she became friendlier toward me. It was at about this time that she suggested

I propose a trade to Balthus, offering him, for his still unfurnished château, my grandmother's living-room rug, in exchange for some slight sketch or drawing—which led, eventually, to a ludicrous denouement. Anyway, we once more began to see each other fairly frequently, Dora and I, had dinner, went to the movies, and it was not at all like old times. We kept each other superficial company, nothing more. There was never a serious conversation, never an argument or scene. In the glass-fronted bookcase I saw the bird by Picasso but did not mention it. She did not refer to the letter I had written. I needed a photograph of myself for the jacket of my second novel. Dora offered to take it, though she had not touched a camera, she said, since well before the war. She got me to pose seated on the floor of her salon, next to a window, now beautifully draped in the filigree of lace plundered from Monglat, which let in a subtle light and concealed the commonplace courtyard. I remarked that she had, in fact, touched a camera since the war and that this was the second time, not the first, I had posed for her in her capacity as a photographer. She had no memory of the first, she said. When I reminded her of the photo taken with Picasso in front of his automobile, she retorted, "That wasn't photography, it was mockery." But her photo turned out very nicely, and I like to believe that I really looked like that then.

In the summer of '57 Bernard and I rented an apartment in the countryside near Aix-en-Provence. We saw a great many people, including Dora, who was very adroit at getting friends and acquaintances to taxi her about the region. She even came to a cocktail party that we gave. About thirty people were there, she being not the least notable by any means, and she quite openly enjoyed herself. But we were never invited to Ménerbes. We once drove past the village and saw that almost all the shutters of her house were closed. I was never again to see the inside of the Général Baron's mansion. And so far as I am aware, very, very few persons have passed across that threshold since.

In November I went to America for four months.

Bernard and I decided to spend the spring somewhere in northern Italy—it turned out to be on the shore of Lake Como—and to conclude our stay with a visit to Venice. Discussion of these plans took place one day in Dora's presence, whereupon she declared that she had always longed to visit that ineffable constellation of palaces and masterpieces

afloat upon the Adriatic and would be very pleased to join us there if her presence should represent no inconvenience. Then we could drive back past the Italian lakes, travel through Switzerland, and stop overnight with Balthus in his rural hideaway, where Granny's rug was already installed. I was particularly pleased by her proposal. It is always delightful to introduce an individual of sensibility to the aquatic miracle of Venice, especially if one shares, or has shared, intense emotions with that person. Oh, I didn't expect that a stay in Venice, no matter how miraculous, would restore to its one-time vivacity what I had known with Dora several years before, but I did think that maybe the experience together—even in company with Bernard, who was also very pleased at the prospect of her company—might rekindle between us a little of that exhilarating sense of intimacy which I have never since experienced with anyone else. To be sure, there is no one else in the least like Dora. And I thought, too, that the mystic aura of the city, its countless churches and supreme religious art, might have some positive effect. It would have seemed odd and unlikely that this excursion would, on the contrary, be the prelude to a gradual termination of relations with Dora. But it was. Not, I think, due to any aspect of the trip itself, but to a gradual, radical change in her, a change, perhaps, not entirely disassociated from our onetime intimacy. Who can tell?

After our stay in Cernobbio, Bernard and I arrived in Venice on the thirtieth of April and put up at the Hotel Europa. Dora had arrived before us, having traveled by the overnight train from Paris. We went and sat in the piazza. At Florian's, of course. The evening was mild, the orchestra played, the Basilica gleamed, soldiers in red-and-blue capes strolled up and down in pairs, we drank Italian champagne. No place in all the world can offer greater enchantment. Dora seemed happier than I had ever seen her. She and Bernard talked about the history of the Serenissima. We had dinner on a terrace facing the Salute across the canal, galaxies twinkling in the indolent thoroughfare.

She knew exactly what she wanted to see. Bellini and Titian, Carpaccio, Tintoretto, the mosaics of San Marco, and Torcello. We walked and walked and walked. Dora had seldom seemed so composed and pleased. She even invited us to dinner in a restaurant appropriately named La Madonna. We took her to meet Peggy Guggenheim, as it seemed fitting that two ladies who had in one way or another made

themselves important to the art of their era should come face to face.
Peggy was always content to parade her collection and flattered to have
in her house a woman who had so often inspired Picasso. (It's odd, now
that I think of it, that, despite her intimacies with numerous artists, I
cannot recall ever having seen a portrait of Peggy, not a beauty, to be
sure. She counted on her collection to create the everlasting image.)
The meeting was not a success, as both ladies liked to be catered to,
though not at all in the same way. There was nevertheless one thing
they agreed upon: that the greatest painting in Venice was the *Crucifixion*
by Tintoretto in the Scuola di San Rocco, though their reasons for
admiring it were doubtless as different as they were. When we had left
the Palazzo Venier dei Leoni, Dora said, "Madame Guggenheim merits
our compassion, but she wouldn't know how to go about being worthy
of it." Bernard asked what that meant, and Dora replied, "That's the
mystery."

After five Venetian days we drove to Milan, visited the Brera, the
Castello, and the *Last Supper*, such of it as remained, and then proceeded
over the mountains to Zurich. In Switzerland, Dora was fascinated by
the forests, insisting repeatedly that she wanted to see the tallest,
straightest conifers on the most precipitous slopes. I can't think why she
was so obsessed by these trees, but there were thousands of them, though
never enough to suit her, along the roads we took. In Basel we saw the
Holbeins, also some fine Picassos, one of which, an adaptation of a
Courbet, I had often carried from the studio in Vallauris out into the
sunlight for visitors to admire. Then we went on to stay with Balthus in
the Nièvre, arriving at midnight, not a glimmer to greet us from the
blind windows of the château. The painter had by this time found some-
one far more suitable to cater to his aristocratic needs than Léna Le-
clercq, much younger and prettier, who could also conveniently, if
incorrectly, be introduced as his niece, being the daughter by a former
husband of the second wife of his elder brother, Pierre. Her name:
Frédérique Tison. Dora and Bernard were loath to intrude upon the
darkness of the château, insisting that I should take it upon myself to
waken our host. The front door luckily being unlocked, I went inside,
turning on lights, going upstairs, and calling out the artist's name. He
appeared from Frédérique's bedroom after a few minutes, shrugging into
a dressing gown, and irritably showed us to our rooms, remarking that

any polite hour for the arrival of guests had long since passed. There was nothing we could say. In the morning he was more affable, insisting that we stay for lunch. Frédérique was quiet but self-possessed and quite as beautiful as she appears in the many portraits Balthus painted of her during this period, his finest. My grandmother's Persian carpet lay on the floor of the principal salon. Bernard, Dora, and Balthus did most of the talking, which was highly cultivated, witty, and malicious. I should have written down some of it but didn't. After lunch we drove back to Paris. Moumoune had been cared for in Dora's absence by the concierge, who was very pleased to be relieved of that duty. We left Dora and her luggage at the rue de Savoie on the eighth of May, saying that we would all meet again very soon.

We did not. I would have been stricken to be told that thirteen years would go by before I saw her again. At first I felt no change. I called her occasionally, but she put me off with some pretext or other, and I knew that she was seeing none of the friends we had had in common for years. Little by little her reclusiveness began to be talked about as a mystery, an aberration, a sad absence; it appeared that she was retreating more and more irretrievably into the confines of her faith and her church. Some even said that she had become an Oblate. But nobody knew. I was sorry not to see her. There were other people, however, other occupations, other aspirations. I traveled and wrote and had love affairs. Then in 1962 I went to live temporarily in America, something I had never expected to do. Every year I returned to France, having kept the small apartment in the rue de Lille purchased in 1958, but I didn't see Dora or attempt to. Still, it mattered much to me to be aware all the while that she was still alive, and I could not believe, or accept, that the story of our friendship—or even of the friendship with Picasso, for that matter—could have come to an end.

C H A P T E R

S I X T E E N

IN THE autumn of 1964 Françoise Gilot published a volume of memoirs entitled *Life with Picasso*. It created a considerable controversy. The admirers and toadies and the many whose livelihood depended on Picasso and on the safeguard of his reputation denounced the book as, at best, willful exaggeration and spite and, at worst, a pack of lies concocted by the vengeful former mistress. There were innumerable newspaper articles pro and con. Picasso himself behaved deplorably in character by going to court in hopes of preventing the French publication of Françoise's book, which had first appeared in the United States. He lost. But in a spirit nicely consistent with Communist tactics he craftily sponsored a manifesto denouncing the book, procured the signatures of people who put preferment before probity, and foisted this device of intellectual terrorism upon the press as an honest outcry of indignation. Few were fooled.

Among those who found fault with Françoise's book was John Richardson. Well before this time, he had at last found life at the Château de Castille intolerable and taken leave of its proprietor, a move attended by considerable unpleasantness, as was all too often the rule in dealings with Douglas. Now John was established in New York, where his native intelligence, fine feeling for art, social virtuosity, and flair for graceful writing gradually made him an eminent figure. Indeed, his eminence has today surpassed that of his one-time mentor, an irony which might

not have been much appreciated by Douglas, though the reactions of a man so perverse are by definition unpredictable. He and I, in any case, had remained irreparably unfriendly. One sunny day in 1971 I was walking along the Boulevard Saint-Germain and passed the Café des Deux Magots, where Douglas and several of his cronies happened to be seated. As I went by, Douglas shouted out in his most strident tone, "Oh no, we don't speak to that one. Everybody knows she's in the CIA." He grew more irascible as he grew older, even contriving to alienate his heroic idol, Picasso, whose late works he denounced as "the incoherent scribblings of a frenetic old man in the antechamber of death." Eleven years later, I happened to be in Geneva, walking alone up the rue de l'Hôtel de Ville, and saw Douglas coming toward me, on the same side of the street, from the opposite direction. A meeting was inevitable, but there was no knowing how it would turn out. He might strike me, spit on me, or ignore me. Instead, he stopped, held out his hand, and could not have been more cordial. We chatted for twenty minutes on the narrow sidewalk. He expressed interest in my work in progress on Giacometti, regretted a sarcastic article he had written about Alberto shortly before his death, and even had a few friendly, nostalgic things to say about John. It was our last meeting. Two years later he died, on April Fools' Day.

John's condemnation of *Life with Picasso* appeared in *The New York Review of Books*, a journal that likes controversy and to which John has contributed many outstanding articles. Picasso and his wife were still living when this hostile review appeared, and I couldn't help feeling that some of John's severity must be due to his desire to remain on friendly terms with the artist, notoriously more touchy as he grew older and older. So I wrote a letter to the editor of *The New York Review*, contradicting John's judgment and praising Françoise for having had the courage to portray Picasso as he really was, a man of galvanic genius and mercurial charm but also of ferocious egotism and unforgivable cruelty. *Life with Picasso*, I said, was the very first book to tell the truth about the most remarkable artist of our time. (It is only fair to John to say that he has since come around to this opinion himself, and in the first volume of his magisterial biography acknowledges the value of Françoise's contribution to our understanding of Picasso.)

My letter found its way to Françoise, of course, whom I had not

seen since April 1954, when she had appeared, to my surprise, in Picasso's bedroom in Vallauris. She was pleased that I had come to her defense and wrote to me, suggesting that I pay her a visit when next I happened to be in Paris. This was not until the end of October 1965, when I was on my way to the Soviet Union. I saw her then and again on my return a month later, but on both occasions we had little opportunity for conversation of much substance, as her young children were present. On the twenty-eighth of February 1966, however, she came to my apartment in New York with a young man named William Miller. They stayed most of the afternoon; we had a long talk, and I finally found out the answers to some questions that had tantalized me for twenty years.

Why, I had always wondered, had I been so readily welcomed in the first place by Sabartés, whose business it was to prevent unauthorized strangers from importuning his employer? And why had he promised, without even consulting the artist, to present me to Picasso?

That was perfectly simple, Françoise said. Both Sabartés and Picasso were fascinated, almost obsessed, by mystery, secrecy, intrigue. They even devised a cryptic manner of communicating with each other which no one else could understand, although what they had to communicate could easily have been said in private and was often of trifling import anyway. And they invented personages who didn't exist but whose activities and adventures they discussed in picturesque detail. The abrupt appearance on Picasso's doorstep of an American military intelligence officer had seemed not only normal but also titillating. They expected that he was there to find out what he could about Picasso's possible subversive actions as a Communist, as they felt certain that the Americans would want to compile a dossier on his doings. (This was not paranoia but shrewd prescience. The United States Federal Bureau of Investigation kept a comprehensive file on Picasso, begun shortly before I first rang his doorbell and lasting till the day of his death. Had the artist been assured of this, he doubtless would have been delighted, for he reveled in the idea that the bourgeois world had much to fear from the consequences of creativity.)

It was ridiculous, I objected, to fancy that I had been sent to spy on Picasso. Both he and Sabartés must have realized this almost at once.

They did, Françoise said, but not before the idea of my being a

spy—whether a real one or not was irrelevant—had become part of the secret games they played. There was more to it than that, however. For some reason which Françoise herself did not grasp, Picasso had been very preoccupied by me when he and I first met. She said that he had been delighted by the nonchalance with which I made myself at home in the studio, particularly the day when I went to sleep on the couch. Of course I hadn't been asleep at all, though I didn't tell Françoise so, but had only wanted the semblance of indifferent, slightly defiant, and childlike behavior to be representative of the relationship to a great man that I aspired to have accepted by him, by others, and by myself. The feigned limp corresponded to the same order of aspiration: a contrivance meant to achieve what I felt I could never achieve simply by being myself. But, naturally, I was being myself more than I could know, and it is ironic that Picasso all his life was given to poses, ruses, and artifice. Françoise went on to say that he talked about me a great deal, seemed, in a way, to be almost infatuated by me. She recalled his having said on some occasion, "I am a lesbian." Anyway, in Picasso's mind, she felt, I had been a sort of counterpart of her. If he had thought of her as a daughter, that is, he had thought of me as a son.

I was astounded by these revelations. At the time I had not been aware that Picasso might have any feeling for me more personal, intense, or subjective than, say, for Chapoval or any of the other young men who gathered around him. I was profoundly intimidated by him, and my fear was definitely essential to the emotional longing I felt for his company and also for his creations, most particularly should these be in my image. And I could never forget that by some impulse which the circumstances could hardly explain I had once actually claimed to be Picasso's son. Once, when we were alone together in the studio in Paris, Picasso attired only in his undershorts, I felt that should he make any sexual gesture toward me, I would be happy to respond. But he didn't. I remembered the erotic dream I had dreamed in Ménerbes and wondered whether it was I who should have made a gesture.

Before meeting Picasso, Françoise had been acquainted, she said, with Luc Simon, whom she married after leaving Picasso. I looked rather like Luc, she thought, and this, too, may have had something to do with Picasso's feeling for me. As for herself, she had realized that it was important to me to maintain the relationship with her lover, and that is

why she was aloof toward me so long as they were together, because if she had been friendly he would soon have made me unwelcome.

I inquired about her stay in Ménerbes. It had scandalized her, she said, that Picasso should have taken her to that house, which epitomized a very different aspect of his existence. But he had felt that the place was his to dispose of because it had been his gift. She also felt that Dora had been weak and masochistic in allowing him to use it. She had hated being there and once tried to run away. But Picasso brought her back and, as a supreme irony, her son Claude had been conceived in that house, which had originally been acquired as the abode of another love. Picasso had found this very amusing.

"Do you remember," I asked her, "that day in Vallauris when I came to see Picasso during the time that I was staying in Ménerbes with Dora? You were there, and I was so surprised to see you."

"He was furious," she said. "All that morning, before you came, he did nothing but find fault with you and feel sorry for himself. He said, 'It's a betrayal. I thought he was innocent and pure. I treated him like a son. You and he were my children, and now you've both betrayed me. And in his case it's a double betrayal because he's a homosexual and doesn't even like women. What's he up to?' But then he said that maybe by living with Dora you were trying to be closer to him. That calmed him down a little, and I thought there might be some truth in it. Was there?"

"I don't know," I said. "Picasso was always present between us. We talked about him constantly, but whether he brought us closer together or kept us apart or made us feel close to him I couldn't say."

I told her about the dinner at Douglas Cooper's, how unkindly Picasso had behaved. She was not surprised. "When Picasso leaves a woman," she said, "he expects her to spend the rest of her life in bitter solitude, yearning for him." Four years later, on April 7, 1970, I learned from Jean Leymarie that Picasso had, indeed, come to Castille that night solely to attack and humiliate us and that before our arrival he had irascibly expressed his animosity and planned his tactics.

Since that afternoon in New York I have seen Françoise regularly, if not often, sometimes with her distinguished husband, Jonas Salk, and have invariably been impressed by her intelligence, discernment, and common sense. Of all those who came very close to Picasso, she alone

seems to have survived the experience not only unscathed but enhanced.

During these years I heard nothing from Dora and very little about her. People said she had become a more and more obdurate recluse, and that was all.

In the autumn of '69 I was asked by a publisher in New York to write a biography of Alberto Giacometti, by that time, alas, dead. In inexcusable ignorance of biographical discipline, I accepted. Besides, I had wearied of America, yearned to return to France, and this would provide a legitimate reason, as I would have much research to do.

Of all the people I hoped to talk to about Alberto, the one with whom a possible meeting most tantalized and excited me was Dora. But everyone I knew who had once known her—Marie-Laure, Man Ray, Rose and André Masson, Sylvia Lacan—said that it would be futile to attempt to see her, as she resolutely refused to meet with anyone, seemed never to go out, and was seen by nobody. So I waited. At the end of February I wrote her a letter, explaining why I would like to see her and asking her to grant my request.

The telephone rang at 11:55 a.m. and as soon as I heard the voice at the other end of the line I realized that it was Dora, though I hadn't spoken to her for more than ten years. She sounded utterly unchanged. I said, "Hello, Dora." She was very friendly, lively, gay, laughing. It seemed marvelously like old times—sixteen years ago—and I had a feeling of extraordinary elation. She said she would be willing to see me, which I regarded as an ineffable kindness on her part, everything considered. But she would have very little to tell me about Alberto, she said. I protested that she had often seen him together with Picasso, which was important, and said I would try to encourage her to remember. "I count on you," she said, laughing, then added, "It's really to see you, though, that I'm calling." I was very moved by that. She told me that she had been reading my *Giacometti Portrait* (a short book in which I describe what happened while Alberto painted my portrait in September 1964) and that she found it a far better likeness of him than his portrait is a likeness of me. We agreed that I should go to see her on Thursday at five-thirty. When I asked whether she was sure that that would not be inconvenient, she said, "Quite sure, because I see absolutely no one."

It was with true emotion and wonder that I looked forward to seeing Dora again. She is one of the very few genuinely remarkable people I

have ever known. The idea that I would once again walk through that familiar courtyard off the rue de Savoie, climb those wide stairs smelling of wax, and ring at the large double doors . . . And then Dora would come to open with her extraordinary gray eyes, the unique tilt of her head, her oblique smile, and that lilting lovely voice which I had just heard again for the first time in twelve or thirteen years.

That apartment, where I spent so many evenings, so many hours with her, where for the space of one year I felt almost as in my home . . . I wondered how it would be now? The same? Would all the Picassos have disappeared from the walls? I knew that some had been sold, the portrait in the striped blouse, the very distorted green-and-gray portrait, both bought by Nelson Rockefeller. But it was about Dora that I wondered, how she herself would be. After so long. And yet I couldn't help asking myself whether it was possible that she could ever be other than she always was.

I can hardly say with what expectation and curiosity I looked forward to the meeting, sentiments intensified by my awareness that her willingness to see me at all represented an extraordinary exception to the rule of her present life. The few people I told that I was going to see her were astonished.

It was a sunny but cold afternoon. I walked. Streets hauntingly familiar. In a shop on the rue Saint-André-des-Arts I bought a large bouquet of tulips, then walked down the rue des Grands-Augustins and turned right into the rue de Savoie at that very corner where Picasso had first introduced me to Dora twenty-six years before. Then I came to number 6 on my left, went through the heavy door into that high, narrow courtyard, repainted but otherwise changeless. At the rear the glass door and up the handsome staircase, which I nevertheless remembered as being wider and more spacious. And there on the second-floor landing I faced those double doors I knew so well from long ago. Strange but seeming utterly natural at the same time, and I felt disconcerted, apprehensive. Wiping my feet carefully on the doormat before ringing, I noticed that there were several letters which had been slipped under the door. So Dora was not entirely cut off from the outside world, after all. It seemed odd that they were there, as mail is ordinarily delivered to apartments by the concierge only in the morning. I rang.

After a moment there were footsteps. On the other side of the door the banging of several locks being opened and bolts drawn back. The

letters were picked up by an invisible hand. And then the door did open.

My first impression was instantly of Dora's greater age. Her gray hair was arranged on top of her head, held tightly in place by a black kerchief. Her face was more lined and fuller, particularly around the jaw; the exquisite and delicate line so dear to Picasso had now disappeared. But her eyes, her voice, and the expressive quality of her entire face remained unchanged.

I entered with my flowers, about which Dora exclaimed before she had even seen them, "Oh, the beautiful flowers. Thank you very much." Then, as I put them down on a small table at the back of the entrance hall, she added, "I suppose they're for me."

"Of course!" I exclaimed, laughing. She laughed, too.

I noticed at once that the hideous and cumbersome chair sent long ago by Picasso had disappeared. But I could not imagine that it had been thrown away. Perhaps it now kept company with the rotting toilet seat and the scorpions in the dusty attic at Ménerbes. I also observed that on the door leading from the hall into the kitchen there was a large hand-lettered sign saying, "N'entrez pas!" I was very startled by it but said nothing. Since Dora had insisted that she saw absolutely no one, I couldn't help wondering for whom the admonition was intended. A ghost? And I remembered her indignation when I had first entered the kitchen, her remark that it was an honor for me to be there, as nobody but Picasso had ever been there before. Could the sign now be intended for herself?

We went into the small salon opening directly off the entrance hall. This was the room in which the glass-fronted bookcase stood and where the large Picasso still life of 1943 had always hung. Both were still there; also the small painting by Balthus, unframed but now signed. And two portraits of Dora by Picasso which I remembered. She removed the paper from the bouquet of tulips, exclaiming over their beauty, then went back into the corridor leading to the bathroom to fetch a vase. While she was gone I peered into the bookcase, its glass now dusty, and the Picasso bird was still there, the law of possession prevailing. It forbade comment. I sat down in one of the two Empire armchairs with their yellow velvet upholstery, the chairs we had always sat in long ago while talking and talking about Picasso and God. There was a tray with glasses, a bottle of Scotch, nuts and crackers, the nuts in a

blue glass bowl in which, I remembered, there had always been nuts.

When Dora came back with the tulips in a vase, she asked at once whether I would like a whisky. I said yes. She said, "I also have Coca-Cola if you prefer. Reading your book about Giacometti, I noticed that you sometimes drank Coca-Cola, so I got some."

I was more awed, really, than touched or surprised. It was a curious feeling, because I realized that she must have prepared for my visit in a way as if it were a rite. I couldn't say quite why I felt this, but I felt it very strongly. Somehow I was completely present but my presence was not my own whole, true self, while at the same time it was. I couldn't explain. But I said that I'd prefer whisky, and when Dora asked me to open the bottle, I thought that she had probably bought it also especially for me, as she said that she had given up drinking as well as smoking.

We sat down facing each other in the two armchairs, Dora with her back to the window. Only a pale gray light came in through the red velvet draperies and the lace curtains from Monglat. She had turned on three electric lights, two lamps and a hanging chandelier new to me that seemed peculiarly ecclesiastical. I had a strange sense that in this room Dora must have meetings of her religious friends or associates. She was dressed completely in black, a handsome gold chain around her neck with a single oblong lorgnon attached to it. She had on the rings I remembered, especially the star sapphire set in agate that she had bought to replace the ruby given by Picasso which in a fit of pique she had thrown into the Seine.

We talked, and I realized very quickly that Dora hadn't changed. She may have become deeply religious, more deeply so even than when we were together in Ménerbes. She may, as was rumored, have entered some kind of religious order and was leading the life of a recluse, but her profound and vital nature was unchanged. Of that, after an hour and forty minutes with her, I was positive. I knew her too well not to know that.

She announced at once that she could tell me nothing about Alberto, as she hadn't known him very well and saw him seldom with Picasso. (This, of course, was not true, and we had a very interesting discussion of relations between the two artists.)

She spoke of Picasso perfectly freely but with a sort of veneration. There was now absolutely none of the ironic sarcasm and/or bitterness that in former times was so frequently present in her references to him.

Not once was he referred to as the C and B. She said that among other artists he had been like a god, recognized and revered as such, which unfortunately is true.

As she asked about my work, I told her a little of what I was doing and hoped to do about Alberto, noticing at the same time that she asked nothing about myself, my life, my expectations, concerned, perhaps, lest such questions addressed to me lead to similar ones addressed to her. I asked Dora whether she was working. She said, "I'm doing enormous abstractions." I thought she must be joking but said nothing. Then she calmly inquired, "Would you like to see a few of them?" We went into the room which had formerly been her bedroom. Both windows were completely covered. Dora turned on two high-powered projectors on tall tripods. And, indeed, she had told the exact truth. The paintings on which she had been working were about four by six feet in size, completely abstract, composed of overlapped lozenges and diamond shapes, the edges very sharp, colors subdued. They didn't resemble the work of anyone else but at the same time peculiarly lacked a personal style and looked as though they could have been painted by almost anyone twenty or twenty-five years before, possessed none of the lyrical quality her landscapes used to have. The strange thing, however, was that she still painted these landscapes at the same time as the large abstractions. She showed me two or three of them, very romantic and beautiful. "I would like to paint much more," she said, "but I don't have time." I noticed the "frames" left, at the time of the last repainting of the apartment, to preserve the insects drawn on the wall by Picasso. It had at the time seemed absurd to us all that Dora should have gone to such trouble to preserve these insignificant doodles, but now it seemed merely an expression of her reverence for anything that came from the hand of a deity.

We went back to the salon and sat for a time still, talking about one thing or another, nothing of moment. Dora asked about Bernard, and said she didn't feel it was at all mistaken for him to have led a relatively idle life so long as it suited him and inconvenienced nobody.

Then it came time for me to leave. Rather, I felt that nothing remained to be said. I hadn't spoken of Alice Toklas or Marie-Laure, so recently dead, which I regretted. But it had become time in the gathering dark to say something personal, and as there was obviously no possibility of that, I had to go.

"Well, I'm going to leave you now," I said.

Without a word Dora accompanied me into the hall. "I've been very glad to see you," she said when I'd got my overcoat on.

"So have I," I said. "I'd like to see you again. But I suppose . . ."

"I see absolutely no one," she hurriedly interrupted. "Besides, I haven't time."

"Yes, yes," I awkwardly agreed. "I understand. I only thought . . ."

"It's very kind of you," she said, and she smiled strangely—with embarrassment, I thought—a peculiar, oblique grimace. Then suddenly she seemed for a moment like a very old woman. As a matter of fact, for an instant it seemed to me as though I'd caught a glimpse of her lying in her coffin.

We shook hands. There would have been no question whatever of kissing her. I said goodbye and went downstairs as the locks and bolts clattered behind me, and outside, into the cold, windy Parisian evening. Thinking of so many moments. Remembering.

That first night we spent together in Ménerbes, when we reached the top of the stairs and there was a palpable, prolonged, specific pause. If I had been different, forceful, effective, then perhaps both our lives would have turned out differently. It is perfectly true that there were moments when I thought of asking her to marry me. But I didn't. *I* would have had to be so different. And Dora? And Picasso? Nothing in our lives can change unless we can transform ourselves. She knew that.

Why did she say several times that she was busy? Busy with what, with whom? So busy she hardly had time to paint. Busy with her religion, perhaps. Like Bernard's, I suppose her life can be counted satisfactory so long as it suits her.

Dora, Dora. No doubt the test of achievement in living terms is simply to survive with some kind of positive persona intact. She has done that. But at what cost?

•

It was some years before I communicated with her again or endeavored to see her. But from that time onward every year I sent her flowers on November 22, her birthday. She acknowledged them only once.

On the nineteenth of March 1973, my brother called me from America to say that if I wanted to see my father once more I should hurry. I left the next morning. He died six days later, having been fully conscious only occasionally. He was ninety. He had wanted no religious

service, so his ashes were interred on March 30 in the town of his birth in Connecticut next to the grave of his father, James Burnham Lord, after whom I am named.

Why Dora was the only person in Paris to whom I wrote announcing this bereavement I do not know. I was not profoundly shaken by the loss of my father, far more so by the grief that it caused my mother after fifty-four halcyon years of marriage. She told me later that in the last years of his life my father had feared for his sanity, feeling he was losing his hold on reality, uncertain of who he truly was. That did shock me. Anyway, I wrote to Dora to tell her of my father's death.

And then on the ninth of April the front page of *The New York Times* carried the news that Picasso had died in Mougins the day before. The juxtaposition of the two deaths startled and moved me. It seemed more than a coincidence, and obscurely adumbrated, I thought, a significance which it was not important that I should understand. I had only to feel that it was significant for it to have its effect. To have pretended Picasso was my father twenty-eight years before was not without its relevance now; also, as Françoise had told me, he in some peculiar sense had regarded me as a son. And so he was dead at last, aged ninety-one.

A week later I received a letter from Dora.

12 April, 1973
Dear James,

 I take part in your bereavement and your affliction.
 And since, a death which touches you less closely but which has certainly affected you: Picasso.
 Write to me when you have returned to Paris. We will meet.
 My sorrowing sympathy,

 Dora

I did write to her when I was settled again in Paris. She telephoned me and we fixed a day in mid-June for our meeting. It was glorious, but in Dora's apartment the light was gray. Her appearance had not changed noticeably since our last meeting, but her manner was not the same. She seemed hurried, as if an important engagement were being delayed

for my benefit, and this did not make for easy conversation. We talked briefly about Picasso. Dora was indignant that he had not been given the last rites and had not been interred according to the prescribed ceremony of the Church. In his heart, she felt certain, as a Spaniard, he would have wanted that, no matter what was said or thought by the irresponsible and amoral people who took advantage of him in his last years. Her own father, she said, had died not long before, after a lingering illness during which she saw him daily and cared for him despite his incessant complaints and his insistence on staying at the Hôtel du Palais d'Orsay till the end. She asked me how my work on Alberto's biography was progressing. Very slowly, I said. Little could I have dreamed that twelve years were still to pass before its publication. Then she said that one of the advantages of seeing no one was that the gradual deaths of one's old friends were not a deprivation. Marie-Laure, for example, who had died three years before, was quite as alive for her as ever. There was something chilling, I felt, about this view of life, as if she were seeing it already from the tomb.

"Are you working still?" I asked.

"More than ever," she said. "But I have so little time for painting. Art, after all, only embellishes truth. It is not truth itself."

I didn't ask her what truth was, because she had long ago made it plain that in her judgment I had no aptitude for recognizing it. And now she must feel that I teetered no longer on the edge of the abyss but had sunk to the very depths of it. Her own status on the heights of revelation and certainty seemed to me to constitute for her a positive footing from which she could condescend to make herself briefly accessible to the likes of me. This sense of her infallibility and pride had always been pronounced. Now it was more so, confirmed, I thought, by the sign on the kitchen door. I said that I would have to be going.

"Yes," she said, rising, "it's time."

At the door we shook hands, and I was reminded of the first time we had shaken hands. She was no less aloof now. I said goodbye, and she did not suggest that I should call her. As I went down the staircase I thought it was for the last time, but it also occurred to me that perhaps I was unjust, for Picasso was now dead, and maybe that animal fact altered everything between Dora and me.

On Wednesday, January 9, 1980, I wrote to her, enclosing a clip-

ping from *The New York Times*, an author's query which asked for
information concerning her life, for eventual use in a biography and
"documentary drama," whatever that might be. She called me the next
morning, as I had expected she would, because, as I also expected, the
prospect of having anything written about her life is unappealing to her.
It's odd that this should be so, because she is at the same time very
proud of her place in history, not only as a great artist's mistress and
model but also as the most remarkable and intelligent of the many women
he loved. And one would have thought that a person on such self-assured
terms with truth, so certain of absolution and so confident of the hereafter,
would not deign to be bothered by any disclosure concerning her mere
mortal life. By what revelation, after all, could she possibly be intimi-
dated in the prospect of eternity? Is it conceivable that she, like everyone
else, has secrets kept even from herself? In any case, she asked me to
come and see her on Saturday at six.

When she opened the door, I found before me a little old lady,
stooped, entirely in black, who looked up at me with the same beautiful
eyes but with a quizzical, mournful expression and a crooked smile. We
shook hands. After closing the door, she went ahead of me to the salon,
and it was obvious that she had difficulty walking. She knew that I would
notice and said, "Rheumatism. Nothing to be done about it." The voice
was as enchanting as ever, but there was no whisky this time. We sat
in the same chairs. I noticed at once that the large still life had dis-
appeared and asked where it was. "I sold it to the Kahnweiler Gallery,"
she said, and I wondered what in the world she could have needed so
much money for. Her living expenses had to be minimal, she paid no
rent, never entertained, had no servants, no automobile, and no depen-
dents. Heinz Berggruen had recently told me that he had bought two
prints from her, the *Minotauromachia* and *The Woman with a Tam-
bourine*, and paid premium prices for them, in hopes of obtaining other
things later. Maybe the money was for the Church.

I told her that I had spoken by telephone with the self-appointed
author of her biography and that he had said he intended to develop
"the feminist angle."

"Picasso took care of the feminist angle," Dora said, "and that's
enough of that. Besides, I don't want anything written about me. It would
only be sensational trash. Writers are traitors, anyway."

"That's not very flattering," I said. "And what are painters?"

"Picasso proclaimed that paintings are lies that tell the truth. Was he wrong? You know that large picture called *The Charnel House*. It's been interpreted to depict the horrors of the Nazi camps. But it was I who led him to do that painting. Picasso and I went to the movies one night at the Salle Pleyel, it must have been sometime in January of '45, and the film had something to do with Spain. One of the images showed a murdered family in a kitchen, lying in a heap in front of a table. I admired it and Picasso developed his picture from that image. This was long before the first photos of the camps appeared. But people thought the painting was inspired by those photos. And Picasso himself later claimed that it was. There was the lie. Maybe that's why he never finished it. But now it's seen as a companion piece to *Guernica* and everyone believes that it represents the horrors of the camps. The fact is that no other painting suggests those horrors so effectively. There is the truth."

I didn't want to argue the issue, because by definition Dora was always in the right. With her I certainly fell under the old charm, but it didn't seem so effective. I felt more than ever a hardness, something almost rapacious about her. Maybe it was this that impelled me to mention the little bird that she had given to me twenty-five years before, then taken back. She pointed to the bookcase and said, "It's right there, and it's yours. But you paraded it. You rather defiled it by parading it. Still, you will have it someday. I made a provision in my will. You gave me many presents, though, so I'll give you some."

She got up and went into the other room, returning very quickly with a yellow folder containing two drawings, still lifes of apples. I thanked her and admired the drawings. They were painstakingly representational, the sort of academic studies one might have expected from a Beaux-Arts student of mediocre talent. I was surprised. She asked whether I would like to see her recent work. I would rather have liked to say no. She was still working on her enormous abstractions, which did not appear as indifferent as I'd thought when I first saw them. They have a personal quality and do seem to hang together as compositions. As works of art in the absolute, however, I thought them lacking in significance. Dora does not share that opinion. At least, she would never allow a hint of doubt to be perceived. Several times she remarked that she was absolutely sure of herself so far as the future was concerned: it

would recognize the enduring quality and unique accomplishment of her work. I was embarrassed by the repeated affirmations of certainties. Never, never would Picasso or Alberto or Miró have made such statements. And there was a bizarre contradiction about them: she refuses to be written about, to allow the world to see her, and yet she yearns for recognition and acclaim. I believe the yearning to be the true Dora. But her pride demands mortification. Or is it her faith? There she sits alone with her hubris and money and Picassos. All alone. Will posterity be kind?

It was time to leave. She made no move to have me stay a moment longer. I was anxious to go, yet saying goodbye pierced me with sadness.

Meanwhile, I was busy finding out about Alberto's life as much as I could, finding out at the same time something about my own, and I didn't worry about Dora, never went near Ménerbes, and dreamed only occasionally of Picasso, though enamored still of my likenesses created by him.

One Monday in mid-December of that same year, 1980, I was startled to hear Dora's inimitable voice on the telephone. She inquired about my health, wished me a Merry Christmas, and asked whether I was planning to go away for the holidays. As it happened, I was. In that event, she said, she would like to come to see me, because there were one or two matters in regard to which she would be pleased to have my advice. I was flattered, amazed, and felt even a little flutter in my chest. That she should turn to me for advice after so long, after all, after everything: it must signify some sentiment, a trust, a confidence, perhaps even a future. And there was nothing that I wanted more—even then, even now—than her confidence and friendship. But the skeptical whisper of caution and doubt insinuated itself into an awareness, and I suspected she must have some motive only slightly stimulated by friendship. I told her to come the very next day if convenient. It would be, she said, at four o'clock, just in time for a cup of tea. How like her to take the politesse of tea for granted, just as she had autocratically taken for granted that I must have tea the first time I went to her apartment.

She arrived at four sharp, so punctually that I thought there must be something businesslike about her visit, and realized I'd forgotten in my happy anticipation that she was coming for advice, not for the sake of friendship or for conversation about the goddess of memory, mother

of the muses. She was dressed entirely in black, with a black fur toque, and more than ever gave the impression of being a little old lady, hunched and lame. Before she could remove her overcoat, she had to remove an oversized purse, which was attached across one shoulder with a very tight black leather strap, and she had considerable difficulty passing this strap across her fur hat. But I knew it would be untoward—and unappreciated—for me to try to help her. Purse-snatching was not prevalent in Paris, but if some ruffian had attempted to snatch Dora's purse, he would have yanked her right off her feet. It would have been far more sensible of her to carry a purse of normal size with very little money in it, prepared to lose this if attacked. But that would not have been Dora. She seated herself on a sofa and kept the purse close beside her.

I employed at this time a charming but embittered French maid named Antoinette, who served the tea with prim pre-war style, which Dora noticeably appreciated and, I thought, deemed a little too good for me but made a show of considering *de rigueur*. While we sipped our tea and nibbled thin cookies, we talked about matters of no consequence, laying a basis of casual interchange preparatory to the seriousness of whatever "advice" she wanted. I suspected that in her case the advice would amount to something more utilitarian than verbal counsel. I was right. After all, to have brought Dora out of her seclusion—and into my presence—some advantage to her must have been at stake.

It concerned the little bird by Picasso that she had given me so long ago. She had a plan. What a good idea it would be, she said, to have this object cast in bronze. That eventuality had been brought up between us before, but it was during the artist's lifetime and we had sensibly assumed that he would refuse to allow casts to be made from an object so unimportant, although he had authorized castings of numerous little things even less noteworthy—these, to be sure, his own property. But now that he no longer had a voice in the matter, it might be advantageous to broach the issue again, this time with a person less likely to be capricious, to whom some advantage would accrue, someone who was on friendly terms with me, the artist's son Claude, who at this time dominated the decisions taken by Picasso's heirs. Dora's idea was that I should obtain permission from Claude to have the bird cast in bronze in an edition of eight, with two additional artist's proofs, which he would be welcome to keep for himself, and as compensation for my

role as intermediary Dora would give me one of her eight bronzes. The flagrant niggardliness of this proposition was typical, did not surprise me, and did not influence my response. I had no desire to fall in with Dora's scheme, but I said that in order to broach the matter with Claude I would have to have the original object in hand to show to him. Perhaps, I hazarded, Dora had brought it with her. Not at all, she said. Claude would be able to judge perfectly well by the photograph reproduced in the book on Picasso's sculpture. It is true that at this time I was quite friendly with Claude, but I knew that he was harassed by people wanting all sorts of favors and profits from the Picasso estate. I would never have agreed to try to exploit our friendship. Oh, if it had been a question of some Cubist masterpiece, I might have been less fastidious, but I had long since ceased my dealings as an occasional peddler of art. I knew that Dora would be too proud to approach Claude personally, he the son of the woman who had ousted her from Picasso's existence, a living symbol of her humiliation and anguish. If her plan was to succeed, it must be with my participation, so I thought I might insist a bit in hopes of recovering what was, after all, my property, and said that I could not undertake to approach Claude unless I had the actual bird in my possession to show him. That, Dora replied peremptorily, was altogether out of the question. Though indubitably mine, it would stay where it was, and under no other circumstances did she care to discuss the matter. Well, I said, that was that.

But it was not all. Did I, she inquired, know of an American collector of photographs named Samuel Wagstaff? Yes, I had known Sam when he was still poor, living in a one-room apartment on First Avenue, when he was as handsome and cheerful a young fellow as one could hope to meet. We had seen little of one another in recent years, as he lived in New York and came rarely to Paris, but I knew that he'd amassed an extraordinary collection of photographs. He had even called me once or twice in hopes that I might persuade Dora to sell him some of her early photographic works. I wrote to her, transmitting the request, but she did not answer. Now, however, having somehow acquired one or two of her Surrealist photos, Sam had published one in a volume of twentieth-century photographs. His letters requesting permission for publication and inquiring as to the fee had gone unanswered, and he had published the photo anyway and now wished to know what fee she

would expect to be paid. Dora assumed that I would be able to tell her, but I hadn't the least idea and suggested she ask Henri Cartier-Bresson, whom I knew to be an old friend of hers and who would certainly be able to advise her. Well, that was a possibility, she said. But Henri told me later that he never heard from her, adding that it was sad to think of her long-ago charm and beauty and to realize that her heart must be an empty husk. It had probably been forty-five years, he said, since she had made love, and that must be the tragic explanation of her present life.

She stayed on for quite some time, talking of Picasso, Paulo, Françoise, the other children, also Alberto and Balthus and André Masson. Now that the ulterior motives had been discussed, it was evident that she enjoyed talking. I thought that the strict seclusion in which she lived must be a severe mortification and—at the same time—a demonstration of overweening pride. We did not speak of our own past. She asked about my work on Alberto's biography and talked at length about her painting. Once more she proclaimed her absolute certainty that posterity would recognize the distinction of her work. Consecration, she said, was inevitable. I was embarrassed by this boasting and did not respond.

Antoinette had taken away the tea service and turned on the lights. Dora by that time had been in the apartment for nearly two hours, and she showed no sign of preparing to depart. I don't know how long she might have remained had it not been for the sudden arrival of my friend Gilles Roy, the young Frenchman with whom I had then been living for more than five years. I introduced him to Dora, who had some difficulty getting to her feet to shake hands with him. She then announced that she must leave. There was the same difficulty in attaching her purse as there had been in removing it. I accompanied her to the elevator. We shook hands, and I said that I hoped that we might meet again soon. She replied that she was very busy and that she expected everyone she knew to respect the imperative pursuit of her affairs. I said that I understood. She got into the elevator and was gone.

•

One day in the winter of 1984, prompted by some twinge of nostalgia, I went to the rue des Grands-Augustins and walked into the courtyard which I had first seen forty years before. It was unchanged.

In the left corner, the same semicircular staircase with its wrought-iron balustrade led upward. On the door of the first landing was a sign saying *Gardienne*, which is a euphemism for "concierge," now for some modern reason thought to be demeaning. I went up. Ugly gray linoleum had been put down on the steps and landings. As I reached the second floor, where Inès had formerly lived, I heard a door thrown open and a woman's voice behind me calling out, "What is it? Who's there? Where are you going?"

Instead of continuing my climb—and I didn't have the least idea of what I was climbing toward—I stopped, embarrassed, as if caught in a situation that put me in the wrong. So I went back down a few steps and found myself confronted by a woman in her fifties, in unkempt attire, with dyed orange hair. This was obviously the *gardienne*, a person whose self-importance and Gallic factiousness were immediately apparent. I said, "I just wanted to have a look. I used to come here long ago."

"It's private," she said. "I am the *gardienne*. There's no Picasso here. It's finished, all that, long ago. I am the *gardienne*."

"But I just wanted to see," I protested.

"No," she shouted. "It's private here. I am the *gardienne*. And all the rest, it's finished. No Picasso here. It's old, old, all that."

"So am I," I said. But I went back down the staircase with exactly the feeling of a child caught trespassing. But trespassing while engaged in an imaginary game with himself, one that left him utterly vulnerable to the misunderstanding, the criticism and blame of adults, defenseless against their incomprehensible prerogatives. So Picasso had once again exercised his old power.

•

I continued to send flowers to Dora on her birthday. She did not acknowledge them. Except once. On the twenty-second of November 1987, she called me in the early evening and after brief salutations at both ends of the wire she said, "Thank you for the eighty years." I wondered immediately whether anyone else had thought to commemorate this birthday, a dramatic one for anybody. I told her that I would be very happy to pay her a visit, but she politely declined, saying that she was very busy and in any case saw absolutely no one. What could I do but acquiesce? I had written to her once or twice in recent years,

requesting that she see me, but she had always refused. Our conversation was not long. Her voice remained as melodious and haunting as ever. Had someone told me that day that I would never hear it again, I don't think I would have been surprised. I have never heard it since. The Dora with whom I drove to Chartres in the middle of the night is not the person with whom I might now converse. Nor am I the impetuous young man who long ago had had unrealistic dreams. Still, she shall have flowers in November year after year till the last.

From my journal:

Paris, May 5, 1989
This night I dreamed of Dora. It had been some time since that happened. Oddly enough, there was nothing whatsoever of the dream to remind one of Picasso. As if he had never existed. Dora was in her apartment, which was also her studio, and the time was clearly some forty years ago, because she was still young, beautiful, as she had been then. We were talking. Her voice was as exquisite as ever, that high, very clear, delicate birdsong best heard at sunset. The conversation was easy, pleasant, even affectionate. Then she went out of the room for a few moments, and I thought how delightful it would be if I were to live upstairs so that we could be together always, not behind the same door precisely, but conveniently adjacent to one another. Nor do I suspect that there was any scheme or ulterior motive in this desire, though I can't swear to that. I noticed by the window a small painting, yellow and orange, an abstraction, of wavy, parallel lines, which I felt I would be pleased to have. Dora returned to the room, and I held her in my arms, happily, securely, with my face pressed down upon her neck. So we remained for some moments, while the sense of lovely contentment completely entered me, and I felt that she must be satisfied also, for the whole scene was suffused with a gleam and revelation of serenity. Then I woke up, alone, and on the walls of my room, I quickly realized, were portraits of me by her, by Picasso, Balthus, Alberto, and a few others. But I was completely alone. I thought it very sad I would never see her again.

It was just forty-five years ago that I saw her for the first time.